Science
and the Arts
in the Renaissance

FOLGER INSTITUTE SYMPOSIA

*Compiled by the Folger Institute of Renaissance and Eighteenth-Century Studies and
Published by the Folger Shakespeare Library*

FOLGER INSTITUTE CENTRAL EXECUTIVE COMMITTEE

An influential collaborative enterprise founded in 1970 and now co-sponsored by twenty-one major universities, the Folger Institute is a rapidly growing center for advanced studies in the humanities. Through support from such agencies as the National Endowment for the Humanities and the Andrew W. Mellon Foundation, the Institute offers a complex interdisciplinary program of seminars, workshops, symposia, colloquia, and lectures. The physical center of the Institute is the Folger Shakespeare Library, an independent research library administered by the Trustees of Amherst College and located on Capitol Hill in Washington.

Science
and the Arts
in the Renaissance

Edited by John W. Shirley *and* F. David
Hoeniger

Folger Books
Washington: The Folger Shakespeare Library
London and Toronto: Associated University Presses

Associated University Presses
440 Forsgate Drive
Cranbury, NJ 08512

Associated University Presses
25 Sicilian Avenue
London WC1A 2QH, England

Associated University Presses
2133 Royal Windsor Drive
Unit 1
Mississauga, Ontario
Canada L5J 1K5

Library of Congress Cataloging in Publication Data
Main entry under title:

Science and the arts in the Renaissance.

 1. Science and the arts—Addresses, essays, lectures.
2. Arts, Renaissance—Addresses, essays, lectures.
3. Science, Renaissance—Addresses, essays, lectures.
I. Shirley, John William, 1908– . II. Hoeniger,
F. David.
NX180.S3S35 1985 700'.1'05 82-49312
ISBN 0-918016-69-X

Contents

Foreword

Science and the Arts in the Renaissance originated as a two-day symposium initiated by the Folger Institute of Renaissance and Eighteenth-Century Studies, co-sponsored by the Smithsonian Institution's National Museum of History and Technology, and supported by a grant to the Folger Institute from the Education Programs division of the National Endowment for the Humanities.

The first day's sessions took place on Friday, October 27, 1978, in the Theatre of the Folger Shakespeare Library. After listening to and discussing three papers on "Rationalizing the Order of Things" and three more papers on "Expanding the World in Time and Space," participants took a break for dinner and then reconvened in the Hall of Musical Instruments at the Museum of History and Technology for a concert by the Library's early music ensemble, The Folger Consort. The evening concluded with an elegant reception in the Hall of Ceramics and Glass.

The second day's sessions took place on Saturday, October 28, in the Carmichael Auditorium of the Museum of History and Technology. Three papers in the morning on "Measurement and the Arts" were followed by a lunch break, a guided tour of the Smithsonian's collections of early scientific instruments, and an opportunity to view a special exhibit of rare books (some from the Folger, some from the Smithsonian) in the Dibner Library of the History of Science and Technology. Then everyone reconvened for a roundtable discussion moderated by Otto Mayr, Acting Director of the National Museum of History and Technology, and yet another lovely reception, this time in the Flag Hall of the Museum.

Thanks in large measure to the conscientious efforts of Mary Rosenfeld, Curator of the Dibner Library (who supervised the assembly of the exhibit of "Rare Scientific Books and Instruments"), Silvio Bedini, Deputy Director of the National Museum of History and Technology (who introduced the guided tour on the second day of the symposium), and Otto Mayr (who committed the Museum's resources to the symposium, commissioned a handsome commemorative poster for the occasion, and participated in the planning of the

event from its inception), "Science and the Arts in the Renaissance" was a pleasant and enriching program—and one that the editors and most of the participants in this volume still recall with delight. Its special ambience is one, alas, that can never be recaptured. But, thanks to the editorial labors of David Hoeniger and John Shirley and the hard work of those who have been so gracious as to contribute to the present volume (including two scholars who were unable to attend the meetings back in 1978), we are now pleased to offer a legacy that may be of equal value: a book that records, in a more enduring form, something of the essence of the occasion.

I speak not only for the editors but also for the Folger Institute when I lament the unavoidable delays that have caused so much time to elapse between the conclusion of the symposium and the publication of the volume proceeding from it. One measure of the change that has occurred in the meantime is to be found in the difference between the brochure announcing the symposium and the page listing the current membership of the Central Executive Committee of the Folger Institute: in 1978 there were thirteen universities co-sponsoring the Institute's various activities, whereas now there are twenty-one. An even more dramatic measure of the elapsed time may be found on the Mall of the Smithsonian. Over the entrance to what in 1978 was known as the National Museum of History and Technology is a banner proclaiming the new name of that splendid building and collection: the National Museum of American History. One thing that hasn't changed, paradoxically, is the Foucault Pendulum. It still swings the way it used to, facing Horatio Greenough's statue of George Washington across the Hall of Flags. And whether thereby hangs a tale I suppose only Shakespeare knows for certain.

John F. Andrews

Introduction

The idea of this book was conceived during the planning of an interdisciplinary conference, "Science and the Arts in the Renaissance," initiated by the Folger Institute of Renaissance and Eighteenth-Century Studies in the summer of 1977. A two-day symposium was presented in October 1978 under the joint sponsorship of the Folger Shakespeare Library and the National Museum of History and Technology of the Smithsonian Institution. Supported in part by a grant from the National Endowment for the Humanities, the symposium attracted a gratifyingly large number of scholars and other participants interested in the Renaissance. The papers presented during the sessions spurred heated discussion, both among the contributors and between them and the audience. This lively response reinforced the idea of the organizers that the symposium should be followed by a more permanent record. It also convinced them that this volume should not simply record the papers as presented, but rather should reflect the second thoughts of the contributors. Two of the participants of the conference were entrusted with the task of compiling and editing such a volume for the Folger Institute, and the fruits of their labor are offered in the pages that follow.

The original purpose for the symposium was expressed as follows:

> Between 1450 and 1700, a revolution in astronomy and physics, associated with the names of Copernicus, Kepler, Galileo, and Newton, transformed Western cosmology and laid the groundwork for the development of modern science. This revolution was a strikingly successful part of a larger movement in the Renaissance, a movement characterized both by the vigorous pursuit of fact in the world of phenomena and by the attempt to bring the resulting wealth of new information under the rule of rational principles and ordering. Mathematics and geometry were developed and applied to the rational ordering. Measurement, observation, experiment, and classification were extended to a variety of new areas, including the fine arts and the practical arts. Although less dramatic in its consequences than the revolution in astronomy and physics, the resulting revolution in the arts had a transforming effect on the understanding of the world of nature and the world of the arts.

Alistair C. Crombie of Trinity College, Oxford, was involved in the planning for the symposium from the beginning, and he prepared a paper to provide the broad philosophical basis for the ensuing discussions. A summary of Dr. Crombie's paper was sent to all prospective lecturers in advance to give the symposium a sense of direction and unity. This paper opened the symposium and it naturally begins this volume.

Although Dr. Crombie's paper was retained in close to its original form, the editors urged other contributors to revise their papers (some of them drastically) to incorporate some of the substance of the symposium discussions and to give the essays greater appeal for the general reader. The editors also took the liberty of omitting some of the papers given at the symposium which were too specialized for a reasonably unified book and of adding two additional papers on subjects not covered at the symposium but believed to be essential parts of the interaction between the sciences and the arts during the Renaissance.

Since the whole experience of the symposium proved highly stimulating for both participants and auditors, the Institute and editors hope that the resulting book—though in some ways quite different from the symposium—will be attractive to an even wider audience of those generally curious about the role of science and the arts in a period when each underwent explosive development. After all, the Renaissance does represent both a high point in Western culture and the beginning of the modern era. In exploring this phenomenon, the present volume is designed to be somewhat more comprehensive than the symposium was. It would be idle to claim that any tight unity has been achieved in this attempt, for any such unity would have had to come at the sacrifice of some diversity in the areas covered as well as in the approaches to them. Yet the reader of this book, we feel confident, will find frequently as he reads one essay that his thoughts are wandering back to passages in another; for instance, when Professor Mahoney is debating a thesis by Professor Edgerton (though not necessarily that of his revised essay in this volume) or when Professors Ackerman, Hoeniger, and Ritterbush each feels the need, though in different contexts and as parts of different arguments, to refer to Hans Weiditz's extraordinarily artistic and realistic botanical illustrations of Brunfels's herbal.

The reader is free, of course, to approach the individual contributions in any order that appeals to his interest, but it might be helpful for the editors to indicate why the essays are arranged as they are in this volume. Alistair Crombie's paper, placed first, provides essential background on the philosophical outlook of the period from Alberti in the mid-fifteenth century to Galileo in the early seventeenth, with a basic thesis showing—in their analytical, rational, and creative approach—how much the great artists and scientists had in common. While most of the following essays develop arguments on more specific subjects or disciplines, most of them involve the context of ideas and happenings of the time. J. L. Bylebyl describes the development in Italy of the learned medical profession over the course of three centuries from ca. 1300 to 1600,

showing how leading physicians were affected first by medieval Aristotelianism and then by Renaissance humanism before they asserted more and more their bold independence from the philosophers in both their medical teaching and their practice. In the third essay P. M. Rattansi gives a lucid account of some of the chief tenets of Paracelsus's Neoplatonic and highly peculiar medical philosophy, which for a while was to challenge all orthodox medical tradition. Rattansi shows how Paracelsus's vitalism and emphasis on the power of the imaginative faculty, dismissed by the mechanical philosophy of the seventeenth and eighteenth centuries, once again exercised a strong attraction for such Romantic poets as Blake, Coleridge, and Wordsworth.

In the fourth and fifth essays we move from abstract and philosophical overviews to exploration of more practical and applied arts. C. V. Palisca examines the revolution that was occurring in music. Following discussion of the acoustical theories devised by philosophers and scientists for both musical theory and practice, he shows how toward the end of the Renaissance musical theorists found such speculations increasingly unsatisfactory and tended to dismiss them, stressing instead the need for independent, empirical investigation. Next J. W. Shirley emphasizes the crucial role that the burgeoning sciences of astronomy, mathematics, and physics were beginning to have on the practical art of navigation. He shows how the theorists of the universities became involved and how the most advanced mathematical innovator of the age, Thomas Harriot, employed his new theories in the solution of some vexing practical problems of his time.

The final five essays concentrate more specifically on the interrelation of the new science and the fine arts. J. Ackerman, an art historian, shows how fifteenth-century painters conceived their art scientifically and attained their fresh goals with the aid of mathematics and optics. He also considers the later contributions of artists to the teaching of anatomy and botany, as well as to the more limited technological developments in architecture and architectural drawing. Similarly, the role of both artistic and realistic illustration of plants and animals is part of the next essay by F. D. Hoeniger. But in addition to showing the contribution that illustrators made, Hoeniger also points out the danger that the sheer appeal of pictures distracts readers of botanical and zoological books from their real content—the text. He describes how, after long delay, the mid-sixteenth century saw a remarkable upsurge in the study of plants and animals by naturalists, and how in Gesner at least we find indications of an interest in morphology and in other aspects of the science of biology. The eighth essay, by P. C. Ritterbush, also involves art and living creatures but from quite a different angle. Taking his initial clue from seventeenth-century collectors' cabinets whose drawer fronts are resplendent with naturalistic paintings of insects and small plants, Ritterbush argues that at this time artists and scientists were still thinking alike in that they shared the habit of viewing organisms as symbols, though in ways that refined the allegorical imagery of the Middle Ages.

In the ninth essay S. Y. Edgerton reverses the coin; he asserts that it was art

which contributed to science. Scientific illustrations, he contends, represent a totally new development and a new form of "visual language." Had Galileo not been educated in this language, Edgerton argues, he could not have made the scientific discoveries he did. It was science which followed the new art and not the reverse. To bolster this thesis, Edgerton contrasts the incongruous use of "scientific illustrations" in non-scientific Chinese books after they had been introduced from the West. The final essay, that of M. S. Mahoney, takes violent issue in a provocative and dramatic opposition to the thinking of more than one of the book's other authors. Mahoney completely rejects the thesis that technical innovations by such fifteenth-century artists as Alberti laid any essential background for the scientific revolution. Scientists, even in the seventeenth century, he insists, dependent as they were on geometrical explanations, were able to communicate visually not the manner of a machine's operation but only what it looked like. No clear communication of the laws of dynamics was possible, Mahoney contends, until there was more mature development of algebra; only then could the scientific revolution be complete. In summary, though the contributors to this book show in many ways the interaction between the sciences and the arts in the Renaissance, the final essay once again stresses the crucial role of invention in mathematical thought in the development of what we call the modern world.

As editors of this book, we wish to express to the Folger Shakespeare Library our gratitude and delight both for inviting us to participate in this symposium and for entrusting us with the shaping of the resulting book. These editorial duties enabled us to continue a happy and fruitful dialogue with those who stimulated our thinking during the symposium. At the same time, we welcome the fresh contributions of two distinguished historians of medicine. Not only have we learned much from our colleagues, expert in disciplines other than our own, but we also have been pleased to find that as Renaissance scholars they were delightfully broad and human as well. Particular gratitude must be expressed to John Andrews, Chairman of the Folger Institute, without whom neither the symposium nor this volume would have happened, and to his former Associate Chairman, Susan Zimmerman, with whom we had many day-to-day contacts during our wrestling with the text. Both have been understanding of our frailties, physical and intellectual, and have given us support in every instance. We pay them our respect and remain in their debt.

F. David Hoeniger
John W. Shirley

Science
and the Arts
in the Renaissance

Science and the Arts in the Renaissance: The Search for Truth and Certainty, Old and New

Alistair C. Crombie
Trinity College, Oxford

"Man is to render praise to God": so wrote Leon Battista Alberti in the mid-fifteenth century, "to satisfy him with good works for those gifts of excelling *virtù* that God gave to the soul of man, greatest and preeminent above all other earthly animals."[1] Works could satisfy their creator with those qualities of *virtù* in any kind of activity ranging from the conduct of family life to painting and architecture. All when they did so shared the common characteristic indicated by Alberti when he explained by the method of perspective for "the painter how he can represent with his hand what he has conceived with his mind."[2]

The term *virtù* in Renaissance Italian indicated a style of intellectual and consequently practical behavior. A man of *virtù*, acting rationally in the image of his creator, was a man with intellectual power *(virtù)* to command any situation, to act as he intended, like an architect producing a building according to his design, not at the mercy of fortuitous circumstance or *fortuna*. Whether in mind or matter, in the natural sciences or the constructive arts, in private or political life, a man of *virtù* aimed always to be in rational control of himself as a moral being and in relation to his fellow men and to nature, in control of what he did and what he made. He was the rational artist in all things.

The conception of the *virtuoso*, the rational artist aiming at reasoned and examined control alike of his own thoughts and intentions and actions and of his surroundings, seems to me to be of the essence of the European morality, meaning both habits and ethics, out of which the European scientific movement was generated and engineered. In this context the rational artist and the rational experimental scientist appear as exemplary products of the same intel-

lectual culture. The rational perspective artist formed in his mind a conception of what he would represent by an antecedent analysis of visual clues organized optically by geometrical perspective; the rational experimental scientist proceeded likewise by an antecedent mathematical and conceptual analysis of his subject matter. They shared an intellectual commitment to the cultivation of *virtù*. This common commitment offers an invitation then to relate the styles of scientific thinking in any period to contemporary styles of thinking in the arts, in philosophy and theology, and in practical affairs. It offers likewise an invitation to analyze the various elements that make up an intellectual style in the study and treatment of nature: conceptions of nature and of science, of scientific inquiry and scientific explanation, of the identity of natural science within an intellectual culture, and the intellectual commitments and expectations that affect attitudes to innovation and change. These questions again, asked comparatively of different cultures, offer a culturally integrated view of the historical problem of the unique origins of modern science in the society of Western Europe.

The scientific movement has been concerned with man's relations with nature as perceiver, as knower, and as agent. If we can characterize the whole intellectual tradition of Western science by the original Greek commitment to the ideal of deciding by argument and evidence all questions about what exists and about what should be done, we can see in the origins of modern science a series of Western responses to the recovery of ancient thought made by a new society with some different mental and moral commitments and expectations. Medieval and early modern Europe had a different view of nature and of man and his destiny, a different theology, a different economy, and a different view of technology. We may distinguish three broad stages of intellectual response and orientation, each developing a characteristic style of formulating and solving its problems.

With the first intellectual impetus given by the recovery of ancient texts from the twelfth century came a primary intellectual achievement. This was the grasp and critical elaboration by the philosophical community of the medieval schools and universities of the construction of a demonstrative explanatory system on the models of Euclid's geometry and Aristotle's natural philosophy. Together with this came a critical elaboration of logical precision, from methods formalized by Aristotle, for the control of argument and evidence to decide a question, including decision by calculation and observation and experiment.

Secondly came a matching of this logical control of argument and calculation with a likewise theoretically designed and measured control of a variety of different materials and practical activities. Programs toward this end already expressed from the twelfth century that urge toward rational analysis and ingenious contrivance for the material mastery of nature,[3] which was to be achieved in action by the practitioners of a diversity of arts. This group, working essentially outside the universities but not without university contacts, came to succeed by making rational and where possible quantitative analysis

precede material construction or action. Thus they achieved control of the measured representation of visual space by perspective painting and sculpture, of time by the mechanical clock, of music by measured temporal patterns of pitch and interval, of spatial location and transport by trigonometric surveying and cartographic coordinates, of building and machines by a search for rational mechanics, and of commerce and administration by systematic bookkeeping and numerical recording. The goals of the arts, whether technological or aesthetic, should not be confused with those of philosophy and the sciences, but it does not seem difficult to recognize in them all a common intellectual style in which each reinforced the others, and all came to contribute to the third stage of the origins of modern science. That was the confident establishment of the "new sort of philosophizing"[4] in the "physico-mathematical experimental learning"[5] of the seventeenth century. The intellectual approaches leading in this way to a conception both of scientific inquiry and of artistic composition as cognate arts of the soluble began with the recognition that theoretical analysis and rational design must precede material analysis and construction. They concluded with an experimental science that combined with effective logical precision a theoretical search for common forms of explanation with a practical demand for accurately reproducible results.

Some of the characteristics of this intellectual culture which produced the rational European movement of both science and the arts can be exemplified from that enterprise of the search for truth and certainty which became explicit in the middle stage of this intellectual orientation, during the fifteenth and sixteenth centuries. European intellectual life received a considerable stimulus in the late fifteenth and early sixteenth centuries from the recovery, publication, and active use of a body of Greek philosophical and scientific writings hitherto either unknown or with little influence in the Latin West. These writings fell into two main groups, with some overlap, each producing a corresponding response, centered at the beginning in Italy.[6]

The first group of writings consisted of philosophical texts, notably the extant works of Plato translated into Latin by the Florentine philosopher Marsilio Ficino together with the associated Hermetic documents, and detailed reports of Greek atomism and skepticism provided especially by Lucretius and by Sextus Empiricus and Diogenes Laertius. These were taken up by philosophers dissatisfied with established academic Aristotelianism who saw them primarily as a means of finding other, more acceptable rational criteria for knowledge in general and for religious knowledge in particular, and of bringing about moral improvement and educational reform. At the same time they introduced a complex intellectual and moral crisis: from Plato and the Hermetics as ambiguous alternatives to the Christian theology of creation with its integral moral doctrine of providence; from the atomists by the elimination of providence altogether; and most pervasively from the skeptics whose arguments, launched into the republic of letters by Montaigne, produced a continuing intellectual insecurity to become, in the discriminating treatment of such as Marin Mersenne and Descartes and Pascal, an integral part of European think-

ing. Texts on the mathematical sciences and arts and their applications comprised the second group of writings. Of these, some came to exert a powerful general influence upon intellectual history, while others of greater specialization about optics and mechanics and music, for example, supplied the theory used and developed by practical mathematicians and artists.

The intellectual commitments of the two groups of persons primarily interested in these writings can best be compared by looking at their conceptions of a common subject, the place of mathematics in intellectual culture. Such a comparison shows that they shared a very general outlook as members of the same integrated world, but that the uses they saw for mathematics and their conceptions of rational choice were poles apart. The debates and practical experience over all these questions promoted in their specialized range a growth of the technical content of the sciences and arts, but more generally and more subtly they promoted shifts of intellectual style, most profoundly perhaps in the commitments and expectations of disagreement as well as agreement. The comparison illustrates again the need for us to understand the whole context of thought about true knowledge and its value, if we are to see how art and science as problem-solving activities fit into the scheme of knowledge and existence at that time.

The most striking characteristic shared by this intellectual inheritance was its mathematical rationalism, dominating the conception of a whole range of knowledge and practice from physics and the visual and musical arts to ethics and theology. The ultimate literary source of this rationalism was Plato, with the Pythagoreans, notably Archytas of Tarentum, behind Plato. Platonic or Pythagorean rationalism had a long history in medieval thought, through Plato's *Timaeus*, through St. Augustine, and also through Aristotle himself. It received a new life in the fifteenth century from Ficino's Latin versions and commentaries and also from other contemporary scholarship, of which much the most important for the mathematical sciences and arts was that included in Giorgio Valla's great work *De expetendis et fugiendis rebus opus* (1501), "On things to be sought and to be shunned." In this Valla presented a compendium of all the sciences and arts, aimed at both intellectual enlightenment and moral education from a point of view which he shared both with the moral philosopher Ficino and with their contemporaries Leonardo da Vinci and Albrecht Dürer and other practical artists.

The point of view that they shared had been established in Platonic thought as a specific theory of nature and of man's relation to nature as perceiver and knower and agent. Nature had been designed by divine art on the analogy of human art with mathematical order and proportion perceptible by sight and hearing, but properly grasped only by the intellect. Conversely, Valla cited Archytas to the effect that man had first to conceive both what he wanted to explain, and what he wanted to make or do. Science was knowledge of stable universal principles such as mathematicians knew. The artist, before making something, by reason "fashions and forms it inwardly, and accordingly makes an image for himself of everything that is to be portrayed."[7] Valla saw both the

experimental science of nature and the constructive arts (mechanical, plastic, visual, musical) as the imposition of reason by antecedent analysis above all through mathematics.

In this view Valla was guided also by two other ancient authors whose works were to exert a powerful influence upon the intellectual history of the sixteenth century. The Roman architect Vitruvius had insisted on the precedence of theory in any rational action, and in particular of mathematical theory in a constructive art. The authors of the first Italian edition of *De architectura* (1521), begun by Cesare Cesariano and continued by Benedetto Giovio and Bono Mauro, developed this in a fascinating exegesis of the words "machinatio" and "machina" (which have in Greek and Latin the same range of meaning from mechanical contriving to political machination as they do in English and other modern European languages) into a view of inquiry into the operation of things as cunning intellectual contriving. Again they cited Archytas as a mechanic, famous for constructing a wooden dove which flew, to illustrate that intellectual contrivance must first find out by reasoning both what men wanted to explain and what they wanted to "put into practice through a burning desire to produce in sensible works with their own hands that which they have thought out with the mind."[8]

Valla's other general guide was the Hellenistic Greek philosopher Proclus. In his commentary on Euclid's *Elements of geometry*, Proclus set out a Platonic and Pythagorean scheme which was to offer probably the most influential program for the mathematical sciences and arts in the sixteenth century. He saw mathematics as an intermediate science, generated by the mind but both stimulated by and projected upon the world of the senses. In one direction its reasoning replicated the complex material world with a world of ideas, and led the mind from the observable uncertainties of matter to the rational certainties of the highest abstractions. In the other direction by descending into matter, it delivered out of itself the principles both for scientific understanding of the material construction of the world and for the materially constructive mathematical arts. These sciences and arts included those to which in both theory and practice above all Renaissance Italy, but also the Netherlands and other European centers, made their major contributions to the intellectual history of the European scientific movement by the development of rational mechanics, of cosmography and cartography, of optics applied to perspective painting and sculpture, and of measured music. All involved a rational inquisition, representation, and finally imitative manipulation of nature. The perspective artists made the geometrical optics they learned from Euclid and his ancient and medieval successors yield a practical method of showing precisely what would be seen under specified conditions of angle of vision, distance, reflection and refraction, shadow, and so on, and of transferring this three-dimensional information to a two-dimensional surface. Albrecht Dürer's assertion, that "a good painter is inwardly full of figures" which pour forth "from the inner ideas of which Plato writes,"[9] was made by an artist with technical experience in the practical mathematics of design and should be so understood. Similarly, a

precise technical bearing should be understood in the mathematical rationalism of Leonardo da Vinci's repeated assertions that all art must begin in the mind before it can issue through the hands, and that nature has necessary laws which art must follow but which, unlike nature, the artist is free to manipulate according to his own design. Thus the rational artist was the exemplary man of *virtù*, always in control of what he made within the rationally examined limits of the possible. For "whatever exists in the universe through essence, presence or imagination he has first in the mind and then in the hands."[10] The inquisition of nature, for this master both of design and of the intellectual play of thought-experiments, was then a pursuit of intellectual contrivance and machination: "Oh speculator on things, I do not praise you for knowing the things that nature through her order naturally brings about ordinarily by herself; but I say rejoice in knowing the end of those things that are designed by your own mind."[11]

The philosopher Ficino shared this view which made man through his rational imitation and manipulation of God's designs nature's rival and master, the sole animal capable of inventive progress. But Ficino's attention was focused on another aspect of Platonism. His was a rational artist's vision of man's moral principles of action. In imposing mathematical order and proportion on matter, the Platonic God in both classical and Christian thought gave the world a morally as well as intellectually normative harmony. This harmony came to have various meanings such as simplicity and economy and fitness, which supplied a conception of sufficient explanation with profound influence in the history of science. Harmony was also the bond linking Renaissance science, the visual and musical arts, medicine, and ethics. For such a philosopher as Ficino, mainly interested in moral enlightenment, virtue like painting must be designed first in the mind before it could issue in action. In this he reinforced with the new Platonism the essentially Aristotelian style conceived for the mastery of human nature, and the cultivation of the habit of virtue true to that nature, by practice guided by right reason. Beyond that he saw with Plato in mathematical ideas an efficacious means of leading the mind from the material world and its concerns upward to theology and the contemplation of the divine creator. Within this Platonic scheme Ficino elaborated a complex system of correspondence between the macrocosm of the world and the microcosm of the human body and soul, and of the harmonious influence transmitted through the primary media of light and sound. From this he developed a practical moral psychology for encouraging virtue by means of visual designs and music, which would draw down corresponding influence from the heavens.[12]

The contrast between the moral philosophers and the practical mathematicians and artists lay in their conception of rational choice. This is yet another illustration of the complexity of the intellectual landscape through which we must follow the scientific movement. It was for the role of mathematical ideas in moral and theological education that mathematics was encouraged by many philosophers of Platonic leanings during the sixteenth

century. It is significant that in Italy there was a link between efforts to promote both Platonism and mathematics in universities, including Jesuit universities, persisting into the negotiations for appointments to chairs in each subject of Galileo's older contemporaries and of Galileo himself. Within this context the moral philosophers saw mathematics essentially as a stage in moral and theological education. Its certainty was for the religious an antidote to skepticism. Its use was to help to induce a general state of mind leading to virtuous action. The philosophers who saw mathematics thus rather as a means to moral and theological education than to solving scientific or practical problems, were often notable too for their eclectic tolerance of apparently opposing systems. This was an ancient and widespread mental attitude, based on the optimistic belief that all great thinkers when correctly interpreted must be found to harmonize in truth. Hence the tradition that the proper work then for philosophers was to look for concordance between apparently opposing authorities, so that Plato and Aristotle and even the atomists, although probably not the skeptics, would all be found to agree in essentials with each other and all with true theology.[13]

In sharp contrast was the brutal insistence of the practical mathematicians and artists that accurate thinking and precisely controlled action alike required the precise identification of specific problems, and that the solution of specific problems required a precise choice. The sciences of nature and the constructive arts were at their cutting edge, alike the products not of a general state of mind but of clear limited decisions. The practical mathematicians and artists found their problems in contemporary practices illuminated by the newly edited and translated Greek works on the mathematical sciences. These were both general—like those of Proclus and Pappus—and specialized—like those of Euclid and Ptolemy on optics and on music, of Aristoxenus on music, and of Archimedes and the Aristotelian *Mechanica* on that subject. These subjects in Greek thought comprised *techne* or art as distinct from *episteme* or true science. But by the turn of the sixteenth century, the success of the mathematical and technical arts in solving limited problems had put them into a position for the claim to be made that they alone could discover the only true science of nature.[14]

The intellectual approaches leading through sixteenth-century thought to this conception of science as an art of the soluble may be broadly summarized as follows. Recognition that theoretical analysis and rational design must precede material analysis and construction led to the conception of rational sciences of mechanics and optics and music and so on all within the limits of the possible. "I have seene all enginiers deceiv'd," wrote Galileo in 1593, "while they apply their engines to works of their owne nature impossible; in the success of which both they themselves have bene deceiv'd, and others also defrauded of the hopes they had conceiv'd upon their promises." For effects could be obtained only "according to the necessary constitution of nature. . . . And . . . all wonder ceases in us of that effect, which goes not a poynt out of the bounds of natures constitution."[15] Art could not cheat nature, but by dis-

covering, obeying, and manipulating natural laws, with an increasing emphasis on quantification and measurement, art was seen to deprive nature of its mysteries and to achieve a mastery exemplified by rational prediction. This rational mastery was illustrated also by the growing popularity of the modeling and extension of the natural by artificial constructions, ranging from clockwork devices to perspective representations as imitative models of the natural clues for perception. In science the model was seen as a means of investigating and explaining the natural. Thus nature, envisaged in Platonic thought at the beginning of the century as an expression of divine geometry, had been given by the mathematical arts an extended image at the end. For Plato, wrote a French regius professor of these arts who was also a physician, in answering the question what God did, should not have stopped at "he always geometrizes" but should have added "and always mechanizes. For this world is a machine, and indeed the greatest, most efficacious, firmest and most shapely of machines."[16]

Such words must be understood in their intellectual context and that context was certainly not yet that of Descartes. Yet without imposing a completely mechanistic conception of nature, the mathematical sciences and arts combined by the end of the sixteenth century to create within European intellectual culture an effective context for solving problems. I shall conclude with one example. The solution by Johannes Kepler in 1603–4 of the fundamental physiological problem of vision, that of how the eye formed an image on the retina, was the first major modern physiological discovery. With this demonstration, Kepler introduced a new conception of how to investigate the relation of perceiver to perceived in all the senses. It became as important as William Harvey's later demonstration of the circulation of the blood in opening new prospects for physiology in general. Before Kepler, developments in perspective painting and in the instrumentation of surveying and astronomy had created both a geometrical theory of visual space and a technique for demonstrating what would be seen under specified optical conditions and for representing this upon a plane surface. Two notable contributions prepared the ground for Kepler's solution. The first was Alberti's conception of a picture as a section of the pyramidal figure formed by the lines of vision connecting the object seen with the eye, and his demonstration of how to make the section correctly by viewing the object or scene through a checkered screen. The second was Leonardo da Vinci's use of another device, a camera obscura for throwing an inverted picture of the scene through a pinhole onto a screen. Leonardo compared the eye to a camera obscura with a lens in it, but assiduous attempts by both anatomists and mathematicians throughout the sixteenth century to explain how the eye effected vision all foundered on the same difficulty: the inverted image. The problem as inherited from Greek and medieval optics had been formulated to include questions of perception and causation which prevented a purely geometrical analysis of the formation of the image. Kepler succeeded by first isolating the geometrical optics of the eye as an answerable question to be treated apart from all other aspects of vision. He answered it by

treating the living eye on the model of a camera obscura with a lens in it, and by reforming the optical geometry of how this device focused the picture on to the retinal screen. This demonstration provided contemporaries both with a model of scientific method and with a scientific basis for reintroducing the investigation of the complexities of the perceptual process, for example, how to understand the retinal image as accurately symbolic rather than literally representative of the scene perceived. It provided at the same time a clear scientific basis from which to correct and extend the natural performance and range of the senses by means of artificial instruments.[17] Later in the century, from a similar background in the development of measured and instrumented music, the resonating strings of a lute were to be proposed as a model for the analysis of pitch by the ear.[18]

We may see then in the mathematical sciences and arts of early modern Europe one fecund cultural source of that conception of man's relation to nature as perceiver and knower and agent which came to characterize the European scientific movement and with it more generally European culture. In this context we may ask ourselves a question. The successes of the mathematical and technical arts in solving limited and clearly defined problems threw a critical light upon all claims to access to the true science of the nature of things. This intellectual experience was paralleled elsewhere in the scientific movement, for example, in the search in biology and medicine for taxonomic criteria that would provide at once a practical classification of living organisms and their diseases and the true natural and causal system. We may ask, then, what is the comparative value, for scientific as for artistic creation and discovery, of precision with its limitation of risk risking a limitation of vision, as against a general state of mind? What is its value as against such intellectual commitments and expectations as likened reasoning towards mechanical design with that towards aesthetic and moral design, and against the suggestive sources of the imagination which may yet yield only verbiage?

Galileo enjoyed the habit of "speculative minds" in reading "the book of nature, always open to those who enjoyed reading and studying it with the eyes of the intellect. He said that the letters in which it was written were the propositions, figures, and conclusions of geometry, by means of which alone was it possible to penetrate any of the infinite mysteries of nature."[19] About this "book of nature, where things are written in only one way" he "could not dispute any problem *ad utranque partem*"[20] as in a scholastic exercise; for the book of nature was "the true and real world which, made by God with his own hands, stands always open in front of us for the purpose of our learning."[21] Galileo aimed to define for his contemporaries the rational identity both of nature and of natural science in specific distinction from other diverse forms of thinking within contemporary intellectual culture. He reminded theologians sacred or profane of "the difference that there is between opinable and demonstrative doctrines; so that . . . they might the better ascertain themselves that it is not in the power of professors of demonstrative sciences to change opinions at their wish. . . ; and that there is a great difference between commanding a

mathematician or a philosopher and directing a merchant or a lawyer, and that
the demonstrated conclusions about the things of nature and of the heavens
cannot be changed with the same ease as opinions about what is lawful or not in
a contract, rent or exchange."[22] Again he wrote of a certain philosopher: "Pos-
sibly he thinks that philosophy is a book and a fiction by some man, like the
Iliad or *Orlando Furioso,* books in which the least important thing is whether
what is written in them is true. Well . . . things are not like that."[23] It was
scandalous "to allow people utterly ignorant of a science or an art to become
judges over intelligent men and to have power to turn them round at their will
by virtue of the authority granted to them—these are the novelties with power
to ruin republics and overthrow states."[24]

Galileo's public controversies dramatized a subtle shift in the commitments
and expectations of disagreement as well as agreement in the intellectual style of
the early modern heirs at once of Moses and of Aristotle. His account of
scientific objectivity is for us a brisk antidote to the more naive sociological
relativism promoted (for whatever motives) by people evidently ignorant of the
distinction between the history of science and the history of ideology. His
arguments communicate the specific identity of the scientific movement, an
identity requiring in its adequate historians, as in those of music or painting, a
specific technical mastery of its content. He lays out for us an intellectual
enterprise integrated by its explicit historic criteria for choosing between
theories and investigations at different levels of the true, the probable, the
possible, the fruitful, the sterile, the impossible, and the false. By means of
these criteria natural scientists have exercised a kind of natural selection of
theories and investigations, which has directed scientific thinking as the history
of solving problems while at the same time embodying them in ever more
general explanations. Thus it is the history of objective progress in knowledge.

Galileo, with his learned love of literature and music and the visual and
plastic arts, his eloquent baroque Italian and his matching skills as lutanist and
as draftsman, his sense of scientific elegance and of cosmological design, his
insistence on being both a philosopher and a mathematician, his desire to win
an argument as well as to win the truth, belongs as recognizably as any of his
literary or artistic or philosophical contemporaries to the Tuscan intellectual
culture into which he was born. With his aggressive creative energy he too, as
he described the musical interval of the fifth, "tempering the sweetness by a
drop of tartness, seems at the same time to kiss and to bite."[25] He was an
exemplary man of *virtù,* the rational experimenter, in all these sciences and arts
of the Renaissance. In that we shall surely find no contradiction. In that con-
text we seem most likely to see how the defining capacity of both art and
science to solve specific problems drew in operation upon the suggestive
sources alike of the analytical and the constructive imagination.

NOTES

1. Leon Battista Alberti, *I libri della famiglia*, ed. C. Grayson (*Opere volgari*, 1, Bari, 1960), 133; cf. for full documentation of this paper with bibliographies A. C. Crombie, *Styles of Scientific Thinking in the European Tradition*, especially chaps. 1: "Historiography of Science: The Variety of Scientific Methods," 2, 4: "Analysis and Synthesis: The Mathematical Arts and Sciences," 3, 2: "The Rational Artist and the Rational Experimenter," and 4: "Hypothetical Modelling Transposed from Renaissance Art into Early Modern Science;" *Galileo and Mersenne: Science, Nature and the Senses in the Sixteenth and Early Seventeenth Centuries*, especially chaps. 1: "Introduction," and 3: "The Idea of Mathematics in Sixteenth-Century Thought" (both forthcoming, Oxford University Press); also "Philosophical Presuppositions and Shifting Interpretations of Galileo," *Second International Conference on the History and Philosophy of Science: Pisa, 4–8 September 1978* (forthcoming); and for guides to further bibliography below refs. 3, 13–19.

2. Alberti, *De pictura*, 1, 24, ed. C. Grayson in *On Painting and On Sculpture* (London, 1972), 58; cf. A. J. Close, "Commonplace Theories of Art and Nature in Classical Antiquity and in the Renaissance," *Journal of the History of Ideas* 30 (1969): 467–86; C. W. Westfall, "Painting and the Liberal Arts: Alberti's View," ibid.: 487–506; J. S. Ackerman, "Alberti's Light," in *Studies in Late Medieval and Renaissance Painting in Honor of Millard Meiss*, ed. L. Lavin and J. Plummer (New York, 1978), 1–28; below ref. 17.

3. Cf. Dominicus Gundissalinus, *De divisione philosophiae*, hrg. L. Baur (*Beiträge zur Geschichte der Philosophie des Mittelalters*, 4, 2–3, Münster, 1903), 10–33, 90–124, esp. 112–24; Adelard of Bath, *Quaestiones naturales*, hrg. M. Müller (*Beiträge . . . 31*, 2; Münster, 1934); also Crombie, *Augustine to Galileo: Science in the Middle Ages and Early Modern Times*, 2 vols., new impression (London and Cambridge, Mass., 1979); *Robert Grosseteste and the Origins of Experimental Science 1100–1700*, chap. 2, 3rd ed. (Oxford, 1971); "Quantification in Medieval Physics," *Isis* 52 (1961): 143–60; "The Relevance of the Middle Ages to the Scientific Movement," in *Perspectives in Medieval History*, ed. K. F. Drew and F. S. Lear (Chicago, 1963), 35–57; and "Some Attitudes to Scientific Progress: Ancient, Medieval and Early Modern," *History of Science* 13 (1975): 213–30: all with further references.

4. William Gilbert, *De magnete*, preface (London, 1600).

5. *Journal Book of the Royal Society*, 28 November 1660, quoted by C. R. Weld, *A History of the Royal Society*, 1 (London, 1848), 65.

6. Cf. Crombie, *Styles of Scientific Thinking*, chap. 3, 2; *Galileo and Mersenne*, chaps. 1 and 3.

7. Valla, *De expetendis*, 1, 3 (Venetiis, 1501).

8. Marcus Lucius Vitruvius Pollio, *De architectura libri dece, traducti de latino in vulgari, affigurati, commentati*, 10, 1 (Como, 1521) fol. 162v; cf. 1, 3, fol. 18; P. Galluzzi, "A proposito di un errore dei traduttori di Vitruvio nel '500," *Annali dell 'Istituto e Museo di Storia della Scienza di Firenze* 1 (1976): 78–80.

9. Cf. E. Panofsky, *The Life and Art of Albrecht Dürer* (Princeton, 1955), 252–3.

10. Leonardo da Vinci, *Treatise on Painting, Codex Urbinas Latinus 1270*, 1, 35, trans. A. P. McMahon (Princeton, 1956).

11. Leonardo da Vinci, *Les manuscripts . . . de la Bibliothèque de l'Institut*, cod. G, fol. 47r, publiés . . . par . . . C. Ravaisson-Mollien (Paris, 1890).

12. Cf. D. P. Walker, *Spiritual and Demonic Magic from Ficino to Campanella*, chap. 1 (London, 1958).

13. Cf. Crombie, "Mathematics and Platonism in the Sixteenth-Century Italian Universities and in Jesuit Educational Policy," in *Prismata: Naturwissenschaftsgeschichtliche Studien: Festschrift für Willy Hartner*, hrg. Y. Maeyama und W. G. Saltzer (Wiesbaden, 1977), 63–94; and *Galileo and Mersenne*, chap. 3.

14. Cf. Crombie, *Galileo and Mersenne; Styles of Scientific Thinking*, Chaps. 3–4; also Crombie, ed., *Scientific Change* (London and New York, 1963); above refs. 1, 3 and below 17–19.

15. Galileo Galilei, *Le mecaniche* (1593), ed. naz., direttore A. Favaro (*Le opere* II, Firenze,

1968), 155, trans. Robert Payne (1636): transcribed from British Museum MS Harley 6796, f.317, by A. Carugo; see Crombie, *Galileo and Mersenne*, chap. 2, 3.

16. Aristotelis *Mechanica, Graeca emendata, Latine facta, et commentariis illustrata*, ab Henrico Monantholio medico et mathematicarum artium professore regio, Epistola dedicatoria (Parisiis, 1599); cf. P. Rossi, *I filosofi e la macchine 1400–1700*, 2d ed. (Milano, 1971); Crombie, *Galileo and Mersenne*, chap. 3, 2; *Styles of Scientific Thinking*, chap. 4, 2: "The modelling of the Senses;" above ref. 1.

17. Cf. Crombie, "Kepler: de modo visionis," in *Mélanges Alexandre Koyré*, introd. de I. B. Cohen et R. Taton, 1 (Paris, 1964) 135–72; "The Mechanistic Hypothesis and the Scientific Study of Vision," *Proceedings of the Royal Microscopical Society*, 2 (1967), 32 sqq.; *Styles of Scientific Thinking*, chap. 4, 2; M. Baxandall, *Painting and Experience in Fifteenth Century Italy* (Oxford, 1972); S. Y. Edgerton, Jr., *The Renaissance Rediscovery of Linear Perspective* (New York, 1975); and Alberti, above ref.2.

18. Cf. Crombie, "The Study of the Senses in Renaissance Science," *Actes du Xe Congrès international d'histoire des sciences: Ithaca, N.Y., 1962* (Paris, 1964), 93–114; "Mathematics, Music and Medical Science," *Actes du XIIe Congrès international d'histoire des sciences: Paris 1968*, 1B (Paris, 1971), 295–310; "Marin Mersenne (1588–1648) and the Seventeenth-Century Problem of Scientific Acceptability," *Physis* 17 (1975): 186–204; *Galileo and Mersenne*, chap. 9; also C. V. Palisca, "Scientific Empiricism in Musical Thought," in *Seventeenth Century Science and the Arts*, ed. H. H. Rhys (Princeton, 1961), 91–137; D. P. Walker, "Some Aspects of the Musical Theory of Vincenzo Galilei and Galileo Galilei," *Proceedings of the Royal Musical Association*, ca. (1973–74): 33–47.

19. Vincenzo Viviani, "Racconto istorico della vita di Galileo" (1654; *Le opere* 19 XIX, 625; cf. R. Mondolfo, *Figure e idee della filosofia della Rinascimento* (Firenze, 1963), 117–59, 291–373; Crombie, "The Primary Properties and Secondary Qualities in Galileo Galilei's Natural Philosophy," in *Saggi su Galileo Galilei* (Firenze, preprint, 1969); "Sources of Galileo's Early Natural Philosophy," in *Reason, Experiment and Mysticism in the Scientific Revolution*, ed. M. L. Righini Bonelli and W. R. Shea (New York, 1975), 157–75; "Philosophical presuppositions," above ref.1.

20. Galileo, note of 1612, *Le opere* 4, 248n.

21. Galileo, *Prima Lettera circa le Macchie Solari* (1612; *Le opere* 5), 96n.

22. Galileo, *Lettera a Madama Cristina di Lorena* (1615; *Le opere* 5), 326.

23. Galileo, *Il Saggiatore*, q.6 (1623; *Le opere* VI), 232.

24. Galileo, notes related to the *Dialogo sopra i due massimi sistemi del mondo* (1632; *Le opere* VII), 540.

25. Galileo, *Discorsi e dimostrazioni matematiche intorno a due nuove scienze*, i (1638; *Le opere* VIII), 149.

Medicine, Philosophy, and Humanism in Renaissance Italy

Jerome L. Bylebyl
Johns Hopkins University

The century between 1250 and 1350 was a crucial formative period for Italian medicine, during which there emerged a system of medical institutions common to most of northern Italy.[1] At the base of this system were numerous positions for "medici salariati," i.e., physicians and surgeons who were given a fixed retainer for their services.[2] Many of these were municipal doctors, hired by communities of varying sizes in order to ensure the presence of qualified practitioners as well as to provide free medical care for the poor. Others served the inmates of institutions such as hospitals, prisons, or religious houses or traveled with armies or on board ships, both naval and merchant. And, of course, there were those who served as personal physicians and surgeons to various secular and ecclesiastical dignitaries and their courts.

Another important component of the Italian medical system was the half dozen or more medical universities, where the physicians and some of the surgeons received a standardized education.[3] These too were maintained at public expense, in part because of civic pride and the desire for the revenue brought in by medical students but in part also because of the genuinely felt need for qualified practitioners. It was at Bologna during the second half of the thirteenth century that the prototype of these medical schools evolved, and then this model was replicated in other cities, first and most successfully at Padua.[4]

A third feature of the Italian medical landscape was the college of physicians, which generally was organized in a city of any size, regardless of whether or not it was also the seat of a medical university.[5] These colleges were essentially elite regulatory corporations rather than comprehensive gilds. Their membership was usually limited to a certain fixed number, and to be eligible one had to

have a doctoral degree and, in many places, to be a native citizen of the town. In the university centers the colleges were responsible for examining and approving the candidates for academic degrees in medicine and surgery, while in most cities they had the authority to examine, license, and regulate all who wished to practice medicine or surgery within their jurisdiction. These might include university-educated physicians who were ineligible to join the college either because of citizenship or because they had not taken a doctoral degree, surgeons whose practical training may have been supplemented by a university degree in surgery or even a full medical doctorate,[6] and barbers who were authorized to perform certain minor surgical procedures but who may also have served as general practitioners for the lower classes.

Given the vigor with which medicine evolved in Italy as a profession based upon university education, it is not surprising that these institutional developments should have been accompanied by the formation of an important "school" of medical learning. Taddeo Alderotti (d. 1295), who taught at Bologna, and Pietro d'Abano (d. ca. 1316), his younger contemporary at Padua, were the two chief founders of this tradition and were commonly acknowledged as such during the fourteenth and fifteenth centuries.[7] Of course, this northern Italian school was itself a variant of the broad mainstream of medical learning that emanated from classical antiquity, and indeed, it is doubtful whether there would have been much basis for granting legal sanction and public support to any medical system which did not represent such an ancient orthodoxy. The two most respected authorities within this tradition were Hippocrates and Galen, but in fact, the most influential figure was the Persian Avicenna (980–1037), whose *Canon* provided an encyclopedic framework within which to study the more specialized monographs of the Greeks. Still, Italian medical authorities from the late thirteenth century onward constituted a highly coherent and influential tradition of teachers and disciples, who did much to enrich the legacy of their Greek and Islamic forebears.

In this essay I shall consider the relations of this medical tradition with two other major intellectual traditions, Aristotelian philosophy and humanism, as they evolved over the course of three centuries (approximately 1300 to 1600). At the beginning of this period, medicine and philosophy existed on terms of intimate symbiosis, such that it is difficult to differentiate the two with regard to the institutions and personnel involved. Medicine, no doubt, benefited both socially and substantively from this association with one of the most distinguished traditions in the history of thought, but the results were not entirely positive. For one thing, philosophy helped to reinforce within medicine an emphasis on scholastic method whose appropriateness is at least questionable in a group that was not only a teaching profession but also a practicing one. More important, the link with philosophy carried the connotation that medicine by itself was somehow not quite respectable, so that the physician preferred to face his society endowed with the greater dignity of the natural philosopher.

The early relations of medicine with humanism were much more overtly destructive, because the humanists tended both to ridicule the physicians for their scholasticism and to despise them as practitioners. Humanism always remained a movement that was essentially independent of medicine, but there nevertheless developed among physicians themselves a tradition of humanistic learning, which by the time of its maturity in the sixteenth century was able to strongly compete with, if not completely displace, Aristotelianism as an adjunct to medicine. The humanistic physician could also present himself as a man of learning, but one whose learning had a more intimate connection with his role as practitioner by opening up to him the medicine of the ancients. Moreover, by idealizing the ancient physicians, notably Galen, as professional models, the medical humanists did much to supercede the older, more abstract scale of values which attached greater worth to intellectual than to practical virtues, and thus they seem to have been more content to perceive themselves and to be perceived by others simply as physicians.

I

One of the distinctive features of the medical tradition established by Taddeo Alderotti and Pietro d'Abano was a close relationship—indeed a virtual fusion—between medicine and Aristotelian natural philosophy.[8] This is not only reflected in their writings and those of their students, but also took on concrete form in the medical institutions discussed above. Thus it soon became common, and eventually routine, for Italian physicians to take a doctorate not only in medicine but in arts as well, with "arts" being understood to mean Aristotelian natural philosophy.[9] Accordingly, the medical universities were hybrid schools of both arts and medicine, in which the two most important subjects were medical theory and medical practice, followed closely by natural philosophy, which was usually taught by someone who either had a medical degree or was planning to take one.[10] Indeed, the typical academic career for one of these philosopher-physicians was to begin with a minor chair in logic, then to advance through the ranks of philosophical chairs, and finally to switch to one or the other of the major medical subjects.[11] Similarly, the doctoral colleges were often joint colleges of philosophers and physicians, though usually their membership included a great majority of individuals who claimed the dual title "philosophus et medicus," along with a few individuals who were laureate in philosophy alone.[12]

The general idea of fusing the role of the physician with that of the philosopher was certainly not novel to late medieval and Renaissance Italy, but neither do the earlier precedents completely fit the situation that evolved there. Galen had taken considerable pride in being a philosopher as well as a physician, but he also made it clear that he was highly unusual among his contemporaries for having been fully educated in both subjects.[13] Furthermore, as philosopher, Galen had studied with representatives of all of the leading schools, and was by no means a strict Aristotelian. In his medical writings he

drew freely upon Aristotle's physical and biological doctrines, but he also expressed frequent disagreement with Aristotle's conclusions.[14]

Moreover, one of these disagreements was of central importance both to Aristotle's biology and to Galen's medicine. This was the question of one versus three "principal" or ruling organs within the body.[15] Aristotle's consideration of the teleological unity of the organism as well as his investigations in embryology and animal dissection had led him to conceive of the heart as the single dominant organ in which all of the body's major functions—nutrition, the maintenance of heat, sensation, and locomotion—are centered.[16] On the other hand, on the basis of both theoretical considerations and a much larger body of empirical evidence, Galen maintained that the major bodily functions are carried on independently of each other, and must be controlled by three separate organs—sensation and locomotion by the brain, the maintenance of heat and vitality by the heart, and nutrition by the liver.[17] Thus Galen had actually made it rather difficult for someone to be both a medical disciple of his and a loyal Aristotelian philosopher.

Nevertheless, in the Islamic world it became common to combine the two offices, and this was especially true of Avicenna and Averroes (1126–1198), the two Islamic authorities who most influenced the philosopher-physicians of northern Italy.[18] However, the nature of that influence was crucially affected by the circumstances that led to the combination of roles in Islam. It was not based upon Galen's example, but resulted from Islam's having inherited from the Greeks a finite body of secular learning which was customarily mastered in its entirety by certain individuals.[19] Galenic medicine was an important part, but the central core was provided by philosophy, which in the Islamic world was almost exclusively Aristotelian philosophy.[20] This meant that intellectual leadership in Islamic medicine came from individuals who were, first of all, committed Aristotelians, and who looked upon medicine as a science that is subordinate to natural philosophy.[21] Along with this went a condescending attitude toward physicians (read "mere" physicians), who were expected to defer to philosophers in certain theoretical questions touching upon their art. Moreover, Galen's own claim to have been a philosopher was not recognized, and he was even sharply criticized for having strayed beyond his medical competence to contradict Artistotle.[22]

However, in some cases of conflict—notably those relating to anatomy and physiology—it was not possible simply to reject Galen's opinion out of hand. For example, his doctrine of three principal organs was not only based upon an impressive body of anatomical and experimental evidence, but it was also crucially important to his medical system as a whole. Hence the frequent need for the Islamic authorities to come to grips with these differences between "the philosophers" and "the physicians," where these words often served as euphemisms for "Aristotle" and "Galen," respectively.[23] Avicenna sought to reconcile these disagreements by a kind of double truth. That is, one thing might appear to be true to a physician, who relies on sense perception, and this should govern medical practice; but quite another higher truth might be per-

ceived by the intellect of the philosopher, and this should be followed when it is a matter of pursuing knowledge for its own sake.[24] Averroes, on the other hand, was frankly less conciliatory toward Galen, whom he often treated with a condescension bordering on contempt.[25] He did concede that Galen had had a better knowledge of anatomy than had Aristotle,[26] but then sought to show by theoretical arguments that Galen's anatomical evidence did not support the physiological conclusions that he had defended in contradiction of Aristotle.[27]

Now, what was distinctive about the situation in northern Italy was that these same attitudes about the relationship between philosophy and medicine, and between Aristotle and Galen, were perpetuated by individuals and institutions that were primarily medical rather than philosophical in character.[28] That is, I think there is little doubt that within the Italian universities philosophy was both studied and taught chiefly as a preparation for careers in the teaching and practice of medicine, and yet the notion of the superiority of philosophy to medicine, and of Aristotle to Galen, was sustained even within the realm of medical teaching. N. G. Siraisi has recently proposed the term "medical Aristotelianism" to refer to the strongly held views of Taddeo Alderotti in this regard, and I believe that with allowances for individual variation the term could similarly be applied to most of the leading Italian medical authorities of the fourteenth and fifteenth centuries.[29] This is scarcely surprising in view of the fact that the teaching of philosophy and medicine was heavily influenced by the works of Averroes and Avicenna, respectively, both of whom expressed a condescending attitude toward the mere physician. But the propagation of these attitudes probably meant that many physicians wished to regard themselves and to be regarded by others as philosophers, even if this did not conform to the reality of their professional lives.

The impact of philosophy on medicine was also reflected indirectly in the scholastic methods of commentary and disputation, which were borrowed from philosophy and applied to the teaching not only of medical theory, but of medical practice as well.[30] A figure such as Ugo Benzi (1376–1439) seems to have achieved a reputation as the greatest physician of his age primarily through his consummate skill at disputing any question in either philosophy or medicine.[31] Probably only a few physicians in a given generation could hope to make their names and fortunes on such a basis, but the whole system of examination and licensing was organized as if the most important skills for a medical practitioner were indeed verbal ones. The typical examination was based upon a number of "puncta" or randomly chosen passages from the prescribed texts on the subject in question (philosophy, medicine, or surgery).[32] The candidate had to explain these passages and then defend his explanation against objections; in other words, he had to show his ability to comment and to dispute. This probably did not mean that the students actually learned nothing but these scholastic skills, but rather that their practical training had to be handled through some sort of informal apprenticeship that accompanied the official curriculum.[33]

This emphasis on philosophy and on scholastic method was by no means

confined to the university medical centers. Thus at Venice there was no university, but the College of Physicians nevertheless required the double doctorate in philosophy and medicine as a condition of entry, and took great pride in having the privilege to confer doctoral degrees, not only in medicine, but in liberal arts, philosophy, and even theology as well.[34] Moreover, the College statutes asserted the right of its members to be received with respect by the colleges of other cities, and offered these reasons in support:

> There are two things from which arises the expertise of any physician and which also constitute the reason why someone deserves to be accepted into the counsel of other physicians as a colleague. One of these is long practice gained in many patients, and the other is theory, derived from frequent disputations. But these two are reasonably to be found in those who have long practiced in this city of Venice, because of the very great abundance of sick people in the city, because of the numerous consultations of physicians which customarily take place for the curing of the sick, and because of the frequent and repeated disputations which take place in the College at the time of testing and examining doctoral candidates. Therefore, whoever has long remained in the College of Physicians of this city of Venice ought reasonably to be regarded as skilled and sufficient, both in curing diseases and in teaching the science of medicine as well as philosophy.[35]

It is, of course, reassuring to see the insistence on practical ability, but this underscores the anomaly that this group of practitioners should also take such evident pride in their skill at disputation, and further, that they should claim for each of their members the competence to teach not only medicine but also philosophy.

Some interesting comments about the validity of such claims were made by a knowledgeable observer of the mid-fifteenth century. Their author was Michele Savonarola (ca. 1385–ca. 1466), a distinguished Paduan physician and medical professor, who also wrote a literary work in praise of the great men of his native city.[36] These he divided into various professional categories, and when he came to the class of "doctors of arts and medicine," he declared that if he considered any of them to be true philosophers, they would be found under the latter heading (where only one of them, Pietro d'Abano, occurs).[37] As for the others, he warned:

> Let them first give proper consideration to the meaning of the word "philosopher", if they wish to be called by that name. For these men, by their illiberal and servile exercise [of philosophy] seem to detract more from their own honor, than they benefit by reason of the dignity of philosophy. For this reason, I have given them the name of *medicus* and not of *philosophus*.[38]

Savonarola then proceeded to eulogize his colleagues under their proper name of *medici*, dividing them into "theoreticians" and "practitioners," and discussing nine individuals under each heading.[39] However, of the nine theoreticians

five are also specifically praised for having been great practitioners as well, so that there can be little doubt as to what he saw as the real strengths of the Paduan medical profession. Of course, his assertion that they are not really philosophers is only one man's opinion, but it is consistent with the fact that the truly eminent professors of philosophy at Padua tended to be men such as Biagio da Parma, Gaetano da Thiene, Paolo Veneto, and Nicoletto Vernia, whose medical credentials were slight or nonexistent.[40] Indeed, from the early sixteenth century onward the major chairs of philosophy at the university were nearly always held by such "career" philosophers, instead of serving as stepping stones to the medical chairs, as they had earlier tended to do.[41]

In explaining why his colleagues should maintain the pretense of being philosophers, Savonarola cited "the dignity of philosophy," perhaps echoing the statutes of the Paduan college which invoke "the dignity of our college" in requiring a degree in philosophy as a condition for entry.[42] This, of course, implies that medicine itself is somehow lacking in dignity, and both the statutes and Savonarola's words point to a major source of concern in this regard. Thus the statutes go on to state that a candidate for entry must also "not have exercised any of the mechanical arts with his own hands."[43] And elsewhere in his treatise, Savonarola referred to those who regard medicine itself as an "illiberal and servile" pursuit,[44] so that by using those same two adjectives to describe the kind of philosophizing that went on in the medical schools, he perhaps meant to imply that such activities were a misguided effort to escape from such criticisms of medicine.

Now the terms "mechanical," "illiberal," and "servile" are all derived from the traditional classifications of the arts and sciences, in which medicine was indeed left in a rather ambiguous position.[45] There was one ancient tradition which, in view of the scientific and philanthropic aspects of medicine, classified it as one of the more dignified "liberal" arts, which are pursued for their own intrinsic worth rather than with an eye toward monetary gain. However, medicine did not find a place among the canonical seven liberal arts, and there was another view that it was definitely to be placed among the "illiberal" or "servile" or "mechanical" arts.[46] Now physicians could argue in support of the former position, and could further emphasize the character of medicine as a theoretical science as well as an art.[47] Indeed, by excluding those who practice "the mechanical arts" the Paduan statutes clearly meant to imply that medicine itself is not one of them. Still, there was no escaping the fact that weighty authorities, including their own Averroes,[48] could be arrayed against them, or that contemporary critics of medicine continued to insist upon its illiberal and mechanical character.

However, while there might be disagreement as to the status of medicine relative to the other arts, there was no doubt that philosophy was superior to them all. Hence by claiming the title of "philosophus" the learned medical practitioner probably hoped to supercede any doubt that might be cast on his status as "medicus."[49] Indeed, during the latter fourteenth and fifteenth centuries, there smoldered a dispute concerning the relative "nobility" of law and

medicine, the two major learned lay professions, and the two dominant facul-
ties of the Italian universities.[50] Rather curiously from the modern point of
view, the defenders of medicine rested their claim to its greater dignity not
primarily on its practical benefits, but on its essential link to natural philoso-
phy, which made it possible to equate medicine with speculative science and,
hence, with the highest exercise of the human intellect.

Of course, while physicians were free to claim the title and status of the
philosopher, they could not force others to accept their claims. Thus in the
mid-fourteenth century Petrarch responded to a physician's "philosophus
sum" by asking, "How can I believe that you are a philosopher, when I know
that you are a mercenary mechanic?"[51] Similarly, in the dispute just mentioned,
the proponents of the law rejected the idea that medicine, as a practical art, is
inseparably linked to natural philosophy.[52] And as we have seen, even a physi-
cian such as Savonarola could see it as more of an embarrassment than an honor
to his profession for its members to style themselves as philosophers. Still, the
picture was not entirely one-sided, for shortly after he wrote his comments,
Savonarola was himself cited in a decree of Leonello d'Este, Duke of Ferrara, as
"a famous natural and moral philosopher."[53] The decree made it known that,
henceforth, Savonarola would restrict his medical services to the duke and his
immediate family, and this suggests that physicians were not the only ones who
had a stake in the idea that they were also philosophers; it was highly flattering
to their patients as well.

II

The fourteenth century saw not only the consolidation in Italy of a learned
medical profession, but also the beginnings of a new group, the humanists,
with their twin goals of the cultivation of "eloquence" in speech and writing,
and the pursuit of the literary and other remains of classical antiquity.[54] Eventu-
ally, medicine would also be caught up in this program, but the initial relations
between physicians and humanists could hardly have been less friendly. Pe-
trarch, the first important humanist, unleashed the full force of his rhetorical
skills against medicine and physicians.[55] Personal idiosyncrasy may have con-
tributed to his feelings, but there were also some basic reasons why the human-
ists should find themselves at odds with the physicians. For one thing, the
medical universities were, in Italy, the main bastions of scholasticism, and here
was nothing that clashed so sharply with the humanists' ideal of eloquence as
did the "barbarous" latinity of the dialectitians. And for another, the humanists
were the more natural allies of the lawyers, who were the academic rivals of the
physicians.[56]

Medicine was, of course, solidly rooted in classical antiquity, but from the
point of view of the early humanists, it came from the wrong side of the ancient
tracks. Not only did it fall well outside of their own focus on rhetoric, history,
and ethics, but it also clashed with their preference for Roman over Greek
antiquity. This bias was partly the result of ignorance of the Greek language,

but the early humanists also felt, as Italians, a strong sense of ethnic identity with the Romans, whereas the Greeks appeared as a talented but nonetheless alien group.[57] And in contrast to law, the intellectual traditions of medicine were overwhelmingly Greek since medicine had remained a Greek profession even under the Roman empire.[58] Indeed, the Latin author whose views on medicine were best known during the fourteenth century was the highly respected Pliny, the Elder, who had denounced Greek medicine at considerable length.[59] Moreover, by invoking the stern words of Cato, the Censor, Pliny left no doubt that to be against Greek physicians was almost a patriotic duty for any true Roman.[60]

Petrarch made prominent reference to Cato and Pliny in his attacks on medicine, and his own anti-medical posture was at least in part a conscious emulation of their attitudes.[61] He was not impressed by the reliance of contemporary physicians on the doctrines of the ancient Greeks, and even expressed disdain for Hippocrates as "that little Greek."[62] Even worse was the dependence on the Arabs, who were for Petrarch an utterly despicable race.[63] In his view, rather than to adhere so slavishly to the doctrines of the Greeks and Arabs, it was the duty of contemporary "Roman" (i.e., Italian) physicians to try to surpass their predecessors and thus make up for this gap in the legacy of ancient Rome.[64]

Another recurring theme in Petrarch's anti-medical rhetoric was that medicine should be an art of deeds rather than of words.[65] This was related to the idea that medicine is one of the lower practical or mechanical arts, but it also embodied a positive concession that the medical art can be of real help to the sick if it is based upon experience of what has proven beneficial in the past.[66] Adding a lot of words and theories is superfluous to an efficacious cure, and often serves as a substitute for the latter, to the detriment of the patient. It was because of the paramount importance of deeds over words in medicine that Petrarch refused to admit that Hippocrates ought to be accorded supreme authority, comparable to that of Cicero in oratory or of Homer and Virgil in poetry.[67] That is, oratory and poetry are purely verbal arts, and therefore, it is quite possible for an intelligent reader to judge that Cicero, Homer, and Virgil were masters in their respective spheres. However, merely from the written words of Hippocrates (which is all that we have to go on) it is impossible to tell whether or not he was an efficacious healer.

Besides the cultivation of authorities, another and worse way in which physicians had perverted medicine from a practical to a verbal art was through their predilection for disputation, both medical and philosophical.[68] As we have seen, Petrarch refused to honor the claim of physicians to be philosophers, and to the extent that they wasted their time in philosophic pursuits, they were all the less competent in their own sphere of medicine. Even worse was when they brought their disputations and syllogisms to the bedside of the patient, and so tried to cure by words where herbs and other concrete remedies were needed. Moreover, in Petrarch's eyes the physician-philosophers were further diminished by their addiction to the doctrines of Averroes, which he regarded as a loathsome source of heresy.[69]

Rather ironically, Petrarch did not distinguish sharply between the physicians' penchant for disputation and their pursuit of poetry and "eloquence," that is, the very humanistic studies which were his own central concern—both were equally inappropriate for medicine because they represented words rather than deeds.[70] Petrarch blamed himself for having made the study of literature so popular that it was being taken up not only by physicians, but also by members of other trades and professions for whom it was also an irrelevant diversion from their duties.[71] From this it might seem that in Petrarch's eyes physicians could do nothing right, although an important mitigating circumstance was that he regarded a number of these physician-humanists as good friends.[72] For example, he not only maintained a cordial correspondence with the Paduan physician Giovanni da Dondi (1318–1389), but in his will he left him fifty gold ducats to buy a ring with which to remember him.[73] Still, there was nearly always a barb; he reported to another correspondent that when he became ill, his physician-humanist associates were admitted to his bedside as learned friends, but not for purposes of offering medical advice.[74]

Interestingly, da Dondi himself provides at least some corroboration to Petrarch's insistence that any connection between medicine and humanism is purely accidental. Da Dondi wrote a treatise on the hot springs of Padua, which is quite scholastic both in organization and style.[75] It is, however, prefaced by a short letter written in a more humanist vein, in which da Dondi expounded upon the theme of his friendship for the addressee, a master Giacopo of Vicenza. At the end of this letter, da Dondi acknowledged that in what preceded "I have spoken with you in the manner of an orator," while in the treatise that follows he had used "the speech that is customary for philosophers and dialectitians."[76] In other words, while da Dondi might employ humanistic eloquence as a kind of ornament for his medical work, it had no really intrinsic connection with what he wrote and did in his capacity as a physician.

Nevertheless, if humanism long remained irrelevant to medicine, the fact that physicians acquired a taste for the activities of the humanists probably helped to smooth the relations between the two groups. Indeed, toward the end of the fourteenth century, one such physician wrote to Colluccio Salutati, the leading humanist of the period, to express his concern over the view of Petrarch that it is inappropriate for a physician to cultivate eloquence.[77] Salutati replied that Petrarch had only been joking, and that "I do not think that your profession should be deprived of the ornament of good language. Indeed, I urge you and all [physicians] to this fluency of speech and to the vigorous pursuit of eloquence."[78] However, Salutati went on to note that such skills would pertain to the physician simply as a human being and not in his professional capacity, because he agreed with Petrarch that medicine should be an art of deeds rather than of words.[79]

Elsewhere Salutati developed the negative side of the latter idea, that medicine is a practical, mechanical art which cannot claim for itself the dignity of natural philosophy.[80] However, his assault on medicine occurred within the

specific context of the dispute on its nobility relative to the law, and therefore lacked the radically condemnatory tone of Petrarch's attacks. Moreover, Salutati's contribution to this old dispute was followed by that of another humanist, Poggio Bracciolini, who used his literary talents to uphold the side of medicine, rather than of law.[81]

The fifteenth century also provides other instances in which humanistic rhetoric was used for the adornment of scholastic medicine and physicians. For example, the physician and humanist Socino Benzi (1406–1479) wrote a life of his father, Ugo Benzi, whom he praised for having been a great philosopher as well as a physician, for his skill at disputation and for his cultivation of the Aristotelian commentaries of Averroes.[82] In other words, the very things which had made the scholastic physicians so hateful to Petrarch are commended by Socino, although he also tried to make his father into a bit of a humanist by claiming that he wrote "in an elegant style," and that in his youth he had given at least a brief period of study to "poetry and oratory."[83]

Socino's life of Ugo may have helped to inspire the humanist Giovanni Tortelli (ca. 1400–1466), to include a highly complimentary history of medicine in his encyclopedic *Orthographia*, an account which he later expanded into an independent treatise *On medicine and physicians*.[84] Tortelli's history focused primarily on the physicians of antiquity, especially Hippocrates and Galen, whose "divine works" have been followed by almost all later physicians. Only brief mention was made of the Islamic authorities, but the story concluded with a somewhat fuller account of the prominent Italian scholastic physicians, beginning with Pietro d'Abano and Taddeo Alderotti, and culminating in Ugo Benzi, "who in the excellent quality of his genius and his skill in healing is thought to have outstripped all those who lived before him in our time."[85]

From the end of the fifteenth century we also have another history of medicine from the pen of a physician, Giacomo Bartolotti (ca. 1470–1530), who drew upon a prodigious range of Greek and Latin authors in constructing his account of "The Antiquity of Medicine."[86] Significantly, it was medicine as a practical art that was at the center of Bartolotti's concern, so that he had little to say about the link of medicine with speculative philosophy which had figured so prominently in the disputes on "the nobility of medicine." For example, Bartolotti did include a short section on Aristotle in relation to medicine, but chiefly to show that he had drawn much useful knowledge from Hippocrates, and that "not only was he zealous in examining the art theoretically, but when his friends were ill he also rendered assistance to them and prescribed certain remedies and precepts about food."[87]

Although Bartolotti's account was about three times as long as Tortelli's, it gave even less space to medicine in the post-ancient period. Islamic medicine merited only a bare sentence listing the names of some of its major exponents, while the many physicians "of our own age" fared only slightly better.[88] Here, the more or less conventional enumeration began with Pietro d'Abano and Taddeo Alderotti, and concluded with some of Bartolotti's own teachers.

Nevertheless, Bartolotti did pay these Italian authorities a very important compliment by noting that all of them "in the very accurate composition of their works called back from darkness this natural medicine which had almost perished."[89] In other words, he allowed the great scholastics to stand as the true heirs of Hippocrates and Galen, and thus to represent within medicine the very rebirth of antiquity that was at the center of the humanists' program.

This must have been about the last time at which a humanistic physician could portray the scholastic medical authorities in this light. For by the 1490s there had already begun to emerge a new conception of post-ancient medicine, according to which the Arabic physicians and their more recent Italian followers were the very cause of a darkness and barbarity into which the medical heritage of ancient Greece had sunk, and from which it needed urgently to be rescued by a revival of ancient sources.[90] Thus physicians themselves began to attack scholastic medicine with all the vigor of a Petrarch, but with the important differences that they exempted the ancient Greek physicians from their criticisms, and that they looked to humanistic scholarship as the tool with which to remedy the situation.

This new perspective reflected some major changes within humanism itself, which during the course of the fifteenth century had expanded beyond its original base in the Latin classics to a much fuller grasp of the language and literature of ancient Greece.[91] Along with this came a broadening of the interests of the humanists beyond literature, history, and ethics to rather more technical subjects such as metaphysics, natural philosophy, and mathematics.[92] And humanism became more technical in another sense as well, by adding to the concern for eloquence a growing preoccupation with textual scholarship and philology.[93] It was at this point that humanistic methods and attitudes could become something more than just an adornment for physicians, and instead have a significant impact on the substance of medicine as it was taught and practiced.

The individual most responsible for the application of these attitudes and methods to medicine was Nicolo Leoniceno (1480–1524), a native of Vicenza who spent most of his long career at Ferrara.[94] Leoniceno was a medical graduate of Padua, but he also had impeccable credentials as a humanist: he was a grandson of the humanist Antonio Loschi, he had been trained in Latin and Greek by Ognibene de' Bonisoli, and he devoted the greater part of his scholarship to textual editing and translation. Some idea of his role in the reform of medicine can be gained from a statement of Politian, who gave a new, optimistic twist to an old Petrarchian theme: "Who does not perceive that a doctor is more a source of danger than the disease itself? For one sickness is treated for another, and one remedy is prescribed for another, while Leoniceno's efforts are rescuing men from the dangers of death."[95] This corresponds to a major theme in Leoniceno's own writings, that the Arabic and medieval authorities, by failing to associate the proper diseases, herbs, and anatomical structures with their Greek names, had so corrupted the practice of medicine as to make it a menace to life.[96]

Of course, by insisting on the crucial importance of this relationship be-tween words and things in the practice of medicine, Leoniceno contradicted the contention of Petrarch that because medicine is essentially an art of deeds and things, it could have no useful relationship with the humanist's preoccupation with words. This changed perception was endorsed by Erasmus, who com-mended Leoniceno's linking of medicine with Greek learning, and then added: "In hardly any other art is error more dangerous, whence . . . I think that in the future medicine will be considered reprehensible without this [foundation in Greek letters]."[97] Similarly, Scaliger wrote of Leoniceno that he was the first "to link medicine itself with humane letters, and the first to teach us that men who practice medicine without good letters are like those who practice law in a foreign court."[98]

Moreover, by the time of his death in 1524, at the age of ninety-six, Leoniceno and his disciples had gone far toward establishing the humanistic orthodoxy as the dominant ideology in European medicine, to replace the Arabist, scholastic tradition that had prevailed since the late thirteenth cen-tury.[99] Thus by mid-century the anatomist Fallopio could look back upon the rebirth of medicine as an accomplished fact, citing Leoniceno as the one "who recalled the medical art from the lower regions."[100] The work had extended far beyond polemic against the Arabs and scholastics, to include the rather large task of editing and translating the full range of the surviving medical literature of antiquity. Major milestones were passed in 1525, with the publication of the first edition of Galen's complete works in Greek, and in 1541–42, with the first issue of the monumental Giunta edition in Latin.[101]

The title page of the Giunta edition, with its eight scenes from the life of Galen, reflects one of the more striking consequences of medical humanism, namely the emergence among physicians of a personal cult of Galen as their professional model.[102] This idealization was facilitated by the fact that Galen had offered himself as such a model, and had related many autobiographical anecdotes precisely to exemplify the qualities that physicians ought to emu-late.[103] And the incidents selected for the Giunta title page add up to a rather different ideal from that which had prevailed during the previous centuries. Thus five of the scenes illustrate Galen's clinical skills in the diagnosis, prog-nosis, and treatment of disease, while the large picture at the bottom shows Galen personally engaged in public anatomical demonstrations. The focus is clearly on the physician as practitioner and anatomist, rather than as specula-tive philosopher and dialectition. In fact, the dissection scene even points to a conflict between the two, because the incident portrayed is a public demonstra-tion at Rome, at which Galen confronted an Aristotelian philosopher, Alexan-der of Damascus, with experimental evidence against the doctrine of the primacy of the heart.[104] Specifically, Galen is about to expose and ligate the recurrent laryngeal nerves in a live animal, in order to show that voice—which in man is the highest manifestation of intelligence—is under the control of the brain, not the heart.[105]

The prominent portrayal of this particular incident on the Giunta title page

Title page of the Giunta edition of the works of Galen, in Latin, with scenes from his life. This particular copy is from the second edition of 1550 (fifth section), but the same woodcut was used in the first edition of 1541–42. The bottom scene shows Galen conducting a vivisectional demonstration before leading intellectuals and statesmen of the city of Rome, while the top scene shows his successful diagnosis of an ailing Roman Emperor. Most of the smaller scenes highlight Galen's clinical skills, except for the upper left, showing Galen's father's dream of Asclepius, and the middle left, showing his teachers. From the Library of the Institute of the History of Medicine, Johns Hopkins University.

may well allude to the fact that by the mid-sixteenth century there had evolved within the Italian universities just such a polarization between the Galenist medical professors and the teachers of Aristotelian philosophy. As noted above, the major professors of philosophy, whether or not they also had medical degrees, tended to become an increasingly distinct group by virtue of retaining their chairs on a permanent basis, rather than in transit to the medical positions.[106] Aristotelianism was itself changed significantly by the same trends in later humanism that affected medicine, but there persisted among the Italian Aristotelians a strong current of unrepentant Averroism.[107] This probably served to perpetuate an anti-Galenic sentiment among the philosophers, which was no doubt intensified by the increasing tendency of the medical professors to close ranks behind Galen.[108]

For their part, the physicians came clearly to resent Averroes' harsh treatment of Galen, and this probably made them less amenable to efforts to reconcile his differences with Aristotle.[109] In addition, a more specific result of humanistic scholarship played a major role in galvanizing medical opinion, namely the publication in 1534 of the first Latin translation of Galen's *On the teachings of Hippocrates and Plato (De placitis)*, the work in which he had mounted his most detailed treatment of his disagreements with Aristotle.[110] Galen was able to marshall a wide array of anatomical and vivisectional evidence in support of his own tripartite physiological system, as well as to defend a general methodological conclusion, that his empirical approach was a more reliable way of arriving at certainty than was the deductive reasoning employed by philosophers.

The resulting realignment of attitudes within the Italian universities is vividly illustrated by some incidents that occurred during a course of anatomical demonstrations at Bologna in 1544. On the first day Andreas Vesalius (1514–1564), happened to be visiting and was invited to conduct the proceedings.[111] The previous year Vesalius had published his monumental *De humani corporis fabrica*, in which he had announced his wide-ranging criticisms of Galen's anatomical doctrines.[112] At Bologna he is reported to have carried his disagreements with Galen to the verge of defending the Aristotelian position that the heart, rather than the liver, is the principal organ of nutrition and blood formation.[113] However, our informant tells us that Vesalius held back from drawing this conclusion:

> Indeed, Vesalius had entangled himself by what he had said and had appeared to supply arguments to those who suppose that blood is primarily generated by the heart. But so that he himself might emerge as somehow agnostic, he finally added at the end of his speech, in the manner of a penitent, that he who was supposed to live for the service of Galen and thus of the art of medicine could not so contradict his opinion and that of the physicians by depriving the liver of the primary power of sanguification. Nevertheless, he did not expect the professors of Aristotle to do [the same], if they added their own arguments to what they had seen in dissection.[114]

Note the sense of "we and they" as between the physicians and the

philosophers, and further, the implication that it would be tantamount to disloyalty to his profession for Vesalius to defend the Aristotelian side in these disputes.

Vesalius unexpectedly left Bologna early the next morning, but the physicians and philosophers of the university continued the disputation without him.[115] The first speaker was the philosopher Ludovico Boccadiferro, who simply followed Averroes in construing Aristotle's views in such a way that they were not in conflict with Galen's anatomical evidence. Indeed, he accused Galen of having deliberately distorted Aristotle's ideas in order to make them easier to refute. This attack on Galen is reported to have been met with hissing and booing by the students, who did not permit Boccadiferro to continue his remarks.[116] Instead, they called upon another philosopher, Antonio Fabio, who pointed out that the interpretation of Aristotle presented by his colleague was that of Averroes, and said that he would agree with it but for the fact that it so clearly contradicts Aristotle's own words. Fabio quoted a number of passages from Aristotle in the original Greek to show that the conflicts between him and Galen were real and irreconcilable. In conclusion he said that his purpose was simply to set forth what Aristotle had actually taught, without presuming to decide the issue as between Aristotle and Galen. The next speaker was a medical professor, Giacopo Pacino, who congratulated Fabio for his adherence to the truth, and said that he could well understand his reluctance, as a philosopher, to pursue the topic further; he had indeed expressed Aristotle's actual opinion, and it is quite clear from the evidence that Aristotle was wrong.[117] Pacino then cited numerous observations and arguments, taken mainly from Galen's De placitis, to show that the liver, not the heart, is the principal organ of nutrition and sanguification. Then, in turn, four other physicians continued the defense of Galen, setting forth the anatomical arguments from De placitis in great detail. By the time they were finished, according to our informant, no one dared to contradict Galen, and the disputation came to a close.[118]

There are reports of similar confrontations between physicians and philosophers at other Italian universities during the sixteenth and early seventeenth centuries, although the choosing of sides between Galen and Aristotle was not always along professional lines.[119] Indeed, Aristotle was to find one of his most partisan defenders against Galen's criticisms in the person of a physician, Andrea Cesalpino (1519–1603), who taught medicine at the University of Pisa.[120] However, in this respect Cesalpino seems to have been a rather isolated figure in Italian medical circles, and his views evoked more of a reaction in Germany than they did in Italy.[121] Indeed, his chief German disciple, Caspar Hofmann (1572–1648), commented on how anomalous Cesalpino was among Italian academic physicians. Hofmann related that while he himself was a medical student at Padua in 1605, he made a visit to Rome where he acquired a copy of Cesalpino's recently published Ars medica.[122] Hofmann saw this book as an effort to show that "our Hippocratic medicine is much more consonant with Aristotelian principles" than with the Galenic doctrines that have only

created many difficulties for the art. Hofmann said that he was much taken with this idea, until he realized how contrary it was to the views of his medical professors at Padua, among whom he named Hieronymus Fabricius, Ercole Sassonia, Giovanni Minadoi, and Giulio Casseri. Hofmann's characterization of the attitude of the Paduan medical faculty is corroborated by another leading professor of the early seventeenth century who could flatly declare that "the authority of Aristotle carries no weight for us physicians *(nobis medicis)*," because "we physicians follow the doctrines of Galen and the truth itself."[123]

Such statements reflect, I believe, a major change in the attitudes of physicians toward themselves and their profession from those of three centuries earlier, although to suggest that the change was a revolutionary one would be an overstatement. All of the institutions described at the beginning of this essay were still intact and would persist with relatively little change until the latter part of the eighteenth century. Virtually all Italian physicians continued to take a double doctorate in philosophy and medicine, and some (though not all) continued to style themselves as "philosophus et medicus."[124] Moreover, if Aristotle no longer enjoyed quite the unique position that he once had among physicians, he would still have appeared rather high on the list of authorities respected by most of them. And despite frequent protests, much of the medical literature of the sixteenth and early seventeenth centuries retained a heavily scholastic overtone.

All of these continuities could be illustrated with reference to the Venetian physician Santorio Santorio (1561–1636), who was the author of the last quoted remarks about Aristotle's authority. However, I would suggest that many of these traits were simple vestiges of a past era and tell us much less about Santorio than similar characteristics had revealed about, say, Ugo Benzi. Thus, university statutes may have required Santorio to deliver, as Ugo had done, a commentary on Avicenna, but they did not prevent him from punctuating these dutiful lectures with demonstrations of the dozens of medical and surgical instruments that he had invented and in which he took as much pride as Ugo had taken in his skill at disputation.[125] And academic tradition may have continued to call the subject that Santorio taught "medical theory," as distinct from "medical practice," but Santorio began his lectures by expressing his resentment at this distinction, if it be taken to imply that he is himself not a practitioner or that his lectures will not be of directly practical value to the students.[126] Clearly for him to be thought of as a mere theoretician was just as repugnant as it once had been to be thought of as a mere physician.

NOTES

1. Medical institutions began at an earlier time in southern Italy but then lagged somewhat behind the further developments in the north. See P. O. Kristeller, "The School of Salerno, Its Development and Its Contribution to the History of Learning," *Bull. Hist. Med.* 17 (1945): 138–94.

2. G. Monticolo, *I capitolari delle arti veneziane* (Rome, 1896), 1:267–381, *passim;* R. Ciasca,

L'arte dei medici e speziale nella storia e nel commercio fiorentino dal secolo XII al XV (Florence, 1927), 290–302; C. M. Cipolla, *Public Health and the Medical Profession in the Renaissance* (Cambridge, 1976), 83–96; S. M. Stuard, "A Communal Program of Medical Care: Medieval Ragusa/Dubrovnik," *Jl. Hist. Med.* 28 (1973): 126–42.

3. H. Rashdall, *The Universities of Europe in the Middle Ages,* ed. F. M. Powicke and A. B. Emden, 3 vols. (Oxford, 1936), 1:233–50; 2:1–62.

4. V. L. Bullough, *The Development of Medicine as a Profession: The Contribution of the Medieval Medical University to Modern Medicine* (Basel, 1966), 60–68; N. G. Siraisi, *Arts and Sciences at Padua: The Studium of Padua before 1350* (Toronto, 1973), 15–31; J. J. Bylebyl, "The School of Padua: Humanistic Medicine in the Sixteenth Century," in C. Webster, ed., *Health, Medicine and Mortality in the Sixteenth Century* (Cambridge, 1979), 335–70.

5. This account is based primarily on the statutes of the Colleges at Bologna, Pavia, Padua, and Venice: C. Malagola, ed., *Statuti delle università e dei collegi dello studio bolognese* (Bologna, 1887), 423–522; L. Franchi, ed., *Statuti e ordinamenti della università di Pavia dall'anno 1361 all'anno 1859* (Pavia, 1925), 119–43; Archivio antico della università di Padova, cod. 301, fols. 1–48; Biblioteca marciana, cod. Ital. 7, 2369 (= 9667). See also C. Webster, "Thomas Linacre and the Foundation of the College of Physicians," in F. Maddison, M. Pelling, and C. Webster, eds., *Essays on the Life and Work of Thomas Linacre* (Oxford, 1977) 213–18.

6. On surgeons with university degrees, see Bylebyl, "The School of Padua," 354–55, 366–68; and R. Palmer, "Physicians and Surgeons in Sixteenth-Century Venice," *Medical History* 23 (1979): 451–60.

7. N. G. Siraisi, "Taddeo Alderotti and Bartolomeo da Varignana on the Nature of Medical Learning," *ISIS* 68 (1977): 27–39; idem, *Arts and Sciences,* 50 and passim. Siraisi's important book, *Taddeo Alderotti and His Pupils: Two Generations of Italian Medical Learning* (Princeton, 1981) appeared after this essay was completed. For early references to Taddeo and Piatro, see Collucio Salutati, *De nobilitate legum et medicinae,* ed. E. Garin (Florence, 1947) 70, and nn. 85 and 88 below.

8. P. O. Kristeller, "Philosophy and Medicine in Italy," in S. F. Spicker, ed., *Organism, Medicine, and Metaphysics* (Dordrecht, 1978), 29–40; Siraisi, *Arts and Sciences,* 109–42; idem "Taddeo Alderotti," 27–39; B. Nardi, *Saggi sull'aristotelismo padovano dal secolo XIV al XVI* (Florence, 1958), passim; D. P. Lockwood, *Ugo Benzi, Medieval Philosopher and Physician, 1376–1439* (Chicago, 1951), 1–10.

9. I.e., the exam for the doctorate in arts was based upon certain works of Aristotle. The known members of the Paduan College between 1367 and 1378 included four doctors of arts, thirteen of medicine, and thirteen of arts and medicine. For the years 1391–95 the numbers are three doctors of arts, fifteen of arts and medicine, and none of medicine alone (A. Gloria, *Monumenti della università di Padova [1318–1405],* 2 vols. [Padua, 1888], 1:78–81.) By the first half of the fifteenth century the great majority of all medical degrees awarded at Padua were to students who either already had the doctorate in arts or who took it simultaneously with medicine (*Acta graduum academicorum gymnasii Patavini ab anno 1406 ad annum 1450,* ed. C. Zonta and I. Brotto, 3 vols. [Padua, 1970], passim). Eventually the Paduan College required the degree in philosophy as a condition of entry and forbade the awarding of a medical doctorate to any Italian student who was not laureate in philosophy (Stat. Coll. Padua, fols. 18r, 37v).

10. Bylebyl, "The School of Padua," 337–39.

11. Nardi, *Aristotelismo,* 157–58; U. Dallari, ed., *I rotuli dei lettori legisti e artisti dello studio bolognese dal 1384 al 1799,* 4 vols. (Bologna 1888–1924), 1 and 2, passim; A. F. Verde, *Lo studio fiorentino 1473–1503 ricerche e documenti,* vol. 2 (Florence, 1973), 32, 54, 126, 142–44, 160, 166, 216, 268, 356, 372–74, 392–94, 430–32, 444–46, 580–82.

12. Siraisi, *Arts and Sciences,* 25, and n.9 above. At Bologna there were, in theory, two colleges, one of philosophers and one of physicians, but membership was largely overlapping (Rashdall, *Universities of Europe* 1:241, n. 4; L. R. Lind, *Studies in Pre-Vesalian Anatomy* [Philadelphia, 1975], 26–31).

13. O. Temkin, *Galenism, Rise and Decline of a Medical Philosophy* (Ithaca, N.Y., 1973), 10–50.

14. Ibid., 17–18, 32–33, 72–76.

15. Ibid., 53–55, 121.

16. A. Preus, *Science and Philosophy in Aristotle's Biological Works* (Hildesheim, 1975), 113–18.

17. Galen's chief discussion of these issues is in *De placitis Hippocratis et Platonis,* in *Opera,* ed. C. G. Kühn, V, 181–805. A new edition and translation by P. de Lacy is now in progress as part of *Corpus Medicorum Graecorum,* 5:4, 1, 2 (Berlin, 1978).

18. Temkin, *Galenism,* 69–80, 97–99, 120–21. Temkin notes (64–68) that the late Alexandrians preceded the Arabs in closely linking Aristotelianism and Galenic medicine.

19. Seyyed Hossein Nasr, *Science and Civilization in Islam* (New York, 1970), 41–79; Elinor Lieber, "Galen: Physician as Philosopher: Maimonides: Philosopher as Physician," *Bull. Hist. Med.* 53 (1979): 268–85, esp. 278–79.

20. F. E. Peters, *Aristotle and the Arabs: The Aristotelian Tradition in Islam* (New York, 1968).

21. Avicenna asserted the subordination of medicine to philosophy at the very outset of the *Canon:* lib. 1, fen. 1, doc. 1, cap. 1 (Venice, 1564), 8.

22. Temkin, *Galenism,* 71–73, 76–80, 120–21; Lieber, "Galen and Maimonides," 382–85.

23. Avicenna, *Canon,* lib. 1, fen. 1, doc. 5, cap. 1, 31–32; doc. 6, sum. 1, cap. 4, 78–79; Averroes, *Colliget* (Lyons, 1531), 17v, 18v–19r, 20v–21r, 26v, 31r.

24. Avicenna, *Canon,* lib. 1, fen. 1, doc. 5, cap. 1, 31–32; doc. 6, sum. 1, cap. 1, 75.

25. See especially, *Aristotelis opera cum Averrois commentariis* (Venice, 1562), 6:130r. See also Averroes *Commentarium magnum in Aristotelis de Anima libros,* ed. F. S. Crawford (Cambridge, Mass., 1953), e.g., 265–67, 291–92, 415–16. Averroes carried this attitude into his medical treatise *Colliget,* e.g., 2r–3r, 18v–19r, 20v, 23r, 24r, 31r.

26. Ibid., 32v. Cf. also *Comment. in de Anima,* 298, 312.

27. Averroes, *Colliget,* esp. 32v, and also 20v–21r, 23v, 24r, 26r–27v, 31v–32r; *Aristotelis opera,* 6:129v–130r, 157v–163r.

28. As noted above, even among academic physicians most of those who taught philosophy would sooner or later give it up to teach medicine. And according to Siraisi, "The teaching of medicine at Padua was in the hands of practicing physicians and largely oriented toward medical practice." (*Arts and Sciences,* 162).

29. Siraisi, "Taddeo Alderotti," 29. Siraisi notes that Taddeo's student Bartolomeo da Varignana was more moderate in his Aristotelianism. However, another disciple of his, Torrigiano, went so far as to reject Galen's pulsific faculty on grounds that it violated philosophic principles. See his *Plus quam commentum in parvam Galeni artem* (Venice, 1557), fol. 58v. See also Pietro d'Abano, *Conciliator* (Venice, 1565) e.g., diffs. 31 and 38; Ugo Benzi, *Expositio super libros tegni Galieni* (Venice, 1498), fols. 16v–18v; Jacopo da Forli, *Singularis expositio, et quaestiones in artem medicinalem Galeni* (Venice, 1547), fols, 104v–107r.

30. Giovanni da Dondi referred to scholastic usage in a medical treatise as "sermone philosophis ac dialecticis usitato." See n. 76 below.

31. Lockwood, *Ugo Benzi,* esp. 139–46, 195.

32. Stat. Coll. Padua, fols. 37v–45r, 47; Stat. Coll. Venice, fols. 13–14.

33. Cf. Bylebyl, "The School of Padua," 339, 346–52 on practical teaching in the sixteenth century. At least a year of such practical experience had long been a standard requirement for degree candidates.

34. Stat. Coll. Venice, fols. 2v–4r, 6r, 12v.

35. Ibid., fol. 18.

36. See Ynez V. O'Neill, "Giovanni Michele Savonarola: an Atypical Renaissance Practitioner," *Clio Medica* 10 (1975): 77–93; Savonarola, *Libellus de magnificis ornamentis regie civitatis Padue,* ed. A. Segarizzi, as vol. 24, part 15 of the revised edition of Muratori's *Rerum italicarum scriptores* (Città di Castello, 1902).

37. Savonarola, *Libellus,* 36.

38. Ibid.

39. Ibid., 36–41.

40. Biagio and Paolo did not have medical degrees. Gaetano took his medical degree ten years after that in philosophy, by which time he was already a "famous doctor of arts" (*Acta graduum,*

1:192, 225). Eight years later he declined an opportunity to transfer from a chair of philosophy to one of medicine (J. P. Tomasini, *Gymnasium Patavinum* [Udine, 1654], 157–58). Nicoletto did not take a medical degree until nearly forty years after taking one in philosophy (Nardi, *Aristotelismo*, 98–99, 115–24).

41. Around 1520 Girolamo Bagolino transferred from an ordinary (major) chair of philosophy to one of medicine, but this appears to have been the last time that this occurred (Tomasini, *Gym. Pat.*, 306–9). At Bologna the custom of switching from ordinary chairs of philosophy to ones of medicine persisted longer, but seems to have died out after 1550 (Dallari, *I rotuli*, vol. 2, passim, and 52, 55, 94, 96, 111, 113 for examples of such transfers).

42. Stat. Coll. Padua, fol. 18r.

43. Ibid., my translation.

44. Savonarola, *Libellus*, 28; cf. also 22–23.

45. Fridolf Kudlien, "Medicine as a 'Liberal Art' and the Question of the Physician's Income," *Jl. Hist. Med.* 31 (1976): 448–59.

46. Siraisi, "Taddeo Alderotti," 28, n. 7; Petrarch, *Invective contra medicum*, ed. P. G. Ricci (Rome, 1950), 29–31, 39–40, 54–57, 61; Coluccio Salutati, *De nobilitate legum et medicinae*, ed. E. Garin (Florence, 1947), 22–24.

47. Siraisi, "Taddeo Alderotti," 29–31; Pietro d'Abano, *Conciliator*, diffs. 3 and 4.

48. Averroes, *Colliget*, 4r.

49. Petrarch (*Invective*, 54–57, 61) stressed the relationship between the claim by physicians that they are philosophers and the view of others that they are mechanics. And even Savonarola tacitly acknowledged the desirability of the dual title by placing *philosophi* at the top of his hierarchy of secular professions while *medici* are almost at the bottom, just slightly above the avowedly mechanical arts (*Libellus*, 21–24, 26–27, 36).

50. The controversy has been summarized by Lynn Thorndike, *Science and Thought in the Fifteenth Century* (New York, 1929), 24–58, and by Garin in his ed. of Salutati, *De nobilitate*, xiv–lviii. Garin has ed. other relevant texts in *La disputa delle arti nel Quatrocento* (Florence, 1947).

51. Petrarch, *Invective*, 42, 54.

52. Salutati, *De nobilitate*, 26–30, 222–28.

53. G. Bertoni, *Guarino da Verona fra letterati e cortigiani a Ferrara* (Geneva, 1921), 148–50; cited by O'Neill, "Savonarola," 80, nn. 39, 40.

54. On humanism, see P. O. Kristeller, *Renaissance Thought, the Classic, Scholastic, and Humanist Strains* (New York, 1961), esp. 3–23, 92–119; and E. Garin, *Italian Humanism: Philosophy and Civic Life in the Renaissance* (Oxford, 1965). For a recent overview, L. Martines, *Power and Imagination: City-States in Renaissance Italy* (New York, 1979), 191–217. Kristeller (pp. 112–14) stresses the near-simultaneous emergence in Italy of the scholastic philosophical-medical tradition and of humanism. Martines (p. 206) notes the status of many of the humanists as parvenues, while J. K. Hyde suggests a similar status for even the elite members of the Paduan medical profession of the first half of the fourteenth century (*Padua in the Age of Dante* [Manchester, 1966], 175–78).

55. Petrarch's major anti-medical tracts include "Febris tue nuntius" (*Fam.* 5:19), translated by J. E. Wrigley in "A Papal Secret Known to Petrarch," *Speculum* 39 (1964): 624–25; *Invective contra medicum*, cited above, and two long letters to Giovanni da Dondi (*Sen.* 12:1, 2), in *Lettere Senili*, trans. G. Fracassetti, 2 vols. (Florence, 1892), 2:207–79. Excerpts from the letters to da Dondi, as well as other comments about medicine, appear in *Letters from Petrarch*, trans. M. Bishop (Bloomington, 1966), 119–21, 170–71, 215, 248–52, 256–57, 277–85, 288–89.

56. Martines, *Power and Imagination*, 204.

57. Deno Geanakoplos, *Greek Scholars in Venice* (Cambridge, Mass., 1982), 1–40; R. Weiss, *The Renaissance Discovery of Classical Antiquity* (New York, 1973), 30–31; Petrarch, *Letters*, 23–24, 153, 158, 160, 191, 192, 209, 235; *Lettere*, 260–62.

58. Petrarch had been educated in law, and in contrast to medicine, he made a clear distinction between his respect for the scholarly traditions of the law and his dislike of lawyers. (*Letters*, 8, 167–69).

59. Pliny, *Natural History*, lib. 29, vols. 1–8, ed. and trans. W. H. S. Jones, 8: 182–201.

60. Ibid., 190–93.

61. "Febris tue"; Petrarch, *Invective*, 31, 50–51; *Letters*, 249; *Lettere*, 240.

62. Petrarch, *Letters*, 281; also 249, 277–83; *Lettere*, 209, 263.

63. Ibid., 235–36, 260.

64. Ibid., 260–62.

65. "Febris tue"; Petrarch, *Invective*, 39–40, 54–57, 60–61; *Letters*, 248; *Lettere*, 235–36, 257.

66. Petrarch, *Letters*, 38, 215, 279–84, cf. also 228–31; *Lettere*, 239, 244, 250, 258.

67. Petrarch, *Lettere*, 233–39.

68. "Febris tue"; Petrarch, *Invective*, 54–57, 60–61; *Lettere*, 244, 245, 257.

69. Petrarch, *Invective*, 52; *Letters*, 246–48.

70. "Febris tue"; Petrarch, *Letters*, 251–52; *Lettere*, 239, 244.

71. Petrarch, *Letters*, 118–21, 167, 172.

72. Ibid., 251–52, 256–57; *Lettere*, 238.

73. Ibid. 267–68. On da Dondi's humanistic and antiquarian activities, and his friendship with Petrarch, see Weiss, *Renaissance Discovery*, 49–53.

74. Petrarch, *Letters*, 251–52.

75. *De fontibus calidis agri patavini consideratio*, in *De balneis omnia quae extant* (Venice, 1553), fols. 94–108.

76. Ibid., fol. 94. See Thorndike, *Thought and Letters*, 334, where a humanistic physician of the mid-fifteenth century makes a similar reference to his use of the language of "philosophy" rather than that of "orators."

77. Salutati, *Tractatus quod medici eloquentie studeant et de verecundia an sit virtus aut vicium*, ed. E. Garin, together with *De nobilitate* (Florence, 1947), 280.

78. Ibid.

79. Ibid., 282–84.

80. Salutati, *De nobilitate*, 20–30, 222–28.

81. Thorndike, *Thought and Letters*, 35–46, 58. Poggio was the son of an apothecary (L. Martines, *The Social World of the Florentine Humanists, 1390–1460* [Princeton, 1963], 123.)

82. *Ugonis vita*, ed. and trans. Lockwood, in *Ugo Benzi*, 20–32, 149–56; on Averroes, 152.

83. Ibid., 149, 152.

84. *De medicina et medicis*, ed. and trans. D. M. Schullian and L. Belloni, in *Two Histories of Medicine of the Fifteenth Century* (Milan, 1954), 1–20, 71–89. On the relation to Socino's *Vita*, see Lockwood, *Ugo Benzi*, 13–15.

85. *Two Histories*, 87–89. Actually, in this longer version Ugo was himself superceded by Simone Tebaldi, the papal physician to whom the treatise was addressed.

86. *De antiquitate medicinae*, ed. and trans. Schullian and Belloni in *Two Histories*, 21–70, 91–142.

87. Ibid., 129.

88. Ibid., 136–37.

89. Ibid., 137.

90. For an early summary of this ideology, see Alessandro Benedetti, in Lind, *Pre-Vesalian Anatomy*, 82. The theme was developed in detail in Nicolo Leoniceno's *De Plinii, et plurium aliorum medicorum in medicina erroribus*, which first appeared as a series of tracts (beginning with Ferrara, 1492) and then as a collected edition (first at Ferrara, 1509). The fact that Leoniceno includes Pliny hints at the complete supremacy which he ascribed to the Greeks in medicine, although he sought to mollify his humanist colleagues by showing that the errors of the Arabic and medieval physicians were far worse. On this whole trend in medicine, see L. Samoggia, *Le ripercussioni in Germania dell'indirizzo filologico-medico leoniceniano della scuola Ferrarese per opera di Leonardo Fuchs* (Ferrara, 1964).

91. Kristeller, *Renaissance Thought*, 15–17; Geanakoplos, *Greek Scholars in Venice*, 1–40.

92. J. E. Seigel, "The Teaching of Argyropulos and the Rhetoric of the First Humanists," in T. K. Raab and J. E. Seigel, eds., *Action and Conviction in Early Modern Europe* (Princeton, 1969), 237–60.

93. Martines, *Power and Imagination*, 208–9.

94. I have surveyed Leoniceno's career in *Dictionary of Scientific Biography*, vol. 8 (New York, 1973): 248–50, where references will be found to Leoniceno's works and to other literature.

95. J. M. S. Cotton, "The Life and Works of Politian" (Ph.D. diss., Wisconsin, 1932), 160. I am grateful to Dr. Cotton for calling this passage to my attention.

96. Bylebyl, "The School of Padua," 341.

97. Erasmus, *Opus epistolarum*, ed. P. F. Allen, vol. 2 (Oxford, 1910): 493.

98. N. W. Gilbert, *Renaissance Concepts of Method* (New York, 1960), 102, n. 68.

99. Bylebyl, "The School of Padua"; C. D. O'Malley, *Andreas Vesalius of Brussels, 1514–1564* (Berkeley and Los Angeles, 1964), 45–47, 65–66.

100. Fallopio, *Opera* (Frankfurt, 1589), 775.

101. N. Mani, "Die griechische Editio princeps des Galenos (1525), ihre Entstehung und ihre Wirkung," *Gesnerus* 13 (1956): 29–52; R. J. Durling, "A Chronological Census of Renaissance Editions and Translations of Galen," *Jl. Warburg and Courtauld Insts.* 24 (1961): 230–305.

102. Temkin, *Galenism*, 125–27. Leoniceno's works (*Opuscula* [Basel, 1532]) are replete with adulatory references to Galen, such as "homo cum in omnium liberalium artium, tum in medicinae praesertim disciplina praecipuus" (p. 1v); "diligentissimus investigator" (p. 4r); "non minor pene philosophus quam medicus" (p. 17v); and "medicus nobilissimus" (p. 22r); and we even read of the formation at Florence of a "Galenica Academia," whose members call themselves "Medici Galenici" (*Novae academiae florentinae opuscula adversus Avicennam et medicos neotoricos qui Galeni disciplina neglecta, barbaros colunt* [Venice, 1533]).

103. Temkin, *Galenism*, 8–50.

104. Galen, *Opera*, ed. Kühn, 14:625–30.

105. Ibid., which compares with 5:226–40.

106. N.41 above.

107. Seigel, "The Teaching of Argyropulos"; Geanakoplos, *Greek Scholars in Venice*, 85–88, 92, 137–40; Gilbert, *Renaissance Concepts of Method*, 51–60, 164–95; and P. O. Kristeller, *Renaissance Thought II* (New York, 1965), 111–18.

108. On Boccaferro, see below. Simone Porzio commended Averroes for "non magnifaciens auctoritatem Galeni" (*De puella germanica* [Florence, 1551], 12). See also his *De humana mente disputatio* (Florence, 1551), 17–18. Zabarella cited Averroes in opposing Galen's tripartite system (*De rebus naturalibus libri XXX* [Cologne, 1597], fols. 738–44). Cremonini's *Apologia dictorum Aristotelis de origine et principatu membrorum adversus Galenum* (Venice, 1627) is a ferocious attack on Galen, with very extensive citations of Averroes.

109. Leoniceno referred to Averroes as "Galeni acerrimus aemulus" (*Opuscula*, 43v) and also denounced the philosophical Averroists (pp. 150r, 162v–163r); he is cited as "ille multis seculis immerito laudatus Averroes" in the *Nova academia florentina*, 13; and for an especially sharp outburst in defense of Galen by a Paduan professor, see G. T. Minadoi, *Disputations duae* (Padua, 1599), 26r. In 1540 Matteo Corti declared at Bologna that he would always follow the "true opinion" of Galen where he differs from Aristotle, and contrasted this approach with Averroes's too great zeal to save Aristotle. See Ruben Eriksson, ed. and trans., *Andreas Vesalius' First Public Anatomy at Bologna* (Uppsala and Stockholm, 1959), 50.

110. On *De placitis*, see above, n. 17; for its impact see, e.g., G. B. Teodosi, *Medicinales epistolae* (Basel, 1553), ep. 15, 424–25; G. B. da Monte, *Idea et characterismus doctrinae Hippocraticae* in *Opuscula varia* (Basel, 1558); Oddo degli Oddi, *In primam fen primi libri canonis Avicennae . . . expositio* (Venice, 1575), 398–406; and the Bologna dispute discussed below. The treatise long remained a focal point for discussing the issue of primacy—see, e.g., Cremonini, *De origine*, passim.

111. O'Malley, *Vesalius*, 98–99.

112. (Basel, 1543). Already in the *Fabrica* Vesalius refrained from extending his criticisms of Galen to the point of agreement with Aristotle "because it is by no means my intention to offer the philosophers an opportunity for attacking us" (pp. 590–91).

113. Gabriel Cuneo, *Apologiae Francisci Putei pro Galeno in anatome, Examen* (Venice, 1564), 70–76.

114. Ibid., 76.

115. Francesco dal Pozzo, *Apologia in anatome pro Galeno* (Venice, 1562), 116v–136v.

116. Ibid., 121v.

117. Ibid., 124.

118. Ibid., 136v.

119. Realdo Colombo, *De re anatomica* (Venice, 1559), 176, 261; Bylebyl, "The School of Padua," 363–64; Temkin, *Galenism*, 141–50.

120. W. Pagel, *William Harvey's Biological Ideas* (Basel/New York, 1967), 169–209; Cesalpino, *Peripateticarum quaestionum libri quinque* (Venice, 1571), 102–12.

121. Pagel, *Harvey's Biological Ideas,* 196–99, on Taurellus and Hofmann. See also Christoph Rumbaum, *De partibus corporis humani exercitationes quaedam* (Basel, 1586), 139–51; and Philip Scherb, *Theses medicae collectae* (Leipzig, 1614).

122. Hofmann, *De usu lienis secundum Aristotelis* (Leipzig, 1615), preface.

123. Santorio Santorio, *Commentaria in primam fen primi libri canonis Avicennae* (Venice, 1626), col. 289: "Nos vero medici insequentes Galeni dogmata et veritatem ipsam, non admittimus, cor esse tantae auctoritatis, quantae existimat Aristoteles, qui putat a corde tanquam a Monarchia non solum vitales, sed animales, et naturales spiritus prodire. Nos cum Gal. defendimus triumviratum." See also col. 62: "Medicus, qui est sensatus philosophus, non tractat, nisi quae sensibus subijciuntur: Medicus enim semper dispicit dogma insensible."

124. We even begin to find a threefold apellation, "Philosophus, Medicus, et Chirurgus," e.g., in Ercole Sassonia, *Prognoseon practicarum libri duo* (Frankfurt, 1610), 85.

125. *Commentaria in primam canonis,* a. 3 and passim. Temkin (*Galenism*, 159–60) notes that Santorio presented his various measuring devices as an outgrowth of Galen's teachings.

126. Ibid., a. 2, a. 3, cols. 2–4, 29, 37–39.

[3]

Art and Science: The Paracelsian Vision

P. M. Rattansi
University College, London

"Paracelsus and Behmen appear'd to me," wrote William Blake in 1800, when recalling the influences that had shaped his poetical genius.[1] Blake believed that Paracelsus had helped to free his imagination from the stifling authority of "the three great leaders of Atheism, or Satan's doctrine": Bacon, Locke, and Newton. Those founding fathers of Enlightenment rationalism belonged for Blake to Satan's party, because "everything is Atheism which assumes the reality of the natural and unspiritual world."[2] Locke's entire system was "completely bodied out" of Cartesian doctrine, according to Coleridge, and it was Descartes who had been the first to conceive nature as "utterly lifeless and godless."[3] It was scarcely surprising, then, that Locke had confounded human imagination with "Enthusiasm" or the false conceit of being divinely inspired, and that he had restricted human knowledge to the "primary properties" revealed in sensible knowledge, while dismissing as "secondary" all that revealed the splendor of the visible world.[4] How could the poetic imagination take wing when oppressed by so narrow and misconceived a view of man and nature, of mind and imagination?

Blake and other romantics discovered in the works of Paracelsus a far more inspiring vision of man and nature. The material and sensible was for Paracelsus no more than a covering through which a fundamentally spiritual reality expressed itself. It was a spiritual kernel that gave everything that existed its properties and qualities. Nothing in the universe was truly lifeless. Descartes had been wrong to set up an unbridgeable gulf between material and spiritual. Since there was a life in all things, man could gain deeper insight into their nature by empathy than by mathematical analysis or the torturing of nature in experiments. "Correspondences" linked the macrocosm of the universe and the earth with the microcosm of man. The language of analogy and symbolism

habitual to the artist and poet made it possible for him to penetrate far more deeply into those correspondences and to articulate knowledge of the nature of things in the kind of discourse that most aptly and truthfully expressed it. The Paracelsian vision helped to remove the mantle of authority from the man of science and restored it to the artist and poet to whom it rightfully belonged. Blake declared:

> Art is the Tree of Life
> Science is the Tree of Death.[5]

The liberating influence of Paracelsian ideas on the romantic generation can hardly be doubted. How authentic was their understanding of those ideas as they tried to select and fashion weapons for their own battles from complex and often seemingly contradictory doctrines scattered through the many tracts which the sixteenth-century iatrochemist had dictated in the course of a wandering existence?

Paracelsus, too, had struggled against what he believed to be a narrow and dogmatic rationalism. It was scholastic rationalism—the medieval "baptizing" of Aristotle, as it was often mockingly described in the Renaissance. It had split the universe into an immutable celestial region and a sublunary region which was the theater of ceaseless change. In the upper region revolved planetary spheres made of the most perfect of substances, the ether. All activity in the lower realm owed its beginnings to those superior motions. On the earth, the "complexion" of physical entities and changes in them were explained by the four elements and their associated qualities. So, too, were health and disease explained by the four humors whose particular balance determined the constitution of an individual. Man was the more or less passive receptor of heavenly and elemental powers and influences, and came closer to God when he engaged in the disinterested contemplation of nature. In understanding nature man focused his attention, above all, on the final causes or immanent purposes and ordered his knowledge through the use of syllogistic reasoning.

This essentially Aristotelian view of nature aroused the derision and contempt of Paracelsus. The principles and elements of the ancients, being general, were powerless to explain the irreducible specificity and individuality manifested by everything that existed. Their explanations dwelt only on the surfaces of things, never penetrating the visible and tangible, which was only the outward "signature," to reach the immanent soul-like power and force. The universe was basically divided between the spiritual and its material covering, rather than between a superior celestial region and an inferior terrestrial one. The macrocosm of the world and the microcosm of man were linked by concordances and coordination. Their relation could not be one of domination or dependence of one over the other.[6]

In order to explain changes in nature, it was necessary to supplement the four elements of the ancients with three additional principles, those of Salt, Sulphur, and Mercury. Those principles repaired a deficiency in the ancient structure of explanation by accounting for structure, solidity, and function. But the ele-

ments and principles were by no means to be regarded as invariant basic components, since each was to be found in many different forms and varied between one particular thing and another. No fixed combination of qualities was yoked to the elements; there could, for example, be a fire that was cold and wet. Moreover, each element and principle had a corresponding form in the world of the stars, on earth, and in man. There was an *aquaster* in the heavens as there was water on earth. The organs in man's body made up an inner firmanent like the stars did in the greater world.

Man was made, according to scripture, of dust; that is, of the matter of the heavens and of the earth: "there is nothing in heaven or in earth that is not also in man . . ."[7] As a result, man was able to gain knowledge of the world much more immediately and directly than by employing his corrupted faculty of reasoning. An act of sympathetic interaction between what lay outside him and its inner representative in him gave him unmediated access to the inner *scientia* of things.[8] It was "experiment" which taught us the working or virtue of a thing, but only when we were able to "overhear" the *scientia* hidden in it could we truly be said to possess experiential knowledge. Since correspondences linked man, the earth, and the universe, it was necessary to gain a deep and extensive knowledge of each realm of nature. It could not be supplied by book-learning, but only by experience. To read the pages of the book of nature it was necessary to travel, converse with all manner of people, even from the most despised social strata, and ceaselessly learn and explore all things.[9]

True knowledge was not gained by manipulating general concepts in accordance with logical rules. The naturalist had to gather experimental knowledge and transform it into experience through an active identification with the objects of knowledge. Man's active role was not confined merely to the pursuit of knowledge. God had created man to make his secrets visible, and that was to be accomplished by man through his *works*,[10] for man was essentially an alchemist, that is, one who carried "to its end something that has not yet been completed."[11] The baker, who turned wheat into bread, was as much an alchemist as the metallurgical worker who extracted the metal from the ore, or the true physician who extracted the *arcanum* from herbs, vegetables, and minerals. Indeed, it was in the art of medicine that the effects of the heathen and perverted view of nature were to be found at their most pernicious. Craftsmen had learned the secrets of nature so as "to imitate in her all things. . . ." Only in medicine had that duty been almost wholly neglected, so that it remained "the crudest and clumsiest of all the arts."[12]

Misled by their false conception of elements, the ancients had placed, as their counterparts, four humors in the human body. Just as the "complexion" of an object was determined by the predominance of one or more elements, so the balance of humors was thought to be responsible for the individual constitution or temperament. Health depended on the maintenance of that balance, while from the disequilibrium of the humors came disease. The physician was concerned with a single general condition, that of distemper. His task was essentially that of deciding how best to remove the humoral excess or to supply that which was deficient.

Paracelsus utterly rejected this conception of disease and of the role of the physician. The most striking characteristic of diseases was their diversity and specificity, which could never be explained by the humors. As in the greater universe, so in the human body, the three principles acted in the matrices of the four elements and generated a variety of species. The body could quite fittingly be compared to a mine, in which mineral constituents, which normally formed part of body substance and were invisible, rose to the surface in the form of a disease.[13] Such an analogy implied that there were at least as many diseases as mineral species. Like minerals, they occurred in a particular site and were localized. Being specific entities, they could not be treated by a general therapy, which only affected the symptoms and not the underlying condition, only the smoke and not the fire. What caused diseases? Paracelsus traced them, on the whole, to the disturbance of the "firmamental" coordination normally existing between the inner "heaven" and the "outer" one. Consumption, for example, could be caused by the microcosmic sun distributing excessive heat. To correct that condition, additional dampness had to be fed to the micro-cosmic sun. The true physician could accomplish that by making "another heaven"—the *arcanum* that would feed it with rain and dew. The *arcanum* must be an extract in which the requisite virtue would be available in its most concentrated form, a chemical medicine in a volatile state, exercising a specific curative action.[14] Efficacious medicines were made not by compounding, that is, putting together substances graded according to the "temperature" of their qualities, but by *separation* or isolation of the *arcanum* through distillation.[15]

The theme of separation had a deep and poignant significance in Paracelsian thought. Creation itself, as described in the Genesis account, was a separation. But since it was a disruption of the primal unity, it implied a fall and degenera-tion. The fall of Lucifer and his host of rebellious angels had led God to create the world.[16] Man, too, had separated himself from God by eating the forbidden fruit. In that *cagastrum* lay the roots of the inexhaustible diversity and the irreducible individuality and specificity of things,[17] but equally of the seeds of conflict that resulted from each being egotistically seeking its own good at the expense of others. Separation and conflict was a transient state. All nature tended toward its own primitive state and would one day return to it. Christ's resurrection foreshadowed man's own repossession of his spiritual body.

Even in his fallen state, man retained his dignity as the creature made in God's image. He revealed the forces and powers God had sown in nature. He completed what God had left unfinished in nature. He had received a material body from the earth, an ethereal one from the stars, and a divine soul from God. Through his ethereal body, man was subject to the influence of the stars. They did not exercise it through stellar influx but by firmamental coordination. The earthly part was exempt from their influence and pursued its animal life by virtue of its own being. Stars did not determine the length of human life, nor was their power unilateral. The magical power of man's imagination could work on stars to benefit himself or, unwittingly and disastrously, produce plagues and epidemics.[18]

All things in nature were first conceived in the divine imagination and were

created as God exteriorized his will.[19] The beginnings of all human actions and creations, too, were in the imagination. The faculty of imagination, which Paracelsus endowed with such great power and potency, was situated for him in man's astral body. Its force converted vital fluids from all parts of man's body into semen; it marked the unborn child with the thoughts of the mother. The imagination was a magical force.[20] Since it was involved in all actions, human actions could be said to be essentially magical.[21]

Paracelsus's conception of the imagination, as a supremely productive and creative power, helps to explain the attraction of his teachings for the romantics, as they attempted to rehabilitate the claims of the artistic imagination in an age dominated by science. Erastus had denounced the Paracelsian opinion in the late sixteenth century from an Aristotelian standpoint, pointing out that an idea could not act as the efficient cause of an object or event.[22] Francis Bacon had attacked it in the early seventeenth century, condemning Paracelsus and his followers for having exalted the power of the imagination so much that they had made it almost the same as "the power of miracle-working faith . . . ,"[23] thereby sanctioning ceremonial magic. Imagination was according to Bacon no more than a messenger between the senses, the reason, and the will. In religion it served as an *instrument* of illumination. That was why faith always first insinuated itself through similitudes, parables, visions, and dreams. But imagination clearly possessed the dangerous power of overmastering reason and could make itself ungovernable. Such a power of mischief lurked in verbal eloquence and all poetry.[24]

The appalled response of Blake to Bacon's attitude emerged in the marginal annotations to his copy of Bacon's *Essays*. Nothing would have seemed to him more opposed to the Paracelsian conception of the imagination than Bacon's remark: "The religion of the heathen consisted rather in rites and ceremonies, than in any constant belief: for you may imagine what kind of faith theirs was, when the chief doctors and fathers of their church were the *poets*"—which Blake annotated with the single word, "Prophets."[25]

But however great the appeal of the Paracelsian idea of the imagination to the romantics, they would have found it difficult to enlist Paracelsus as a champion of their own lofty conception of the status and function of the poet and artist. Paracelsus took pains to deny that "acting, poetry, music" came from the devil. Nor were they human inventions. They were to be ranked as "high arts," just as much as astronomy, geometry, alchemy, medicine, philosophy, and theology. Like them, they came from God.[26] Paracelsus compared the artistic work of the woodcutter, separating the wood "from that which does not belong to it" to the separation wrought by God in the work of creation.[27] But such comparisons served for him generally to affirm the dignity of the craftsman's calling rather than to celebrate the artist. The woodcarver, whose work resembled God's, "discovered" in a piece of wood, indifferently, not only the forms of plants and animals, but also those of implements for human use.[28] The first invention of the lyre was compared to that of the forge and of the alphabet as examples of the gifts bestowed by the divine spirit on fallen man.[29]

Paracelsus prescribed severely practical ends to the arts. They existed, above all, to gratify needs "and help us to serve our fellow men." That applied to the art of music; it helped to cure melancholy and disordered fantasy, and to drive out the spirits of demons and witches.[30] Knowing and doing must never be severed. All arts and crafts came into being only after the expulsion from Eden, when God in his mercy created the "light of nature" which enabled man to sustain himself—but only by toiling by the sweat of his brow to put his gifts to productive use.[31] Paracelsus's ideal man, who combined knowing and doing in the highest measure, was the true physician. He was moved solely by compassion and the duty of charity to his neighbor: "Privilege and lineage pale to nothingness, only distress has meaning."[32] God had planted a remedy for each disease, and the physician's insight into firmamental coordination enabled him to relieve suffering.[33] The physician brought his vast knowledge of correspondences to the task of diagnosis; he read the condition of the urine in the macrocosm, related the pulse to the firmament, chiromancy to the minerals, breath to east and west winds, and fevers to earthquakes.[34] He emulated the work of God, who in the greater world "himself practices medicine."[35]

There were resemblances between the calling of the artist and that of the physician. The woodcarver and sculptor "separated" the essential from the dross as did the physician in collecting the *arcanum.* "Signatures" guided the physician to the hidden virtues lying within an object, and "physiognomy" and chiromancy to the mind and soul of a man. The artist and sculptor had to achieve equal mastery of the "art of signs" if he was to produce truly accomplished work.[36] But while recognizing and praising the God-given talent of the artist, who used the visible appearance of men and women to lay bare their souls, the Paracelsian view was bound to confer preeminence on the physician-alchemist-philosopher as one who contributed most to fulfill God's plan in creation.

Moreover, a pervasive theme of Paracelsian thought was separation, the breaking up of the original unity, which brought conflict. Nothing could be said to be bad or evil in itself, only relative to something else. What was good for one was bad for another; fish inhabited the element of water, while men drowned in it.[37] From such differences and divisions came disease, suffering, and death. The theme of harmony, and of beauty as the product of harmony, had given a peculiar importance to the artist in Renaissance thought. It is not a conspicuous feature of Paracelsian teachings. Paracelsus did not follow Galen in pointing continually to the aptness of structure to purpose in the animal body, nor in deriving from the correspondence between macrocosm and microcosm the strongest argument for the beauty and harmony of all creation.[38] His work is replete with allusions to "anatomy," but it signified either chemical anatomy, which revealed the true nature of things, or the study of the concordance between the greater and lesser worlds.[39]

Concordance served in Paracelsian thought as a continual reminder of the original unity from which the creation was a falling away. The term, *cagastrum,* was coined by Paracelsus to convey the loss and alienation resulting from a disjunction which gave rise to conflict, diseases, and death.[40] Harmony could

not have appeared to Paracelsus the leading characteristic of a world whose creation was a consequence of the rebellion of Lucifer, and where the acquisition by man of an astral body and the concordance between it and the stars followed man's disobedience in eating the forbidden fruit.

Indeed, the contrast between Paracelsus and Galen on beauty and harmony serves to illuminate the difficulties commonly experienced in placing Paracelsus within a convenient historical niche.[41] Was he a Renaissance humanist or a medieval mystic, was he a great pioneer of modern science and medicine, or a purveyor of irrational and superstitious ideas in a confused, semiliterate form? Paracelsus pointed to the impotence of ancient concepts and categories when confronted with the inexhaustible diversity and irreducible individuality of the myriad beings in the world. That would seem to make him a spokesman for the Renaissance individualism. Paracelsus rejected the scientific and medical doctrines inherited from the ancients and affirmed that "the new time confronts us with new tasks." He wished to substitute "experiment" and experience for logical analysis in explaining natural phenomena. He offered a "chemical" conception of physiological as well as geological and meteorological processes. He developed an ontological conception of disease-entities to replace that of ancient medicine. He turned alchemy decisively from the search for metallic transmutation to the quest for chemical medicines. All these features of his teaching would appear to give Paracelsus an assured place as a great scientific and medical innovator.

However, these "progressive" aspects of Paracelsian thought were counterbalanced by others which are far less likely to evoke our commendation—but which emerged from the same general outlook. Paracelsus's novel interpretation of firmamental coordination justified the assumption that the sympathy between the *astrum* hidden in things and man's astral body offered the sole avenue to true insight into their virtues or working principles. Those virtues could be extracted by chemical distillation but could also be captured from the stars in amulets and talismans. Chiromancy and the science of physiognomy were essential to the physician since they disclosed the meaning of "signatures" carried by human beings no less than plants and minerals. While severely critical of the astrology and alchemy of his own time, Paracelsus conceived the ideal man as a *magus* who could capture the *astra* hidden in all things to work miracles in nature.

The mechanistic world view which the romantics sought to undermine attained its dominance only a century after the death of Paracelsus. But his work already embodied a protest at the increasing tendency of his contemporaries to materialize Peripatetic elements and physiological "spirits" by confusing them with tangible chemical substances. He insisted on the spiritual character of the working principles of all things, urging that beneath the tangible and perceptible lay the invisible and intangible kernel.[42] Blake, who found an affinity of outlook in Paracelsus, believed in the necessity of such a "double vision":

For double the vision my Eyes do see,

And a double vision is always with me . . .
May God us keep
From single vision and Newton's sleep![43]

Wordsworth was close to Paracelsus when he expressed his sense of "a motion and a spirit" that rolled through all things:

Whose dwelling is the light of setting suns,
And the round ocean and the living air,
And the blue sky, and in the mind of man . . ."[44]

Blended in Paracelsian doctrine were ideas from ancient Gnosticism and Neo-Platonism, medieval mystics, the alchemical tradition, and Renaissance humanism and the northern Reformation. All were stamped with that unique and individual vision which makes Paracelsus one of the most striking figures of a "transitional" century.

NOTES

1. Letter to John Flaxman in Blake, *Complete Writings*, ed. G. Keynes (London, 1966), 794.
2. Cited in Kathleen Raine, *Blake and Tradition* (London, 1969), 2: 169.
3. S. T. Coleridge, *Philosophical Lectures* (London, 1949), 376; *Collected Letters* (Oxford, 1956), 699.
4. Raine, *Blake and Tradition*, 2: 101–130.
5. "The Laocoön" (ca. 1820) in Blake, *Complete Writings*, 777.
6. See Walter Pagel, *Paracelsus: An Introduction to Philosophical Medicine in the Era of the Renaissance* (Basle-New York, 1958); A. Koyré, "Paracelse" (from *Revue d'Histoire et de Philosophie Religieuse*, 1933) in *Mystiques, spirituels, alchimistes* (Paris, 1955), 75–129.
7. Paracelsus, *Selected Writings*, ed. J. Jacobi, Eng. trans. (London, 1951), 119.
8. Pagel, *Paracelsus*, 60.
9. Ibid., 56; Paracelsus, *Selected Writings*, 81, 131.
10. Paracelsus, *Selected Writings*, 183.
11. Ibid., 24, 166–67, 182, 215–17.
12. Ibid., 167.
13. Paracelsus, *Von der Bergsucht und anderen Bergkrankheiten* (Dillingen, 1567); "On the Miners' Sickness and other Miners' Diseases," trans. George Rosen, in H. E. Sigerist, ed., *Four Treatises of Theophrastus von Hohenheim called Paracelsus* (Baltimore, 1941).
14. Pagel, *Paracelsus*, 68–69.
15. Ibid., 144–45.
16. Koyré, "Paracelse," 106.
17. Pagel, *Paracelsus*, 113–14.
18. Ibid., 179–81.
19. Koyré, "Paracelse," 99.
20. Pagel, *Das Medizinisches Weltbild des Paracelsus* (Wiesbaden), 115–17.
21. Koyré, "Paracelse," 97.
22. Pagel, *Paracelsus*, 316–17.
23. Bacon, "Advancement of Learning," bk. 2, 119, in *Works*, ed. Spedding, Ellis, and Heath, (London, 1858), 1:381.
24. "De augmentis scientiarum," bk. 5, chap. 1, in ibid., 615.

25. Blake, *Complete Writings*, 399.

26. Paracelsus, *Selected Writings*, 212.

27. Ibid., 88.

28. Ibid., 191.

29. Ibid., 205.

30. Ibid., 124–25.

31. Ibid., 175–76, 189.

32. Ibid., 146.

33. Ibid., 147.

34. Ibid., 137.

35. Ibid., 168.

36. Ibid., 196.

37. Koyré, "Paracelse," 118–22.

38. E.g., Galen, *De usu partium* (Eng. trans., M. T. May), 2 vols. (Ithaca, N.Y., 1968), 1:79, 2:529–30.

39. W. Pagel and P. M. Rattansi, "Vesalius and Paracelsus," *Medical History* 8 (1964): 309–28, esp. 310–14.

40. Pagel, *Medizinisches Weltbild*, 89–90, 95–98.

41. Pagel, *Paracelsus*, 35–49, 344–50; *Medizinisches Weltbild*, 1–32; Koyré, "Paracelse," 77–86.

42. Paracelsus, *Selected Writings*, 92.

43. Blake, *Complete Writings*, 817.

44. "Tintern Abbey" (1798) in *The Poetical Works*, ed. E. de Silincourt (Oxford, 1944), 2:262.

[4]

The Science of Sound and Musical Practice

Claude V. Palisca
Yale University

The concerns of the practicing musician and of the acoustic scientist of the Renaissance intersected particularly at three points in the musician's work: (1) when he built an instrument, (2) when he tuned an instrument, and (3) when he tried to analyze how sounds and music affected him and to reason why.

What leading thinkers believed about the science of sound was, therefore, of more than theoretical interest to musicians. I shall attempt to show that the revival of ancient scientific knowledge and its interpretation by Renaissance commentators were intertwined with investigations of practical musical problems.

The questions scientists and philosophers asked about sound that proved to be significant for music were several. What is sound and how is it produced? What causes differences of pitch? How are sounds related to numbers? How is sound propagated? Why do some combinations of sounds appear to us as consonant?

In speaking of early science it is necessary at times to adopt a rather broad definition of it that includes, for example, magic, astrology, numerology, and alchemy. I should prefer to work within narrower limits. Take, for example, numerology, which had an important influence on music theory. Certainly the generalizations about the proportions of things in nature were the beginnings of science, for they constitute a search for principles behind the diversity of appearances. The discovery of the ratios of string and pipe lengths that produce certain consonant intervals was a major scientific advance, which legend attributes to Pythagoras. But when these ratios became part of a rigid numerology and from there were incorporated into artistic theory, the interaction was no longer between art and science but between art and mysticism. Scientific prin-

ciples based on observation sometimes become myths, and when the artist is ruled by them, he is ruled by myth, thinking it is science.

Pythagoras himself was probably not as much interested in music as in the harmony of sounds as a manifestation of the rule of proportion. The mathematical doctrine of the Pythagorean cult, however, found its way into musical theory and fixed the theoretical boundary between consonance and dissonance. Much of this doctrine was transmitted by Boethius, whose *De institutione musica*, written around A.D. 500, is the foundation of early Renaissance music theory. It is a compendium of Greek music theory based mainly on the second-century Hellenic mathematician of the Pythagorean school, Nicomachus. In it mathematical reasoning is applied to the selection and ordering of the tonal system. The pitches, scales, tunings, consonances, the gamut, and other relationships that are the basis of melodic composition are determined by numerical proportions. The limits to the field of consonance and to the acceptable tunings, for example, are set by numbers that were thought by the Pythagoreans to have divine power, such as the number 4.

Number theory required that to be considered a consonance an interval had to be represented by a ratio that was either in the multiplex (xn/n) or superparticular $(n + 1/n)$ class of ratios and furthermore expressible by numbers from 1 to 4. The intervals that qualified were: the octave, $2:1$; the octave-plus-fifth, $3:1$; the double-octave, $4:1$; the fifth, $3:2$; and the fourth, $4:3$.

The tradition that stemmed from Pythagoras discouraged further investigation of sound, and those most influenced by him as late as the sixteenth century refused to recognize new scientific facts that were at odds with the doctrine. Myths tend to be more attractive to artists than facts, because they are formed in man's own image. Dawn riding a golden chariot is more poetic than a globe revolving on its axis. So science sometimes has created myths that have caused art to lose contact with science.

An important achievement of the Renaissance was to bring musical theory and practice back in touch with true science, as opposed to magic, numerology, and astrology. In the works of Aristotle, Aristoxenus, Euclid, Strato, Ptolemy, Nicomachus, and Themistius, a high degree of integration between scientific knowledge and musical theory had been achieved. Aspects of this synthesis were also summed up by Boethius. Before the fourteenth century little was added to the understanding of the mechanics and mathematics of sound transmitted by Boethius.[1] The first advances made in the Renaissance were through the recovery of antique acoustical science.

Our account must begin with that fountainhead of early science, Padua, and specifically with Pietro d'Abano (1250–ca. 1316), whose commentaries on the Aristotelian *Problems* on physics he completed in Padua in 1310.[2] D'Abano was convinced that the *Problems* were a genuine work of Aristotle and strove to elucidate them with the help of others of his works, particularly *Politics, De anima,* and *De generatione animalium*. The Latin translation accompanying the commentaries had been generally assumed to be by Pietro also, but recently it has been shown that it was done by Bartolomeo da Messina, active in the

court of Manfredi, King of Sicily, who died in 1266.[3]

If d'Abano had set out to investigate the physics of sound, he could not have started with a more provocative text than the *Problems*. Though that was not his object, in the course of the commentary he did undertake to explain the mechanics of sound. In relation to Problem XI.1, which deals with the perishability of the sense of hearing, d'Abano makes the acute observation that to produce sound a body must "vibrate violently and rapidly so that the air is stretched; because of this we see that air, when a rod is suddenly and forcefully moved within it, causes sound."[4]

Problem XI.19 gives d'Abano the opportunity to apply this theory to strings. The Aristotelian author observed that a shrill sound is more audible at a distance, because it is thinner and thus has greater longitudinal extension. D'Abano expands on this, saying that a string must be thin and tense to produce a sound: "A thin and stretched string that is struck repercusses the air with numerous impulses *(ictus)* before it ceases, so that the jingle *(tinitus)* persists for a long time after the blow, for which reason the medium is filled with the jingle. This does not happen, however, with a thick and loose string."[5] The implication is that the thinner and tenser a string, the higher the pitch, but this rule is not explicitly stated. Moreover d'Abano points out that in the case of a higher pitch the air breaks up into smaller parts.[6] It is clear that d'Abano understood the action of the string on the air as causing alternately rarefactions and condensations, more of them for a higher than lower pitch, and this is consistent with the modern view. •

D'Abano clarifies his position and that of the author of the text in his remarks on Problem XI.6. Here the text explains that sound does not move like a projectile but by means of air impelling air, and it dies not as a projectile falls but when the initial force is spent and air can no longer impel other air. D'Abano sets this rather incidental comment into the context of a theory of sound propagation based partly on *De anima*. Sound does not travel like an arrow. The air that strikes the receiving ear is not the same as was set in motion by the sounding body. The air that was first moved is calm by the time the sound arrives at its destination. Moreover, sound is diffused throughout the medium around the vibrating body, while a projectile moves in a single direction. D'Abano takes pains to point out that Aristotle disagreed with Plato, who believed that high sounds travel faster than lower sounds. In *De anima* Aristotle had insisted that "the speedy is not acute (in pitch) nor the slow grave, but high pitch is caused by speed of motion and low by slowness."[7]

The precise relationship of high to low sounds emerges in the musical section XIX. In Problem XIX.39 the question is why we prefer the consonance of the octave for magadizing, that is the simultaneous singing of boys and men of the same tune an octave apart. The author of the *Problems* answers that the periods of the two sounds agree: "for the second stroke which nete makes upon the air is hypate [the note an octave below]."[8] D'Abano, elaborating on an analogy made by the author to poetic meters, compares the combination of a dactyl and anapest, both made up of two breves and a long adding up to two tempora, and

the combination of tribrach, consisting of three breves, and a spondee comprising two longs. While the first combination joins equals, the second joins unequals and the tribrach ends on a fraction of the spondee:

dactyl —— ᴗ ᴗ
anapest ᴗ ᴗ ——

tribrach ᴗ ᴗ ᴗ
spondee —— ——

This is analogous, Pietro says, to men's and youths' voices, which produce a poorer consonance—the fifth—than men's and boys' voices, which are an octave apart. In terms of ratios the poetic and musical examples are not strictly analogous. The ratio of the tribrach to the spondee in tempora is 3:4, while that of the fifth is 2:3, that is, in the time that the higher sound makes three ictus, the lower sound makes two, so that the upper sound has completed one and one-half in the time of a complete ictus of the lower sound.

D'Abano here faithfully transmitted and explicated a conception of the physical basis of pitch and consonance that laid the foundation for later Renaissance advances in the understanding of their acoustical properties. Pitch is seen as originating in cycles or periods of vibration (tinitus) of the air set off by plucking a string. A string tuned to nete will move through two such cycles during the time a string an octave lower (hypate) completes one cycle, the terminations of the two cycles coinciding. This relationship holds only for the octave, which is thus the mistress of consonances. Neither d'Abano nor Aristotle was correct, however, in the assertion that the termination of one period of the hypate coincides with those of all higher notes of the octave-scale. At some higher octave all the notes (pitch-classes) of the scale, it is true, will be coterminal with the hypate, but not within the octave hypate-nete.

In commenting on Problem XIX.35, d'Abano went a step farther than Aristotle in insisting upon the unique position of the octave. He cited the authority of Ptolemy's Harmonics: any consonance added to an octave remains a consonance, which is true only of the octave.[9] In d'Abano's remarks on section 41, he showed that he accepted the consequences of this statement in including the octave-plus-fourth as a consonance, that is despite its having the ratio 8:3, which is neither superparticular nor multiplex and was therefore excluded by the Pythagoreans and their followers, among them Aristotle.

Pietro d'Abano's commentaries were published in 1475 (Expositio problematum Aristotelis cum textu, latine [Mantua: Paulus Johannes de Puzpach]), and other editions came out in 1482, 1484, and 1497, as well as later. The first work by a musician that could have utilized the printed commentaries was Franchino Gaffurio's Theoricum opus musice discipline of 1480. Not surprisingly—for Gaffurio (1451–1522) was constantly on the lookout for ancient sources—he did, indeed, take advantage of d'Abano's work. He cited Problem XIX.21 to support the contention that the interval of the fourth was tolerated in the higher parts of a contrapuntal texture, but not when it was the lowest

interval. The higher sounds, he argued, citing the Problem, produced by faster and weaker motion, make a more fleeting impression on the ear than lower notes, since these are a product of slower and more powerful motion and make a stronger impression.[10]

In the same book, however, Gaffurio failed to profit by d'Abano's superior explanation of sound and consonance and relied instead upon Boethius, whom he paraphrased.

> According to Plato, consonance strikes the ear in this way: the higher of the two sounds, which is speedier, precedes the low sound and enters the ear quickly, and the innermost part of the ear, having been hit, bounces the impulse back, as it were, with repeated motion. But now it arrives more slowly, not fast as when emitted by the first impulse. For this reason this higher sound, now returning lower, presents itself as similar to the approaching low sound and it is blended with it, making one consonance.[11]

Boethius, embroidering on the explanation in Plato's *Timaeus*, tried to account for how the speed of the higher sound slowed down in the ear.[12] He seems not to have been totally convinced, however, for he went on to cite the view of Nicomachus[13] (or perhaps he was translating Nicomachus throughout these chapters). Gaffurio reported that Nicomachus did not accept Plato's theory and offered another explanation. We know the theory of Nicomachus on this matter only through Boethius, since the surviving *Manual* and the fragments contain no mention of it. Nicomachus, according to Boethius, held that sound consists of not one impulse but many percussions in quick succession. When a string is tense, it produces more frequent and dense pulsations; when it is loose, it produces slow and rare pulsations. It should not be thought that when a string is struck it yields only one sound; rather a continuous series of rapid motions are heard as an uninterrupted sound, and this consists of many vibrations, less frequent for the lower sound, more frequent for the higher one. If the percussions of the low sounds are commensurate with the high, then consonance results.[14]

In his next book, *Theorica musice* of 1492, Gaffurio went to what was probably the most enlightened source then available on the science of sound, the *Paraphrases* of Themistius (ca. A.D. 317–388) on the *De anima* of Aristotle in the Latin translation of Ermolao Barbaro.[15] Themistius now became Gaffurio's main source for the theory of sound and hearing. Themistius had insisted, as d'Abano did, that the air struck by the sounding object was not the same as that which reached the ear. He noted, following Aristotle, that the notions of grave and acute were assigned to sounds by analogy with touch and elucidated this by saying that the acute voice stabs the air and pungently wounds it, while the grave tone hits bluntly and spreads as it hits. While the acute sound moves the sense a great deal quickly, the grave sound moves it little slowly.[16] Gaffurio depended on Themistius also to explain the mechanism of hearing. The nature of the ear is akin to that of air in that the ear is congenitally filled with air which is excited by the air outside and transmits the motion to

little sensitized tinders inside a tissue of little breadbaskets (paniculae) filled with air. The outside and inside air are continuous, which explains why animals do not hear by their other bodily parts.[17]

With the exception of the citation of Plato by Boethius, these interpretations of the nature of sound and consonance all issued from the Peripatetic tradition. In the late fifteenth and early sixteenth century they collided head-on with the Pythagorean and Platonic revival. This clash is already evident in Gaffurio, who could not reconcile Themistius's and Ptolemy's empirical tendencies with the strong influence he felt from the side of Ficino and Plato. The split was intensified in Gaffurio's last treatise, *De harmonia musicorum instrumentorum*, finished in 1500 but not published until 1518, in which he exploited his reading of several newly translated Greek writings by Ptolemy, Bryennius, Bacchius, Aristides Quintilianus, and the so-called anonymous of Bellerman.[18] Although Ptolemy, particularly, offered solutions to practical problems that should have appealed to Gaffurio as a composer and choir director, he could not shed the deeply ingrained Boethian-Pythagorean bias.

It is surprising that Gaffurio should have been blind to the incompatibility of the ancient theory of intervals and the way composers of his day employed the consonances. As was shown, ancient theory as transmitted by Boethius accepted the fourth as consonance but rejected the thirds and sixths.[19] The musical practice of the fifteenth century, on the other hand, required that the fourth be treated in most polyphonic situations as a dissonance and that the perfect consonances be mixed and alternated with the so-called imperfect consonances, the thirds and sixths, whose ratios $5:4$, $6:5$, $5:3$, and $8:5$ were all outside the inner sanctum of the first four numbers. The tuning described by Boethius, which is based on the ratios determined by Plato for the basic structure of the world soul in the *Timaeus*,[20] was ideal for monophonic music and polyphonic music such as organum that treated thirds and sixths as dissonances. But it was not suitable to more recent polyphonic music, which depended very much on the sweeter sounds of the thirds and sixths obtainable in other tunings and which treated these intervals as more consonant than the fourth. The mathematician Bartolomé Ramos de Pareja (ca. 1440–after 1491) in 1482 had proposed such a tuning purely as a practical strategy.[21] Gaffurio opposed it as late as 1492 because he knew no theoretical basis or authority for it. When, in the late 1490s, he discovered that Ptolemy was an authority behind it, he did not seize upon this support but continued to defend the Pythagorean tuning. Gaffurio's opponents, meanwhile, grasped at this ancient authority and not only confronted him with it but started the ground swell that eventually led to the adoption of the tuning, called by Ptolemy "syntonic" or "intense" diatonic, as the ideal system. Giovannis Spataro (1458–1541), a pupil of Ramos, was the main champion of the Ptolemaic tuning,[22] which was later adopted by Gioseffo Zarlino (1517–1590) in the most widely read musical textbook of the sixteenth century.

When physical facts, such as the terminations of cycles of vibrations, rather than numbers, are recognized as the basis of consonance, as they appear to be

by the author of the *Problems* and d'Abano, then there is no precise limit beyond which intervals may no longer be considered consonant. The practiced ear is the final judge. This point of view was first clearly articulated by Lodovico Fogliano (before 1500–after 1538) in his *Musica theorica* of 1529.[23] Fogliano had the unusual competence for a musician and composer of reading Greek well enough to contemplate an Italian translation of works of Aristotle.[24] His chapters on sound and hearing, indeed, are an extension of what is said about these matters in Aristotle's *De anima* and *Physics*. He declined to consider music subaltern to mathematics, as most of his predecessors had classified it. Insofar as music is sound, it is natural; insofar as it is measured motion, it is mathematical. Sound is generated through the violent expulsion of air, which may happen in a number of ways, as through the collision of a solid and fluid body, for example a switch impetuously moved through the air. "Air thus torn is very quickly compressed and flows together from every direction, since nature abhors a vacuum. Thus a very rapid condensation of air comes about that resists the striking switch, and this condensation is discharged by exchange with the solid body." Thus "at least three things concur in the generation of sound, namely that which violently expels the air, the air violently expelled, and the motion or the expulsion."[25] None of these three is formally sound, which is therefore an accident. It is a passive quality deriving from the violent motion of the air and is commensurate with it in that it lasts as long as the motion, and it has the potential to move the sense. Hearing is similarly a natural potential, activated by sound through the medium of the air outside and within the ear. Therefore, the sense of hearing is the final judge of consonance and dissonance. And the senses, in preferring the thirds and sixths to the fourth, contradict reason.

Fogliano applied his empirical methodology to the tuning of the practical musical scale. He contrasted to the usual mathematical method of dividing the monochord his "nouo modo quasi secundum sensum: & materialiter."[26] His system permitted a chromatic scale that contained not only pure fifths and fourths, as in Pythagorean tuning, but also pure major thirds. Whereas the Pythagorean tuning yielded pure fifths and fourths, its major thirds were too large, $81:64$ instead of $80:64$ (which reduces to $5:4$). On the other hand, the syntonic diatonic tuning of Ptolemy, although it yielded mostly pure major thirds, did not do so uniformly.

For example, if B-flat–D were a pure major third, then D–F-sharp would be too large, namely $81:64$. If a compromise D were found, neither third would be pure, but both would be acceptable. This requires splitting in half the small interval called the syntonic comma, $81:80$, by finding the geometric mean between the two quantities. According to Pythagorean mathematics, this is not possible, as there is no mean proportional between the terms of a superparticular ratio, a circumstance known already to Archytas (fourth century B.C.).

Fogliano proposed a geometric solution for the required division, relying upon Euclid's construction of Book 6 proposition 9 (now numbered 13).[27] In Fogliano's figure, AB/BD $= 81/80$. According to Euclid, if a semicircle is

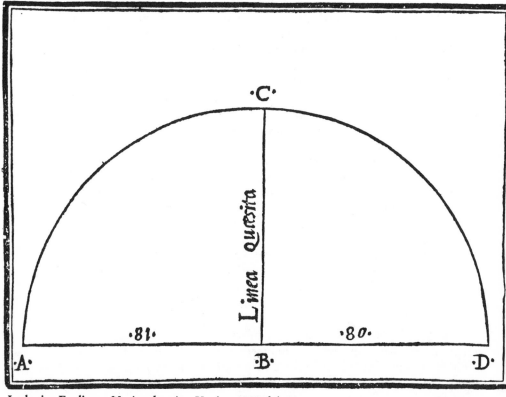

Lodovico Fogliano, *Musica theorica*, Venice, 1529, fol. 36r.

described around line AD and a perpendicular to the circumference is drawn from B, BC is the required geometric mean. Then AB/BC = BC/BD. The string length BC, which cannot be represented by a whole number, will sound the desired mean major third against the length 64.

Fogliano was not the first to challenge the impossibility of finding a mean proportional between the two terms of a superparticular ratio. Those who preceded him in this had profited, like Fogliano, by the revival of interest in the *Elements* of Euclid on the part of humanist mathematicians. The medieval translation by Campanus had been published in 1482.[28] In 1496 Jacques Lefèvre d'Étaples showed how Euclid 6:9 and 6:13 could be applied to find the mean proportional between two string lengths.[29] Heinrich Schreiber (Grammateus) in 1518 applied the construction to locate a mean-tone between the two diatonic steps, for example, the tone between G and A that could serve as both G-sharp and A-flat.[30] Erasmus of Höritz in his manuscript *Musica* of around 1506 showed how the 9:8 tone may be divided by computation and proved the method by Euclidian propositions.[31] So the revival of and spreading knowledge of Euclid contributed to solving some of the practical problems that surfaced once theorists began to shed some of their prejudices about numbers.

Up to this point I have been speaking, not of any new scientific findings, but of the recovery of what had been preserved of Greek acoustical science and its application to practice. With the work of Giovanni Battista Benedetti (1530–1590) we enter into a period of real advance in acoustical theory. In two letters addressed to the composer Cipriano de Rore (1516–1565) of around 1563, published in *Diversarum speculationum mathematicarum & physicorum liber* of 1585[32], Benedetti confronted the dilemma of instrumental tuning more realistically than any of the musical theorists had done. In the process he gave the best account thus far of the mechanics of consonance.

I have translated the entire passage elsewhere[33], so I shall simply summarize it. Everyone knows, he says, that the longer a string, the more slowly it moves. If a string is divided so that two thirds are on one side and one third on the other side of a bridge, and if the two sides are plucked, the consonance of the octave will be heard. The larger portion of the string will complete one period of vibration *(intervallum tremoris)* while the shorter completes two. If two fifths of the string are on one side of the bridge and three fifths on the other, the consonance of the fifth will be generated, the longer portion of the string completing two periods of vibration while the lesser portion completes three periods. Benedetti then arrives at the law which states that the product of the number representing the string length and the number of periods of the longer portion of the string will equal the number representing the string length of the shorter portion times the number of periods of this portion. For example, in the case of the fifth, string length 3 will have 2 periods, and the product will be 6; string length 2 will have 3 periods, and the product will also be 6. He proceeds to calculate the products for each of the consonances recognized by Fogliano: diapason, 2; fifth, 6; fourth, 12; major sixth, 15; ditone, 20; semiditone, 30; minor sixth, 40. He notes that these numbers agree among themselves with a wonderful reasonableness *(mirabili analogia)*. I am not sure what it is he saw in this series of numbers other than that it provided the basis for establishing a hierarchy of consonances.[34] It is not clear how he managed to count the vibrations, if he did; he may simply have assumed, as the Aristotelian commentators before him, that they were in inverse proportion to the string lengths, the tension being equal, a valid enough assumption, but one that begs for experimental proof.

On the one hand, Benedetti theorized that consonance was produced by the frequent concurrence of the terminations of periods of vibration and that this concurrence was most frequent in the consonances produced by simple ratios. On the other hand, he knew that to base the construction and tuning of instruments on these simple ratios, as Fogliano had done, was impractical. There were some serious difficulties with the simple ratios. One is the famous Pythagorean comma, the difference by which a cycle of twelve fifths exceeds a cycle of seven octaves, a phenomenon discovered in antiquity. A tuning system in which both D-sharp and E-flat could be used in the same piece—and such pieces were being written in the 1560s by de Rore, among others—required a compromise tuning that tempered the fifths (made them smaller) so that a cycle

of fifths would equal a cycle of octaves. As we shall see, Benedetti proposed a
system of this kind to de Rore.

Another difficulty, and this was first mathematically demonstrated by Bene-
detti, was that if singers intoned the precise pure consonances at all times, as
Zarlino claimed they did, the pitch would constantly rise and fall. This is a
phenomenon painfully familiar to choral conductors.

If in this example, made up by Benedetti, the true tuning of the consonances
through simple ratios is maintained through the common tones that link one
interval to the next, the pitch will fall one syntonic comma (81 : 80) during each
statement, totaling at the end of the example nearly a half semitone, or more
precisely 44 percent of an equal tempered semitone.

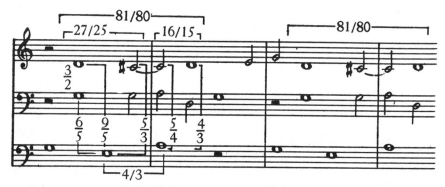

Giovanni Battista Benedetti, *Diversarum speculationum mathematicarum & phy-
sicorum liber*, Turin, 1585, p. 280.

He showed that even if there were no accidentals (sharps or flats), certain
simple progressions would lead to the same fluctuation of pitch, for example,
the diatonic sequence of chords illustrated here. The pitch in this example will
fall in the course of four statements of the pattern nearly a whole semitone;
while in the first example of the fluctuation was caused by two different sizes of

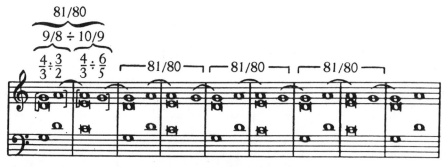

G. B. Benedetti, *Diversarum speculationum*, p. 279.

semitones, in the second case it was caused by two different sizes of whole tones.

Needed was a tuning in which all semitones were equal and all whole tones were likewise equal, and this Benedetti proposed to de Rore. After tuning the low G to the E-flat above it, making this minor sixth as consonant "grosso modo" as possible, de Rore was instructed to tune on his harpsichord a series of fifths each of which was slightly small until he reached G-sharp, remaining, however, within a three-octave span by finding the lower perfect octave whenever room was needed to complete the upward spiral. Each note was to be checked against the upper or lower major sixth, which had to be as large as bearable. (Modern tuners use the major third; Benedetti may have preferred the major sixth, because its rank number, 15, the lowest of the imperfect consonances, places it higher than the major third, 20.) The resultant tuning was an approximation of equal temperament, not unlike the one proposed by Giovanni Lanfranco (d. 1545) in 1533.[35] Lanfranco, however, began with F, alternating tempered fifths and fourths, and used the major third rather than the major sixth to tune as sharp as acceptable as a guide to tempering the fifths and fourths. Both Benedetti and Lanfranco went only as far as G-sharp into the sharps and no farther than E-flat into the flats. In their keyboards G-sharp doubled as A-flat, and E-flat similarly functioned as D-sharp. I assume, further, that Benedetti's starting point, E-flat, sounded a good tempered fifth against the G-sharp that terminated the cycle.

Benedetti's solution overcame the two main obstacles that had impeded progress in tuning. The Pythagorean comma he eliminated by taking a little of it off each of seven fifths, so that as much of the cycle as was used in practice now equaled the parallel cycle of octaves. The fluctuation of pitch he solved by doing away with the unequal whole tones and semitones of the earlier tunings. Of course, having done this, he banished from practical music the simple ratios, about which he had theorized with reference to the coincidence of vibrations of consonance. This did not seem to bother him. Whereas Gaffurio and Zarlino expected art somehow to conform to and follow nature, Benedetti knew that this was impossible, that musical practice was not science.

No one resolved the conflicting demands of science and art more clear-headedly than the classicist Girolamo Mei (1519–1594), who had heard Benedetti's lectures on the *De anima, De caelo,* and *De generatione animalium* in Rome in 1560. It was to Mei that Vincenzo Galilei (ca. 1520–1591), father of Galileo, turned in 1572 for advice when he was torn between the ideal of justly tuned consonances and the practical necessity for temperament. Mei responded:

The science of music goes about diligently investigating and considering all the qualities and properties of the constitutions, systems, and order of musical tones, whether these are simple qualities or comparative, like the consonances, and this for no other purpose than to come to know the truth itself, the perfect goal of all speculation, and as a by-product the false. It then lets

art exploit as it sees fit without any limitation those tones about which science has learned the truth.[36]

Galilei, in his *Dialogo della musica antica et della moderna* of 1581, paraphrased this passage.[37] It was to become a principle for the elder Galilei: to establish securely by experiment the laws of acoustics, but to investigate musical practice by observing how the materials of music—the consonances and dissonances and the notes of the scale—were actually applied in composition and performance.

For example, the usage of many accidentals (sharps and flats) in modern music made it necessary to temper the tuning of instruments, and the best method for doing this, in Galilei's opinion, was through the "intense" diatonic of Aristoxenus. "Nor can any other demonstrable distribution with stable tuning besides this be found that is simpler and more perfect and more capable of being played as well as sung."[38] This intense tuning of Aristoxenus is, in

Vincenzo Galilei, *Discorso intorno all'unisono,* Florence, Bibl. Naz. Cent., MS Galilei 3, fol. 61r (barlines added).

effect, equal temperament, and to prove that it was the only tuning equal to the demands of modern music, Galilei composed a piece that could be played by no other means.

With Galilei, music theory became a purely empirical discipline, independent of both physics and metaphysics. Following his example, seventeenth-century music theory, when it sought grounds for its speculations outside of music, turned—quite properly perhaps—away from acoustics toward rhetoric and logic. What Renaissance science achieved for musical practice, then, was to reveal the inadequacy of theories based on Pythagorean and Neo-Platonic number systems and thereby to encourage musicians to look elsewhere or within their art itself for theoretical foundations.

NOTES

1. It may be that current studies on Aristotelian commentators will modify this impression. For example, A. C. Crombie, in *Medieval and Modern Science*, vol. 1, 2d ed. (Garden City, New York: Doubleday Anchor Books, 1959), 103, has shown that Grosseteste in his commentary on the *Posterior Analytics*, 2:4, gave an explanation of the echo that is quite sophisticated.

2. The date appears in several MSS of the work: Venice, Bibl. Marciana, MS Cl. 6, no. 127; Paris, Bibl. nationale, MS lat. 6540; and Cesena, Bibl. comunale Malatestiana, MS Plut. 24, destro 2. In the latter the colophon states that it was begun in Paris and finished in 1310 in Padua. See Sante Ferrari, "I tempi la vita, le dottrine di Pietro d'Abano," in *Atti della università di Genova*, 14 (1900): 98. A similar colophon appears in the first edition: "Explicit expositio succinta problematum Aristo. quam Petrus edidit Paduanus ea nullo prius interpretante incepta quidem Parisius et laudabiliter padue t[ermi]nata anno legis christianorum 1310." It is this edition that was used for this paper: Mantua: Paulus Johannis de Puzpach, 1475.

3. A MS of Bartolomeo's translation is in Padua, Bibl. Antoniana, cod. 17, no. 370, dating from the early fourteenth century. A modern edition of Bartolomeo's translation of section 11 on acoustics, based on the Padua MS, collated with Rome, Vatican Burghes 37, and Venice, Marciana, lat. 2488, Cl. 6, no. 43, is in Gerardo Marenghi, *Aristotele, Problemi di fonazione e di acustica* (Naples: Libreria scientifica editrice, 1962), 99–117.

4. ". . . uerberatur euhemens et uelox ut aer fortiter extendatur propter quod videmus aerem subito et fortiter virga in ipso ducta sonum causare . . ."

5. ". . . uidemus enim quod tacta corda subtili et tensa repercutit aerem pluribus ictibus antequam cesset unde tinitus diu remanet post tactum quare medium tinitu repletur. In grossa uero corda distensa non eunit illud."

6. D'Abano, commentary on Pr. XI. 19: ". . . in uoce accuta aer mouetur et frangitur in partes minores."

7. Aristotle, *De anima*, 2, 8.8: my translation of d'Abano's Latin: ". . . dicente uelox non esse accutum neque tardum graue. sed accutum causatur ex uelocitate motus, graue autem ex tarditate." Pr. XI. 6.

8. Pr. XIX. 39, trans. E. S. Forster in W. D. Ross, *The Works of Aristotle* (Oxford: Clarendon Press, 1927), 921a.

9. Ptolemy, *Harmonics*, 1.6. D'Abano evidently knew this theory of Ptolemy through Boethius, *De institutione musica*, v. 9–10.

10. Franchino Gaffurio. *Theoricum opus musice discipline* (Naples: Franciscus di Dino Florentinus, 1480), 5.8, fols. 112v–113r.

11. *Ibid.*, 2.3. This statement is repeated in Gaffurio's *Theorica musice* (Milan: Philippus Mantegatius, 1492), 2. 4, fol. c5ᵛ. The source is Plato, *Timaeus*, 80a.

12. Boethius, *De inst. mus.*, 1.30.

13. *Ibid.*, 1. 31.

14. Gaffurio, *Theoricum opus*, 2. 1, 3; *Theorica*, 2. 1, fol. c1v; 2. 4, fol. c5v.

15. *Themistii Paraphraseos de Anima libri tres, interprete Hermolao Barbaro* (Paris: P. Calvarin, 1535; ed. Richard Heinze, Berlin, 1899).

16. Ibid., 2. 30, fol. 74.

17. Gaffurio, *Theorica*, 2. 2; Themistius, 2. 28, no. 81.

18. (Milan: Gotardus Pontanus Calcographus, 1518).

19. Known up to that time through a multitude of MS copies, Boethius's musical treatise was published in 1492 as *De musica libri quinque* in vol. 1 of his *Opera* (Venice: Johannes et Gregorius de Gregoriis de Forlivio fratres). It was reissued in 1499 as vol. 3 of the *Opera*. The standard modern edition is that of G. Friedlein (Leipzig: B. G. Teubner, 1867). An English translation by Calvin Bower is in preparation for the Yale Music Theory Translation Series.

20. *Timaeus*, 35b–36b.

21. *Musica practica* (Bologna, 1482).

22. *Errori de Franchino Gaffurio* (Bologna: Benedictus Hectoris, 1521), pt. 4, Error 26.

23. Fogliano, *Musica theorica* (Venice: Io. Antonius & fratres de Babio, 1529).

24. In a letter quoted by Girolamo Tiraboschi, *Biblioteca modenese* (Modena, 1781–86), 2. 307, from Pietro Aretino of 30 November 1537 to Fogliano, Pietro encourages him to translate Aristotle's works from Greek into Italian.

25. Fogliano, *Musica theorica*, 2. 2, fols. 15r–15v: "aer enim sic scissus uelocissime congregatur: & confluit ex omni parte: uacuum abhorrente natura: unde fit uelocissima quaedam aeris condensatio: quae resistit uirgae percutienti: & talis condensatio fungitur uice corporis solidi. . . . ad generationem soni ad minus tria concurrunt: scilicet: illud quod uiolenter expellit aerem: & aer uiolenter expulsus: tertium est ipse motus. . . ."

26. Ibid., 3. 1, fol. 33r.

27. Cited ibid., fol. 36r.

28. *Elementa geometriae lat[ine] cum Campani annotationibus* (Venice: Erhardus Ratdolt, 1482).

29. *Musica libris demonstrata quatuor* (Paris, 1496). In the edition I used (Paris: Gulielmus Cavellat, 1552), this occurs in bk. 3, chap. 35, fol. 29v. In Lefèvre's demonstration the object is to find the geometric mean that would divide the intervals formed by the fractions 9 : 8 (whole tone), 4 : 3 (fourth), 3 : 2 (fifth), and 2 : 1 (octave), so that ab:bc = 8 : 9; ab:bd = 4 : 3; ae:be = 3 : 2; and ab:bf = 2 : 1. A circle is constructed around line abc; similarly around abd, abe, and abf. Then a perpendicular to abc is drawn at b to intersect the circles. The distance from b to the intersection with the circle is the geometric mean. So bg is the mean of 8 : 9, bh of 4 : 3, bi of 3 : 2, and bf of 2 : 1. These lengths are marked on the string bc. The only means of practical interest are those of the whole tone (a mean semitone) and the octave (a tritone).

30. *Ayn new kunstlich Buech* (Nuremberg, 1518).

31. Rome, Vatican Library, MS Reginensis latinus 1245. See Palisca, "The *Musica* of Erasmus of Höritz," in Jan LaRue, ed., *Aspects of Medieval and Renaissance Music* (New York: W. W. Norton, 1966), 639.

32. (Turin: apud Haeredem Nicolai Bevilaquae, 1585), 277–83. The two letters are reprinted in Josef Reiss, "Jo. Bapt. Benedictus, De intervallis musicis," *Zeitschrift für Musikwissenschaft*, 7 (1924–25): 13–20.

33. "Scientific Empiricism in Musical Thought," in H. H. Rhys, ed., *Seventeenth Century Science and the Arts* (Princeton: Princeton University Press, 1961), 106–8.

34. In *Studies in Musical Science in the Late Renaissance* (London: The Warburg Institute, Leiden: E. J. Brill, 1978), 31, n. 16, D. P. Walker contested my claim that Benedetti was establishing here a hierarchy of consonances. That Benedetti was indeed doing so is evident from the paragraph that introduces the demonstration:

Nam, nulli dubium est, quin unisonus sit prima principalis audituque amicissima, nec non magis propria consonantia; si[c] intel-	For there is no doubt that the unison is the first, principal, and friendliest to the hearing, and also more properly a consonance; and let

ligatur, ut punctus in linea, vel unitas in num-
ero, quam immediate sequitur diapason, ei
simillima, post hanc vero diapente, caeterae-
que. Videamus igitur ordinem percussionum
terminorum, seu undarum aeris, unde sonus
generatur.

it be understood as the point is to a line or
unity to number, which the diapason, similar
to it, directly follows, then the diapente, and
so forth. Let us see, therefore, the order of
concurrence of the terminations of percus-
sions or waves of the air through which
sounds are generated.

35. *Scintille di musica* (Brescia, 1533), 132. See J. Murray Barbour, *Tuning and Temperament* (East Lansing: Michigan State College Press, 1953), 45ff. Benedetti probably did not know Lanfranco's treatise, since it was an elementary practical tutor rather than a scientific work such as that of Fogliano, which Benedetti did cite.

36. Mei to Vincenzo Galilei, Rome, 8 May 1572, ed. in Palisca, *Girolamo Mei; Letters on Ancient and Modern Music* (American Institute of Musicology, 1960; 2d ed., 1977), 65 (translation), 103 (original text).

37. (Florence: G Marescotti, 1581). The interlocutor, Bardi, states: "Vi rispondo à questo, che le scienze hanno diuerso procedere & diuerso fine nell'operare che non hanno le arti. le scienze cercano il vero degli accidenti & proprietà tutte del loro subietto, & insieme le loro cagioni; hauendo per fine la verità della cognitione senza piu: & le arti hanno per fine l'operare, cosa diuersa dall'intendere."

38. Galilei, *Discorso intorno all'unisono*, Florence, Bibl. Nazionale Centrale, MS Galilei 3, fols. 55r-61v: ". . . ne altre Distributione dimonstrabile fuor' di questa, può trouarsi trà corde stabili più semplice e' più capace tanto sonata quanto cantata. . . ."

[5]

Science and Navigation in Renaissance England

John W. Shirley
University of Delaware

The period between the late years of Henry VIII and the death of James I saw England evolve from an insular and rustic nation to a sophisticated world power. Most of this change may be laid directly to Britain's naval activities. Whereas at the death of Henry VIII only a score of seamen were competent to sail out of the sight of land, by the accession of Charles I in 1625, British seamen had twice circumnavigated the globe; had probed the oceans of both polar regions; had established and maintained direct commerce with Russia, India, Persia, and Japan; had vanquished both Portugal and Spain in wars at sea; and had established permanent colonies in Virginia, Massachusetts, and the Sugar Islands of the West Indies. Britain had assumed the role of mistress of the seas, and the British Empire had been founded.[1]

Quite naturally, this expansion in their physical horizons greatly changed the daily lives and mental outlook of the British people of all classes. Propagandists like the two Richard Hakluyts and Samuel Purchas (usually at the instigation of one or another group of merchant adventurers) spread the word of each new discovery to stimulate even more widespread participation in the burgeoning venture risks. Members of the rising middle class with money to invest for the first time began to subscribe to speculative enterprises of exploration, piracy, or colonization. The manning of more ships automatically brought more members of the aspiring lower class and the rising middle class into direct involvement in foreign travel. What in previous generations had been the finishing education of the young noble, now became a way of life for the plowman who had abandoned his farm labor to become one of the "sea boys" needed by both the expanding Royal Navy and the merchant marine to work the sails, swab the decks, and man the guns while seeking riches and high adventure on exciting and strange new oceans. This new generation of

Elizabethan seamen had been places and seen sights totally undreamed of by generations of their progenitors.

Excitement also permeated those who stayed at home. As men and ships pressed further in extending the boundaries of known lands and peoples, they returned with new tales of mystery and wonder, of hushed accounts of untold wealth in gold and pearls, of amazing new races, languages, and customs— some as noble as Adam before the fall, some as evil as the devil incarnate, and some who were cannibals with heads below their shoulders and eyes in their breasts, as Sir John Mandeville had reported,[2] and as Sir Walter Ralegh insisted had existed just beyond his Orinoco camp in Guiana.[3] Tangible proof of some of these wonders could even be seen in England itself as intrepid explorers and traders brought evidences of these strange cultures back with their new commercial products. From 1584 when Amadas and Barlow brought to London from Virginia in the New World two Indian "Princes," Manteo and Wanchese,[4] until the death of the "Princess" Pocahontas at Gravesend in 1617,[5] there was scarcely a time but that Amerind natives were to be found in all their primitive color as guests in the homes of merchant adventurers, in London taverns, or even as visitors in the exclusive courts of Elizabeth or James.

Certainly the novelty and excitement of these wonders affected the popular culture of the time. Books on geography and cartography found a tremendous market among aspiring navigators. Maps and globes began to grace the libraries of country, as well as urban, homes. As Louis B. Wright has pointed out, this was largely a middle-class enterprise, so that:[6]

> out of utilitarian works on geography and the homespun account of merchants and seamen, grew a vast literature, perhaps more completely than any other inspired by and appealing to the middle classes.

Much of the formal literature of the age reflected the wonder and excitement of these new world vistas. Mariners' tales are scattered throughout the scribbling of the pamphleteers and in the poems, masques, and plays of Marlowe, Dekker, Jonson, and Fletcher, to name but a few. Shakespeare himself made so many references (and such exact ones) to matters of ships and sailing, that at least one book has been written to show that during his so-called lost years from 1584 to 1590 he must himself have served in the navy, undoubtedly, therefore, participating in the world-shaking defeat of the Spanish Armada.[7]

But more important than the intellectual stimulation of sensational literature to many upper- and middle-class Englishmen was the business opportunity of the fantastic profits offered by the new economic ventures into world trade or open piracy. Richard Chancellor's establishment of the Muscovy Company in 1554 had furnished a trade wedge with Russia that was to break the trade monopoly of the Hanseatic League. Organized as a joint stock company, this proved so successful that it furnished a new model for financing future trading, colonizing, or raiding expeditions, and enlisted the resources of many investors to underwrite activities far beyond the means of individual merchants, sea captains, or even government itself. For the next hundred years almost all sea

ventures were handled in this fashion, governed by a council elected by the shareholders and charged with the responsibility of managing company affairs to bring maximum return to the many investors.[8] And while the success of the expansion of the British naval activity can be attributed in large part to the courage and hardiness of the British character and the fearlessness of her seamen, equal credit must be given to the hardheaded entrepreneurs who brought practical wisdom to the management of these projects.

The problems arising from the change from local pilotage to worldwide navigation were immense.[9] For generations, British seamanship had been limited to operating small coastal vessels for fishing and commerce within a very limited geographic area. Ships were out of sight of land for only hours, or at most a day or two at a time. Sailing techniques had been based on sensual observation of water depths, tides, and coastlines. To have a safe passage, a master had only to recognize the promontories, capes, steeples, and harborages of the port he was to visit. His tools of the trade were simple: a rutter (occasionally a map, but more often just a narrative of the changing skyline profile, frequently illustrated), an almanac, and a table of tides. For navigation he used a simple compass housed in a binnacle which might hold a candle at night, a lead and line for measuring the depth of water, and an hourglass to mark the passage of time and measure his progress.

But the move from shoreline to open ocean changed all of this. Ships were out of sight of land for weeks, sometimes months, at a time. Sensory pilotage was worthless, since only the sea and the heavenly bodies were in sight, and the master was forced to make his way by sightings of these frequently obscured elements and to translate these positions against charts and globes which were recognized as very imperfect. Navigation was inordinately complicated by the fact that the surface of the oceans was spherical and maps were two-dimensional. As a result, they did not compensate for the fact that though latitudinal distances remained constant in miles or leagues per degree, longitudinal distances per degree grew shorter as one moved from the equator to the pole. A ship sailing by compass in a northeast or northwest direction as portrayed on a flat map (even if correction were made for the deviation of the compass from true north) would not actually cross the seas in those directions. Translated to a spherical surface, such a course would end up as a spiral with the ship moving further off course with each degree of longitude crossed. To correct for this inadequacy in mapping and lack of sophistication in mathematics, the simplest solution was to sail the ship north or south to the latitude of its final destination and then to head due east or west until the goal was reached. This was safe pilotage, but unfortunately costly in time and supplies since it took the ship on two sides of a spherical triangle instead of on the shortest great-circle route.

Business efficiency, therefore, called for greater skills than ever before asked of seamen. Ocean travel required greater knowledge of astronomy and more understanding of spherical geometry to fix positions than coastal pilotage had ever required. Charts and globes needed constant improvements in locating

more accurately the exact positions of cities, islands, or land masses. Observational instruments had to be more accurately constructed and used with better understanding. And mathematical corrections were needed for travel in great-circle routes. Trade with far-off lands was potentially rewarding economically, but it was costly in both men and materials and could be effective only if improvements in the safety of vessels and surety of sailing routes and methods could be achieved.

In all of these respects, the Portuguese and Spanish sailors, who had preceded the English in open navigation, were well ahead of their English counterparts. Not only had they learned from experience such practical matters as the direction and intensity of ocean currents, the nature of prevailing winds, and the significance of the appearance of seaweed, floating objects, or the flight of birds, but they had also made cartographic and technological advances far beyond those dreamed of by the British. Under the auspices of Henry the Navigator (1394–1460), the Portuguese had established in Lisbon in the fifteenth century the Casa de Guinea a India, a modern hydrographic office which became a training focus and examinations center for pilots who had mastered the theories of their craft and were to be entrusted with the command of a ship.[10] By 1508 the Spaniards had followed suit and had established the Casa de Contratación, virtually a national school of navigation, at Seville.[11] Both these centers of navigational science collected information from all returning vessels, corrected maps in accordance with new data, and evolved manuals of navigation for both the training and the improvement of pilotage. Such national efforts went far beyond anything the Tudor monarchs supported, in spite of their avowed intent to build a strong British navy and to improve the quality of English seamanship.

Britain's most noteworthy seamen during the reigns of Henry VII and VIII were the two Cabots, John (1450?–1498?) and his second son Sebastian (1474–1557). Granted a charter for exploring by Henry VII, the Cabots first discovered Newfoundland in 1497 and opened up those rich fishing banks off the New World coast to the Bristol merchants.[12] But these most famous of British seamen were not typical of the seamen of the day; as a matter of fact, it is questionable whether the Cabots were even English.[13] Certainly they held Venetian citizenship at the time of their active explorations, and John Cabot was known as a Venetian pilot long before he adopted England as his base of operations. Sebastian Cabot, too, was trained in the Casa de Contratación at Seville and possessed the skills of the Iberian pilot, rather than the English seaman.[14] And in spite of his contemporary fame, Sebastian's efforts to get England to establish a navigational center similar to those of Portugal and Spain aroused no response from the thrifty Tudor monarchs.

As a result of England's failure to train her own pilots adequately, much of the pilotage throughout the early reign of Elizabeth was in the hands of Spaniards and Portuguese. Freebooters like John Hawkins would sail openly into Spanish waters, capture a ship, steal all its maps and charts, and kidnap the pilot, forcing him to serve his new British master.[15] Sir Francis Drake circum-

navigated the globe, abducting a new pilot each time he ravaged another Span-ish or Portuguese vessel.[16] And Sir Walter Raleigh relied heavily on a Portuguese pilot, Simon Fernandez, for his colonization efforts in the New World.[17] Such conscription of pilots appears to have been common practice throughout the reigns of both Elizabeth and James.

It was the economic pressures of the new trading companies which forced English shipping to embrace new navigational science and technology. The original charter monopoly stock company, the Merchant Adventurers, who had controlled trade in the raw materials of the cloth industry, had long been governed by cloth merchants and members of the guild who knew all the pitfalls of merchandising. They had demonstrated that if they were to make a profit, they must be knowledgeable about all the latest advances in the handling of wool and the weaving of cloth. In keeping with this long tradition, the governors of the new Muscovy Company saw immediately that they must adopt more modern science and technology if they were to solve their prob-lems of cartography, navigation, and shipbuilding. What knowledge they could, they bribed or stole from their continental rivals. But from the first establishment of the Muscovy Company in 1554, these merchant adventurers also prepared to put a part of their risk capital into employing the services of the best mathematical scientists of their day (using mathematics in the broad Elizabethan sense[18] which embraced not only the fundamental arithmetic, geometry, and trigonometry, but also such learning as astronomy, cartog-raphy, geography, and hydrography as well). Stephen Borough, who suc-ceeded Richard Chancellor as chief pilot of the Muscovy Company, was sent to the Casa de Contratación at Seville in 1558 to study their methods, and on his return to England he brought back the standard manual of the Spaniards, Martin Cortes's *Arte de Navegar*. This the company adopted for their own use, and another of their employees, Richard Eden, was asked to translate it into English for the easy use of their pilots. This was printed in English in 1561 under the title *The Arte of Navigation*. According to Commander Waters:[19]

> . . . It is probably not too much to say that this was one of the most decisive books ever printed in the English language. It held the key to the mastery of the sea.

Two of England's most outstanding mathematicians were also brought into their councils: Robert Recorde, the most popular vernacular writer on science of the sixteenth century,[20] and Dr. John Dee, who in spite of being a mystic and dabbling in the occult, was truly a powerful mathematician of worldwide acclaim.[21] It was only natural that the Muscovy governors should first think of Robert Recorde for the instruction of their pilots; his work on elementary arithmetic, *The Grounde of Artes*, which first appeared in 1542, had attracted considerable attention as the first arithmetic text in English and had already been reprinted. A second book, *The Pathway to Knowledge*, carried the stu-dent into the elements of simple geometry and included a section on the use of

the quadrant. This work, first issued in 1551, brought him to the attention of the English seamen, since his was the first English work covering the fundamental mathematics of navigation. Officials of the Muscovy Company, interested in the upgrading of their navigators, commissioned Recorde to write a treatise on the sphere which he published in 1556 under the title of *The Castle of Knowledge.* The following year Recorde dedicated a more advanced arithmetic, *The Whetstone of Witte,* to the governors of the Muscovy Company. He also promised to complete his series of texts with books dealing with surveying, dialing, cosmography, and the art of navigation, but he died before these works were published. Yet, though he had not fulfilled his whole promise in the training of British seamen, Recorde did begin to develop the mathematical sophistication of the new generation of navigators.

Recorde was followed as advisor to the Muscovy Company by one of the most controversial mathematicians of his day, Dr. John Dee of Trinity College, Cambridge. Though in many ways a mystic and a recluse, Dee had already proved himself interested in the practical application of the mathematical sciences. Shortly after his graduation, in 1547 Dee had visited the continent to meet a number of the most famous European mathematicians. In the exuberance of youth he had become convinced that mathematics was the key to knowledge, and that the application of its principles could change the world. On his return to Cambridge he brought many "rare and exquisitely made instruments mathematical," "sea compasses of divers sorts," "two great globes of Mercator's making," and a large group of other mathematical instruments which he declared more accurate than any then in use in England.[22] These rare and valuable mathematical and navigational aids Dee donated to Trinity College "for the use of the Fellows and Scholars" in the hope that their use would improve the practicality of their instruction. It was this practical bent and these material aids which brought Dee to the attention of the Muscovy Company and brought them to enlist his aid in preparing for their voyages and for training their seamen. In this enterprise Dee was most generous of his time and talents. He was always willing to share his knowledge with others, though chary of publishing for the public at large. He worked with many of the seamen in preparing charts and maps and in planning for various expeditions. He gave classes for the Company's mariners and individual instruction to those who sought it. He also gave primary attention to the problems of accurate navigation in northern latitudes, claiming a marvelous new navigational discovery which he called his "Paradoxall Compass." Just what this "Paradoxall Compass" was is not known, since no published account of it remains, but it was highly respected in his own time and was probably a sea chart constructed on a zenithal equidistant projection.[23] The extent of Dee's understanding of the current problems of navigation and his ability to apply new scientific methods to their solutions may be best seen today in his comprehensive and "very fruitfull Praeface . . . specifying the chiefe Mathematicall Sciences, what they are, and whereunto commodious . . ." which introduced Henry Billingsley's translation of Euclid published in 1570.

Dee liked nothing better than working directly with individuals in the solution of their problems. When Martin Frobisher and Christopher Hall were preparing for expeditions seeking the northwest passage in 1576 and 1578, Dee coached them in cosmography and geometry "to improve their use of Instruments for Navigation in their voyage."[24] It is highly probable that some of the charts carried by Frobisher in these voyages were drawn by Dee, as was the chart drawn for Sir Humphrey Gilbert in 1582. Dee also was friendly with many of the younger mathematicians who were coming along, with John Davis, Thomas Digges, and young Thomas Harriot, whom he called "Amici mei."[25]

It was the success of academics like Recorde and Dee that led the merchants and explorers to turn to the universities for help in solving their vexing navigational problems. For example, Walter Raleigh, to avoid the tragedy of the faulty navigation which had befallen his half-brother, Sir Humphrey Gilbert,[26] decided to make maximum use of the new learning of the Renaissance before beginning his explorations and colonizations in the New World. To this end, he returned to his old college at Oxford to recruit the services of the brilliant young mathematician, Thomas Harriot. Hakluyt called public attention to the fact:[27]

> . . . By your experience in navigation you saw clearly that our highest glory as an insular kingdom would be built up to its greatest splendor on the firm foundation of the mathematical sciences, and so for a long time you have nourished in your household, with a most liberal salary, a young man well trained in those studies, Thomas Hariot [sic]; so that under his guidance you might in spare hours learn those noble sciences, and your collaborating sea captains, who are many, might very profitably unite theory with practice . . .

Similarly, when Thomas Cavendish began his two-year circumnavigation of the globe in 1586–88, he took with him another young mathematician and friend of Harriot, Robert Hues,[28] to document details of the voyage and to make constant corrections to their inaccurate maps and charts. Following his return to England, Hues used his firsthand observations to work with Molyneux on the construction of new terrestrial and celestial globes and wrote a scholarly Latin treatise on their use, *Tractatus de Globis et eorum Vsu*, before returning to Oxford to resume his life at Christ Church, Oxford, as a college don. Yet another young Oxonian, Lawrence Keymis of Wiltshire,[29] B.A. and M.A. Balliol, was enlisted by Ralegh to join Harriot in bringing his university learning to the cause of Ralegh's explorations. Keymis (who quickly assumed the title of "Captain Keymis") was put in charge of Ralegh's 1595 and 1596 voyages to Guiana to search for the fabled city of gold, El Dorado. This experience so excited Keymis that he left his scholarly life to become one of Ralegh's trusted adherents and a follower of his fortunes at sea. It was Keymis who headed the final tragic expedition to Guiana with Ralegh and his son in 1617, where he committed suicide on board when the whole voyage ended in disaster.[30]

Probably the most influential of the new mathematical scientists who worked closely with the improvement of Renaissance English navigation was the distinguished Cambridge mathematician, Edward Wright (1553–1615).[31] Wright, B.A. and M.A. in mathematics at Caius College, was "called forth to the public business of the nation by the Queen" in 1589 when Elizabeth was determined to go on the offensive against the Spaniards. Feeling uncertain of the practical aspects of navigation, Wright set sail with the Earl of Cumberland on a raiding mission against the Spanish treasure fleets of the Azores. As a mission, these raids were unsuccessful; they produced little gold and did not return the sailors home for Christmas as promised, but they did serve a useful purpose: they firmly convinced Wright of the seriousness of the current errors in navigational techniques and gave him the resolve to devote his full talents to their correction. Very shortly, he had presented the Earl of Cumberland with a draft of a major work, *Certain Errors in Navigation, Arising either of . . . erroneous making or using of the Sea Chart, Compass, Cross Staff, and Tables of Declination of the Sun and fixed Stars, detected and corrected.* This work was widely circulated and used by the British sea captains even before it was published in 1599, and much more thereafter. In the Preface to this work, Wright graphically cites his own experience to show how faulty and erroneous British navigation was even at this late date. Sailors going from the West Indies to the Azores, Wright contends,[32] "often fell in with those Islands when, by their account, according to the chart they should have been 150 to 200 leagues to the Westward of them." In his own experience in 1589, sailing from the Azores to Ushant, Wright said they sighted land "when by account of the ordinary chart we should have been 50 leagues short of it." Such gross errors led Wright to review again all the basic tools of the trade, to examine critically the matter of variation of the compass, the accuracy of observations by cross staff, and the errors remaining in charts of the altitude of the sun and its daily declination. In doing all of these things, Wright was going over exactly the same grounds previously explored by both Dee and Harriot, but neither of them had published their findings, and Wright was prepared to do so. Wright's work on the compass led him to assist the physician, William Gilbert, on his important work on magnetism, *De Magnete* (1600), and to translate Napier's *Mirifici Logarithmorum Canonis Descriptio* for the use of the East India Company, to whom he dedicated it. Like Harriot, Wright gave personal instruction to Prince Henry; he also served as an advisor in building the Royal Navy and in the last years of his life, spent much time in giving lectures for the East India Company.[33]

Largely as a result of such individual efforts, during the late years of the sixteenth century, demands for instruction in the new sciences grew among the general public. Such public education began in the year of the Armada when the city of London organized a militia for its own defense against invasion by the Spaniards. To provide instruction for these officers, the Lord Mayor and aldermen established a Mathematical Lecture which was soon opened to the general public.[34] With funds provided by a wealthy London merchant, Thomas

Smith, a Fellow of Trinity College, Cambridge, Thomas Hood, was appointed to the post. These lectures were so popular and effective, in 1597 a bequest of Sir Thomas Gresham, founder of the Royal Exchange, endowed a number of such lectureships for the citizens of London in what they liked to call a Third University. Oxford and Cambridge were asked to nominate candidates for lecturers in astronomy, divinity, geometry, law, music, physic, and rhetoric.[35] From these nominations, Henry Briggs of St. Johns College, Cambridge, was named first professor of geometry of Gresham College (as it was called), and Edward Brerewood (or Briarwood) of Brasenose College, Oxford, was made first professor of astronomy. Statutes for this early venture into adult education called for lectures to be read twice daily, in Latin in the morning and English in the afternoon—Latin for the formally learned and for foreigners not proficient in English, and the vernacular "for the greatest part of the inhabitants within the City [who] understand not the Latin tongue."[36] The popularity of the Gresham teaching furnished a significant stimulus to the advancement of the new sciences in the developing trade and industry which was revolutionizing British economy.

So successful were these efforts that the universities, which had been slow to interest themselves in the worldly potential of their scholarship, began to take the initiative. At Oxford, Sir Henry Savile, warden of Merton College and provost of Eton and a close friend of Sir Thomas Bodley, in 1619 dedicated his accumulated wealth to found two new university chairs as Savilian Professors of Geometry and Astronomy.[37] He named Henry Briggs, who had held the post of professor of geometry at Gresham College since its inception, as first Savilian Professor of Geometry. John Bainbridge, a London physician, B.A., M.A., M.D. of Emmanuel College, Cambridge, who had written extensively on the great comet of 1618, was named his counterpart Savilian Professor of Astronomy and incorporated in Merton College.

In this way, in a sort of mutual feed back, the new science, at both London and Oxford, was finally firmly established in the British educational system. Out of these two groups grew much of the popular interest in the theories and applications of the new science which led, later in the seventeenth century, to the formation of the Royal Society and the widespread public acceptance which that organization was to generate. Modern industrial science, based on science and technology, was finally established.

A rare and intimate view of how these Renaissance mathematical reformers brought their theories to the practical problems of the seamen may be seen by studying some of the actual manuscripts which have fortuitously survived the intervening centuries. Thomas Harriot, Sir Walter Raleigh's friend, mentor, and expert on things nautical, published nothing on these subjects. But on his death in 1621 he left all his manuscripts to his patron,[38] the ninth earl of Northumberland (Ralegh had been executed three years earlier). Among these manuscripts are several hundred folio pages of Harriot's navigational notes and jottings, notes on his lectures to Ralegh's sea captains, charts on the variation of the compass and the sun's declination, calculations of rhumbs, and detailed

drawings and notes for the improvement of shipbuilding. Scholars have only recently begun to explore their contents, which are summarized by Professor John V. Pepper as follows:[39]

> . . . The stages of Harriot's work on navigation appear to be three. First, in the early fifteen eighties, he solved the problem of reconciling sun and pole star observations for determining latitude, introduced the idea of using solar amplitude to determine magnetic variation, and, as well as improved methods and devices for observation of solar or stellar altitudes, he recalculated tables for the sun's declination on the basis of his own astronomical observations. Secondly, probably about the same time and certainly· by about 1594, he produced a practical numerical solution of the Mercator problem, most probably by the addition of secants, as Dee may have done earlier, and as Wright also did about the same time. Thirdly, between 1594 and 1614, no doubt with considerable breaks in his efforts, he produced his great tables of meridional parts calculated (in effect) as logarithmic tangents. The first two stages apply traditional mathematics ingeniously, but the third stage had to call into existence a whole new range of mathematical techniques, such as the conformality of stereographic projections, the rectification and quadrature of the logarithmic or equiangular spiral, the exponential series, and the derivation and use of interpolation formulae.

These are evidences of the formal scientist at work, but Harriot's rough notes and jottings also reveal much of the personal learning process of both master and student. The appended illustrations show just a few of the rough manuscripts which reveal some of this day-by-day exchange.

Before mastering the new field of interest and teaching it to practical sea captains, Harriot, fresh from the university, had to immerse himself in the vocabulary and techniques of the sea before he could bring his art to the craft. A number of his pages of notes are a crude dictionary of those words and phrases he had to master. For example:

> Whipping of ropes endes—with twyne to fasten the endes to keep him from fuzing out or riueling.

> Kinking of a cable or stiffe rope—a fold that happens when the cable runneth out to fast & it doubles, for want of well ouersetting the flukes in paying out of it, & then they say stopp stop to get out the kink.[40]

> A shot of cable is two cables bent together & wound one about an other & frayed & tied to make as one in length.

> a splice. to splice is to ioyne two ropes or cables together by opening their endes & working one in an other with a fid.

> A Fid is an iron about a foot long & less, of the fashion of a bodkin.[41]

Harriot's logical and mathematical mind can be seen at work in his notes as

he reviews the construction and operation of the various segments of the vessels of the Ralegh fleet.[42]

Again, in making an analysis of the construction of a one hundred-ton vessel, Harriot wrote several pages of "Notes," which include the following:[43]

> The keele in a ship of (100t), 12 ynches deep; 10 ynches broad. The sterne post & sterne are below as the keele but aloft the stern is thicker in & out, (& otherwise also)
> it endes in a quadrant, & comes into the breake head as a stump. the beake hed is ⅛ or ⅕ of the keele in length.
> The timbers of 100t of the midship bend, and 7 inches in & out below & 8 inches brode & a lofte about 3 inches eueryway.
> The lower wales are in thicknes 5 ynches & about 6 in bredth, the other are lesse. the planke between is 3 inches & so downe to the keele. vpward they are thinner in degrees.

One of Harriot's most interesting notes deals with the officers of the ship. This note is historically important in that (1) it is one of the very rare listings of the personnel of an Elizabethan privateer giving the number of shares of loot to be assigned to each seaman and officer, and (2) it is the earliest known account of the ship's watches, their names, and the records of the "bells" which timed each watch.[44] Following a diagram of a twenty-four clock divided into six four-hour watches, Harriot calls attention to the fact that

A watch is: 8 [half-hour sand] glasses = 8/2 houres. = 4 houres.
The men are then divided up for duty:

> All starbord men on the masters side & larbord men on the mates side. or on bothe mates sides [if there are two mates].
> The watch from 4 to 8 at night is deuided into two partes: the later parte from 6 to 8 they call the *looke out*.
> These two partes are as two watches, that the same men may not haue the first watch. the first watch beginnes at 8 at night; then they set the watch.
> 1. watch [8 to midnight]
> 2. watch [midnight to 4am]
> Day watch
> or morning watch.

Harriot's notes on ship organization. Add. MSS 6788, f. 21. By permission of the British Library.

Harriot's notes use the same terminology current today.

Though Harriot's observations of ships begin by casual notes on what the current practice was, it is obvious that the importance of making improvements in present usage led Harriot to study carefully the purposes Ralegh's vessels were to serve and the optimum design which might render them more efficient. In this regard, one of Harriot's notes gives a valuable insight into how a British captain viewed the English ships he was called upon to sail. The notes give important insights into this matter. Headed "Notes taken out of Captayne Edmund Marloe, his booke intituled: Ars Naupegica, or the art of ship build-

Edmund Marloe's notes on ship construction. Add. MSS 6788, f. 39. By permission of the British Library.

ing," these notes summarize the contents of an Elizabethan "booke" which apparently was never published:[45]

The Easterling, Duch or Fleming build floty ships by reason those contryes are subiect to flats and shoulds. And because they often bring them a ground they haue much flat flore to rest vpon. There sides also are vpright, and are built so for burthen & small draught of water. And they beare sayle not so much for there sides, but by reason of the great wayght that lyeth below vpon the flore (being so broad & long). But these for the most part are euill conditioned ships in the sea, being suiect to rowle, tumble, & leape in a wrought sea; so that you must allwayes keep some sayle abrode.

Contrarywise the Spaniard (not accustomed to bring his ships a ground but allwayes to ride a flote, & also to trimme his ships vpon the carine [careen]). As you may se by there Carvells. And there Caractes likewise for the most part flare much of aloft. Now these hold a better wind & are easier in a wrought sea, and will comonly hull well, & wether quoyle. But they draw much water & are not well to be brought a ground without good shoring for feare they fall ouer.

The Frenchmen are nerest to perfection in bearing sayle & going well, being neat moulded ships. But they are not commonly so great in burthen as they loome for [appear]. They haue long rakes [projections of the upper part of the ship's hull and stern beyond the keel] & sharp forward on; and there decks steeue [incline upward] much forward. Where contrarywise the Easterling and Duch haue short vpright rakes, & are bloof [bluff] ships forward on [presenting a broad, flattened front, opposed to sharp or projecting, and having little rake or inclination]. Also there deckes steeue or hang backwardes on.

But our English ships are intended to haue such perfection, that (according to the intent of the builder) they hold burden with the Fleming; bearing with the Spaniard; going well with the French, &c.

Euery Nation aymeth at this: to haue there ships go well & steer well. Which proceedeth especially from the well weying of a ship fore & afte; for the Runne [that part of the ship's bottom which rises from the keel and bilge and narrows toward the stern] & Tuck [the gathering of the ends of the bottom planks under the stern].

These are the chief propertyes of a ship in the sea. To go well; to steer well, & beare a good sayle. As for the Burthen that belongeth to the owners profit, which some to much affecting hath made vs to haue so many furred ships. [In his own definitions[46] Harriot defines "furring" which is not given in the *OED* as "The Furring of a ship is when she will not beare sayle for want of bredth is to build her broader with [new] outsides with timber on the plumbes [vertical sides] & thin bord below & thicker vpward so far from below as is fit; & howsing it in vpward to agree with the vpper worke by thinner bordes agayne. Many marchantes shippes are fyne to be furred" though this was obviously a makeshift correction of poor ship design.]

Harriot's manuscripts show that his duties for Sir Walter Ralegh went far beyond training sea captains in mathematical navigation; he was also called upon to assist in the selection, design, construction, and manning of the ships needed for all his enterprises. He also was helping Ralegh obtain financing for his voyages, and was directly responsible for the maintenance of his accounts. This personal involvement led Harriot to give over a long period full attention to the selection and construction of ships which, even under adverse conditions, would go well, steer well, and bear a good sail, while at the same time having proper depth and breadth for the stowing of merchandise or loot. To improve his grasp of the state of the art of ship construction, Harriot cultivated the acquaintance of one of the preeminent shipbuilders of the time, Matthew Baker,[47] the Queen's chartered shipwright, and the first man to be titled "Master Shipwright." Harriot, still in his mid-thirties, though obviously well informed of Baker's theories and principles, was in no way overawed by them, nor fearful of challenging the reasoning of the Master Shipwright.

Harriot began his criticism of Baker and his practices by considering the way in which Baker computed the tonnage of his vessels:[48]

> It is knowne by experience that a ship whose depth .10. foote
> is of burden a 100 tonne. bredth. .20.
> length. .50. by the keele

> Mr. Baker makes this rule & findes it little more or lesse then truth otherwise tried. He makes a solid nomber of 10. 20. & 50. & then devides it by a hundred. the quotient is the tonnes of burden (in ye hold) as I take it. the sayd length bredth & depth must be in feet for this rule.

> ffor tonnes & tonnage of the Kinges ships he multiplyes as before but deuides by 70. & the quotient is counted her tonnage. By these rules the Tonnage of shipps is measured for the King.

> Tonne & tonage is what a ship doth carry of ordinance master sayles & yardes together with that which she carry in hold.

Harriot's immediate reaction is that these calculations are much too crude for serious use. Baker, he complains, considers the bulk of the ship to represent a parallelepiped, which is in fact almost three times the actual bulk of a vessel of these dimensions. Much more accurate results could easily be found by dividing the "solid number" or cubic feet of the parallelepiped by three, and multiplying the result by sixty-four (the number of pounds in each cubic foot of water displaced by the vessel). But even greater accuracy could be obtained by simply determining the volume of the vessel's displacement—a feat which should easily be within the capability of the Queen's shipbuilder.

Harriot was also unimpressed by the almost linear proportions used by Baker in designing vessels of different displacements. For more than a dozen years Harriot kept notes on the dimensions of ships of various sizes which had proved to be efficient sailers. In some instances he took the measurements himself; in others he accepted the figures given by Hakluyt or other observers.

Calculation of ship's tonnage. Add. MSS 6788, f. 41r. By permission of the British Library.

Among others he noted were the detailed measurements of the East Indian Carrack and the *Madre de Dios*, the richest privateering prize captured by English sailors in 1592 during Elizabeth's reign.[49] He later noted the statistics of the highly controversial *Prince Royal*, the largest English warship constructed

up to the time of its launching in 1610, noting that estimates of its displacement varied from 1000 to 1400 tons.[50] From his observations, Harriot arrived at some original quick conclusions of his own:[51]

> I am of opinion that depth is to be regarded with the bredth for [determining] the length of the mastes . . .
> The length of the ship in this reckoning I thinke also to be litle regarded because, when the mast is fitted in bredth & depth. it cannot be amisse for the longest dimension . . .

As a scientist, Harriot saw that this hypothesis should be resolved in mathematical terms which would correct the straight-line proportionality then in use. And in the tradition of a Renaissance scholar, Harriot began his search among classical mathematicians, finding the answer he sought in Proposition 21 of Book 1 of the *Conics of Apollonius of Perga* in a geometric construction which he quickly resolved into a numerical chart.[52] On the rough sheet of calculations, Harriot recorded the event:[53]

> Invented this Feb. 28 [Saturday] 1607/1608. & gaue it to: E. Marlow for Mr. Baker the shipwrite.

Thus the study of the classics came to the aid of the practical art of shipbuilding in the English Renaissance.

By the end of the reign of Elizabeth, the pattern was clear: the scholars, the classics, the new experimental techniques, and the practical arts were beginning to fuse, and as science and the fine arts were strengthening each other, science and the applied arts were doing the same. The work of Recorde, Dee, Wright, and Harriot was affecting the arts of navigation and shipbuilding during the years that the Stuarts were bringing their navy to new efficiency. And other commissions followed, as James called on the theoretical professors of Gresham College, of Oxford, and of Cambridge for specific advice and counsel. For the first time the universities, which had long maintained a position of semi-isolation, became immediately involved in solving the practical problems of their day. The work of these men demonstrate what Richard Hakluyt called "the link of theory with practice" which marked the union of science and the practical arts of navigation in Renaissance England, and which brought "almost incredible results."

NOTES

1. Details of the growth and development of both the British Royal Navy and the merchant marine are fairly well documented. Among standard works which may be consulted are: H. C. Hunter, *How England Got Its Merchant Marine* (New York, 1935); R. E. Marsden, "English Ships in the Reign of James I," *Transactions of the Royal Historical Society*, 19 new series (1905), 309–42; N. H. Nichols, *History of the Royal Navy*, 2 vols. (London, 1896); Boise Penrose, *Travel and Discovery in the Renaissance, 1420–1620* (Cambridge, Mass., 1952); A. E. Oppenheim, *The*

Administration of the Royal Navy, 1509–1620 (London, 1896); E. G. R. Taylor, *The Haven-Finding Art* (New York, 1971); David W. Waters, *The Art of Navigation in England in Elizabethan and Early Stuart Times* (New Haven, 1958).

2. Sir John Mandeville's tales of exotic travel were widely circulated in manuscript as well as in numerous printed editions. Tales of the Anthropophagi were widespread, found in Marston's *Pygmalion* and Shakespeare's *Othello*. For an example of Mandeville's original tale, see Malcolm Letts, *Mandeville's Travels*, 2 vols., The Hakluyt Society, Second Series, nos. 101, 102, vol. 1, 142.

3. Sir Walter Ralegh, *The Discoveries of the large and bewtiful Empire of Guiana*, ed. V. T. Harlow (London, 1928), 56.

4. "Arthur Barlowe's Narrative of the 1584 Voyage," reprinted in Richard Hakluyt's *Principall Navigations* (1600). Part 2:251 closes, "We brought home also two of the Savages being lustie men, whose names were Wanchese and Manteo." See also David B. Quinn, *Roanoke Voyages*, 2 vols., The Hakluyt Society, Second Series, nos. 104 and 105 (1955), especially vol. 1:16–17, 119.

5. Philip L. Barbour, *Pocahontas and her World* (Boston, 1970), chap. 14, 178–93.

6. Louis B. Wright, *Middle Class Culture in Elizabethan England* (Chapel Hill, 1935), 547–48.

7. A. F. Galconer, *Shakespeare and the Sea* (New York, 1964).

8. Thomas S. Willan, *The Muscovy Merchants of 1555* (Manchester, 1953).

9. The changing technology of this period is thoroughly discussed by Lt. Commander Waters in *The Art of Navigation in Elizabethan and Early Stuart Times* (New Haven, 1958). See particularly, 495–98.

10. Taylor, *Haven-Finding Art*, 175; Waters, *Art of Navigation*, 62.

11. Taylor, *Haven-Finding Art*, 174; Waters, *Art of Navigation*, 62.

12. For a full account of the Cabots and their accomplishments, see James A. Williamson, *The Cabot Voyages and Bristol Discovery under Henry VII*, The Hakluyt Society, Second Series, no. 120 (1962).

13. Ibid., 33–38.

14. Waters, *Art of Navigation*, 84, n. 1.

15. Ibid., 116–20.

16. Ibid., Appendix 12, 535–36.

17. Quinn, *Roanoke Voyages*, especially 1:79–81, 98, n. 2.

18. For a comprehensive view of how the Elizabethan mathematician saw his craft, see John Dee's "The Mathematicall praeface" attached to *The Elements of Geometrie of Euclid of Megara* (London, 1570). This has been reprinted with an introduction by Allen G. Debus by Science History Publications (New York, 1975).

19. Waters, *Art of Navigation*, 75–77, 104.

20. A brief account of Recorde is included as Biography 5, p. 167, of E. G. R. Taylor's *The Mathematical Practitioners of Tudor and Stuart England* (Cambridge, England, 1954). A fuller account is that of Joy B. Easton in the *Dictionary of Scientific Biography* (New York, 1975), 11:338–40.

21. A fairly comprehensive study of Dee is that of Peter J. French, *John Dee: the World of an Elizabethan Magus* (London, 1972). Dee is also included as Biography 17, p. 170–71, in Taylor's *Mathematical Practitioners*. The life in the *D. S. B.*, 4:5–6, also by Joy B. Easton, is not sympathetic and tends to downplay Dee's real mathematical and scientific achievements. By far the best account of Dee's contribution to navigation is to be found in E. G. R. Taylor's *Tudor Geography, 1485–1583* (London: Methuen, 1930). See particularly chap. 5, "John Dee and the Search for Cathay: 1547–1570," 75–139.

22. These gifts to Cambridge are catalogued by Dee in his *Compendious Rehearsal* (9 November 1592). They are reprinted as Document 8, in Taylor's *Tudor Geography, 1485–1583*, 256.

23. Dee may have published a work on his "Paradoxal Cumpas"; his work *General and Rare Memorials pertayning to the Perfect Arte of Navigation* (London, 1577), says on the title page that it is "Annexed to the Paradoxal Cumpas, in Playne: now first published: 24 yeres, after the first Inuention thereof." This would place the invention as of 1553. However, no such publication exists. In a marginal note on sig. ε iijr, he records that "M. Steuen and M. William Borowgh, two of the chief Moscouy Pilots (after the incomparable M. Richard Chancelor his death) and be

sufficient witnesses" to his invention also. This would place the invention during the time that Dee served as consultant to the Muscovy Company.

24. In 1576 Frobisher and Hall wrote to Dee saying, among other things, ". . . we do remember you, and hold ourselves bound to you as your poor disciples, not able to be Scholars but in good will and diligence to the uttermost of our powers. . . ." See Taylor, *Tudor Geography, 1485–1583*, Document 11, 262–63.

25. The British Library copy of *El viaie qve hizo Antonio de Espeio en el anno de ochenta y tres* carries on the title page a note in Dee's hand, "Joannes Dee: A° 1590. Januarij 24. Ex dono Thomæ Hariot, amici mei."

26. The story of the noble and tragic death at sea of Sir Humphrey Gilbert was publicized by Richard Hakluyt in his *Principall Navigations* (1589), 695. This very important work had been reprinted by The Hakluyt Society, 2 vols. (Cambridge, England, 1965), with an introduction by David B. Quinn and R. A. Skelton, and beautifully indexed by Alison Quinn.

27. Hakluyt printed these comments in the dedicatory epistle to his edition of *De Orbo novo Petri Martyris . . . Decades octo* (Paris, 1587). This dedication to Sir Walter Ralegh is reprinted by E. G. R. Taylor in *The Original Correspondence and Writings of the two Richard Hakluyts*, 2 vols, The Hakluyt Society, Second Series, nos. 86, 87, as Document 56. The Latin original is in 2:356–62 and an English translation in 2:362–69.

28. Robert Hues is briefly treated by Taylor in her *Mathematical Practitioners*, Biography 47, p. 178. More detail is given by Waters, *Art of Navigation*, 191–96; he is not included in the *D.S.B.* After leaving the service of Ralegh, Hues was for a time under the patronage of the ninth earl of Northumberland. Aubrey lists him along with Walter Warner and Thomas Harriot as one of "The Wizard Earl's 'Three Magi'." There is some evidence of this association, but it was not as close as frequently assumed.

29. Lawrence Keymis, who has received only passing notice from historians, is known almost exclusively for his account of his 1596 voyage to Guiana, *A Relation of the second Voyage to Guiana. Perfourmed and written in the yeare 1596.* Anthony Wood mentions him briefly in his *Athenae Oxonienses* (London, 1721), col. 433. Additional details may be found in the author's *Thomas Harriot, a Biography* (Oxford, 1983), passim.

30. The tragic end of Ralegh's Guiana voyage is graphically told by Edward Edwards, *The Life of Sir Walter Ralegh*, 2 vols. (London, 1868). See 1:638–40.

31. Details of the life and work of Edward Wright are adequately covered by Taylor, *Mathematical Practitioners*, Biography # 53, p. 181–82; Walters, *Art of Navigation*, passim, especially, 219–29; and by the biography by P. J. Wallis in the *D.S.B.*, 14:513–15.

32. "The Praeface to the Reader," *Certaine Errors in Navigation* (London, 1599), sig. GG. This book has been reprinted by the Walter J. Johnson Company, 1974.

33. Taylor, *Mathematical Practitioners*, 182.

34. Francis R. Johnson, *Astronomical Thought in Renaissance England* (Baltimore, 1937), 198–205.

35. Andrew Clark, ed., *Register of the University of Oxford*, 2 vols. in 5 pts. (Oxford, 1887). For a discussion of the Gresham Lectures at the university in January and February 1597, see vol. 2, pt. 1:232–33.

36. John Ward, *The Lives of the Professors of Gresham College* (London, 1740), iii–viii.

37. The Statutes of the Savilian Professorships are included in the *Statutes of the University of Oxford codified in the year 1636*, ed. John Griffiths (Oxford, 1888), 244–53.

38. Harriot's manuscripts, nearly 9,000 folio sheets in all, have been lost or neglected, found, disorganized, and scattered in the three and one-half centuries since his death in 1621. The majority are now in the British Library or in the private libraries of Lord Egremont-Leconfield at Petworth House, Sussex. Through the activities of an editorial committee, Xerox and microfilm copies are now available for scholarly use in the Bodleian Library, Oxford; the Science Museum in South Kensington, London; and in the History of Science Reading Room at the University of Delaware in the United States.

39. "Harriot's Earlier Work on Mathematical Navigation: Theory and Practice," chap. 4, 54–

90, of *Thomas Harriot, Renaissance Scientist*, ed. John W. Shirley (Oxford, 1974). This quotation is from p. 54.

40. British Library, Additional MS 6788, fol. 3.
41. Ibid., fol. 36r.
42. Ibid., fol. 28r.
43. Ibid., fol. 30r.
44. Ibid., fol. 21r.
45. Ibid., fol. 39r.
46. Ibid., fol. 33r.
47. Philip Banbury, *Shipbuilders of the Thames and Medway* (Newton Abbot, 1971), passim.
48. British Library, Additional MS 6788, fol. 41r.
49. Robert Lacy, *Sir Walter Ralegh* (New York, 1974), 173. Waters, *Art of Navigation*, 233–34.
50. British Library, Additional MS 6788, fol. 41r.
51. Ibid., fol. 41r.
52. Ibid., fol. 8r, 10r.
53. Ibid., fol. 3r. It might be noted that this is one of the few dating errors to be found among Harriot's notes. The day 28 February 1607/8 was a Sunday, not a Saturday that the astronomical symbol for Saturn indicates. It was a Sunday on 28 February 1606/7.

The Involvement of Artists in Renaissance Science

James Ackerman
Harvard University

Art and science in the fifteenth century were in a symbiotic relation. The artists began by setting themselves goals—like the invention of rationalized perspective or the representation of natural light—that could be reached only with the help of mathematical and scientific tools. And once the new techniques were available, they proved to be a key factor in the genesis of the descriptive sciences.

What distinguishes the art of the fifteenth century from that of the preceding generations was not what Burckhardt represented as a reawakening to the world—late medieval artists were already awake—it was the submission of observed data to a rational and mathematically definable order. The fine visual discrimination of artists in the fourteenth century is attested to by vivid depictions of flowers, animals, and objects of the everyday world that appear in manuscript borders, sculpted capitals, model books, painted panels, and nature studies intended to divert rather than to instruct. These often are as precise in recording characteristic features and significant details as those of the Renaissance; the difference is that they are not presented in convincing proportions nor with the illusion of three-dimensionality, weight, texture, light, and position in relation to the observer, and that they were rarely used in a context that could be called scientific.

This essay aims to define the ways in which the rationalized visual and intellectual perceptions developed by Renaissance artists as the basis for a new visual communication contributed to the definition and attainment of scientific goals in the Renaissance.

An insight into the genesis of this process is provided in the writings of two

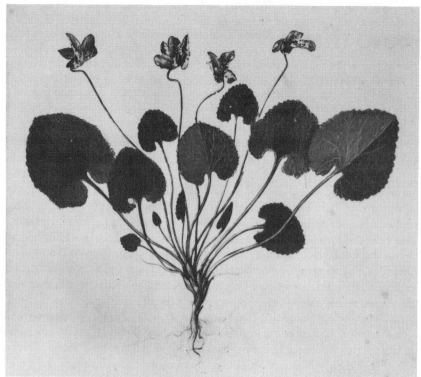

Violet, **British Museum, Egerton MS. 2020, fol. 10. Photo: British Museum.**

of the most original and influential men of the early Renaissance: Leone Battista Alberti and Leonardo da Vinci. Alberti almost single-handedly reformulated the goals of painting and architecture in two treatises, *De Pictura* (1435) and *De Re Aedificatoria* (1450) which, among other aims, sought to elevate the artist from the rank of artisan to that of a person of learning and refinement capable of meeting the exacting intellectual demands of an art which he saw virtually as a branch of philosophy. As a humanist, Alberti was committed to a classical intellectual preparation based on the study of ancient literature, history, and moral philosophy in contrast to the content of the medieval trivium and quadrivium promoted by the scholastics, who controlled university curricula, particularly in the scientific faculties.[1]

Leonardo's approach was less intellectual and scholarly, but he also was committed to a synthetic approach to knowledge. He did not perceive science as belonging to a distinct category of learning, but as giving structure to all inventive endeavor; he followed the lead of Alberti in starting his *Treatise on Painting* with the following question:[2]

Whether or not painting is a science

Science is that mental analysis which has its origin in ultimate principles

beyond which nothing in nature can be found which is part of that science
. . . [but] no human investigation can be termed true science if it is not
capable of mathematical demonstration. If you say that the sciences which
begin and end in the mind are true, this is not to be conceded, but is denied
for many reasons, and chiefly the fact that the test of experience is absent
from these exercises of the mind, and without it nothing can be certain. . . .

The first principle of the science of painting is the point, then comes the
line, then the surface, then the body. . . .[3]

Both the question and the answer look a little strange today. We think of
painting as something like giving ordered expressive form to values and feel-
ings, and of science as something like the systematic investigation and explana-
tion of the causes and effects of natural processes. The two remain distinct in
the modern ordering of culture. But Leonardo, who never stopped trying to
practice what we call science as well as what we call art, wanted his readers to
agree that the two were simply aspects of a single endeavor which he called
science and which he characterized by its search for principles or laws based on
and proven by experience (or experiment), and expressible in a mathematical
language. The language of painting, as he put it, is geometry; Euclid's point,
line, plane, and solid provide the parameters for the science.

In the passage just quoted, Leonardo starts with a question: whether paint-
ing is a science, and makes his points in terms of a debate: ("if you say so-and-
so, it is not to be conceded, but denied") in which his imaginary adversary,
"you," is a theoretician who believes that science may be practiced entirely
from an armchair without being stimulated or vindicated by experiment. While
he is clearly intending to attack the scholastics, his method is purely scholastic,
starting with the *quaestio* and proceeding by the dialectic method. From this
point through the more than one thousand paragraphs of his *Treatise*,
Leonardo proves himself to be the master of observation. The notes are actu-
ally more useful for the explanation of physical phenomena than for the prac-
tice of painting; an account of how the world looks was destined to be less
useful to painters than what they could see when they looked for themselves.

But for all his fabulous knowledge of the natural world, of technology, of
the art of war, the figural arts, music, the theater, Leonardo was rejected by
scientists because he succeeded only in experiment and not in theory or ex-
egesis, and by humanists because he could not write Latin and probably had
difficulty even reading it.[4] With respect to the advancement of science, human-
ists and scholastics had in common one major shortcoming—apart from isolat-
ing themselves in exclusive coteries—that their concept of knowledge was
restricted to what could be found in the texts of earlier authors. The typical
fifteenth-century scientist, for example the professor of anatomy, depicted here
from the first illustrated printed medical book, lectures from his text—Galen's
De usu partium?—while an assistant in workman's clothes, probably a barber-
surgeon, performs the section on the corpse. In the event of any conflict
between the evidence of the book and that of the body, the book surely would

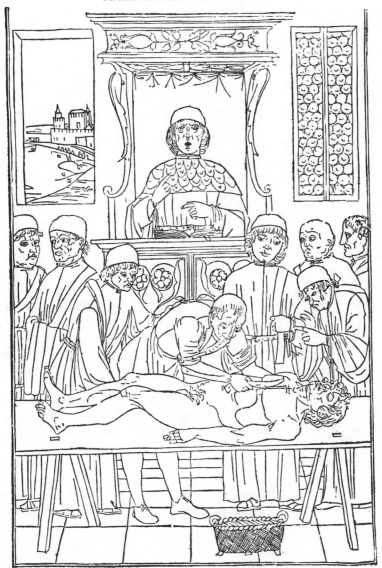

Anatomical Lecture, from Johannes de Ketham, *Fasciculo di Medicina,* **Venice, 1495 ed.**

have emerged victorious in the minds of the aspiring doctors, though Galen had had only animals to work from.[5] Respect for empirical evidence was rare outside the painters' workshops.

Leonardo reacted passionately to his critics. "Those people go about," he said, "inflated and pompous, clothed and decorated not by their own achievements but by those of others, and do not allow credit to me for mine." Leonardo was, in fact, much closer to the scholastic than to the humanist

tradition in his rhetorical style, his immersion in thirteenth- and fourteenth-century scientific writings, and his Aristotelian method.[6] He differed with the professors primarily because he was committed to observation and experiment while they preferred to discuss data transmitted from the ancients and questions of method.[7] Moreover, he applied his science to technology and art, which only served to alienate him further.

The kind of scholar Leonardo was addressing in his polemic statements would not have differentiated between artists, empirical researchers, and the inventors of machines and other technical devices. He would have excluded them all as practitioners of the "mechanical arts" from the company of educated men, and surely he would have ranked them intellectually below the level of astrologers and alchemists, who had to be as learned as those who discussed Aristotelian principles. Social rank corresponded: artists and craftsmen came from working-class families in the fifteenth century and dressed like laborers; their long apprenticeship prevented them from getting more than an elementary formal education, though it gave them a broad technical foundation and perhaps more applied mathematics than the average gentleman would have acquired.[8]

What kept Leonardo from being an important scientist was his failure to live up to his own standards. He never got to the general theory that would have given his observations scientific significance, perhaps because he moved from observation to observation and never synthesized his findings into a law or theory. But Leonardo and his artist-contemporaries contributed to the formation of a new era of science and technology, not primarily through their discoveries or hypotheses, but through their readiness to allow evidence gathered by eye to challenge the authority of the word, and their ability to present it in a vivid and effective visual form. In an epoch committed to the revival of antiquity, the independence of artists from the authority of ancient explanations of natural phenomena helped to create a milieu in which the scientific revolution could take place.

The following sketches of three different instances of the involvement of artists in scientific and technological issues will help to define this process.

Optics

The closest bond between art and science in the fifteenth century developed in the field of optics. Optics was the foundation on which rationalist painters could build a technique for conveying the illusion of consistent and rational space and of three-dimensional objects within that space in correct proportion to one another. It suggested ways of imitating the action of natural light to give the effect of relief. Thus in both of the first two theoretical writings of the Renaissance, Leone Battista Alberti's *De Pictura* of 1435 and Lorenzo Ghiberti's *Commentarii* of 1447–48, one of the three parts was devoted to a discussion of the application of optics to art.[9] Alberti's small but closely packed treatise is the best guide to the assimilation of this science into art. It was the first

Renaissance book on art and possibly the most influential and imaginative one of all time. (On the other hand, Ghiberti's third commentary has recently been shown to consist of transcriptions and notes from medieval texts.)

"In writing about painting in these short books," Alberti began, "we will, to make our discourse clearer, first take from mathematicians those things which seem relevant to the subject. When we have learned these, we will go on, to the best of our ability, to explain the art of painting from the basic principles of nature." And so he proceeds by defining a point, a line, and a surface, and from there to the effects of light and how it is transmitted to the eye by rays. The basically geometric approach of ancient and medieval science to the study of optics, which postulated rays of light traveling in straight lines between the object seen and the eye, made it possible for Alberti and his contemporaries to rationalize vision through mathematics, and thereby to produce an illusion of the complex three-dimensional world on the two-dimensional surface of a painting. Because the science was dominated by mathematics, physiological optics—the study of the implications of vision with two eyes, the effect of the motion of the head and eyeball, distortions in peripheral vision, and the like—was not a factor in Alberti's system, though some medieval writers were aware of it, and it was to preoccupy Leonardo.

The medieval term for optics, *perspectiva*, survives today as "perspective," but what we understand by this term is only half of the discipline as defined by Alberti. He divided Book One of *De Pictura* into two parts: the first is an exposition of the operation of light in transmitting images of objects to the eye, a review of the tradition of *perspectiva* as received by fifteenth-century scholars, with observations on its application to the practice of painting.[10] The second is a description of the method of constructing on a two-dimensional surface by geometrical means an illusionary three-dimensional spatial framework within which the dimensions of any object could be made proportional to its distance from the observer. This, by contrast to what preceded it, was entirely an invention of Alberti, aided by the earlier experiments of his older contemporary Filippo Brunelleschi, but not anticipated in ancient or medieval art or science. By way of differentiation, the traditional study of optics was referred to in the Renaissance as *perspectiva naturalis* or *communis*, and Alberti's invention—perspective in the modern sense—as *perspectiva artificialis*.

Although optics, in its geometrical aspect, had been developed to a sophisticated level in antiquity by Euclid and Ptolemy, and in its physiological and anatomical aspect by Galen, it was science in which medieval experts clearly surpassed their predecessors.[11] The Renaissance theorists who turned to optics to solve problems of representation did not have to revive a lost body of learning; they continued a tradition that had reached a peak in Arab writers of around A.D. 1000, most notably in the work of Ibn al-Haitham called Alhazen (905–ca. 1040), and was sustained by translators and commentators throughout the later Middle Ages. Fresh contributions in the medieval tradition were still being made by Biagio Pelacani of Parma, whose career extended into the time

of Brunelleschi and Alberti, and whose work was known in Florence.

Alhazen, who was the primary source of later theory, decisively refuted ancient theories postulating the emission of a spirit from the eye. In his description, rays come from the object to the eye in a pyramid; they are received on the entire surface of the eye in such a way that any point on the eye can receive a light impulse from any point on the object. One of the rays, however, by virtue of coming from a point on the object straight into the pupil along the axis of vision, is stronger than all the others because it is not diffused or lengthened by refraction.[12] Alberti, in *De Pictura,* called it "centric."[13] It was the preferential position of this ray that inspired Alberti to build his artificial perspective system around a central point (called the "vanishing point" today) exactly opposite the eye: "as it occupies the place where the centric ray strikes, I shall call this the centric point."[14] Probably Brunelleschi, too (in experiments that contributed to Alberti's standard construction), had the Alhazen tradition in mind when he made the first perspective picture of the Renaissance so that it would be viewed from the back through a hole in the center, as reflected in a mirror held at arm's length, the purpose being to fix the "centric" position of the eye and the viewing distance.[15]

In order to recast the geometrical perspective of ancient and medieval science in a form that artists could use, Alberti had to resolve one problem that was of no interest to optical scientists—how to project the impression that reaches the eye from the outer world into the flat surface of a painting—and one that the scientists had not solved—how to explain and then to represent the volatile effects of light, shadow, and color, which are not subject to geometrical rationalization.

The solution of the first was brilliant. It was prompted by looking out of the window. If the image of the outside world comes to the eye via a pyramid of light rays, the same image could hypothetically be caught at any place between the object and the eye by interposing a vertical screen, or intersection of the pyramid. The view out the window made this highly abstract proposition concrete: there, within a frame, is a piece of the outside world that could be thought of as projected onto the glass, though it passes through the "screen" to the eye. If one took a brush and pigments and painted onto the window glass all the outside objects visible there, one would have a picture that was a geometrically precise imitation of what was seen through the window. Albrecht Dürer illustrated a practical application, for use in portraiture, in his discussion of perspective. The translation of this inspiration into a geometrical process for projecting any image onto a surface in accordance with the distance and position of the painter's eye is complex and some details of it are still mysterious, to judge from the fact that after a generation of interpretation in our time every new contribution unfailingly represents its predecessors as wrongheaded. Professor Edgerton has persuasively proposed that the system is indebted to projective techniques explained in Ptolemy's *Geographia.*[16]

To deal with what he called the "accidentals" of light, color, texture, etc., Alberti invented a distinction between "extrinsic" rays, which transmit the

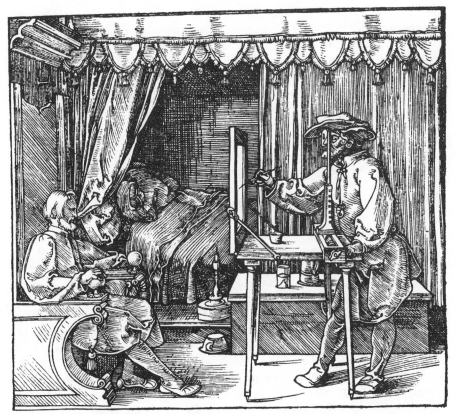

Painter using a transparent screen, from Albrecht Dürer, *Underweysung der Messung,* **Nuremberg, 1525.**

outlines of objects—their basic palpable form—and "median" rays which transmit their surface character—the qualities that are properties of accidentals.[17] This made it possible to attempt a rationalization of color and chiaroscuro in painting.

Alberti's adaptation of the optical tradition, later refined by Piero della Francesca,[18] was translated into simple workshop rules that profoundly affected early Italian Renaissance painting. These rules gave painters a means of mathematically rationalizing the representation of the outer world to a degree that did not interest painters of the northern Renaissance (although Albrecht Dürer was attracted to Italy partly in the hope of learning them). Initially they did not and were not intended to increase verisimilitude in representation. The standard perspective construction was an abstract technique that produced an initially uninhabited spatial box viewed strictly on axis. It was not hospitable to the irregularities of the actual world; few Renaissance pictures were done from nature. The ray theory as interpreted by Alberti led to practices in chiaroscuro and color handling quite divorced from perception.[19] Objects were lit from an

unspecific source at ninety degrees to the axis of vision and their color was conceptual; the blue tunic of a figure would be made exclusively with blue pigment (modeled by white and occasionally black) and its yellow shirt with yellow. This explains the brilliance of early Renaissance pictures and their lack of tonal unity.

The purely geometric *perspectiva artificialis* of the early Renaissance already was attacked by Leonardo da Vinci, precisely because it failed to account for the realities of visual perception. He cited the distortions resulting from viewing perspective constructions from points close to the surface, and he mocked the light and color practices of his predecessors because they failed to account for the color of natural light, the reflection of one color onto another, and above all, for the fact that in the absence or deprivation of light, color is seen as absorbed into a neutral darkness. Leonardo had a profound knowledge of medieval optics, which he used in writing an unfinished treatise on the eye, but his criticisms and revisions of perspective and color practice were derived less from this accomplishment than from his tireless interest in experiment and observation.[20] In this he was the antithesis of the humanist Alberti, whose theory was never based on, or checked by, observation. The contrast between these two brilliant men symbolizes the ambivalence of the Renaissance mind that operated against a fully matured scientific enterprise. Albertian geometric theory and Vincian perceptual principles and practice combined to support the great art of the sixteenth century. In the first half of that century there was an abrupt abandonment of new theoretical activity, and when it resumed at the prime of Mannerist art in mid-century, it was far removed from scientific concerns and, with rare exceptions, has remained so ever since.

Scientific Illustration

Fifteenth-century techniques for rationalizing images—artificial perspective, the illusion of relief through modeling with light and shadow, control of proportion, and scale—opened the way for a productive interaction between art and science.[21] The fourteenth-century tradition of minute naturalism that continued into the fifteenth century in Italy[22] and, more pervasively, in northern European art, could not serve scientific ends until it was joined by those mathematically controlled methods of presentation.

The early evolution of scientific imagery was closely linked with the appearance of the printed book in the 1460s and 1470s.[23] Because illustrations cut on wooden blocks could be passed through the press together with the text at the same time, figures could be produced as fast and as inexpensively as words. But just as the great majority of scientific texts published in the first decades of printing were editions of ancient and medieval authors, so early book illustrators did not represent the world they saw, but made woodcut versions of the painted illuminations of surviving manuscripts.[24] At first the printed book was considered to be a machine-made manuscript (just as the first automobiles were modeled on horse-drawn carriages), and type fonts imitated hand script. Early

wood-block illustrations were consequently more decorative than functional. The medieval models were as abstract and symbolic as medieval scientific thought,[25] while illustrations in texts that had survived from antiquity had become so distorted by repeated reproduction—as each copyist in turn passed on the errors and oversights of his predecessors and added some of his own— that the end product was useless even as a symbol.

The printed image, however, offered two revolutionary potentials: first, that, in contrast to individually produced manuscript illuminations, every copy of a printed picture exactly duplicated the original plate made or approved by the author, so that the didactic effectiveness of a text could be safely extended by graphic illustrations;[26] second, that beyond its capacity to extend the author's written statement, the mechanically duplicated image could itself be the statement. In all fields of technology and descriptive science, books could be produced in which the substance was communicated primarily by images. Ultimately, in an abrupt reversal of functions, texts were partly or wholly devoted to elucidating the accompanying pictures.

An age so profoundly committed to the written word as the Renaissance found this concept difficult to accept; it took an inordinately long time to shed the medieval tradition. Although the first illustrated books appeared around 1470, it was not until the decade 1530–40 that the didactic validity of illustrations began to be recognized as comparable to that of the text.[27] Typical of early scientific illustration were the two editions (Venice, 1491, 1493) of the *Fasciculus Medicinae* based on manuscripts (fourteenth century?) attributed to a shadowy figure called Johannes de Ketham.[28] The five illustrations in this volume repeat a traditional medieval set; the zodiac man from *Fasciculus Medicinae* differs from his thirteenth-century predecessor only in style of presentation, not in content. This type of figure was used in astrological medicine; when the moon was in phase with the sign indicated over the afflicted organ, bleeding was proscribed. In using the figure, the physician actually employed a quadrant to take bearings from the heavens. Thus, unlike some early printed illustrations, this one was not merely decorative, but functional, though in itself it had no scientific validity; it was a mere sign. The figures in the second edition of 1493 are far more advanced in artistry and technique than their predecessors in the edition of 1491; the publisher had turned to an artist in the circle of Andrea Mantegna, one of the most eminent painters of the time and the first great Italian engraver. But because of the scientific content of the text, the change increased only the aesthetic quality of the cuts and not their didactic value. It also gave the book a contemporary, *all' antica* look.

The plates in Hans von Gersdorff's *Feldtbuch der Wundartzney* of 1517, published a generation later, symbolize a new era. The naturalistic cadaver stood for the substitution of empirical science for astrology, as suited a manual for military surgeons. But its value was almost purely symbolic, because it conveyed no useful information. In its description of the interior organs it was no less tied to tradition than the zodiac man. (See p. 106.)

Herbals, compendia of medicinal simples, were the most popular class of

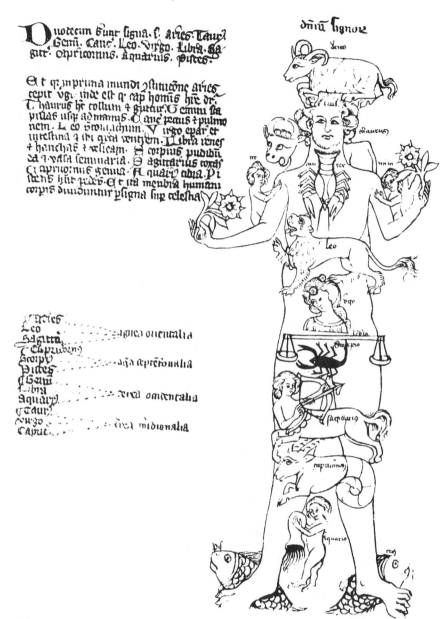

Zodiac Man. Thirteenth century, MS. 14414, Munich, Staatsbibliothek.

scientific publication in the Renaissance and were invariably illustrated.[29] All the incunabula were based on surviving medieval herbal manuscripts of the Greco-Roman writer Dioscorides and variants of that source, particularly the so-called Secreta Salernitana. The illustrations were not made from nature but

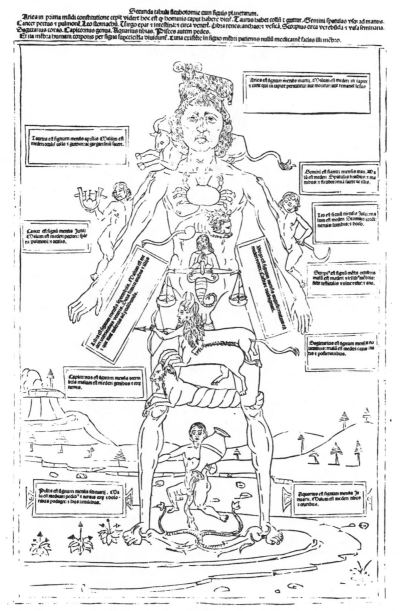

Zodiac Man, from Johannes de Ketham, *Fasciculo di Medicina*, Venice, 1493 ed.

from copies of medieval manuscripts many generations removed from the antique originals and were technically primitive (see "Nomen herbae asparagi agrestis," p. 112). There was one exception, however, the *Gart der Gesundheit* printed in Mainz by the great competitor of Gutenberg Peter Schöffer in 1485.

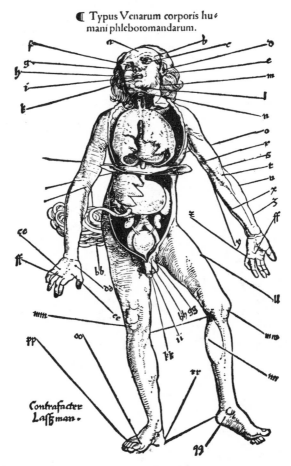

Cadaver, from Hans von Gersdorf, *Feldtbuch der Wundartzney*, Strassburg, 1517.

The majority of the large figures in this volume were copied from manuscripts, but the text also called for the representation of plants that did not appear in the ancient sources, and these had perforce to be reproduced from nature. Thus, two figures may appear on facing pages one of which (on the left) is purely symbolic and the other (on the right), within the limits of an emerging technique, representational. But the door opened by Erhard Rewich, the artist of the *Gart*,[30] immediately closed again for over four decades, probably because the botanists themselves were slow to turn from traditional authority to observation.

Between these printed images and the contemporary drawings of Leonardo da Vinci there was an astonishing gap. Leonardo's earliest anatomical and

Serapio in dē capitel karabe beschribet vns vn spricht daz es fast gūt sy vo augsteyn gedrucken wan sie benemen den buch werbin vn benemen auch die fluß an vē lybe vn darvmb dyenen sie fast wol dē frauwen die zu vil flussig synt an yrer zyt. Jtē augsteyn gestrichē vber die bloden augen machen sie clare vnd benemen yn den fluß.

Jtē augsteyn ist gūt gestrichen vff die geswern die do bitzig synt vnd zyehen die bitz vß. Jtē welche augsteyn by yn dragen de schaden keyn bliden vß der nasen. Auch stoppen sie das vberflussig blūt den vß der nasen vn behalten das hertz geblide. Jtē etlich meister heyssen karabe lapides gagatis deß halben das der gagates dē augsteyn so gar glich ist an dogenden vn auch an gestalt. Von disem steyn gagates fyndestu syn doget in disem buch in dē ecciii capitel.

Jtem eyn rauch gemacht vo augsteyn ist verdryben slangen. Augsteyn ist auch gūt widder das brechen. Vn ist auch verdryben den bosen geyst. Albertus magnus spricht daz vß puluer von augsteyn mit wasser gesotten vnd dar vo gegeben eyner iūgfrauwē macht sie nit harn vnd geben eyner frauwen macht sie harn.

karabe augsteyn ¶ Capitulū .cxxxij.

Brabe latine et grece arabice electrum ¶ Die meister sprechen daz diß sy eyn gummi eynes baums· vn das gummi glichet dem edel gesteyntz· ¶ Der meister Paulus in dem capitel karabe spricht daz diß gummi sy von natuer heyß machen vn temperiert mit eyner cleynen kelte ¶ Auicēna in dē büch genant de viribus cordis beschribet vns vnd spricht daz karabe synt heyß an dē ersten grade vn drucken an dē andern· Jr dogent ist stercken das hertz vn machen frolich· vn benemē das zyttern vo dē hertzē

Simples, from *Gart der Gesundheit*, Mainz, 1485.

botanical studies dating from the first years of his residence in Milan (1489 on) are best exemplified in his depiction of a human skull on a sheet that is virtually a compendium of early Renaissance achievements in the rationalization of sight.[31] The upper drawing is particularly remarkable in combining the technique of foreshortening (an application of artificial perspective), which permits us to see the horizontal cut through the cranium, with the newly developed architect's technique of presenting a three-dimensional structure in plan, section, and elevation. An advanced control of chiaroscuro modeling helps to bring the significant parts into relief and to make the skull almost "alive." The lower drawing makes use of cartographic coordinates to indicate the proportions of the parts. This drawing is such a forceful statement and so attentive to the actual nature of the object that one is surprised to find that the artist suppressed visual evidence in favor of traditional Galenic theory; the spine is hollow in order to allow the passage of a so-called generative power that was said to issue from the brain to control the function of other organs.[32]

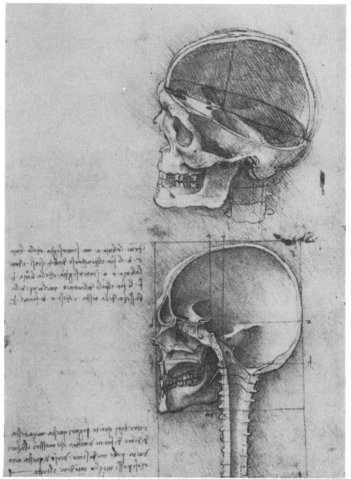

Skull Studies. Leonardo da Vinci, Windsor Castle Library, no. 10957. Photo by gracious permission of H. M. the Queen.

Leonardo invented several other devices to demonstrate data that could not be seen in a normal view of an object. He illustrated the internal female organs and the vein and artery systems by drawing the nude body with a transparent torso; he made the first "exploded" images, in which connected parts such as the vertebrae are separated just enough to show the nature and position of the couplings; he drew the ventricles of the brain from a cast made by filling them with wax—a graphic invention that later became standard in anatomical illustration.[33] But most of Leonardo's achievements, which far outstripped other early sixteenth-century attempts, had to be rediscovered by later generations because they were not known. And even if the drawings had circulated, their effectiveness depended on a skill that no copyist could emulate.

Over thirty years later, a widely used and scientifically advanced book by the Bolognese surgeon and anatomist Berengario da Carpi, *Isagoge brevis . . . in anatomiae humani corporis* of 1522, was illustrated with numerous cuts (see "De anatomia") that undertook to demonstrate information derived from dissection, but which, because of the ineptitude of the artist and the block cutter, provided extremely limited information.[34]

Leonardo's depiction of plant life was equally advanced and prophetic.[35] His work was not in the tradition of the herbals, the purpose of which was to aid in

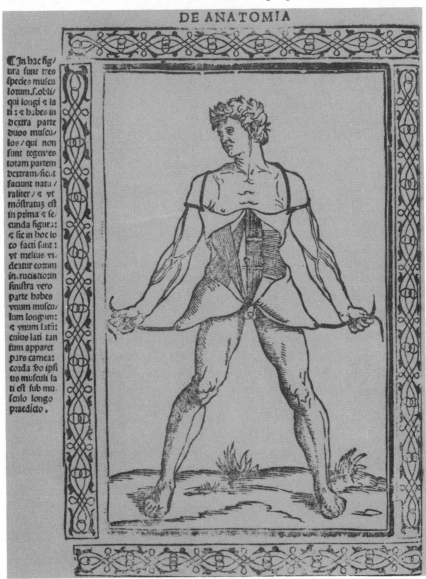

Anatomical Figure, from Berengario da Carpi, *Isagoge Brevis*, Bologna, 1522.

the identification of simples for pharmaceutical use. Most of the drawings, including the best-known and most vital, are simply naturalistic works of art prompted by Leonardo's insatiable curiosity about and desire to record the natural world. Others are the first attempts to initiate a botanical taxonomy. The comparison of the two types (numbers 3 and 4 in Leonardo's series of unknown extent) of swamp reed in a drawing is now at Windsor Castle. The text indicates the height, thickness, locale, and the color of the stalk, the flower, and the seed. In the lower drawing the triangular section of the reed is graphically exaggerated as it would not be in one of the non-scientific draw-

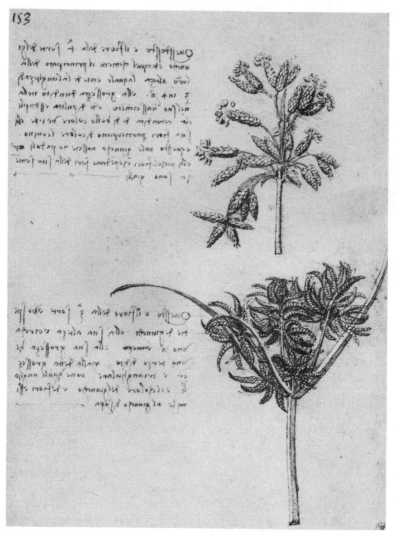

Swamp Reeds. Leonardo da Vinci, Windsor Castle Library, no. 12427. Photo by gracious permission of H. M. the Queen.

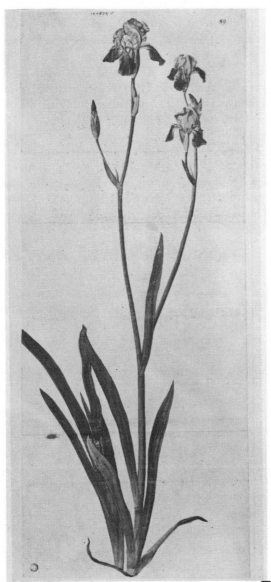

Iris. Albrecht Dürer, Bremen, Kunsthalle, no. 35. Photo: Kunsthalle.

ings. These drawings are distinguished also by the fact that they show specimens taken for study rather than the plant growing in its setting.

Leonardo's contemporary, Albrecht Dürer of Nüremberg, was also wonderfully skillful at reproducing living and growing things. He was trained in the northern tradition of minute observation, but he found it necessary to travel to Italy to learn the principles of the new rationalization of sight.[36] His drawings and watercolors of plants, animals, and even of insects and shellfish cannot be

called scientific in the sense of Leonardo's anatomic and botanical studies; they are much more highly finished equivalents of Leonardo's naturalistic sketches and may have been made for sale. The famous watercolor of an iris, the antecedents of which are Italian rather than northern,[37] was executed on parchment, which itself suggests that it was conceived as a work of art that deserved expensive and permanent material. The technique added the dimension of color to precision of description and launched a tradition of flower pictures that merged with and furthered the evolution of the herbal.

Dürer's principal contribution to the history of scientific illustration was technical. He raised the level of woodcutting craft from the crude ineptitude of earlier illustrations to a refinement close enough to the pen drawings of Leonardo (which could not be reproduced) to permit the illustrator to undertake images of great finesse and complexity. Further, he showed—as no Italian of the time had been able to do—how artists of the first rank could come before

NOMEN HERBAE ASPARAGI AGRESTIS.

Asparagus, from Pseudo-Apuleus, Rome, ca. 1483.

an enormously expanded public by producing book illustrations and large editions of prints in single sheets and in series. But, except in his own illustrated books, particularly the *Vier Bücher von menschlicher Proportion* of 1526, the implications of this achievement were not appreciated until the 1530s.

The earliest instance of a book with illustrations as an essential element in the scientific message is Otto Brunfels's *Herbarum vivae icones* of 1530, discussed in F. D. Hoeniger's essay. The word *vivae* in the title was calculated to underscore the distinction of this volume from predecessors in which the plates had been copied from preceding books. The illustrator was Hans Weiditz, who adopted Dürer's technique and style. We do not know whether the watercolors he made in preparation for the book in 1529[38] were typical of his work or whether he adjusted his art to suit the needs of his client. In either case, Brunfels's publisher made an inspired choice, and the woodcuts such as the one illustrating the Plantain set as high a standard in their field as did the contemporary plates of Vesalius in anatomy. Comparison of the watercolors and the woodcuts underscores the difference between mimetic and didactic imagery. The former seeks to reproduce individual specimens with their idiosyncracies and imperfections, recording a unique encounter of an object and an artist with a specific interest and viewing position. The latter formulates a type, a class of objects (though like the watercolors some of the cuts show damaged leaves); plants are presented so as to reveal their distinctive forms most clearly, by placing flowers and leaves in profile, often flattening them out. The flowers are shown in various stages of maturity. But Weiditz did not sacrifice aesthetic appeal; the design of the plant on the page, the delicate counterpoint of its parts, place these plates among the earliest monuments of the art we now call graphic design. Like the Vesalian illustrations, they were not equaled again in effectiveness or refinement during the sixteenth century, and perhaps never again in the technique of woodcut. (See following page.)

Brunfels's herbal was followed in 1542 by Leonhart Fuchs's *De historia stirpium*, which was illustrated with 512 cuts of even greater fidelity and effectiveness, though with slightly less elegance. Fuchs's awareness of the importance of the image to his enterprise is indicated by his insertion at the close of the text of portraits of his two draftsmen and the block-cutter, and by a preface that includes the first celebration of the didactic power of the image. After promising to follow nature rather than "shades," and to limit the individual desires of the artists, Fuchs writes:

> The woodcutter Veit Rudolf Speckle, by far the best in Strassbourg, has so ably carried out in carving the design of each picture that he seems to compete with the painter for glory and victory. But though the pictures have been prepared with great effort and sweat, we do not know whether in the future they will be damned as useless and of no consequence and whether someone will cite the most insipid authority of Galen that no one who wants to describe plants should try to make pictures of them. But why take up more time? Who would in his right mind condemn pictures which can communicate information much more clearly than the words of even the

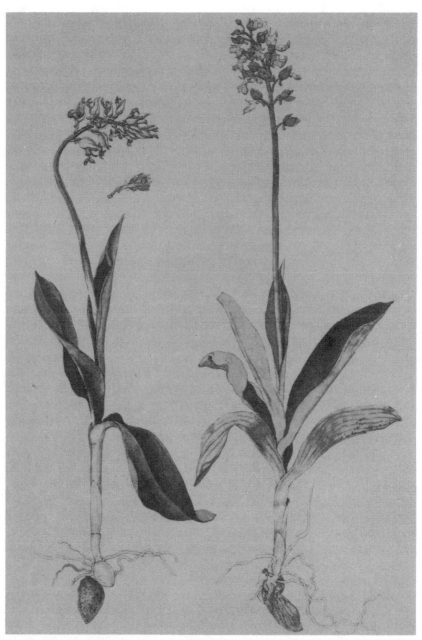

Orchis Militaris; Orchis purpureus Hudson. Hans Weiditz, Bern, Botanisches Institut, Platter coll. Photo: Botanisches Institut.

corum, T O M V s Primus. 23

A

Plantago Maior.

B

Breyter Wegrich.

Plantago major, from Otto Brunfels, *Herbarum Vivae Icones*, Strassburg, 1530. Photo courtesy of "The Wellcome Trustees."

most eloquent men? . . . those things that are presented to the eyes and depicted on panels or paper become fixed more firmly·in the mind than those that are described in bare words. (Pp. x–xi)

In the years between the publications of Brunfels and Fuchs, anatomical illustration overcame the perceptual and conceptual blocks that had limited its usefulness in the first seventy years of the printed book. In 1530–32 several full-page cuts were prepared that were eventually to appear among the sixty-two illustrations in a lavish volume sponsored by the humanist physician

Charles Estienne: *De dissectione partium corporis humani*, printed in Paris in 1545. The publication would have preceded that of Vesalius but was delayed by a legal suit launched in 1539 by Étienne de la Rivière, the surgeon who was responsible for the scientific content of the text, and who designed the skeleton plates and portions of others. At least three artists were involved in the work, and their plates, as is evident from the two reproduced here, vary in character and in scientific utility. The muscle man is more advanced than his predeces-

CORP. HVMANI LIB. I. *103*

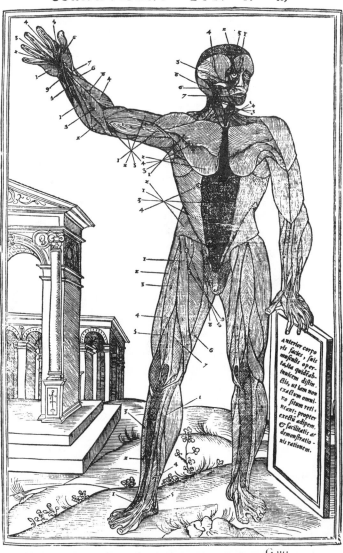

G.iij.

Muscle Man, from Charles Estienne (Carolus Stephanus), *De Dissectione Partium Corporis Humani*, Paris, 1546. Photo courtesy of "The Wellcome Trustees."

sors, but cannot have been especially useful for didactic purposes because of the graphic limitations of the artist.

The figures in this volume, like those of Vesalius, reveal the strong impact of Italian art of the High Renaissance; they often stand in landscapes with classical structures or ruins and strike the dramatic poses of characters in Raphael's frescoes. One series of plates was actually plagiarized from a set of salacious engravings designed by Raphael's associate Perino del Vaga, illustrating the loves of the Gods. The print of Venus and Amor is freely revised, with a surgical razor, knife and pitcher replacing the abandoned weapons. The anatomical study of the abdominal wall was not designed by the artist but by Rivière and was cut on a different block and set into a square hole in the center.[39] This permitted the block of the sleeping beauty to be repeated while her abdomen was progressively uncovered by a series of the small insets. The technique is a very distant ancestor of film animation. Perhaps it was these very illustrations that prompted Sylvius, the greatest French anatomist of the time, to speak of illustrated anatomical works as "sumptuosa quidem sed nullam in rem utilis";[40] he believed that scientific book illustration was a medieval survival and unworthy of the new empirical consciousness (see pp. 118–19).

We do not know whether Sylvius would have said the same for Andrea Vesalius's *Fabrica humani corporis*, printed in Basle in 1543 with over two hundred plates cut in Venice while the author was teaching in Padua.[41] There is no doubt that these illustrations revolutionized anatomical imagery and swept aside the medieval tradition. Perhaps the progress they represented was not so much in the science of anatomy as in the teaching of that science to university students, to literate laymen, and to artists. Their didactic power is of a piece with the title page of the *Fabrica*, which shows the author, in marked contrast to the traditional professor from *Fasciculo di Medicina* (above) at the dissecting table with knife in hand, demonstrating to a large audience what he is uncovering. These plates are close to what the drawings of Leonardo might have looked like had they been translated into woodcuts (see pp. 120–21).

Many of the didactic conventions devised by Leonardo appear again in the Vesalian plates (the Vein man has a direct antecedent in a small sketch by Leonardo, but the device probably was rediscovered). They differ primarily in the degree of simplification imposed by a technique that could not achieve subtle changes of light and texture or minute detail. These limitations give them a force and a clarity that make them memorable.

The artist of the Vesalian illustrations may or may not be Stefan von Calcar, who collaborated with the author in designing the three skeleton plates of the *Tabulae anatomiae sex*, printed for teaching purposes in 1538.[42] Whoever it was had been trained in the High Renaissance style of Rome and Venice—I believe in both places—and yet had a figural style faintly northern in character. Didactic images of this sort are hard to attribute because they are valid to the extent that they minimize individual modes and idiosyncracies. Vesalius must have been involved closely with the planning of every plate, but he could not himself have been the artist. The three plates made after his drawings for the

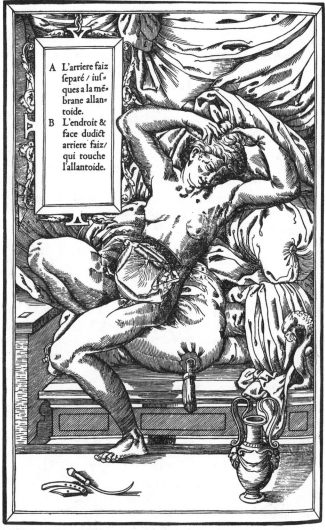

A L'arriere faiz separé / iusques a la mébrane allantoide.
B L'endroit & face dudict arriere faiz/ qui touche l'allantoide.

Anatomical Figure, from Charles Estienne, *De Dissectione Partium Corporis Humani*, **Paris, 1545 ed. (facsimile).**

1538 *Tabulae* show him to have been a strictly amateur draftsman; he also grumbles in the text about the high prices exacted by his artist. The latter brought much from the field of art; the first Vesalian shows the Raphaelesque pose and proportion referred to above. The second, like several other torso plates, is presented as an antique sculptural fragment that can be identified as the *Belvedere Torso* that had been on exhibit in the Belvedere court of the Vatican Palace since the second decade of the century and was Michelangelo's favorite.

Venus and Amor. Giovanni Jacopo Caraglio, engraving, 1527. Photo: Rome Gabinetto Fotografico Nazionale.

The exceptional marriage in the *Fabrica* between science and imaginative imagery did not, of course, assure accuracy. In many places the cuts convey incorrect Galenic tradition (the same is true of the text) and, by their very

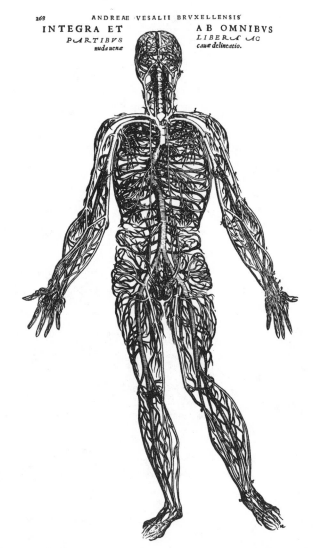

Anatomical Figure, from Andreas Vesalius, *Humani Corporis Fabrica*, Basle, 1543.

vividness, reinforced old errors. But they laid the groundwork for progress by establishing a model that could be improved step by step as each error or omission was discovered by practicing anatomists.

Unfortunately, the model was at first such a tempting source that many later sixteenth-century anatomy books were illustrated by copies of the Vesalian plates and copies of the copies until they lost validity. The same occurred in herbal publication: the high artistic level of Weiditz's and Speckle's work was not achieved again in the following decades of the century, though Konrad Gesner, the first important scientist who was also a proficient draftsman, made

renis *subſtantia ſeptum illud conſtituens,cultello orbiculatim adempta ſit,neque aliter ſane ſep-*
ti illius figuram ob oculos ponere licuit . Conſpicitur hic itaq; ſecundus renis ſinus uniuerſus , at
non quemadmodum eſt bipartitus,eo quod ſeptum abſtulerim ſinum hunc in exteriori ipſius late
re dirimentem.α igitur & β & γ & λ eadem hic quæ in prima tabella notant . Circulus autem
β. *inter α & β ductus,ſecundum renis indicat ſinum.θ uero anteriorem partem primi ſinus,ſeu mem*
ι *branei corporis,qua hæc in ramos diſcinditur. ι corporis membranei poſteriorem partem indi-*
κ. *cat . adeo ut θ & ι ſimul membraneum notent corpus,ſeu primū renis ſinum:κ autem urinarij mea*
tus inſignitur origo. Tertia tabella primi ſinus ſeu membranei corporis ra
mos omnes inſinuat.renis enim ſubſtantia,quæ ſummis eius ſinus ramis adnaſcitur,penitus deraſa
eſt.Atq; hæc citra characterum operam ſunt obuia.

VIGESIMASECVNDA QVINTI LIBRI FIGVRA·

VIG B·

Anatomical Figure, from Andreas Vesalius, *Humani Corporis Fabrica,* **Basle, 1543.**

drawings that contained more precise and complete information.

Observing the evolution of scientific illustration in these two fields, we can see how differently it behaved from the evolution of the "high" art that nourished it. It did not develop in the measured and cumulative way that Leonardo's and Dürer's painting emerged from preceding art, but rather burst suddenly into maturity after generations of experiments that remained ineffectual long after the means for improvement were at hand. Then, having achieved an apex in the 1530s and 1540s, the quality of illustration declined somewhat to a plateau on which it remained until fresh challenges such as the need to

document microscopic studies in the seventeenth century stimulated another peak.[43] The decline was due to the retirement of distinguished artists from the field once the challenging problems of presentation had been resolved, leaving illustration to poorly paid craftsmen who lacked the capacity for imaginative innovation and often even the capacity to copy accurately. But the design quality of Renaissance illustration was not overshadowed by later centuries. After the Renaissance, artists of the first rank rarely became involved in science because its significant discoveries were not based primarily on visual induction. Artists and scientists no longer shared a common language.[44]

Architecture

Architecture was less closely bound to scientific tradition and innovation than the figural arts. No significant technological development is associated with Renaissance architecture, as is concrete vaulting with Roman architecture or the rib and the flying buttress with Gothic. But two major concerns of Renaissance architects were analogous to the parascientific researches of painters: the rationalization of proportion, and the refinement of techniques of representation.

A significant innovation of Renaissance architectural theory was the effort to systematize proportional systems guiding relationships of width, height, and depth of the parts of buildings and of the parts to the whole. This interest, which paralleled the effort of figural artists to fix rules for relating the parts of the human body, derived in part from the belief that the universe itself functioned according to a mathematically determinable harmony. The belief was furthered by the discovery that when musical consonances are translated into spatial ratios (by taking the lengths of the organ pipes or lute strings which sound their constituent notes), the resultant spaces are as agreeable to the eye as the consonances are to the ear.[45] In this way the harmony that, as Professor Crombie points out in his essay, played a central part in the philosophy of the humanists could be made sensible. But the mathematics of humanist music and architecture had little to do with scientific progress. They involved geometrical and arithmetic functions known in the fourteenth century, and no new discovery in pure mathematics resulted from artistic theory.

Architecture, like the figural arts, may be imitative, and the evolution of Renaissance architecture was furthered by advances in the capacity to describe the outer world accurately and systematically. The world in this case was not that of nature but—as dictated by the ambitions of humanism—of ancient architecture. As in the figural arts, early efforts to imitate and to represent were symbolic rather than literal. The buildings of Brunelleschi, Michelozzo, and Alberti (and still more of their colleagues in Venice, Rome, and elsewhere) employed the ancient orders and ornament without concern for the rules by which ancient buildings had been designed, combining with them—as did contemporary anatomic illustrators—fantasy and medieval tradition. But architects in the early sixteenth century began to approach the surviving ruins

with the nascent analytic and taxonomic method of the descriptive sciences and, like the scientific illustrators, evolved new and more effective formulas for recording their findings in images.

The chief graphic innovation was orthogonal projection, a method of repre-

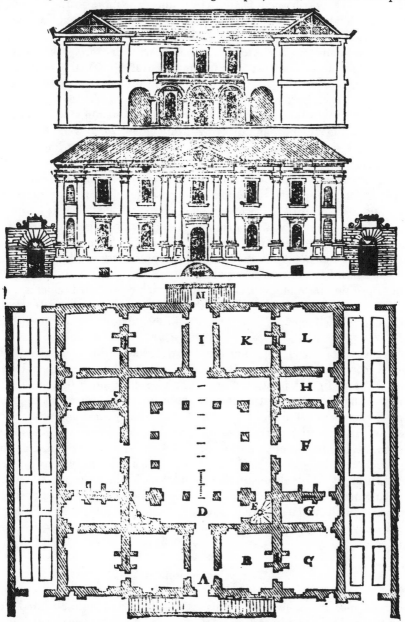

"The Seventeenth House Outside the City," from Sebastiano Serlio, *Settimo libro dell'architettura*, Venice, 1584.

senting the interior and exterior elevations of buildings as one would a plan, not in perspective as seen by an observer standing at one point, but laid out flat in consistent scale, so that every measurement and relationship of parts to each other and to the whole may appear on the drawing as on the building itself, only reduced by a consistent factor. The result was a more abstract image, but one that could be translated directly from the drawing into the actual building, or vice versa. This had not been possible with earlier perspective drawings in which measurements are affected by the position and distance of the observer.[46] Orthographic projection gave a great stimulus to the production of illustrated books on architecture in which designers could present models for others to follow. The work of Sebastiano Serlio, published between 1537 and 1575, at the time of the first functional illustrated herbals and anatomic works of Brunfels, Fuchs, and Vesalius, and that of Palladio (1556, 1570) were, by virtue of their images, the principal vehicles for the dissemination of the Italian Renaissance style throughout the world.[47]

Orthogonal projection, combined with newly developed surveying techniques adapted from navigation, also made possible the representation of cities and regions in terms of flat (ichnographic) plans to scale.[48] The new type, the first instance of which was the plan of Imola drawn by Leonardo da Vinci in 1510, was far more functional (especially as a tool for urban planning and fortification) than the bird's eye perspective representations (the best of which were also based on accurate surveys) that appeared in profusion after the diffusion of printing technology. But the latter, which represented buildings, hills, and harbors as if actually viewed from the air, appealed far more to Renaissance taste, and few ichnographic plans were published before the seventeenth century.

Because a command of proportional systems and of imitation were fundamental accomplishments for the Renaissance style, architects emerged from the workshops of figural artists and were not specially trained for building.[49] It followed that Renaissance designers would make few contributions to the history of engineering and building technology.[50] The greatest technical achievement of the fifteenth and sixteenth centuries, the construction of the dome of Florence Cathedral without scaffolding and with the aid of a number of hoisting machines newly invented by the architect Brunelleschi, was as much the culmination of medieval construction technology as the form of the dome was the culminating expression of Italian Gothic design.[51] Characteristically, Brunelleschi's machines did not generate a new technological evolution; instead, they continued to appear unchanged in books on building for a century.[52]

Conclusion

Renaissance artists invented means of visually describing the natural world precisely and measurably and found ways of vividly presenting their evidence to a huge public for didactic purposes. But these achievements, though valu-

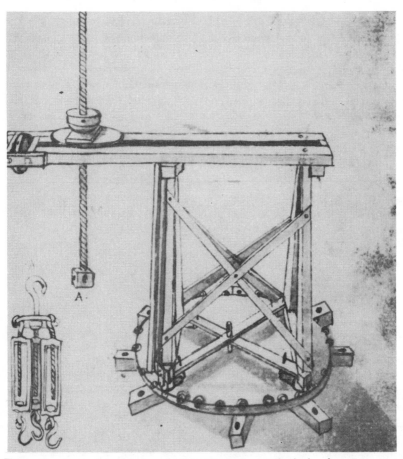

Brunelleschi, Hoist for the Lantern of Florence Cathedral, after Buonaccorso Ghiberti, *Zibaldone* (Florence, B. N., BR 228, fol. 104). Photo courtesy of Gustina Scagliae.

able, were not essential to the evolution of modern science. Essential was the perceptual attitude on which they were based—an attitude of respect for empirical observation and a will to devise systematic and repeatable techniques for recording the results of observation. Empiricism is relative because perception is inevitably colored by interests. Renaissance artists did not find ways to avoid this rule but they did cast off the authority of a tradition that had given the written word precedence over the experience of the senses. This was due in part to their social and educational disadvantages. The scientific tradition was passed on by manuscripts and books written in Latin and Greek, and reached artists at second hand, if at all. The social structure that gave scholastic and humanist scholars an honored position in their communities made it harder and riskier for them than for artists and technicians to break through the perceptual

and ideological barriers that preserved a traditional world view.

Furthermore, in an age when the highest ambition of cultivated men was to emulate the achievements of the ancients, the will to progress, an essential ingredient of the modern scientific attitude, was inhibited. The visual arts, however, were an exception—though they were equally committed to reviving antiquity—because of the irrepressible pride of artists and their public in presenting a convincing three-dimensional world in pictures and sculptures. If, as in the formulation of Giorgio Vasari, the evolution of modern art could be seen as one of steady progress from Giotto to Michelangelo, then the restraints on the concept of scientific progress—imposed by the authority of Aristotle, Galen, Ptolemy, and other idolized ancients—could be overcome.

The chief contribution of artists to Renaissance science was the realization of a new perception of the natural world and of the individual's relation to it, and of new ways of communicating that perception.

NOTES

1. For the relationship of humanism to scholasticism, see esp. P. O. Kristeller, "Humanism and Scholasticism," *Studies in Renaissance Thought and Letters* (Rome, 1966), 553–83; idem, *Renaissance Thought: the Classic, Scholastic and Humanist Strains* (New York, 1961)—both collections of earlier articles; idem, "The Impact of Early Italian Humanism on Thought and Learning," *Development in the Early Renaissance*, ed. B. S. Levy (Albany, 1972), 120–57; Charles Trinkaus, "Humanism," *Encyclopaedia of World Art*, vol. 7 (1963), 702–43; M. Baxandall, *Giotto and the Orators* (Oxford, 1971), pt. 1; R. Weiss, *The Dawn of of Humanism in Italy* (London, 1947); E. Garin, *L'umanesimo italiano* (Bari, 1952).

2. On the relationship of Leonardo and other artists to scientific investigation, see G. di Santillana, "The Role of Art in the Scientific Renaissance," *Critical Problems in the History of Science*, ed. M. Clagett (Madison, 1959), 33–66; E. Panofsky, "Artist, Scientist, Genius: Notes on the 'Renaissance-Dämmerung'," *The Renaissance, Six Essays*, ed. W. Ferguson (New York, 1962), 121–82; V. Zubov, *Leonardo da Vinci* (Cambridge, Mass., 1968); and the papers of J. Ackerman, E. H. Gombrich, and K. Keele in *Leonardo's Legacy*, ed. C. O'Malley (Berkeley and Los Angeles, 1969); Martin Kemp, *Leonardo da Vinci: The Marvellous Works of Nature and Man* (Cambridge, Mass., 1981).

3. Leonardo da Vinci, *Treatise on Painting (Codex Urbinas Latinus 1270)*, trans. and ed. A. P. McMahon, 2 vols. (Princeton, 1956), no. 1 (cf. other statements by Leonardo on the relation of painting to science in J. P. Richter, *The Literary Works of Leonardo da Vinci* [London, 1883], nos. 1–8). The opening paragraph was inspired by Alberti, *De pictura* (cf. *Opere volgari*, 2, [Bari, 1973], no. 1). Writing in 1435, Alberti did not refer to painting as a science, but undertook "to explain painting from the basic principles of nature." He also started with Euclidean distinctions.

Leonardo's *Trattato* was never written as such but was compiled from his notebooks by his chief assistant, Francesco Melzi, who inherited the books. Its history can be found in the Introduction by L. H. Heydenreich of the edition cited above, and in C. Pedretti, *L. d. V. on Painting, a Lost Book* (Berkeley-Los Angeles, 1964).

4. Leonardo himself says that he was looked down on as an "omo sanza lettere" by educated contemporaries: "I know well that because I am not literate [e.g., in Latin] it has seemed justified to a certain individual to reprove me by claiming that I am a man without letters. Stupid crowd! . . . They try to say that because I do not have letters I cannot expressly properly what I have to say. But these people do not know that my things are drawn from experience rather than from any word, and [experience] has been the mistress of whoever has written well; therefore I take her for a

mistress and will claim the same in every case" (G. Fumagalli, *Leonardo "omo sanza lettere"* [Florence, 1938], 38 from cod. Atl. 119r a).

5. Fig. 2 was interpreted in this way by Erwin Panofsky, "Artist, Scientist, Genius"; a passage from John of Arezzo, *De procuratione cordis*, 1, 110, addressed to Piero de' Medici, father of Lorenzo, complements the illustration: "For in these matters I would not presume to advance anything of my own; since the richest treasures have been found rather by the opinion of the ancients than by reason, it is better for anyone to acquiesce rather than to attempt something new." (Lynn Thorndike, *Science and Thought in the Fifteenth Century* [New York, 1928], 109–22).

6. Pierre Duhem, in his pioneering *Etudes sur Léonard de Vinci* (Paris, 1906–13; reissued 1955) was the first to show that Leonardo's concepts of the physical sciences were based on readings in the treatises of the fourteenth-century Paris school, particularly Albert of Saxony, Buridanus, and Oresme; subsequent research has shown that Oxford science of the fourteenth century was equally important. Much of Léonardo's knowledge of these sources may have come from handbooks. Cf. G. di Santillana, "Léonard et ceux qu'il n'a pas lus," *Leonard de Vinci et l'expérience scientifique au XVIe siècle* (Paris, 1953), 43–59; J. H. Randall, *The School of Padua and the Emergence of Modern Science* (Padua, 1961), 117–38; E. Garin, "Il problema delle fonti del pensiero di Leonardo," *La cultura filosofica del Rinascimento* (Florence, 1961), 388–401.

7. Randall, *School of Padua*, showed that the basic concern of the scientists at Padua, the foremost center of scientific education in the Renaissance, was not experiment but methodology. The characteristically Aristotelian/scholastic question debated for over a century was whether to investigate causes through effects (induction) or effects through causes (deduction).

8. See Paolo Rossi, "Arti mecchaniche e filosofia nel secolo XVI," *I filosofi e le macchine* (Milan, 1962), 26ff; E. Zilsel, "The Sociological Roots of Science," *American Journal of Sociology* 47 (1942): 542–52.

9. On *De pictura*, see C. Grayson, "The Text of Alberti's *de pictura*," *Italian Studies* 23 (1978): 71–92; M. Simonelli, "On Alberti's Treatises on Art and their Chronological Relationship," *Yearbook of Italian Studies* (1971), 75–102.

10. See James Ackerman, "Alberti's Light," *Studies in Late Medieval and Renaissance Painting in Honor of Millard Meiss* (New York, 1978), 1–27.

11. Relevant reviews of ancient and medieval optics may be found in G. F. Vescovini, *Studi sulla prospettiva medievale* (Turin, 1965); A. C. Crombie, "The Mechanistic Hypothesis and the Scientific Study of Vision," *Historical Aspects of Microscopy*, ed. S. Bradbury (Cambridge, 1967), 3–112; S. Y. Edgerton, *The Renaissance Rediscovery of Linear Perspective* (New York, 1975), 64–90; (see the critique of M. Kemp, "Science, Non-science and Nonsense: the Interpretation of Brunelleschi's Perspective," *Art History*, vol. 1 [1978], 134–61); D. C. Lindberg, *Theories of Vision from Al-Kindi to Kepler* (Chicago, 1976); and James Ackerman, "Leonardo's Eye," *Journal of the Warburg and Courtauld Institutes* 41 (1978): 108–46, esp. pt. 2.

12. Alhazen, in *Opticae Thesaurus* (Basel, 1572), bk. 1, chap. 18, p. 10: "not only perpendicular to the surface of the thing seen but perpendicular to the surface of the glacial humor." The hypothesis was widely diffused outside scientific circles. Prof. Edgerton (*The Renaissance Rediscovery of Linear Perspective*, 85) quotes a restatement of it by Dante in the *Convivio*, 2:10.

13. "Della pittura/De Pictura," 1, section 8, *Opere Volgare*, ed. C. Grayson (Bari, 1973), 20–23.

14. Ibid., 1, section 19, 36–37. The Albertian system is explained by Edgerton, *The Renaissance Rediscovery of Linear Perspective*, 40–49.

15. Ibid., 124–42; R. Krautheimer and Trude Krautheimer-Hess, *Lorenzo Ghiberti* (Princeton, 1956), 229–53, and many other interpretations of the description of Brunelleschi's perspective panels in Antonio di Tuccio Manetti's *Life* of the artist (see the edition of H. Saalman [University Park, Md., 1970], 43–47).

16. Edgerton, *The Renaissance Rediscovery of Linear Perspective*, 106–23.

17. Ackerman, "Alberti's Light," 6ff. See 10n.

18. Piero della Francesca, *De prospettiva pingendi*, ed. G. Nicco Fasola (Florence, 1942). One of Piero's major innovations was the exposition of methods of foreshortening which had not previously been treated by theorists.

19. James Ackerman, "On Early Renaissance Color Theory and Practice," *Studies in Italian Art*

History, vol. 1 (Rome, American Academy, 1980), 11–40.

20. Idem, "Leonardo's Eye," passim.

21. G. di Santillana, "Role of Art" passim; E. Panofsky, "Artist, Scientist, Genius," passim.

22. O. Pächt, "Early Italian Nature Studies and the Early Calendar Landscape," *Journal of the Warburg and Courtauld Institutes* 13 (1950): 13–47.

23. L. Febvre and H. J. Martin, *L'apparition du livre* (Paris, 1959); E. Eisenstein, *The Printing Press as an Agent of Change,* 2 vols. (Cambridge, 1979), esp. 2, section 5, 453–520.

24. The early evolution of the printed image was brilliantly discussed by William Ivins, *Prints and Visual Communication* (Cambridge, Mass., 1953), esp. chaps. 1–2. It was this study that first attracted me to the subject of Renaissance art and science.

25. The naturalist tendency of late medieval art and illustration never came into contact with scientific literature. It originated in an aristocratic court environment far from the universities.

26. As the printing industry became established and economically profitable, the pirating of books prompted careless copying of texts and illustrations with the degenerating effects that medieval copying had suffered.

27. The one exception is in the literary work of Albrecht Dürer, who was not only the most influential pioneer in the art and technique of book illustration but, late in life, the first to publish didactic treatises in which the illustrations were as important as the words: *Underweysung der Messung . . .* (Nuremberg, 1525); *Etliche Underricht von Befestigung des Stett, Schloss und Flecken* (Nuremberg, 1527); *Vier Bücher von menschlicher Proportion* (Nuremberg, 1528 [posthumous]).

28. K. Sudhoff, *Fasciculo de Medicina, Venice, 1493,* ed. and trans. Charles Singer (Florence, 1925). On the "Zodiac man," see F. Saxl, "Microcosm and Macrocosm in Medieval Pictures," *Lectures* (London, 1957); H. Bober, "The zodiacal Miniature of the Très Riches Heures of the Duke of Berry," *Journal of the Warburg and Courtauld Institutes* 11 (1948): 1–34.

29. L. Treviranus, *Die Anwendung des Holzschnittes zur Bilddarstellung von Pflanzen* (Leipzig, 1855); W. S. Schreiber, *Die Kräuterbücher des XV And XVI Jahrhunderts* (Munich, 1924); A. Arber, *Herbals, Their Origin and Evolution* (Cambridge, 1938); Carl Nissen, *Die botanische Buchillustration: ihre Geschichte und Bibliographie* (Stuttgart, 1966).

30. Rewich was also the artist who accompanied Bernard von Breydenbach in order to record in woodcuts the unprecedented exploration voyage reported in *Peregrinationes in Terram Sanctam* (Mainz, Schöffer, 1486). Breydenbach also worked as editor on the *Gart* (G. Künze, *Geschichte der Buchillustration in Deutschland,* 2 vols. [Leipzig, 1975], 327).

31. K. Clark and C. Pedretti, *The Drawings of Leonardo da Vinci at Windsor Castle,* 2 ed., 3 vols. (London, 1969), no. 10957. The upper half of the sheet was copied in 1645 by the engraver W. Hollar; this is one of the few demonstrations that some of Leonardo's scientific drawings were accessible after his death. Dürer also copied an anatomical study. On the anatomical drawings see also, S. Braunfels-Esche, *Leonardo da Vinci: das anatomische Werk* (Stuttgart, n.d. [1961]); P. Huard, "Die anatomischen Texte und Zeichnungen des L. d. V.," *Frühe Anatomie* (1967), 228ff.; see now the splendidly published facsimile edition of the anatomical corpus, with new evidence on dating and a complete transcription and commentary: Leonardo da Vinci, *Corpus of the Anatomical Studies in the Collection of Her Majesty the Queen at Windsor Castle,* ed. K. Keele and C. Pedretti, 3 vols. (London and New York, 1980).

32. Martin Kemp, "Il concetto dell'anima' in Leonardo's Early Skull Studies," *Journal of the Warburg and Courtauld Institutes* 34 (1971): esp. 126ff. For comparable cases of the influence of tradition on observation in Leonardo's anatomy, see idem, "Dissection and Divinity in L.'s Late Anatomies," ibid. 35 (1972): 200–225; K. D. Keele, *Leonardo da Vinci on the Movement of the Heart and Blood* (Philadelphia, London, and Montreal, 1952.)

33. See Windsor Castle nos. 12281, 12624, 19005 (transparent figures); 19007 (exploded figure); 19127 (wax models) in Clark and Pedretti, *Drawings of Leonardo;* and C. Saunders and C. O'Malley, *L. d. V. on the Human Body* (New York, 1952). Cf. R. Herrlinger, "Die didaktische Originalität in L.'s anatomischen Zeichnungen," *Medizinische Monatsschrift,* 3 Mar. 1966, 118–27.

34. The figure seen alone looks more inept than it does in its place within the accompanying series of six that show successive layers revealed by the dissection.

35. G. B. de Toni, *Le piante e gli animali di Leonardo da Vinci* (Bologna, 1922); A. Baldacci, "La Botanica vinciana," in vv. aa., *Leonardo da Vinci,* Ist. Geografico de Agostini (Novara, 1939),

449–54; R. Corti, "Intuizioni di biologia e di ecologia vegetale . . . di L. da V.," *Studi Vinciani,* 2 (Florence, 1954).

36. For Dürer's Italian voyages, see E. Panofsky, *The Life and Works of Albrecht Dürer* (Princeton, 1945), 32ff., 37, 116ff. The principle of isolating a natural object for study and representing it in an ambient light is Italian rather than northern. Similar flower drawings were done by Pisanello, the most influential naturalist contributor to the art of Leonardo and Dürer.

37. For a review of Renaissance anatomical illustration, see R. Herrlinger, *Geschichte der medizinischen Abbildung,* vol. 1 (Munich, 1967; [English ed., London, 1970]).

38. W. Rytz, *Pflanzenaquarelle des Hans Weiditz aus dem Jahre 1529* (Bern, 1936).

39. Discovered by C. E. Kellett, "Perino del Vaga et les illustrations pour l'anatomie d'Estienne," *Aesculape,* 37 (1955), 74–89; idem, "A Note on Rosso and the Illustrations to Charles Estienne's *De Dissectione," Journal of the History of Medicine* 12 (1957): 325–36.

40. Kellett, "Perino del Vaga," 75.

41. The Vesalius literature is huge; the most valuable recent work is C. O'Malley, *Andreas Vesalius of Brussels, 1514–1564* (Berkeley and Los Angeles, 1964).

42. William Ivins, in *Three Vesalian Essays,* ed. S. W. Lambert (New York, 1952).

43. H. Lehmann-Haupt, "The Microscope and the Book," *Festschrift für Claus Nissen* (Wiesbaden, 1973), 471–502.

44. J. Ackerman, "The Visual Arts," *Seventeenth Century Science and the Arts,* ed. H. Rhys (Princeton, 1961).

45. For the relationship of Renaissance proportion systems to contemporary musical theory, see Rudolf Wittkower, *Architectural Principles in the Age of Humanism* (London, 1949 [and many later editions]), pt. 4.

46. On the development of drawing techniques, see Wolfgang Lotz, "the Rendering of the Interior in Architectural Drawings of the Renaissance," *Studies in Italian Renaissance Architecture* (Cambridge, Mass., 1977), 1–65 (originally published in German in *Mittheilungen des Kunsthistorischen Instituts in Florenz,* 7 [1956], 193–226).

47. The first book of *Tutte le opere dell'architettura* by the Bolognese architect Sebastiano Serlio was printed in Venice in 1537 and other books followed in 1540, 1545, 1547, 1551, and 1575. Andrea Palladio was the illustrator of Daniele Barbaro's commentary and translation of the ten books of the Roman architectural writer Vitruvius (Venice, 1556), and in 1570 he published his *Quattro libri dell'architettura,* the most influential architectural book of all time. Earlier illustrated Vitruvius editions of 1511 and 1521 (see the reference to the latter by Prof. Crombie) did not observe the sophisticated archeological criteria of these authors. All of these works are discussed in Julius Schlosser, *La letteratura artistica,* 2d rev. ed. (Florence, 1956), 251f., 414, 418f., the standard guide to pre-nineteenth-century writings on art theory.

48. See John Pinto, "Origins and Development of the Ichnographic City Plan," *Journal of the Society of Architectural Historians* 35 (1976): 35–50 (the plan of Imola appears as fig. 1), which includes a discussion of surveying techniques and instruments.

49. James Ackerman, "Architectural Practice in the Italian Renaissance," ibid. 13 (1954): 3–11.

50. One of the greatest of all Renaissance architects, Donato Bramante, the designer of St. Peter's in the Vatican, consistently built unsound structures that threatened to collapse shortly after his death (see my "Notes on Bramante's Bad Reputation," *Studi Bramanteschi* [Rome, 1974], 339–49).

51. On the dome, see the recent works of E. Battisti, *Filippo Brunelleschi* (Milan, 1976), 114–71 with bibliography, 360; and Rowland Mainstone, "Brunelleschi's Dome," *The Architectural Review* 162 (Sept. 1977): 156–66. Also P. Sanpaolesi, "Ipotesi sulle conoscenze matematiche, statiche e mecchaniche del Brunelleschi," *Belle Arti,* 2 (1951), 25–54, a revised version of which is forthcoming in the Acts of the Brunelleschi conference held in Florence in 1977.

52. On Brunelleschi's machines and their aftermath, see G. Scaglia, "Drawings of Brunelleschi's Mechanical Inventions for the Construction of the Cupola," *Marsyas,* 10 (1961): 45–68; F. Prager and G. Scaglia, *Brunelleschi: Studies of His Technology and Inventions* (Cambridge, Mass., 1970), esp. 65–107; Mariano Taccola, *De Machinis: the Engineering Treatise of 1449,* ed. G. Scaglia, 2 vols. (Wiesbaden, 1971).

How Plants and Animals Were Studied in the Mid-Sixteenth Century

F. David Hoeniger
University of Toronto

When one thinks of sixteenth- and early seventeenth-century science, one usually does not think of botany and zoology at all; one thinks of developments in mathematics, physics, astronomy, anatomy, and physiology. Thus the whole field which forms the subject of this essay has been rarely studied.[1] It is not that we are unfamiliar with the herbals and animal books of the time. Most of us have gazed admiringly at their woodcuts in exhibition cases, but even among scholars there are few who have felt the urge to read them. Rather, these books have become rare objets d'art, avidly collected by the few who can afford them. Many of them include illustrations of remarkable realism and beauty by skillful artists, and there are indications that their original publishers counted on their pictorial appeal. Aware of how much potential buyers would be attracted by them, they sometimes issued the pictures separately, as *Icones.* The authors surely must have had mixed feelings about such an emphasis on the pictures at the expense of the text whose descriptions they were meant further to clarify. Even in Vesalius's famous *De Fabrica* of 1543, one year after Leonhart Fuchs's herbal, the sheer splendor of the illustrations may distract readers from the text. Still, both Fuchs and Vesalius took care in relating the illustrations closely to their writing. In Otto Brunfels's herbal of 1530, the very first such work[2] marked by illustrations of astonishing lifelikeness, one has reason to wonder how much the author was in control of the book. The artist, the famous Hans Weiditz, a student of Dürer, had been hired by Schott, the Strassbourg publisher. Brunfels complained that he could not even organize the plants in the book as he had planned, because he depended on the step-by-step progress in the preparation of drawings and wood-

cuts.[3] Later, Brunfels expressed his concern to his friend Schenckbecher that more attention was being paid to the "dead lines" of the illustration than to his writing. Great artist as Weiditz was, he could hardly have pleased Brunfels when several times he drew withered or damaged specimens.[4] (See p. 134.) Still, the work became deservedly famous and influential because of the amazingly realistic detail in Weiditz's pictures, while there is little that is fresh or original about Brunfels's botanical descriptions. It is Hans Weiditz's rather than Brunfels's herbal. Leonhart Fuchs, in 1542, knew better, hired artists himself, and instructed them exactly how and where to draw.[5] In the 1550s and 1560s, Konrad Gesner knew still better, as did his publisher, Froschauer of Zurich. He not merely hired artists but also trained himself in drawing and watercoloring. The period from 1522 on[6] witnessed a startling development in the scientific, artistic book, notably in anatomy, botany, and zoology. These works reflect the new interests of both authors and publishers, who were able to utilize new techniques. In the medical books before 1520, in the various versions of the *Hortus Sanitatis*, and in *The Grete Herbal* of 1526 and 1529, the quality of the illustrations and their ability to illuminate content had been miserably poor. The new knowledge was communicated with the help of a new art, and that development is most clearly exhibited in the life sciences.

There are two basic reasons why historians of science seldom encourage us to study Konrad Gesner and his fellows. The first is that they appear to have contributed little to the scientific revolution of the seventeenth century. Biology and geology became revolutionary only in the nineteenth, the age of Lyell and Darwin. The revolution in the late Renaissance arose from developments in mathematics, physics, astronomy, and physiology. Botany and zoology were affected much less than the other sciences by mathematical theory and practice. They depend little on numbers, measurements, or calculations. Further, no pope or inquisitor, no Calvin or Puritan, as far as I know, wished any student of plants or animals to be silenced, or any of his books to be destroyed or censored. If some of the new botanists experienced difficulties, they did so not on account of their botany but because of their religious views. William Turner wrote rather extreme religious tracts and became a Marian refugee. But when he and other botanists attacked the ignorance of practicing physicians of their time, they received much support, as learned men who respected Galen and whose medical drugs, newly tested by them, often helped their patients. No botanist or zoologist acted like Paracelsus or Galileo or even Servetus. Botanizing and the study of birds or fish are quiet, harmless occupations that keep men away from bonfires or meetings of protest. When these men discovered that certain cherished beliefs, even some attested by high religious authorities, rest on no foundation—that, for instance, barnacle geese do not propagate by spontaneous generation but mate off the coast of Greenland;[7] that no unique phoenix lives in Arabia and builds its funeral pyre at Heliopolis, but many phoenixes or paradise birds live in Indonesia[8]—they did not then proclaim these discoveries in a polemic spirit. When they came to realize more and more how much of animal creation had not been known to Aristotle, the revered

De Nenufare.

Water-Lily, *Grete Herbal*, 1526.

classical authority on zoology, and that Aristotle sometimes was mistaken about the nature and behavior of certain species[9], they pointed this out respectfully and quietly. So quietly, indeed, that several generations later, Sir Thomas Browne still felt the need to write a book on *Vulgar Errors*, which in spite of its title was directed at his learned contemporaries. By then, vulgar errors in zoology and medicine had been a subject for over a century.[10] The sixteenth-century students of plants and animals regarded themselves as reformers, not revolutionaries. If we therefore ignore or only depreciate them, our understanding of developments of science in the Renaissance will be incomplete, perhaps even mistaken. For what these men did was remarkably new, very much in the late Renaissance spirit, and essential to scientific progress.[11]

Yet we are often told that these men were not serious biologists at all, that the terms "botanist" or "zoologist" are inappropriate for them, that they were naturalists. A biologist's task is to examine the basic nature of life and to discover more about how the diversity of life is organized and interrelated in the kingdoms of plants and animals. We are told that these writers seldom investigated

Kuchenschell.

Kuchenschell/nennen etlich alte kräutlerin Hackerkraut/vnnd sagen da
bey/das es gewaltige krafft hab wunden zů heylen. Weiters ist mir nit zů wiss=
en/wie sein nam im Dioscoride sey.

Pasque Flower, Weiditz in Brunfels's herbal, 1530–31.

such matters systematically. For instance, they contributed only sporadically
to taxonomy. Pierre Belon did provide a few juxtapositions in comparative
anatomy, including his famous comparison of a skeleton of a bird and one of
man (see p. 136),[12] but he ought to have developed this much further. Gesner
named his enormous work on animals *Historia Animalium*, after Aristotle, but
he did not organize it in Aristotelian fashion; Gesner divided the animals into
Aristotle's large classes but then listed them alphabetically. Konrad Gesner and
Pierre Belon, it is true, contributed many data based on direct observation in
the field, discovered many new species, and even dissected in their simple labs.

Burdock (withered), Weiditz in Brunfels's herbal.

But all that does not make them biologists; it makes them students of natural history, the Roger Tory Petersons of the sixteenth century.

There are other reasons why, until quite recent times, historians of science tended to slight the attitudes and contributions of sixteenth-century writers on flora and fauna. The herbals continue to emphasize preponderantly the medical virtues of plants. Naive credence is still being given to some fantastical lore. Gesner was, above all, a humanist rather than a zoologist; his books on animals are encyclopedic, more like Pliny's *History* than Aristotle's, cluttered up with all sorts of philological, literary, and moral material. The books by Pierre Belon, Rondelet, Fuchs, Bock, William Turner, and others seem better and more useful because they are more concise. The very fact that these men researched a more limited area—only birds and fish or only plants—made for better results. But that is a modern view which began at the time of the Royal Society. Gesner's grammar, philology, and hieroglyphics then became irrele-

vant to the discipline of zoology,[13] and pure botany was separated from pharmacology.

Such a separation of disciplines was contrary to the whole outlook of the Renaissance and still the sixteenth century. And much in these writers' work that today may strike us as backward was part of what they considered essential to a meaningful study of living nature. Further, as historians of science, it behooves us to imagine the enormous difficulties which sixteenth-century naturalists faced. A scientist today begins with the recent literature on his subject. They could not. Their work was chiefly new because for many centuries before them, hardly anyone had studied plants and animals widely in the field. Nor indeed had anyone studied as comprehensively as they did the ancient writers on the subject. The sixteenth-century naturalists had virtually no predecessors.

When Guillaume Rondelet, a medical professor at Montpellier, set out to study marine life on the French coast around 1550, he was the first ever to do so energetically. When Gesner, after learning about all the plants and animals in Switzerland, both in the valleys and quite high up in the Alps, attempted to learn also about plants and animals in Poland or England from correspondents, he was the first to do so. As a consequence, these men discovered an enormous number of species, and indeed, many hitherto undescribed genera. At the same time, they studied many ancient authors, a task difficult enough in itself. It would seem fantastic to expect them to concentrate on improving Aristotle's system of animal classification or even to attempt to devise a sound system of botanical taxonomy for which the ancients provided little guidance. As I will indicate later, Gesner and others were indeed interested in morphology, structure, and classification, but first things had to come first. First there had to be some order in the very names given to plants and animals, some standard international and therefore Latin name, and some standard vernacular name for local recognition and use. Then all the species referred to by the ancients needed reliable identification and a full description, much clearer than some in Aristotle or Dioscorides. Such description involved clear separation of related species, and as hundreds and thousands more were discovered, all these required study. An entirely new descriptive vocabulary was often needed, in Latin and English and French. What words does one use for different stems and leaves in plants? Here is William Turner on *Marrumbium* or horehound: "Whorehound is a whitish bush full of branches and something rough. The branches are four-squared. The leaf is as big as a thumb, something rough, full of rinds, and with a bitter taste. The seed groweth about the stalk, and the flowers which are sharp grow insunder, by certain equal spaces one from another. And they are like unto whorles, in compassing about the stalk, as a whorl goeth round about a spindel"[14] (part 2, 51r). You note the imagery; it is new.

When we try to recall what these men needed to do first, we should remember that they were also humanists, both as scholars and in their desire to benefit their fellow men. The very concept of truth for its own sake would have been

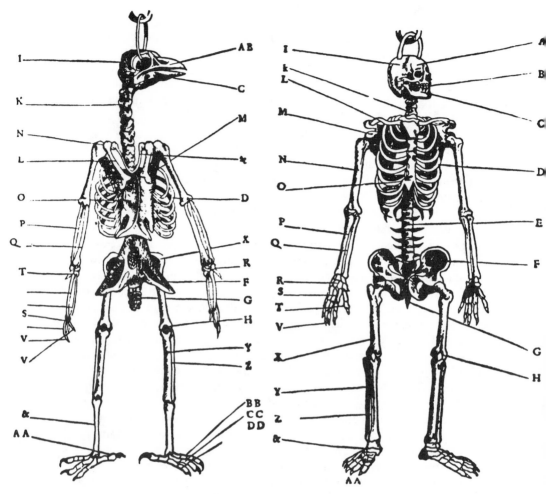

Skeletons of Bird and Man juxtaposed, Belon, 1555.

meaningless to them, however much they were interested in gathering facts. To them, science meant applied science, applied for man's better understanding of a divine universe in which, with his special faculties, he can behold and study living creation—a universe moreover intended to be in many ways beneficial to man. Such humanism was bound to distract sixteenth-century biologists from what we call biology.

Most of the new writers on natural history had a thorough humanistic education which emphasized the precise understanding, analysis, and relevance of a

variety of classical texts, plus an education in the Bible and in theology, plus an education in medicine. In other words, they studied the sciences of man's mind, body, and soul. In botany and zoology, they were almost the first generation that studied the best classical works, by Aristotle, Theophrastus, and Dioscorides, in humanistically edited texts. They also studied Pliny but they knew well that Pliny is often inferior and unreliable.[15] They studied Galen, of course, several of whose most important works were only rediscovered and edited by Linacre and Vesalius's teachers.[16] And they studied many other ancient writers on botany and animals. These required collation and checking; for instance, Turner often refers to disagreements between Aëtius[17] and Dioscorides. But above all, the animals and plants described required proper identification, and that could not be done in the study. So these naturalists placed their Aristotle and Dioscorides in a packsack and went out into nature searching for their plants and animals. Some they rediscovered easily, some they could not rediscover at all because they were not found in the north until Belon had the good fortune of being able to travel to the Near East, and some puzzled them a great deal because of the inadequate descriptions of the ancients. Inevitably they discovered much that was totally new. Next, some of these naturalists wrote little books about the ancients in order to clarify them; for instance, Gesner wrote on what plants and parts of plants several of the ancients, especially Dioscorides, Theophrastus, Paulus Aegineta, and Pliny, were actually writing about.[18] And William Turner presented the results of the search for the birds described by both Aristotle and Pliny in a similar book.[19] In it he also mentions other Latin names besides Pliny's, sometimes corrects Pliny and even Aristotle, and refers to a host of related species he has found, with their locale and habitat.

Turner and Gesner thus devised a new method for humanistic scholarship in botany and zoology, one which combined field study with philology. The philology is reflected in the titles of the first two little botanical books by Turner: *Libellus de re herbaria novus, in quo herbarum aliquot nomina greca, latina et Anglica habes,* and the enlarged *The Names of Herbes,* now in English.[20] In Gesner's later work on animals, each section begins with a particular animal's many names, in Hebrew, Greek, Latin, and several modern languages and dialects. Names are important for identification, for scientific communication, for any work on classification to begin, and for still more. These writers remembered that God asked Adam to name the animals and plants. And we still believe that names are important, if not for animals, then for our sons and daughters, or for Washington.

Whatever the multiplicity of names of drugs today, a physician cannot afford to be ignorant about what they mean. Much in Turner's *Herbal* is about precisely what plant Dioscorides gave a certain name to, and what plant in England corresponds to it. He had to face the problem of different plants being called by the same name. Dioscorides was properly edited only in the sixteenth century, by Ruel and Mattioli.[21] Almost as soon as these editions were available, botanists made it their task to devise a new Dioscorides for physicians in

their own region, a Dioscorides for Southern Germany or for England. The first of them, Brunfels in 1530, went about it pedantically and awkwardly. His herbal includes what he took to be Dioscorides's species found in the neighborhood of Strassbourg. He hardly improves on his descriptions. Apologetically he added the odd new plant, of which he says that it has no medical virtues.[22] Fuchs, Bock, Turner, Dodonaeus, and others were far more expert and careful. They were shocked by the ignorance of native doctors who had little Latin and depended for their drugs on herb-women.[23] They realized acutely that Dioscorides's descriptions were often inadequate and that many of his plants could not be found in their region. Many could, partly because monks long ago had brought them north from the Mediterranean. Yet another problem is found in the following sentence by Turner: "Dioscorides maketh but one kind of Sage, but Theophrast maketh two kinds of Sage." Do both act similarly? That, of course, could be answered only by testing. Turner tested in two ways: first, by applying Galen's method, that is, chiefly by tasting for the plant's degree of heat or coldness; then also by watching the effect on his patients—that at least would make him adjust the dose.

Of course, plants were admired not only for their medical virtues. Some were loved for their sheer beauty and aroma. Others had yet different uses. When Gesner was plant hunting in an Alpine valley, he became aware of various aspects of what we would call the valley's dairy economy and wrote a little book on it, *Libellus de Lacte*.[24] Increasingly, botanists returned from their wanderings with specimens and seeds, and planted gardens for further study and delight. Gesner sent seeds to Turner in return for Turner sending him descriptions and specimens of birds and fish.

In medieval towns or castles there was little room for gardens. Medieval gardens were for simples, plants for medical use, though some contained a few for delight, especially roses. Then as now, the blessed Virgin was decked in flowers, and some courtly ladies adored by minstrels desired similar treatment. In quattrocento Italy, the wealthy went in for gardens more and more as places for leisure, and town planning came to include gardens. More's Utopians enjoyed their gardens. But then in the sixteenth century a further development was begun, I think, by the naturalists I am speaking about. They started their own gardens, and these were often in three parts: one for medical simples, local, and imported; one devoted to the wild flora of the neighborhood; and one for exotic plants raised from seeds procured, via apothecaries or sailors or other naturalists, from the Orient, America, and Africa. Soon certain aldermen, statesmen, countesses, and members of medical universities became impressed. And so public gardens arose. In France this occurred from the mid-century on. Guillaume Rondelet of Montpellier, best known as the medical teacher of Rabelais, provided as chancellor of his university much of the inspiration that led to the founding of the city's large Jardin des Plantes. Today the garden contains Rondelet's statue.

Montpellier is only a few miles from the Mediterranean, and Rondelet had a country house near the coast where he pursued studies that were extraordinary

for a professor of a famous medical faculty. He had a big hole dug in his garden for a pond. In it he placed whatever fish and other marine animals he could procure alive. He studied them and wrote a book on them. In 1551, a new student called Charles de L'Escluse or Clusius arrived from Flanders, ostensibly to study medicine.[25] But Rondelet allowed him instead to study the flora of Languedoc, the neighboring district. In return he asked his student to help him collect marine animals and to turn his French manuscript into good Latin. Clusius describes how after major storms, Rondelet and he would dash to the seashore and pick up whatever animals, living or dead, the waves had cast up. Much later, Clusius published a tract on the flora of Languedoc[26] and founded the famous garden at Leiden in Holland.

Both in his novel methods of study and in the basic organization of various classes of marine life, Rondelet was inspired by Aristotle. But for many of his species, he could draw on no previous description. For them, he depended totally on his own study and on what he could learn from people around him, chiefly from fishermen. He published his book first in Latin, to ensure international circulation and to give it some authority. Then he also published a French version, so that it could be useful locally. The book, after all, dealt with the local marine animals. Many could be observed by others on the beach, many provided a part of Montpellier's food supply. Though Montpellier was not right on the coast, fishing must have been quite an industry. Through his scholarly work on fish the renowned rector of the town's university became all the more appreciated by his fellow citizens.

The work is not held in such high regard any longer. The few short modern accounts that exist of Rondelet as an ichthyologist or student of fish, several of them by members of his ancient university, make amusing reading. Harant and Jarry[27], for instance, praise Rondelet particularly for anticipating Linnaeus in using Latin binominal names for different species and for his discovery and correct description of the *Sepiola*, a kind of cuttlefish, still named after him. They laugh when Rondelet writes that mullets love rain yet that violent storms blind them. Rondelet certainly was less critical than his countryman Pierre Belon or Turner. But that he accepted, for instance, spontaneous generation, sanctioned by Aristotle, is surely not surprising. That doctrine was finally disproven only in the nineteenth century. Consider that he could study only some species alive with his unaided eyes, and that he necessarily depended on a few ancient works, accurate and inaccurate, and on the knowledge and lore of fishermen. What parts of his information was he to accept as sound, what parts not? For zoologists that problem has since become much easier, but no one has solved it totally.

I will now turn to Gesner's encyclopedic work on animals. He set himself the task of compiling, though with some critical sifting, all that had been written by ancient and some medieval writers on various animals together with all he could learn himself, either by direct study or, if that proved impossible, through data sent by correspondents in many countries, and to present all this material in organized form. Five folios were published; a sixth, on insects, was

Hedgehog, Gesner, *Historia animalium,* 1551.

planned.[28] He called his work a pandect. It required, of course, immense learning. It also required that Gesner turn himself into a kind of one-man Royal Society, collecting and sharing information from everywhere. Why did he impose on himself such an enormous labor? So that zoologists for the first time would have a modern tool with all the information they needed for further study. Modern scientists still depend crucially on compendia and bibliographies in their field. Because of the very encyclopedic nature of his work, it seems quite unlike Aristotle's *Historia Animalium,* more akin to Pliny's and even medieval encyclopedias. That has often been said. But what needs saying is that Gesner wrote his pandect because Pliny's, and of course medieval ones, proved totally inadequate.

Except for dividing the animals by Aristotle's large classes, Gesner organized them alphabetically, but he grouped together closely related species like different eagles, and sometimes even different families in the same habitat, like grebes and ducks, though he knew that their anatomy and behavior are different. Gesner's fundamental aim almost precluded any serious contribution to taxonomy. Late in life, he expressed his regret about this in a letter to a friend;[29] his already vast task had made such work impossible. Further, as a humanist, he wished the work to be useful not only to fellow naturalists, and, as we know, it indeed came to be used by all sorts of people, from literary men and churchmen to falconers. When in the 1670s Ray dissociated himself from all the grammar, theology, and poetry in Gesner's volumes, the separation of disciplines, which has become such a problem in our universities and society, had begun.

Being a humble man, Gesner in his pandect de-emphasized or hid away his own contributions. A sifted compilation of them today might form a very useful Ph.D. thesis, or rather, three theses.[30] New species are treated briefly by Gesner; animals known long ago are described at length under several headings. For most, he provides a splendid, large picture.[31] The first section deals with the animal's names in many languages. Earlier I dwelt on the reasons for

this. The second, third, and fourth sections are about what modern students would consider proper subjects: precise description, the animal's morphology, its food, manner and time of generation, its enemies, its ecology. Sections five to seven deal with particular uses, in medicine, agriculture, etc. The final section, often very large, treats what the animal has meant to man in different civilizations: symbolic and moral meanings, rivers that have been named after it, its place in poetry, and so on. It presents the animal's cultural history.

The parts dealing with the animal as such also often include abundant quotations from the ancients. But as one studies them, one notes Gesner's careful, though perhaps too generous, critical attitude; one becomes aware of how thoroughly Gesner himself examined the animals whenever he could[32] and how many people across Europe sent him drawings, skins, and descriptions. Gesner acknowledged their aid conscientiously.

The section on the salamander is characteristic of his approach. He first gives a realistic picture and a quite thorough description. Later, he also provides a picture from a bestiary or emblem book with all the lore about salamanders being immune to fire, etc.[33] He knew from experiment that they are not. But the lore endows the salamander with a rich meaning which perhaps deserves

DE SALAMANDRA.

De Salam. A. Lib. II. 81

Figura prior ad viuum expressa est. altera vero quæ stellas in dorso gerit, in libris quibusdam publicatis reperitur, conficta ab aliquo, qui salamandram & stellionem a stellis dictum, animal vnum putabat, vt coniicio. & cum a stellis stellionem dictum legisset, dorsum eius stellis insignire voluit.

Salamander, real and imaginary, Gesner, 1554.

remembrance. First, though, we should know what a salamander really looks and behaves like. This is neither medieval nor modern—it is Renaissance.

Astonishingly enough, Gesner also planned to write a vast *Historia Plantarum*, and in a quite different way. When he died of the plague in 1565, he left, besides other manuscripts, 1,500 careful drawings, many colored, on 490 folio pages, front to back, of plants and parts of plants. The instructions he left to his friends on how to publish them proved too difficult. They did publish, in 1587, his short *De collectione stirpium tabula*,[34] which received some notice. It went well beyond Theophrastus in sketching the first truly informative treatment of plant morphology in the Renaissance. On the basis of it, Tournefort around 1700 praised Gesner as the greatest of his predecessors. He did not know about Gesner's drawings. They were rediscovered and published in part only in the eighteenth century at Nuremberg, well after Linnaeus.[35] They were lost once more at Erlangen until 1929.[36] Recently several samples have been lavishly published in Switzerland.[37]

The watercolors at Erlangen give plants a startlingly beautiful, lifelike appearance. They reveal clearly such details as the serration of leaves and whether the stems are round or square, smooth or hairy. Separate drawings are devoted to morphologically important parts like stems and roots. Some present seeds in greatly enlarged form. These sketches are accompanied by notes in ink—most by Gesner, some by Thomas Penny, who, had he published himself, might well have become recognized, as Canon Raven tells us, as an even greater botanist and zoologist than Turner. Both the drawings and notes intimate that Gesner had a remarkable understanding of the hierarchical organization of the plant kingdom. His concept of a species involved its inheritable characteristics. He broached the concept of genera which include several species whose flowers, fruits, and roots are similar in shape and perhaps even anticipated the concept of families. He recognized correctly the importance of flowers (with their petals, sepals, stamens, and pistils), of fruits with their seeds, and of roots (rhizomes, stolons, storage organs such as bulbs) for plant taxonomy.[38] Like Rondelet he suggested some two-part names for species.

Some recent Swiss writers are persuasive in claiming that Gesner was the most advanced of all the botanists of his day and that his studies point in the direction of Linnaeus's taxonomy of the plant kingdom.[39] Gesner's notes for his drawings include nothing about their medical virtues, perhaps because this matter was being looked after abundantly by his contemporaries. Still, in our enthusiasm we must not forget that what we have from Gesner is a large sketchbook, not a complete manuscript. In the light of Gesner's other work, we need to be wary of turning him into an eighteenth-century botanist whose primary interest was the better analysis and understanding of the whole organization of the plant kingdom. In the last small book, devoted to minerals, which Gesner did publish in his lifetime, he reflected the hermetic beliefs of his time that everything in the universe interacts, thus accounting for the animal shapes of certain fossils and stones.[40] An Aristotelian or Linnaean order, by comparison, lacks in dynamism, in life. Nor is what first hits us when we look at

Crane's Bill, Gesner, MS, ca. 1565.

Bladder Campion, Gesner, MS, ca. 1565.

Gesner's watercolors, or for that matter at some of his woodcuts of animals, their sheer beauty, even the absorbing beauty of detail, irrelevant. For purposes of scientific understanding, such beauty or art is only sometimes essential—as still today in enlarged micrographs revealing the structure of bacteria. For Gesner art still had that other purpose of deepening "our appreciation of the world as a work of divine artistry."[41]

In this essay I have tried to show that Gesner and some of his contemporaries studied the living universe in ways that were entirely new in Western civilization. They deserve to be called the fathers of modern botany and zoology for, besides engaging in large-scale systematic surveys of natural history based on (as far as they were able) direct observation, they, particularly Gesner, also anticipate some of the scientific concerns with the fundamental nature and order of life that characterize the work of leading investigators centuries later. Yet they were obviously not pure biologists in the modern sense. The reasons for this, however, are not those which until quite recently were suggested in the standard histories of science: that they were still half-medieval (in several striking ways they were not), or that they were fettered by a humanistic reverence for classical authority (that tended to be the case around 1480 but much less so by 1550 when many, though not Gesner, wrote in their own vernacular and concentrated on species both of their own country and newly discovered parts of the world never dreamt of by Aristotle or Pliny), or that they were mere naturalists. Rather, the chief reason is to be found in their peculiar philosophy characteristic of the later part of the Renaissance. The impact of the hermetical writings edited by the Florentine Neoplatonists, of the Protestant Reformation[42], of the discovery of America and other new worlds, of the printed book disseminating information to a wider audience, and of the growing practical and thus realistic-minded mercantile class in the north—these and other factors produced a special climate for the study of nature. Whatever medical students learned in 1450 about plants they almost invariably learned from books or at most from a small herb garden cultivated at the university. But by 1550 it became increasingly frequent for groups of medical students to be sent to the surrounding countryside so that they would learn how to recognize the most important medical herbs in the field.[43] The change occurred partly because Galen, the great classical authority, had urged physicians to do so, but also because an interest in botany as such was developing. Plants were studied as a part of God's creation and for their meaningful place in a living, extraordinarily vital and rich universe.

As the essays in this book by James Ackerman and Philip Ritterbush indicate, some artists from the fourteenth century on delighted in the realistic presentation of plants and animals. Yet the impact of art on the work of the writers of botanical and zoological works was delayed until shortly before the time on which my essay has concentrated—the mid-sixteenth century. Until the publisher of Otto Brunfels's herbal in 1530 called in Hans Weiditz to illustrate it, art appears to have had no effect on writers in this discipline. The humanistic translations and editions of Aristotle, Pliny, Theophrastus, and

others are unillustrated, and the herbals, fundamentally medieval in content, continue the stylized pictures, often simplified beyond recognition, that appear in earlier manuscripts. In a well-documented essay, Karen Reeds has shown that fifteenth-century humanists, impelled by classical example, indeed distrusted the use of illustration.[44] But for Konrad Gesner and several of his contemporaries, the artistic representation of animal and plant species—and in some instances, as I showed, in great detail and with an enlargement of morphologically important parts—came to be regarded as a welcome means that assisted them in communicating precise botanical or zoological data as well as serving to arouse in their readers a sense of the wonderful variety, beauty, and purpose of divine creation. Thus, ideally, art, science, and the advancing technology of the printing trade went hand in hand, and sometimes this ideal was accomplished. At other times, however, publishers were happy for financial reasons to allow the visual appeal of their books to distract from their real matter and purpose, the author's text. And however much we value the beauty of some of the illustration in Gesner's animal books and some sixteenth-century herbals, their fate in our own time ironically suggests that the earlier humanists had a point. The union of art and science, or for that matter of different arts, rarely does equal justice to both.

NOTES

1. For Raven, who is an exception, see note 11 below. For a recent discussion of the period just before mine, see Karen M. Reeds, "Renaissance Humanism and Botany," *Annals of Science* 33 (1976): 519–42.

2. For a typical earlier sixteenth-century illustration, from *The Grete Herbal* (1526, several later editions), see that of the water-lily.

3. See Claus Nissen, *Die botanische Buchillustration*, 2d ed. (Stuttgart, 1966), 40.

4. For an example, see illustration of burdock (withered). The preceding illustration, by contrast, shows Weiditz's perfect drawing of a Pasque Flower.

5. Fuchs's herbal includes a page with the portraits of two painters, Heinrich Füllmaurer and Albrecht Meyer, and of the woodcutter Veyt Rüdolff Speckle. For these, see Nissen, *Die botanische Buchillustration*, 45ff.

6. Berengario da Carpi's *Isagogae Breves*, illustrated with anatomical drawings, appeared in 1522.

7. That barnacle geese and barnacles are entirely different animals was first demonstrated by Fabio Colonna in *Phytobasanos* (Naples, 1592). The first true account of the nesting of barnacle geese is found in Gerritt de Veer, *Diarium nauticum, seu vera descriptio trium navigationum admirandum* (Amsterdam, 1598).

8. Pierre Belon juxtaposes illustrations of the traditional or "vulgar" phoenix and of the "true" phoenix, a skin of a paradise bird, in *Portraits d'oiseaux* (1557). Soon after, several species of paradise birds came to be known.

9. For instance, Turner points out in his small book on birds (1544) that he often saw both redstarts and robins nest in England during the same season, though in different ways, thus refuting Aristotle's notion that robins change into redstarts in the spring. See note 19 below.

10. I do not mean merely that there were earlier works of similar titles. Browne mentions three in his preface "To the Reader": Laurentius Joubertus, *Erreures Populaires et Propos Vulgaires touchant la Medicine* (1579), a jumble of old wives' tales and popular beliefs, treated quite uncriti-

cally; Scipio Mercurii (i.e., Girolamo Mercurio), *Degli Errori Popolari d'Italia* (1603), concerned with medical errors; James Primrose, *De Vulgari Erroribus in Medicinae* (1639; English translation, 1651).

11. My point was stated more forcefully and extremely by Charles E. Raven thirty years ago in one of his Gifford lectures (for 1951) on *Natural Religion and Christian Theology* (1953), in a chapter devoted chiefly to Gesner (pp. 80–98) that deserves to be better known. He writes that the popularity of emphasizing the astronomers and mathematicians of the sixteenth century "is of course due to the subsequent development of the scientific movement—to the triumph of mechanical methods and techniques in the eighteenth century which produced the industrial age and to the restriction of the New Philosophy, at the same time, to the mathematical and qualitative field. To read the origins of science in terms so limited is as unhistorical as to interpret the history of the earliest Church as if its only concern was the preparation for the Nicene creed. In the sixteenth and seventeenth centuries it is obvious that the scientific revolution owed more to the botanists and zoologists and to the doctors and explorers than to the astronomers" (p. 80).

12. See illustrations of bird and man, from *L'histoire de la Nature des Oyseaux* (Paris, 1555).

13. See the rejection of irrelevant data in Francis Willughby's and John Ray's *Ornithologiae* (1676; English version, 1678).

14. William Turner, *Herbal* (Cologne, 1568), pt. 2, fol. 51r.

15. Nicolo Leoniceno pointed out many errors in Pliny's botanical descriptions as early as 1492.

16. E.g., Galen's *Anatomical Procedures (De Anatomicis Administrationibus)* was rediscovered and edited by Johannes Guinther (Latin text, 1531; Greek text, 1538). See Marie Boas, *The Scientific Renaissance, 1450–1630* (Fontana-Collins, 1970), 125ff.

17. Aëtius of Amida, a Byzantine physician of the sixth century.

18. *Enchiridion historiae plantarum* (1541).

19. *Avium Praecipuarum, quarum apud Plinium et Aristotelem mentio est, brevis et succincta historia* (Cologne, 1544). Edited with English translation by A. H. Evans, as *Turner on Birds* (Cambridge, 1903).

20. *Libellus* (1538); *The Names of Herbes* (1548). Gesner's *Catalogus Plantarum* (1542) is similar in kind and intent. Lists of names in different languages do appear already in some earlier herbal manuscripts but in them for practical reasons alone.

21. By Johannes Ruellius in 1516; by Petrus Andreas Mattiolus from a better manuscript in 1544, several times reprinted.

22. Brunfels called such plants *"herbae nudae."* One of them is the Pasque Flower; see illustration, above.

23. For instance, both Fuchs and Turner express this in the dedications to their herbals.

24. Zurich, 1541.

25. See Pierre Boeynaems, "Le séjour de Charles de L'Escluse à Montpellier (1551–1554)," *Monspeliensis Hippocrates*, no. 4 (juin, 1951), 16–21. See also F. W. T. Hunger, *Charles de L'Escluse*, 2 vols. (The Hague, 1927; 1942).

26. Rather, he describes fifty plants from Gallia Narbonensis, i.e., the district around and south of Montpellier, in his *Rariorum plantarum historia* (Antwerp, 1601).

27. Hervé Harant and Daniel Jarry, "L'oeuvre zoologique de Guillaume Rondelet," *Monspeliensis Hippocrates*, no. 12 (ete, 1961), 5–10. Page 10 includes a modern picture of Rondelet's farmhouse.

28. Four volumes appeared between 1551 and 1558; the fifth, on serpents, posthumously in 1587. Gesner merely began the work for the sixth, on insects. It was carried on by Thomas Penny, then by Thomas Moufet, but finally appears, in greatly altered form, only in 1634.

29. Letter to Professor Thomas Zwinger of Basel, November 1565; cited in Hans Fischer, *Conrad Gessner, Leben und Werk* (Zurich, 1966), 111.

30. Prof. Marianne S. Meijer has alerted me to the recent doctoral thesis at Utrecht by C. A. Gmelig-Nijboer on Konrad Gesner's *Historia Animalium* (1977).

31. An example, though of a small animal, is the hedgehog (see illustration).

32. For instance in his volume on birds, he clearly differentiates between various thrushes and six different tits, including Cole and Marsh tit which even expert amateur bird watchers today find notoriously hard to distinguish.

33. See salamander illustrations.

34. It has been pointed out to me by Prof. Hans H. Wellisch that this is merely a revised version of an appendix to Gesner's edition of David Kyber's *Lexicon rei herbariae trilingue* (1553).

35. About one-third were published by C. C. Schmiedel in *Conradi Gesneri opera botanica* (Nurnberg, 1751–71).

36. Rediscovered by Bernhart Milt in the university library there.

37. As Konrad Gesner, *Historia Plantarum*, 4 vols. (Zurich, 1973–76).

38. See illustrations. Crane's Bill, so called after the long axis or beak of the ovary, shows florettes on the left and separated seed vessels or carpels on the right. Bladder Campion, *Silene nutans*, shows well the creeping rhizome or root, and on the right, above the center, seeds coming out of the bladder.

39. Bernhart Milt's estimate of Gesner's contributions, in *Gesnerus* (1947), however, is excessive. For a more cautious estimate, see Heinrich Zoller in Hans Fischer et al., *Conrad Gesner 1516–1565, Universalgelehrter, Naturforscher, Arzt* (Zurich, 1967), 57–63.

40. See M. J. S. Rudwick, *The Meaning of Fossils* (London and New York, 1972), chap. 1.

41. George Boas, "Philosophies of Science in Florentine Platonism," in Charles S. Singleton, ed., *Art, Science and History in the Renaissance* (Baltimore and London, 1968), 244.

42. Charles Raven, *Natural Religion and Christian Theology*, emphasizes how many of the early botanists and zoologists (e.g. Brunfels, Bock, Fuchs, Gesner) were liberalminded Protestants, influenced at least as much by Erasmus and Zwingli as by Luther, who regarded the study of nature as a part of their religion. The impact of Protestantism in general on science and medicine has been the subject of much recent scholarly discussion. Paracelsus's innovations in medicine, for instance, appealed to reform-minded Protestants who distrusted ancient authorities as "pagan."

43. For instance at Montpellier. See Karen M. Reeds, "Renaissance Humanism and Botany," *Annals of Science* (1976), 519–42.

44. See note above.

[8]

The Organism as Symbol: An Innovation in Art

Philip C. Ritterbush
Institute for Cultural Progress
Washington, D.C.

Assessing the relations between science and art during the Renaissance involves difficulties of interpreting both pursuits because they were not regarded as altogether distinct at the time. The organization of collectors' cabinets suggests that art and science were not recognized as distinct realms of thought because natural objects were intermingled with art works in many collections. Cut gems and carved stones were combined with mineral crystals, for example, suggesting that the artistic skills employed on the former were not distinguished from the regularities of nature responsible for the crystal forms.[1] While serving on the staff of the Smithsonian Institution, the museum agency of the national government, I encountered an object that seemed at first sight to embody principles of scientific truth, while further study disclosed an artistic program. Distinguishing artistic from scientific elements in considering that object has prompted me to inquire more generally into their historical relations.

The object is a veneered chest whose exterior is inlaid with rich marquetry designs after the manner of the cabinets of some Renaissance collections. Double doors open to reveal ten drawer fronts resplendent with naturalistic paintings of European insects and flowers. On the hinged panel covering a central recess in this drawer front are paintings of insects, spiders, a lizard, and a scorpion. The presence of a rhinoceros beetle, lantern fly, and tarantula suggests that the artist was shown a collection from the New World tropics, whose varied and colorful forms of life so powerfully stimulated the descriptive natural sciences during the age of exploration.[2] The whole composition was executed in the manner of the Flemish still-life painter Jan van Kessel, although it must have been copied onto the drawer surfaces by a later hand, as the cabinet

Center panel from the painted surface, total dimensions 106 × 65 cm., of an eighteenth-century cabinet, consisting mostly of faithfully executed renderings of New World insects, except for a chimerical creature in the lower center. Smithsonian Institution.

seems nearer two centuries old than the three that have elapsed since van Kessel's death in 1679. The cabinet appeared in the London art market in 1964. Dillon Ripley, who had just become secretary of the Smithsonian, strongly believed that museums should feature objects signifying rich contextual relationships. I entreated him to acquire the painted cabinet as an exemplar of early science. After it had entered the collections of the Institution, I found that my desire to equate naturalistic representation with science gradually gave way before the demands made by a complex object.

The first surprise was presented by the painted drawer surfaces, each of which figures a dozen or more bees, butterflies, moths, caterpillars, beetles, or dragonflies. Sprigs of gooseberry or branches with flowers such as thistles appear as well. They do not portray a collection directly. We do not find the nymphalid butterflies all together on one panel as though in the drawer of a systematically arranged collection but spread across five different panels. Underwing moths appear on three of the panels; pierid butterflies, on five. These images correspond not simply in their white background and general arrangement of insects but also in the closest details of individuals to other panels by van Kessel. In addition to panels in museum collections or offered for sale from time to time by dealers, two sets of twelve painted copper panels are known which correspond very closely to the drawer fronts of the Smithsonian cabinet.[3] Instead of portraying a particular collection of objects the array of painted surfaces seems to reflect an artistic program.

The white background struck me at first as a way of divorcing objects from the context of art to encourage viewing them as objects for scientific study. It appears, however, that this feature of van Kessel's work derives from the technique of a predecessor, Georg Hoefnagel, a Flemish artist born in 1542. He became court painter to the greatest collector among the humanist princes of the Renaissance, the emperor Rudolph II. Professor Ingvar Bergström of the University of Göteborg has closely studied the artistic motives underlying the naturalistic portrayal of organisms, as in the parchments of Hoefnagel. The flowers and butterflies of this artist were sometimes painted so as to frame a death's head, along with Biblical verses, signifying a religious theme.[4] Faithful rendering of anatomical details need not, of itself, make an image scientific. Netherlandish flower paintings were commonly intended to convey intimations of mortality.[5] The insects that appear so often among the flowers were regarded as apt symbols for the soul's emergence from the body (as insects do from pupae).

The center panel of the cabinet includes a sinister-looking creature with a destructive mouth unlike any insect's, protruding eyes, and a forward-pointing spiral appendage as well as two robust antennae. Its body terminates in a venomous spike. The legs are covered with scales and end in webbed feet. Four wings unfold over its back. For a time I supposed this was a closely naturalistic rendering of a fabricated specimen, a fraud perpetrated with the aid of a gluepot by some curio merchant who profited from the sale of fabulous specimens. One of the early illustrated books of New World insects contained such a figure. According to the biographer of the illustrator, Maria Sibylla Merian, the fabricated specimen was "composed of the body of a *Tettigonia* [leafhopper] surmounted by the mitered head of a lantern fly, the manufacture, in all probability, of some cunning Negro, who doubtless turned the unique specimen to good account."[6] If such a deceptive object existed, the image would be a faithful rendering of it. The origins of the image are not, however, so direct. In the Renaissance holdings of the Zentralbibliothek in Zürich, I chanced to locate two sixteenth-century woodcuts portraying creatures whose features resemble

George Hoefnagel, panel of a diptych on parchment, 126 × 185 mm., mono-grammed GHF, dated 1591, Musée de Lille. Naturalistic imagery symbolizing human mortality.

those of the Smithsonian chimera. Their subject is a plague of locusts that overran Silesia in 1542. Locust infestations were looked upon as divine punishment for human wickedness. Illustrators portrayed migratory locusts as evildoing beings whose staring eyes and threatening antennae derive from conventional representations of the devil. The image on the Smithsonian cabinet is an echo or survivor of a metaphorical portrayal of a European insect. The advent of naturalism in art has sometimes been regarded as a result of refinements in technique. If that were so, renderings such as those of the locust woodcuts would have to be attributed to lack of skill. We ought not to suppose that painters' techniques were then inadequate to render locusts faithfully. A drawing of *Locusta migratorius* had been faithfully executed by Pisanello around 1420.[7] Van Kessel's image is not an imperfect representation of an object of nature but faithfully renders an idea about a role divinely assigned to the insect. It is naturalistic without being scientific, in a way that casts doubt on the equation of these attributes by historians.

The reappearance of the locust image on a panel of tropical insects may be attributed to recopying, a common practice among still-life painters that imparted to some images a kind of life of their own. Jan van Kessel sometimes painted snakes in the form of letters of the alphabet to sign his works. They also appear in his important triptych in the Prado. Yet some of them are to be found in a much earlier work by Rubens, the *Medusa's Head*. The connoisseur

(a)

(b)

Anonymous woodcuts of the migratory locust as an emblem of divine wrath, 18 ×
12.5 cm., monograph Æ and 1542 added in ink, 18 × 16 cm. dated 1556 (MS F13, f88a
and MS F13, f80, Sammlung Wickiana), Zentralbibliothek, Zurich.

Constantin Huygens (1596–1678) saw this picture in Amsterdam in 1626, shortly after it was completed. "To this woman's face, already surrounded with foul reptiles, though but recently dead," he wrote, "the painter's perfect art has given so striking an appearance that the spectator, suddenly confronted with it (for the picture is usually covered), is not less impressed by the horror of the subject than by the beautiful features of the lovely countenance."[8] The "perfect art" of the reptiles was that of Jan Bruegel (1568–1625), one of the originators of flower painting. Most of the animals in Rubens's *The Earthly Paradise* in the Mauritshuis in The Hague as well as those in *The Virgin Surrounded by a Garland of Flowers* in the Alte Pinakothek in Munich were also painted by Jan Bruegel. Rubens executed a portrait of Jan Bruegel and his family in 1613. Perhaps the little girl shown is his daughter Paschasia, who married Hieronymus van Kessel (1578–1635) and became the mother of the painter who reused the reptile images of his grandfather.[9] While such images seem naturalistic by definition, their repeated re-use by painters can hardly be considered scientific activity.

Naturalism in the portrayal of objects of nature was the subject of a historical essay by Lynn White. He traced its origins to twelfth-century manuscript illumination and cathedral column capitals where, as he put it, "floral sculpture becomes botanizing." This seemed to him a fundamental change in European attitudes toward nature. "Thus began that 'confusion between science and art,' that passion for the exact copying of nature, which dominated the development of art in the West for seven hundred years."[10] Yet if naturalistic portrayal were scientific per se, how could an image derived from the preceding religious outlook survive in a group portrait of plants and insects? Why would organisms be portrayed exactly in still-life paintings whose underlying purpose was to depict the migration of the soul? Consider, for example, the way organisms were employed in an important painting that typifies some of the purposes of Renaissance art, the *Madonna and Child Enthroned with Saints and Angels* by Francesco Botticini. This work in the Metropolitan Museum of Art has been analyzed by the naturalist and historian Herbert Friedmann.

Figuring in the composition are weasel fur, a dove, two goldfinches, a lizard, a pig, and a turtle. The dove is rendered realistically in a lifelike pose that contrasts markedly with stylized doves which figure in trecento compositions as emblems of the Holy Spirit. It lacks the nimbus or halo which had been customary in paintings of the Annunciation. One of the saints in the altarpiece is St. Benedict. The bird, Friedmann suggests, represents his sister, St. Scholastica, head of the first community of Benedictine nuns, always shown with a dove, for, as the story goes, after her death St. Benedict saw her soul fly up to heaven in the form of a dove. The weasel fur is there, it seems likely, as a symbol for the purity of the Virgin. The pig represents the temptations of sensuality and gluttony that one of the other saints portrayed, St. Anthony Abbot, was noted for having overcome. The goldfinch and the lizard symbolize resurrection and salvation, while the turtle symbolizes wisdom and also charity. Among the plants figuring in the composition are thistle, symbolizing

Francesco Botticini, *Madonna and Child Enthroned with Saints and Angels*, detail.

the crown of thorns placed on the head of Christ before the Crucifixion. Plantain, a lowly plant that thrives where trodden upon, symbolizes the multitudes who seek the path of righteousness. Buttercup is associated with both St. Anthony Abbot and the Virgin. Hawkweed was believed to confer clearness of vision, and bindweed, another plant shown, was called "Our Lady's Nightcap" because its cuplike blossoms were said to last but a single day.

As an ornithologist who was the director of the Los Angeles Museum of Natural History, Friedmann might have been expected to emphasize the naturalism with which these creatures were portrayed. Instead he elucidated a symbolic role for them. He has made a particular study of the meanings attached to the European goldfinch, which so often appears in Renaissance paintings. Most commonly it served to represent the human soul and suggested other general spiritual themes such as resurrection, sacrifice, and death. In some compositions it had more specific meanings as an augur of death or a symbol of fertility. "These creatures are not merely idle whims of the artists," Friedmann contends. "They had significance, they conveyed meanings to the people of fifteenth-century Italy and their inclusion was probably passed on and approved, if not actually requested, either by those who commissioned the

paintings or by the clergy or by both. A very large part of the audience for whose eyes the works were intended was illiterate; people were accustomed to 'read' pictures and probably looked more intently at all parts of the paintings than we are apt to today. We may see only decoration in paintings that were once understood as richly symbolic."[11]

As another example, we may consider a picture painted by Piero di Cosimo in the 1490s, whose meaning was the subject of one of Erwin Panofsky's most discerning essays. The central event depicted is Vulcan working at his forge in the Isle of Winds, with Aeolus, god of winds, working the bellows. A horseman regards both with close interest. Panofsky thought a proper title for the painting, which he had to reconstruct from the events depicted, would be *Vulcan as Arch-craftsman and First Teacher of Human Civilization.*[12] In the middle distance men build a lattice of unsquared tree trunks, recalling Vitruvius's comment about the origin of civilization: "And at the beginning they put up rough spars, interwove them with twigs, and finished the walls with mud." A family is shown awakening. It is dawn, the time when Virgil said Vulcan was fondest of working. The entire composition therefore represents the dawn of civilization. A giraffe is shown—probably drawn after one in a shipment of rare animals that the Sultan sent to the Signoria in 1487. What the painter seems concerned to convey is that the viewer beholds civilization at a time when domestic animals (like a tiny camel in the background) had been tamed but wild animals were not yet shy. The recumbent figure in the foreground might be viewed as the sleep of reason, from which civilization is the awakening.

In *Forest Fire,* a panel in the Ashmolean, Piero shows an earlier stage of human evolution. There is a thatch-roofed shepherd's dwelling, very crude, whose owner wears a coat of cured leather. Cattle are being tended and primitive boats are in use. We behold a sow with the face of a man, probably representing Lucretius's theory of evolution. At the Metropolitan Museum of Art there are two more paintings on the same theme, *Primitive Hunt* and *Return from the Hunt,* in which the tree trunks in the boats and rafts are not only unsquared but also untrimmed for want of saws. Lacking woven cloth or tanned skins, people go naked. There are no domesticated animals, no families, and no real buildings. Fires burn out of control in the forest, frightening away animals unregarded by man. Human passions seem to exist on an animal level.[13] It is remarkable that so complex a theme as the evolution of the human mind and the gradual acquisition of the arts of civilization could be dealt with in fifteenth-century art. This accomplishment must be credited to the symbolizing faculty rather than to any scientific observations of primitive man by travelers.

Piero's account was derived from classical sources. The rediscovery of classical learning was an inherently humanistic enterprise at first, as Professor Hoeniger says of natural history elsewhere in this volume. Techniques such as critical acuity and fidelity to sources were perfected in literary studies before they were taken up in experimental science (such as the inquiries of Pascal in

Piero di Cosimo, *Vulcan and Aeolus,* The National Gallery of Canada, Ottawa. The figure in the foreground may symbolize the sleep of reason from which civilization is awakening. The invention of the horseshoe at the dawn of civilization.

atmospheric physics, for example). In the preface to his *Treatise on the Vacuum* (1647) Pascal complained vehemently about the predominance of humanistic motives. "The common respect for antiquity is today at such a pitch, in matters where it should have little force, that people make oracles of all of antiquity's thoughts, and sacred mysteries even of its obscurities; so that one can no longer propose novelties without peril, and the text of an author is enough to upset the strongest reasons." He argued that such respect for authority might be appropriate in history and theology, "in short, all those matters which have for principle either the simple fact, or the divine or human institution. . . . It is quite otherwise with those matters which are subject to the senses or the reasoning process; authority there is useless; reason alone has the right to judge of them. . . . Thus geometry, arithmetic, and all the sciences which are subject to experiment and reasoning, must ever be augmented to become perfect. The ancients found them only outlined by their predecessors; and we shall

leave them in a more perfect state than we received them."[14] Two centuries earlier, the visual arts were intent on conveying meanings derived from literary traditions. In 1500 the general European public had barely any knowledge of the New World or of Portuguese voyages to the Orient. Their world was still the classical oecumene, that portion of the globe known to men of ancient times, from the Fortunate Islands to China, north to Scandinavia, and south to the Equator.[15] When Ermolao Barbaro criticized the natural history of Pliny in his *Castigationes plinanae* (1492–93) he reexamined the textual sources he thought Pliny had consulted. He did not seek evidence from contemporary scientific observation.[16] Even after observing wildlife or plants on voyages, some travelers provided illustrations so stylized as to be of little descriptive value.[17] The impulse to render organisms naturalistically did not become manifest in the reports of travelers until late in the sixteenth century.

The early Christian church had restricted the employment of visual imagery in a conscious effort to safeguard spirituality. In this it was in agreement with ancient Hebrew canons as well as the attitude of Islam. Early Christian art was deliberately primitive in style, confined mostly to murals, mosaics, and low relief carvings. Jesus and his disciples were hieratic figures. The lack of pictorial depth and naturalistic detail in sacerdotal art was deliberate. Rather than engage people's sense of immediate experience, this symbolic program offered emblems with spiritual meanings that were fixed by convention, such as the lamb as an emblem of Christ or fish to signify the souls of the departed. The *Book of Miracles* of the Physiologus was a prime source for emblems such as these, including the self-wounding pelican, the unicorn, and the phoenix. The facts of nature were of little interest in such an outlook. Legends were prized for signifying divine truth with little regard for the truths of observation. The eagle, for instance, was supposed to be able to fly toward the sun and gaze unblinking into its glare. Parent birds would fly toward the sun carrying fledglings on their backs. Those unable to endure its brilliance would fall off and die. Only those who passed this test would be allowed to return to the nest with the parent birds. In this figure, the eaglets are like Christ's disciples, who alone are able to look on the face of God. Emblems like the eagle could be portrayed in a stylized manner because they were types bearing an allegorical relation to Scripture. "So it was," according to an account of religious symbolism given by Gilbert Cope, "that the natural history of the Middle Ages was subjected to a fantastic allegorization on the assumption that the phenomena of plant and animal life typologically reflected the divine order of the spiritual realm. Generally speaking, no effort whatever was made to check the accounts of animal life which were so used and the Bestiaries of the period are a fascinating jumble of fact and fiction."[18] Nonetheless, the artist who executed the hieratic emblem of the eagle family also left a book of designs with several straightforward naturalistic portrayals of birds such as the hoopoe. The transition from the emblematic to a more complex symbolic realm was to take place primarily through the representational gifts of such artists as Giovannino de Grassi (active in the latter part of the fourteenth century).[19]

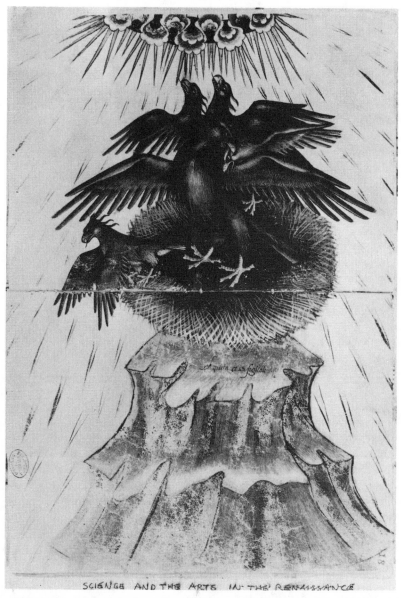

An emblematic portrayal of an eagle bearing fledglings toward the sun, from Giovannino de' Grassi, *Taccuino di Disegni codice della Bibliotheca Civica di Bergamo*, "Monumenta Bergomensia," 5 (1961), 18.

The medieval emblem was a direct substitute for what it signified. Because it corresponded in this direct way with its object and its meaning was fixed, the emblem functioned as a sign in the sense C. S. Peirce ascribed to that term. Organisms in the works by Piero and Botticini function on a more complex

level, as symbols. They do not merely *indicate* their objects in a static manner; they *represent* them, which is a more dynamic process.[20] They are capable of conveying a wide range of meaning, of engaging the imagination of the viewer and enabling him to transcend prior experience. It is this capacity to enrich the meaning of what is conveyed that makes both visual and spoken language so important in elaborating human culture. E. H. Gombrich considers this capacity to enlarge meaning the principal accomplishment of Renaissance art. "Maybe it is only by learning to appreciate the marvel of language that we can also learn to understand the growth of those alternative systems of metaphor which make great art more profound than any mystic hieroglyph can ever be."[21]

A remarkable instance of the wealth of reference and fecundity of meaning that may result from the symbolic faculty in a work of art is *Melencolia I* (1514) by Albrecht Dürer. In his discussion of the engraving, Panofsky emphasized that these capacities derived from the replacement of the narrow range of the emblem by the wider range of the symbol. He considered the primary meaning of the work to be the attainment of knowledge by magical means.[22] As a historian of science, I am inclined to interpret the saturnine aspect of Dürer's geometrical muse in the engraving as frustration over the failure of Renaissance mathematicians to discover simple numerical harmonies when they started measuring objects from the world of nature. The German poet and novelist Günter Grass adds a modern note, that the figure represents "the dark side of utopia," a social state of mind resulting from our century's stubborn clinging to the status quo.[23] That a single work could be taken to represent Dürer's theory of art, the powers of magic, the condition of Renaissance science, and frustration over the slow pace of social change is a remarkable testament to the power of the symbolizing faculty.

Images that served merely as emblems or icons for conventionalized items of religious faith did not have to render their objects naturalistically. The medieval images that are most recognizable to the modern naturalist are those whose function was decorative. "Naturalistic representation must be sought not in learned treatises," A. Rupert Hall observed, "but in the work of craftsmen, artists, wood-carvers, and masons."[24] The distinguished ecologist G. Evelyn Hutchinson has taken a strong interest in the way birds and insects were portrayed in decorative works of art in the Middle Ages, such as illuminated devotional manuscripts. "Nature is here primarily interesting as a source of beautiful images," he writes of the late thirteenth-century Alphonso Psalter, remarking on a "splendid herring gull," a wood pigeon, cock and hen bullfinches, song thrush, green woodpecker, kingfisher, crane, blackbird, raven, and "beautiful green lizard."[25] The artist's lack of observational data is evident from his showing a wood pigeon with too many eggs. But, Hutchinson assures us, most of the organisms portrayed in these decorative works are recognizable as to species. This affords us a criterion of verisimilitude. In another manuscript, the Bird Psalter at the Fitzwilliam Museum, dating from about 1300, Hutchinson finds that characters diagnostic of the smew, mallard,

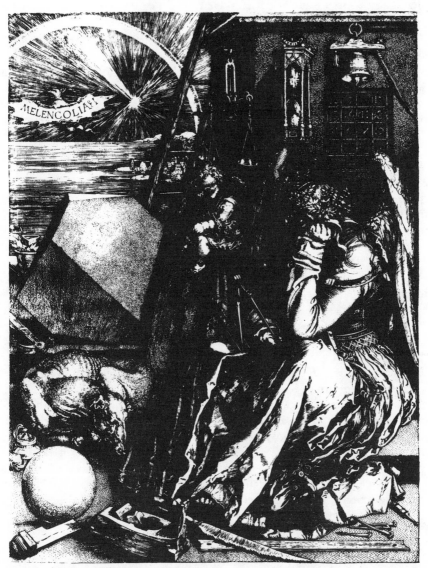

Albrecht Dürer, *Melencolia I* (1514), 239 × 168 mm., copperplate engraving, National Gallery of Art, Washington, D.C. Heinrich Wölfflin remarked that the geometrical solid presents a "mächtige Geheimnis," *Die Kunst Albrecht Dürers* (1905), 247. It is the figure of an acute rhombohedron truncated at either end of its principal axis so that its threefold rotational symmetry is preserved. Mathematicians did not elucidate these symmetry properties in crystals until three centuries later.

chough, jay, long-eared owl, and crane can be recognized in the birds appearing as marginal ornaments in the manuscript, and that there are excellent depictions of the woodcock and bullfinches. In all, twenty-three "reasonably

identifiable" species out of twenty-seven shown could be determined. "I sus-pect in general the avian decorations in the group of manuscripts here con-sidered are introduced primarily for aesthetic reasons and have little or no symbolic or didactic connotation."[26]

"Naturalism is older in art than in science," Hall concludes.[27] In Giorgio de Santillana's phrase, "art runs ahead of science."[28] De Santillana has argued that mere depiction of form did not suffice to make a portrayal scientific. Analysis of the relation of parts to whole and of the way characters delineate species differences among organisms is required in order to assimilate an image to the enterprise of science. "At a time when what *we* mean by science was still beyond the horizon, when the *name* of science was monopolized by scholastic officials, who officially denied to mathematics any link with physical reality, these men had conceived of an original prototype of science based on mathe-matics, which was to provide them with a creative knowledge of reality, re-peat—creative, and could claim the name of true knowledge in that it dealt with first and last things."[29] De Santillana regarded Brunelleschi as a key figure in a "flashover" from abstraction to practice as the basis of knowledge. This was accompanied by profound change in the social role of the artist, a reorientation toward material reality, the development of new sources of patronage, and the elaboration of a new theory of beauty. The result was "an assumption of responsibility for the whole body social, not only in the running of its affairs, but in its decisions about the first and last of things." On this interpretation, the innovation of greatest importance for the cultural program of Renaissance Europe was "a transformation of the intellectual axes" occurring in the arts.

Science needs to weed out ambiguous words from its discourses. Multi-plicities of meanings, to which artists could attain by employing symbols, are carefully avoided. Representations of objects become scientific not when they become recognizable but when they serve to convey knowledge of nature. When the *Herbarium vivae eicones* of Otto Brunfels appeared in 1530 it in-cluded woodcuts by Hans Weiditz whose aim was not to serve the canons of beauty but to refer unequivocally to the natural features of plants. "Prior to this production," George Lawrence has pointed out, "most of the early illus-trated herbals suffered from highly stylized representations that had been car-ried over from pre-incunable manuscripts. Weiditz's figures . . . were so literally accurate as to show the withering of a leaf, or damages due to insect depredation."[30] Dürer's noteworthy drawing of columbine in the Albertina dates from 1502. Agnes Arber spoke of a botanical renaissance in the sixteenth century, to which the arts made an indispensable contribution because natu-ralism was by then so well developed. She observed of the Brunfels herbal, "There was, as the title indicates, a real return to nature. The plants are repre-sented as they are, and not in the conventionalized aspect which had become traditional in the earlier herbals through successive copying of each drawing from a previous one, without reference to the plants themselves."[31]

If we want to assign a date to the advent of naturalistic observation in science, we might consider the great works of 1542–43, *De humani corporis*

EMBLEMA XLII. *De secretis Naturæ.* 177

In Chymicis verſanti Natura, Ratio, Experientia & lectio,
ſint Dux, ſcipio, perſpicilia & lampas.

EPIGRAMMA XLII.

DUx Natura tibi, túque arte pediſſequus illi
 Eſto lubens, erras, ni comes ipſa viæ eſt.
Det ratio ſcipionis opem, Experientia firmet
 Lumina, quò poſſit cernere poſta procul.
Lectio ſit lampas tenebris dilucida, rerum
 Verborúmque ſtrues providus ut caveas. Z CAS-

The philosopher and chemist must follow in the footsteps of nature, an allegory of naturalism from Michael Maier, *Atalanta fugiens, hoc est, Emblemata nova de secretis chymica* (Oppenheim: J. T. de Bry, 1618).

fabrica by Vesalius and *De historia stirpium commentarii* of Leonhard Fuchs.[32] Both reveal their debt to the art of painting, Vesalius in the landscape of the Euganean hills visible in the background of the plates of dissected figures and Fuchs in a more direct way. The last page of his botanical compendium included a woodcut of the draftsman and engraver who so greatly contributed to its success. Shortly afterward, in 1551 and 1553, the first two volumes of Konrad Gesner's *Historia animalium* inaugurated a new approach to zoological illustration.[33] Some title pages of scientific works continued to display artistic motifs in baroque profusion well into the eighteenth century, but the role of the arts was a circumscribed and auxiliary one by that time.

Herbert Read concludes that art has repeatedly aided the human mind in the

Heinrich Füllmaurer and Albert Meyer, illustrators of *De historia stirpium commentarii* (1542) by Leonhard Fuchs.

development of its powers. It has been by groping beyond the threshold of current knowledge with the aid of sensuous imagery that men have been able to extend their awareness of reality. "It is only in so far as the artist establishes symbols for the representation of reality that mind, as a structure of thought, can take shape. The artist establishes these symbols by becoming conscious of new aspects of reality, and by representing his consciousness of these new aspects of reality in plastic or poetic images."[34] The elevation of organisms to the symbolic level required a refinement of imagery to replace the allegorical illustrations of the Middle Ages. By elaborating decorative motifs into naturalistic representations of organisms, artists succeeded in meeting the demands of the more complex symbolic program they sought to pursue. It was to be another century or more before this innovation in art made itself felt in contributions to the sciences of anatomy, botany, and zoology. Naturalistic representation then began to play its role as an auxiliary scientific technique. The visual faculty with which these sciences observed nature was earlier employed by painters and owed its perfection to the demanding symbolic programs they pursued.

NOTES

1. Julius Schlosser, *Die Kunst- und Wunderkammern der Spätrenaissance* . . . (Leipzig: Klinker

& Biermann, 1908). For an example of art and natural objects intermixed in a collection see Frans Francken d.J., *Kunst und Raritätenkammer*, in Walter Bernt, *Die niederlandischen Maler des 17. Jahrhunderts* 1 (Munich: Bisher Bruckman, 1948): 290. Also G. Evelyn Hutchinson, "The Naturalist as an Art Critic," *Proceedings of the Academy of Natural Sciences of Philadelphia* 115 (1963): 99–111.

2. G. E. Hutchinson, "The Influence of the New World on the Study of Natural History," in Academy of Natural Sciences, Philadelphia, Special Publication 12, *The Changing Scene in Natural Sciences, 1776–1976* (1977).

3. One set is in the collection of Mrs. Paul Mellon; the other was sold to an anonymous purchaser by a London gallery in the 1950s. For individual panels see Ralph Warner, *Dutch and Flemish Flower and Fruit Painters of the XVIIth and XVIIIth Centuries* (London: Mills & Boon, 1928), plates 58a and 58b.

4. Ingvar Bergström, "George Hoefnagel, le dernier des grandes miniaturistes flamands," *l'Œil*, no. 101 (May, 1963): 2–9. Also Ernst Kris, "Georg Hoefnagel und der wissenschaftliche Naturalismus," in Arpad Weixlgärtner und Leo Planiscig, eds., *Festschrift für Julius Schlosser* (Zurich: Almathea, 1927), 243–53.

5. On "disguised symbolism" see Erwin Panofsky, *Early Netherlandish Painting; Its Origins and Character* (Cambridge: Harvard University Press, 1953), 140–44. Also Ingvar Bergström, *Dutch Still-life Painting in the Seventeenth Century*, trans. C. Hedström and G. Taylor (New York: Thomas Yoseloff, 1956), figs. 8–15 and pp. 14–19, 33, and 291–93. Also I. Bergström, "Disguised Symbolism in 'Madonna' Pictures and Still Life," *The Burlington Magazine* 97 (1955): 303–8 and 340–49.

6. Wilfrid Blunt and William T. Stearn, *The Art of Botanical Illustration*, "New Naturalist" (London: Collins, 1950), plate 16 and 123.

7. P. C. Ritterbush, "The Shape of Things Seen: The Interpretation of Form in Biology," *Leonardo*, vol. 3 (1970), fig. 4, 310. Another, highly naturalistic, leaf of the *Taccuino di Disegni* is also reproduced. Cf. Ritterbush, *The Art of Organic Forms* (Washington, D.C.: Smithsonian Institution Press, 1968) and "Organism: An Environmental Theme in the Arts," *The Structurist*, no. 11 (1971), 19–23.

8. Émile Michel, *Rubens His Life, His Work, and His Time*, trans. E. Lee (London: William Heinemann, 1894), 2:85.

9. M. Éemans, *Breughel de Velours* (Brussels: Éditions Meddens, 1964), frontispiece and fig. 3. Also Gertrude Winkelmann-Rhein, *The Paintings and Drawings of Jan "Flower" Bruegel*, trans. Leonard Mins (New York: Harry Abrams, 1969), plate 9 and fig. 23; fig. 1 for the portrait. Also Roger Avermaete, *Rubens and His Times* (1964), trans. Christine Trollope (New York: A. S. Barnes, 1968), chap. 8.

10. Lynn White, Jr., "Natural Science and Naturalistic Art in the Middle Ages," *American Historical Review* 52 (1947): 421–35. Also Otto Pächt, "Early Italian Nature Studies and the Early Calendar Landscape," *Journal of the Warburg and Courtauld Institutes* 13 (1950): 13–47.

11. Herbert Friedmann, "Footnotes to the Painted Page; the Iconography of an Altarpiece by Botticini," *The Metropolitan Museum of Art Bulletin* (Summer 1969): 16. Also *The Symbolic Goldfinch; Its History and Significance in European Devotional Art* "Bollingen Series VII" (Pantheon Books, 1946). Also *A Bestiary for St. Jerome* (Washington, D.C.: Smithsonian Institution Press, 1980), esp. his discussion of the grasshopper or locust in "Master of the Life of St. John the Baptist," *Madonna and Child with Angels*, National Gallery of Art, Washington, D.C. For Platonic philosophy as a source of pictorial symbolism see Otto J. Brendel, *Symbolism of the Sphere; a Contribution to the History of Earlier Greek Philosophy* (Leyden: E. J. Brill, 1977), and William M. Ivins, Jr., *Art and Geometry; a Study in Space Intuitions* (Cambridge: Harvard University Press, 1946).

12. Erwin Panofsky, "The Early History of Man in Two Cycles of Paintings by Piero di Cosimo," *Studies in Iconology; Humanistic Themes in the Art of the Renaissance* (Oxford: Oxford University Press, 1939), 33–67.

13. Mina Bacci, ed., *L'opera completa di Piero di Cosimo*, "Classici dell'Arte" (Milan: Rizzoli, 1976).

14. Morris Bishop, *Pascal; the Life of a Genius* (New York: Reynal & Hitchcock, 1936), 71–72.

15. Paul Hazard, *The European Mind (1680–1715)* [1935], trans. J. Lewis May (London: Hollis & Carter, 1935), 363–64 on paintings by travelers. Also John H. Parry, *The European Reconnaissance, Selected Documents* (New York: Walker, 1968) and Boies Penrose, *Travel and Discovery in the Renaissance* (Cambridge: Harvard University Press, 1967).

16. Allen G. Debus, *Man and Nature in the Renaissance* (Cambridge: Cambridge University Press, 1978) cites this and quotes an early plea for direct observation by Peter Severinus, 21; also Rabelais, *Les œuvres*, ed. Ch. Marty-Leveaux, vol. 1 (Paris: Lemerre, 1870), 256. On the persistence of the classicizing temper in ethnography see Bernard Smith, *European Vision and the South Pacific 1768–1850; a Study in the History of Art and Ideas* (Oxford: Oxford University Press, 1960).

17. L'Institut Français d'Archéologie Orientale du Caire, *Voyage en Egypte, Pierre Belon* (1547). Also Joan Barclay Lloyd, *African Animals in Renaissance Literature and Art* (Oxford: Oxford University Press, 1971).

18. Gilbert Cope, *Symbolism in the Bible and the Church* (New York: Philosophical Library, 1959), 56. Also Johan Chydenius, "The Theory of Medievel Symbolism," Societas Scientarum Fennica, *Commentationes Humanarum Litterarum* 27:2.

19. Sir Martin Conway, "Giovannino de'Grassi and the Brothers van Limbourg," *The Burlington Magazine* 18 (Dec. 1910) 93:144–49 including a reference to "another book of animal drawings on vellum by the same hand as the Bergamo volume."

20. Susanne Langer, *Philosophy in a New Key: A Study in the Symbolism of Reason, Rite, and Art* (Cambridge: Harvard University Press, 1942), 60, 103. Cf. C. S. Peirce, *Collected Papers*, C. Hartshorne and P. Weiss, eds., vol. 2 (Cambridge: Harvard University Press, 1932), bk. 2. Cf. Arthur W. Burks, "Icon, Index, and Symbol," *Philosophy and Phenomenological Research*, 9 (1949): 673–89.

21. E. H. Gombrich, *Symbolic Images: Studies in the Art of the Renaissance* (New York: Phaidon, 1972) "Icones Symbolicae: Philosophies of Symbolism and Their Bearing on Art," 191. Michael Roberts distinguished sign from symbol in his *Critique of Poetry*, one of a number of works cited by F. W. Dillistone in *Christianity and Symbolism* (London: Collins, 1955).

22. Erwin Panofsky, R. Klibansky, and F. Saxl, *Saturn and Melancholy Studies in the History of Natural Philosophy, Religion, and Art* (New York: Basic Books, 1946).

23. Günter Grass, *From the Diary of a Snail* (London: Secker & Warburg, 1974), 115 and concluding essay, "On Stasis in Progress," 310.

24. A. Rupert Hall, *The Scientific Revolution 1500–1800: The Formation of the Modern Scientific Attitude* (London: Longmans, 1954), 28.

25. G. E. Hutchinson, "Zoological Iconography in the West after A.D. 1200," *American Scientist* 66 (1978): 677. Also see W. B. Yapp, "The Birds of English Medieval Manuscripts," *Journal of Medieval History* 5 (1979): 315–48. He cites several instances of identifiable birds, principally in manuscript decoration, between 1260 and 1330, and suggests that this nearly always means that the artist was drawing from nature or a specimen. Also Francis Klingender, *Animals in Art and Thought to the End of the Middle Ages*, ed. E. Antal and J. Harthan (Cambridge: MIT Press, 1971). On pastoral as a genre in which allegorical portrayals of rural society during the Middle Ages were displaced by "values of art" see Helen Cooper, *Pastoral: Mediaeval into Renaissance* (London: Rowman & Littlefield, 1977).

26. G. E. Hutchinson, "Attitudes toward Nature in Medieval England: The Alphonso and Bird Psalters," *ISIS* 65 (1974): 22, plates 1–3, 8–13, and taxonomic list, 18.

27. Hall, *Scientific Revolution 1500–1800*, 29.

28. Giorgio de Santillana, "The Role of Art in the Scientific Renaissance," *Critical Problems in the History of Science*, ed. Marshall Clagett, University of Wisconsin, Institute for the History of Science (1959), 33, 60–61. Cf. Robert Oertel, *Early Italian Painting to 1400* (New York: Frederick A. Praeger, 1968), 10.

29. Ibid., 45, 48.

30. George H. M. Lawrence, "Herbals, Their History and Significance" *History of Botany*, University of California at Los Angeles, Clark Memorial Library (1965), 14.

31. Agnes Arber, *Herbals Their Origin and Evolution; a Chapter in the History of Botany 1470–1670*, 2d ed. (Cambridge: Cambridge University Press, 1938), 55.

32. Münchener Beiträge zur Geschichte und Literatur der Naturwissenschaften und Medizin, no. 13–14 (1928), Eberhard Stübler, *Leonhart Fuchs Leben und Werk.*

33. Hans Fischer et al., Conrad Gesner 1516–1565 Universalgelehrter Naturforscher Arzt (Zurich: Orell Füssli, 1967).

34. Herbert Read, *Icon and Idea: the Function of Art in the Development of Human Consciousness* (Cambridge: Harvard University Press, 1955), 53. A sketch for the figure in the Sächs. Landesbibliothek appears as fig. 68, plate 18, in Max Steck, *Dürers Gestaltlehre der Mathematik und der bildende Künste* (Halle: Max Niemeyer, 1948). Steck interpreted the figure as derived from the octahedron on the advice of gemologist Paul Grodzinski, "Theoretische Beiträge zu Albrecht Dürers Kupferstich 'Melencolia I' von 1514," *Forschung und Fortschritte*, 32d year (1958), 246–51. Although Steck thought it "a skillful fantasy" and Wölfflin remarked on its "unkristallinische Oberflächenzeichnung," nineteenth-century crystallographers found that the mineral calcite in fact crystallizes in this form. Cf. Alfred Lacroix, *Minéralogie de la France . . .* (Paris: Librairie du Muséum René Thomas, 1977), vol. 3, fig. 109, 488, and Jacques-Louis, Comte de Bournon, *Traité complet de la chaux carbonatée . . .* (London: William Philips, 1808), vol. 3, fig. 156.

The Renaissance Development of the Scientific Illustration*

Samuel Y. Edgerton, Jr.
Williams College

There is hardly a more familiar artifact of modern life than the so-called scientific illustration. That is, the diagram or picture in isometric or linear perspective with notations for scale and measurement which show how machines or houses or even human beings are put together and taken apart and how they work. Who, indeed, has never depended on such an illustration for assembling a Christmas bicycle or a Sears & Roebuck porch swing (not to mention for constructing an atomic reactor or preparing for open heart surgery)? So taken for granted is the ubiquitous scientific illustration that few scholars have ever sensed that it has any historical interest. Most art historians have disdained it. They have investigated scientific pictures only when drawn by great creative geniuses like Leonardo da Vinci. Otherwise, they consider the genre remarkably inimical to creativity, a mere prostitute to someone else's verbal text.

Historians of science have shown a little more curiosity, but they too tend to treat scientific pictures only as afterimages of verbal ideas. Few historians of any kind have studied the scientific illustration as a unique form of pictorial language, with its own "grammar and syntax"; that is, symbols and conventions conveying information just as do words and sentences.[1] Nor have many scholars ever applied to the scientific illustration the tools of iconology, that wonderful subdiscipline of art history which explains how pictorial symbols work, how they are derived and change in form and meaning, and most important of all, how they reveal profound truths about the society which produced them.[2]

I would like to offer here some ideas of my own about the origin and

development of the scientific illustration, indeed, its special iconology in the context of Western Christian civilization at the time of the Renaissance from the fourteenth through the sixteenth centuries. What is especially interesting about this development was its steady progress toward the sheer objectification of forms without due sacrifice of esthetic quality. No other tradition of pictorial representation, in classical antiquity, in China or Islam during their artistic heyday, ever achieved such objective power. In fact, at its best, the Renaissance scientific picture gave precise information about the physical world not only without need of explanatory texts but without the need for the viewer to refer to the actual objects depicted. It may have been of no small significance to their later contributions that the first generations of "modern" scientists like Francis Bacon, Galileo, William Harvey, and Descartes, were also the first to have before them as schoolboys scientific textbooks illustrated in the new Renaissance chiaroscuro and linear perspective style.

Art historians of all periods and cultural specializations recognize one other quality of Western art unshared with the arts of anywhere else. This was the propensity, first noticeable in the painting of classical antiquity, to think of the picture as a fictive window or hole in the wall or book page. During the early Middle Ages, this concept was somewhat forgotten as Christian art was more influenced by oriental flatness. But suddenly, in the late thirteenth century, the picture-as-window was revived, especially in the fresco cycles celebrating the life and miracles of St. Francis of Assisi in central Italy. The startlingly sculpture-like figures in these paintings, many attributed to Giotto and enframed as if inset on a three-dimensional stage, mark the beginning of the Renaissance for art historians. Almost at the same time, the revival of the picture-as-window began to occur in the manuscript illuminations of artists working in the royal court of France.[3]

What is important to our subject here is that this revived "window" notion had inexorable consequences for Western art. It began to force the artist to think of the various details in his pictures as seen from a more or less fixed view point, as if he were looking at them from the center of an opening through a frescoed wall or illuminated page. This tendency culminated, of course, in linear perspective and in the perfection of drawing light and shadow effects; i.e., the representation of chiaroscuro in two-dimensional artistic media. A superb example of this purely Western achievement is a painting by Antonello da Messina, circa 1450–55, entitled *St. Jerome in his Study*. It is interesting to compare this masterpiece of the flowering Italian Renaissance to a Chinese painting of about the same period, that is, from the Ming Dynasty, circa 1530, by Zhou Chen called *Dreaming of Immortality in a Thatched Cottage*. What these two pictures together show is not just a difference in artistic style but a monumental difference in perception of nature itself. In the Chinese painting we see a philosopher leaning on the sill of his hut at the lower right. In his dreamy contemplation, the philosopher projects himself into the infinite landscape where we see him again, mystically levitated, as he ponders the transience of nature. Whether the artist intended this lovely mountainscape to be an

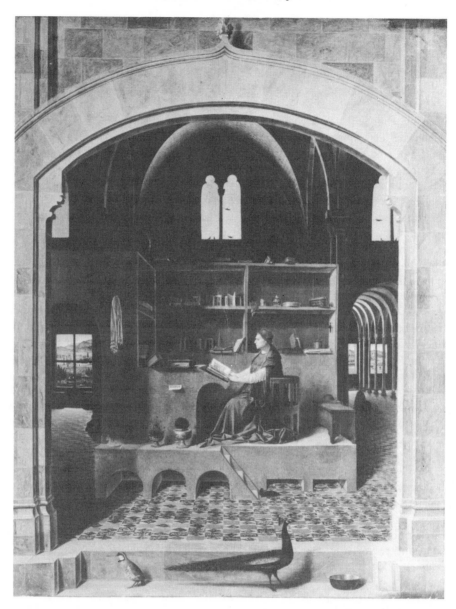

Antonello da Messina, *St. Jerome in His Study*. Trustees of the National Gallery, London.

illusion of extending space or not, he still added the inscription, at upper left, right on the picture surface without any apparent conflict in his mind that the flatness of the verbal inscription contradicted the illusion of pictorial depth. Indeed, Chinese artists never considered that they should portray nature as if

Zhou Chen, *Dreaming of Immortality in a Thatched Cottage*, ca. 1530. Freer Gallery of Art, Washington, D. C.

seen through a window, so they never felt bound by the need for consistency which the fixed viewpoint demanded of their Western counterparts. In Antonello's painting, on the other hand, St. Jerome, the quintessential Western philosopher, sits rationally in a perfectly tangible space, constructed illusionistically but according to the same geometrical principles as any actual, carpentered room. This illusionistic room is filled with light and shadow according to the exact laws of geometric optics, the same science from which were derived the principles of linear perspective. St. Jerome ponders immortality just as does the Chinese philosopher in Zhou Chen's painting, but in Western Christian thought, the ineffable is fixed and static, conforming to Euclidian rules. Indeed, the very laws of Euclidian geometry and optics, so much a part of the iconology in Antonello's picture, were believed even by the early Christian fathers to explain how God spreads his divine grace throughout the universe. Chinese philosophy, on the other hand, argued for a dynamic cosmos undergoing flux and change. The Chinese philosopher in Zhou Chen's painting contemplates this fluidity of nature as he floats in an imprecise atmosphere. His thoughts, like the lack of rationale for his levitation, transcend the fixedness of Euclidian geometry, a science which the Chinese did not known until it was introduced to them by the Jesuits in the seventeenth century. "Space" in Chinese philosophy was thus never endowed with abstract structure; that is, it was never imagined as a static medium into which objects could be fitted as if in a three-dimensional lattice-work. Chinese artists like Zhou Chen did develop sophisticated and esthetically beautiful iconological conventions for communicating the transience and rhythms of nature, but they were never interested in representing nature as a static entity. Hence, they never felt the need to develop those other iconological conventions necessary to Western art, namely convergent linear perspective and light and shadow rendering.

One of the earliest and most persistent iconological conventions to appear in European picture making, which shows how Western artists were indeed responding to the peculiar consistencies of the picture-as-window, was the curling banderole or scroll as a device for bearing verbal inscriptions. Instead of merely inscribing on the picture surface as did the Chinese artist, the Westerner

felt the need to have his verbal inscription conform to the same illusionistic space structure which ordered all the other objects in the picture-as-window. In religious art especially this convention proved useful, for presenting conversations between holy figures such as the Angel Gabriel and the Virgin Mary and also for identifying prophets and saints.

In a woodcut print of the human skeleton published by Ricardus Helain of Nuremberg in 1493, we see how the illustrator borrowed the same convention for displaying the names of the various bones. To be sure, the by-now ubiquitous banderole in Renaissance art did not lend clarity to scientific pictures, and illustrators quickly returned to flat, easier-to-read labels. However, if the banderole was not an adjunct to clarity, it was to the macabre effect of the image, thereby making the print more salable and popular in the Christian context of a memento mori. Helain's diagram is a good example showing the ease with which Renaissance artists could apply the iconography of Christianity to secular science. Since earliest times Christian art had been didactic in purpose, like no other artistic tradition uninfluenced by the West has ever been. Helain's skeleton indicates how a stock Christian motif could be reenlisted in scientific service with little change in didactic intent. By knowing the names of the bones in his body, the good Christian should better appreciate his own mortality and inevitable fate.

The greatest impetus to scientific illustration during the Renaissance, however, came from yet another peculiarity of Western European culture. This was the special profession of *ingegnere*, best translated into modern English as "artisan-engineer." Both Filippo Brunelleschi, the architect, and Leonardo da Vinci, the painter, considered themselves as *ingegneri* first and "artists" in our more familiar self-expressive sense only secondarily. The profession of *ingegnere* was much honored in the Renaissance because it descended from a venerable classical tradition, from Archimedes, Philon, and Hero of Alexandria.[4] In fact, the legends of Archimedes never even went out of fashion during the Middle Ages as Marshall Clagett has shown.[5] In the thirteenth century, the Archimedean tradition was associated with the construction of Gothic churches, as is evident in the surviving notebooks of Villard d'Honnecourt, the Picard artisan-engineer who may have worked at the Cathedral of Rheims. Kept alive in Villard's drawings was also the ancient fascination for gear-driven automata, toylike machines powered by wind, water, or animal.[6]

Yet another attitude encouraging the renascence of Archimedean tradition was what we may call the "crusade mentality" of medieval Christian Europe. Certainly, fear of the Turk was one of the foremost "red herrings" of European politics of the time, and the desire to retrieve the Holy Land became an archetype imbedded in the European imagination to this day. As the Roman popes continually urged the sending of expeditionary armies against Islam, Christian princes began assiduously to patronize military science, even if they had little enthusiasm for crusading and much more for acquiring the lands of their own Christian neighbors. In response to these politics, many ambitious artisan-engineers found employment at court serving as military advisors, instructing

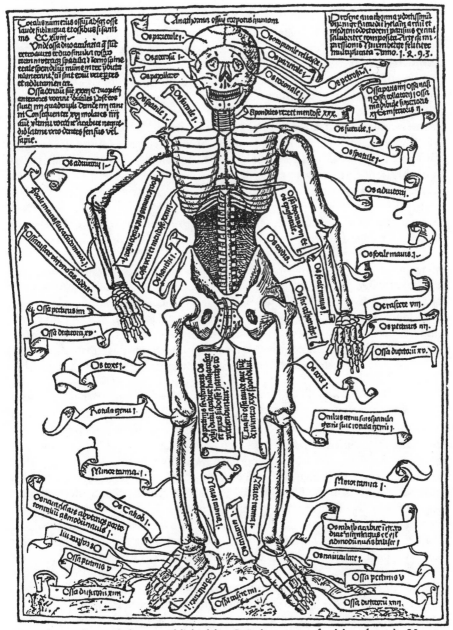

Ricardus Helain, *Skeleton*, published by Grüninger as a fugitive sheet in Nuremberg, 1493.

their lords on how to build offensive and defensive weapons and also hydraulic machinery, mills, pontoon bridges, and all other needs for an army on the march and fighting in a hostile environment.

A good example of this sort of patronage is that of King Philip VI of France

for Guido da Vigevano, Italian engineer and physican during the mid-trecento. Guido wrote two treatises, the first dedicated to the king in 1335 called *Texaurus Regis Francie acquisicionis terre sancte . . .* , or "Treasury of the King of France for the Recovery of the Holy Land," in which are descriptions and pictures of military machines.[7] The second treatise is entitled simply *Anathomia* and was written about ten years later.[8] It also contains a handsome set of colored illustrations concerned with medical practice. As one may quickly note, each of the two examples shown here seems to be drawn by a different hand. Guido, in spite of his diverse talents, was not an artist and probably sent out his texts to be illustrated by local manuscript illuminators. The artist of the illustration from the *Texaurus* has tried to follow Guido's instructions for designing a mobile assault tower. However, he had difficulty in showing the complex crank, gear, and wheel mechanism which propelled the tower. Since he had no ready convention at hand for depicting how gears intermesh or the way wheels turn on perpendicular axles, he resorted to what some perceptual psychologists today would term a "split-view" interpretation. He represented all the details of the machine as if seen each from its most characteristic aspect. Wheels, axles, and gears thus appear to be collapsed on one another, so that the essential mechanical feature of this machine, the transmission of power across right angles, is impossible to discern from the picture. Modern psychologists have often noted that this form of "naive" representation is frequent among so-called primitive peoples and even children.[9]

The artist of Guido's anatomical diagram, however, seemed to possess a more sophisticated sense of how to render the third dimension. Here he showed a full-length view of a cadaver with a degree of naturalism almost befitting the contemporaneous Giotto school in Italy. What is especially noteworthy is the detail of the abdomen, which the artist displayed as if the skin were cut and pulled apart like open doors. This picture introduced a number of others in the text showing the same figure with its various internal organs exposed. Guido's artist was trying to make his human figure intelligible as a hollow cylinder. He needed a convention by which the viewer could be convinced that he was looking beyond an external surface and into the concave hollow which contained the visceral organs. This artist, in fact, has anticipated the "cutaway view" which today everyone, even school children, take for granted in textbook explanatory diagrams (see p. 176).

There are probably hundreds of such artisan-engineer manuscripts still extant in libraries throughout the world. Some are beautifully illustrated, some crudely, and some not at all, but it must be said that all the illustrations from manuscripts before the Renaissance are in the "naive" category, uniformly lacking in perspective naturalism. Few even show much perception of light and shadow modeling.

Indeed, not until about the middle of the fifteenth century in Italy do we find any artisan-engineers who apply "realistic" artistic techniques and conventions. This is only natural because linear perspective and chiaroscuro rendering were both products of the Italian Renaissance. The introduction of linear per-

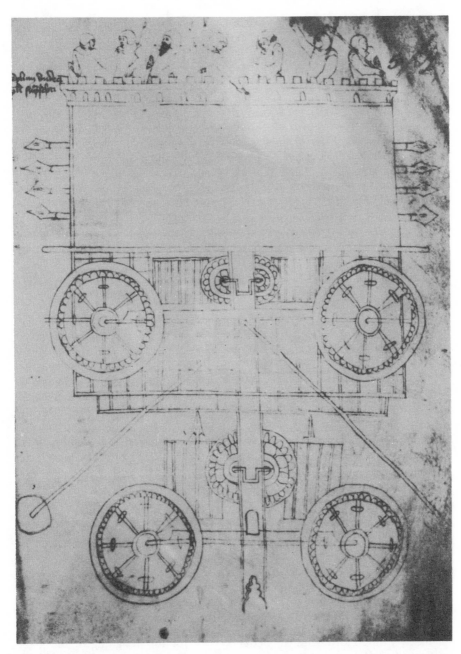

Drawing for a Mobile Assault Tower, from the *Texaurus* of Guido da Vigevano, MS. Lat. 11015, Bibliothèque Nationale, Paris.

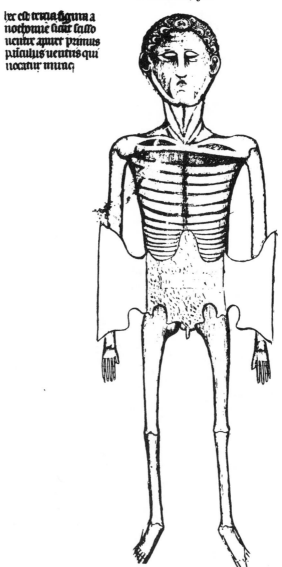

Drawing of a Cadaver from Guido da Vigevano, *Anothomia.* **MS. 334, Musée Condé, Chantilly.**

spective in particular can be directly traced to the experiments of one artisan-engineer, Filippo Brunelleschi, better known for his designing of the great dome over the Florentine Duomo completed in 1436. Brunelleschi himself left us not one single drawing of any sort. Whatever notebooks he may have kept, illustrated or not, have disappeared. We only know of his exploits through the testimony of contemporaries. Fortunately, one of these did keep illustrated notebooks which are not only extant but give evidence in their own right of the

Renaissance artistic revolution in scientific drawing technique and in the designing of practical, workable machines. This contemporary artisan-engineer was Mariano di Jacopo called Taccola. He lived in Siena, officially as a notary, but his real passion was to become the "Sienese Archimedes" as he called himself. He managed to secure commissions working on the city's roads and water supply, and, in the 1430s, hoped to gain an even more prestigious appointment as engineer to the Holy Roman Emperor. This latter ambition might have been the occasion for his writings, for we now have a number of preparatory manuscripts for at least two treatises, one called *De ingeneis* and the other *De machinis*, "On Engines" and "On Machines."[10] The texts of these notebooks are in Latin accompanied by numerous little drawings. Taccola was certainly not a great artist, but he did have more talent than any of his artisan-engineer predecessors since Villard d'Honnecourt. He had been raised after all in Siena, a city second only to Florence as art center in the early Renaissance. He also knew Brunelleschi personally and recorded a conversation with the great man about the tribulations of the engineering profession.[11] Taccola, however, mentions nothing of Brunelleschi's perspective experiments, nor is there any evidence that he applied these theories directly in his drawings. Nonetheless, he was the first artisan-engineer to follow certain corollaries inherent in Brunelleschi's perspective system: namely, a more or less uniform viewing point for all objects in the same picture, and the drawing of size relationships in the picture which correspond to the real perspectival world.

A page from Taccola's *De ingeneis* shows a number of sketches of cannon types (see illustration). In the upper right corner, we may observe how this artisan-engineer tried to depict one cannon as if pulled apart with its powder chamber away from the barrel and the cannon ball suspended in front. Here is perhaps one of the earliest "exploded views" in the history of modern engineering. Oddly enough, the new Brunelleschian perspective system not only guaranteed geometric consistency in pictures, but it also granted the artist the right to suspend the laws of gravity in his pictorial world. Once perspective consistency is understood and the depicted objects perceived in their proper size, scaled according to distance, the viewer may imagine solid objects floating freely in space, such as the two halves of the cannon which he can then reconnect in his mind's eye because the nipple on one part and the hole in the other are proportioned to fit one into the other.

Of the two additional drawings from Taccola's notebooks shown here, the former shows a catapult for hurling fire bombs. The artist not only designed the complete machine but also added scale details of variations on the throwing mechanism. These are each identified by a letter and referred to in the text. What Taccola achieved in all these drawings were not new machines as such but new or improved conventions for *designing* machines, based on the new art-science of applied optics.

Perhaps his most far-reaching contribution to scientific drawing is seen in the "transparent view" of a suction pump. The viewer is asked to observe this device as if its encasing cylinder, here shown with a bit of shading to indicate

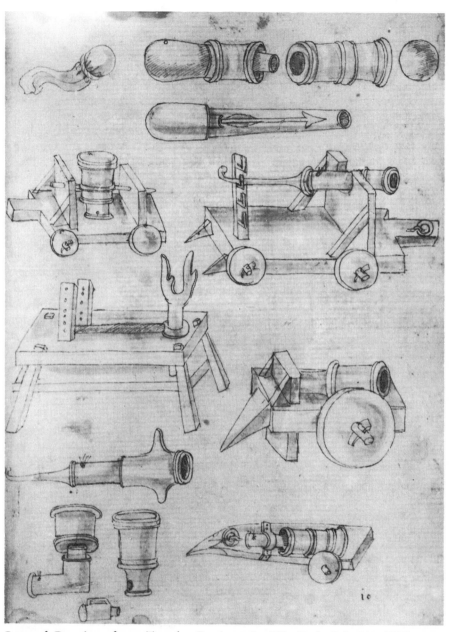

Page of Drawings from Taccola, *De ingeneis,* MS. Cod. Pal. 766, Biblioteca Nazionale, Florence, ca. 1433.

the convex outer surface, is transparent, exposing the piston and flap-valve mechanism inside. I would like to think that Taccola did not just invent this pump type, as one historian of technology has recently claimed,[12] but that he was the first to develop the perspectival "transparent view," and that only because of this latter contribution do we have first evidence of the machine. In other words, whether or not this suction pump was already known, Taccola's drawing now made it possible for anyone to understand the principle and to construct the pump without having to see first hand an actual working model.

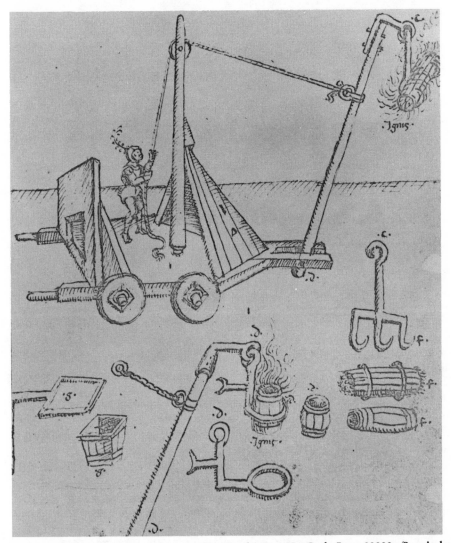

Page of Drawings from Taccola, *De machinis*, MS. Cod. Lat. 28800, Bayrische Staatsbibliothek, Munich.

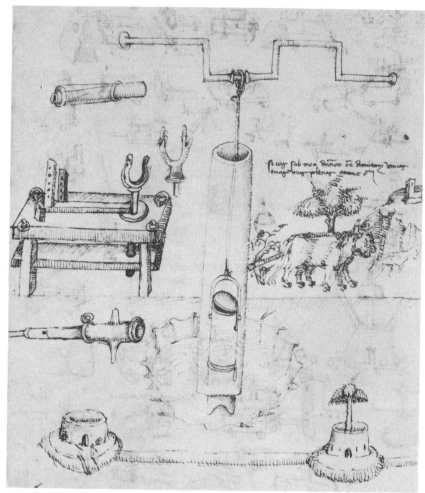

Page of Drawings from Taccola, *De ingeniis*, Cod. Lat. 197, Bayrische Staatsbibliothek, Munich.

Taccola's ideas and many of his original drawings passed into the hands of his fellow Sienese Francesco di Giorgio Martini during the second half of the fifteenth century. The latter had also read the recently available ten books on architecture by the ancient Roman Vitruvius. It therefore occurred to Francesco di Giorgio to write an even more ambitious treatise than Taccola's, covering not only military and civil engineering but containing designs for classical-style buildings.[13] He was also a better artist than Taccola; in fact, he was a practicing painter with a distinguished *oeuvre*, many examples of which are known and admired today. The manuscript pages shown here were written and illustrated by Francesco di Giorgio about 1475. The former is a description and reconstruction of a Roman bath. The artist neatly applied Taccola's "trans-

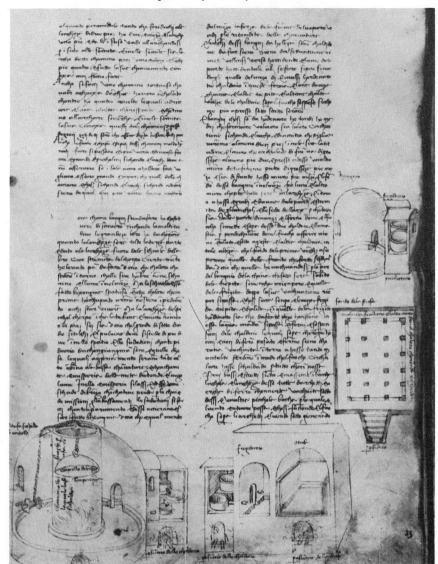

Page of Drawings from Francesco Di Giorgio Martini, *Trattato di architettura*, MS. Cod. Ashb. 361, Biblioteca Laurenziana, Florence.

parent view" technique to the exposition here of *tepidarium* and *frigidarium*. Perhaps Francesco di Giorgio's most ingenious application of the "transparent view" was to his own modification of Taccola's suction pump which we may observe in the second illustration of his pages, this one (from his *Trattato* manuscript now in the *Biblioteca Nazionale* in Florence) showing a number of water-raising devices. In fact, Francesco di Giorgio designed so many different

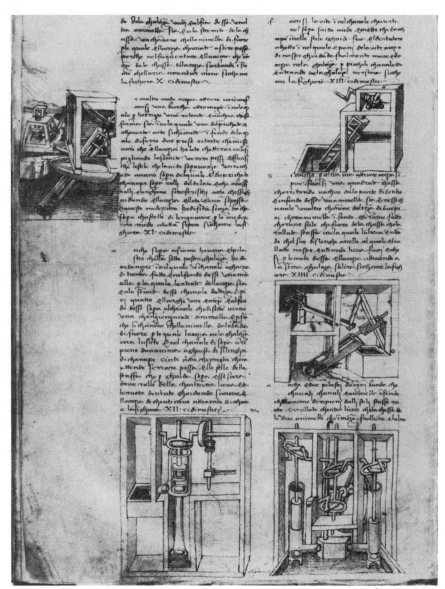

Page of Drawings from Francesco di Giorgio Martini, *Trattato di architettura,* ca. 1480. MS. Cod. Ashb. 361, Biblioteca Laurenziana, Florence.

water pumps that one can hardly believe that his drawings were merely copies of already existing, working models. It would seem, indeed, that these designs were either creations of his own imagination or modifications of drawings by others. This is to say that Francesco di Giorgio is one of the very first inventors in the history of technology who tested mechanical principles, designed appro-

priate machines, and worked out certain bugs apparent in the similar designs of his predecessors, almost entirely through the medium of drawing. Francesco di Giorgio's example may well have inspired Leonardo da Vinci, who owned and annotated one of the Sienese artisan-engineer's manuscripts.[14]

Let us analyze one such design in the *Trattato* example. In the lower right-hand corner of the illustration, we see Francesco di Giorgio's representation of a reciprocal suction pump after Taccola. In the original Taccola design (see illustration above), we note that the piston is attached to the crank by only a rope. This is because Taccola realized that the crank makes a rotary motion as it raises and lowers the piston, and this must naturally cause whatever connects the crank to the piston to oscillate. Since a rope is flexible, Taccola thought to use it instead of a more stable connecting rod which might unduly force the piston to bind against the cylinder sidewalls. Francesco di Giorgio, on the other hand, apparently felt that Taccola's pump was still inefficient so he compensated for the rotary motion of his crank by designing a solid connecting rod with a loop. A hollow roller was to be placed around the connecting arm of the crank which then slipped inside the loop. This would allow the connecting rod to move up and down without oscillation and without decreasing the pump's efficiency through unnecessary friction.

Francesco di Giorgio's machine-drawing conventions, derived and modified from Taccola, were much disseminated and copied during the late fifteenth and sixteenth centuries. Art historian Gustina Scaglia has examined dozens of manuscript notebooks from the period which attest to his widespread influence. Science historian Ladislao Reti has traced this influence on the printed "theater of machines" literature of the sixteenth, seventeenth, eighteenth, and even nineteenth centuries.[15] Since Leonardo da Vinci also had access to Francesco di Giorgio, it may well be true that his own scientific drawings, the most beautiful as well as informative pictorial documents on science ever seen up to the sixteenth century, owed to this revived artisan-engineer tradition which began in quattrocento Siena with Taccola. In a remarkable article on the fifteenth-century notion of "genius" and "invention," art historian Martin Kemp has shown that until the time of Leonardo, the word *ingegno* was rarely applied to makers of pictures. To earn that accolade, as did Brunelleschi in his epitaph, one had to be an architect or builder of actual machines. Toward the end of the century, however, the word *ingegno* begins to be associated with painters. This was clearly a tribute to their ability, as with Francesco di Giorgio and Leonardo, to draw pictures from which actual buildings and machines could then be constructed.[16]

Yet it is a sad fact that neither Leonardo's nor Francesco di Giorgio's manuscripts were ever set to type in the new printing press. Their revolutionary illustrations were never published over their own names until centuries later. Leonardo's drawings showed special ingenuity in the application of "exploded," "rotated," and "transparent" or "cutaway views," and he was also the first artisan-engineer to apply these postlinear perspective conventions to the representation of anatomical details. Leonardo himself was not resistant to

printing; he even made a drawing of a printing press, but he did not trust the artisans of his day who cut other people's pictures into woodblocks or copper engravings. In the 1490s there were few *Formschneider* skilled enough to render the subtleties and nuances of Leonardo's art into an acceptable print.

Another force also intervened in late fifteenth-century Italy which helped delay the printing of Francesco di Giorgio's and Leonardo's notebooks. This was the publication of Roberto Valturio's *De re militari* in 1472, the first printed book on engineering to appear in Western Europe. It had been commissioned originally by Sigismondo Malatesta, Lord of Rimini, infamous *condottiere* and famous patron of classical learning. Valturio's book was not so much a practical treatise as a humanist tract on ancient Roman warfare. Valturio himself was a Latin scholar with little field experience in engineering. He seems also to have bade his illustrator not to draw diagrams as aids to construction but rather as deliberately archaized images fashioned to look like ancient cameo decorations. Nonetheless, so popular did his book become that other princes and classical buffs ordered their own hand-illuminated manuscripts copied from the printed edition.[17] The Duke of Urbino even had sculptural reliefs made from some of Valturio's prints which were then mounted on the facade of his palace.[18] Valturio's *De re militari* only added to the general European obsession for things antique during the late fifteenth and sixteenth centuries, and managed, unfortunately, to discourage at the same time the printing of more practical books on military and civil engineering.

Not until the second decade of the new century, really, did the printing industry turn out scientific books in which the illustrations approached the quality of Francesco di Giorgio's or Leonardo's drawings. This resurgence of interest was due in part to the tremendous technological advances in the printing trade itself, in the reproduction techniques of the woodblock and copper engraving. In any case, the scientific illustration conventions of "exploded," "rotated," and "transparent views," were then carried over into the print media, and suddenly, after about 1517, there began a flow of books on all manner of technical subjects, such as surgery, architecture, mining and metallurgy, anatomy, ballistics, machines for hauling and lifting, hydraulics, and even books on how to draw in linear perspective. These illustrated treatises all exhibit consistent, highly developed scientific pictures in which the conventions we have been speaking about were commonly used and assumed to be universally understandable by all readers.

In this paper I can do no more than present a random sampling. This page from a German language surgical text written by Laurentius Phryesen was published by Johannes Grüninger of Strasbourg in 1518. The illustration is by an artist named Hans Wechtlin, a follower of Dürer, who drew a male cadaver, obviously from "life," in a sophisticated "cutaway view." Moreover, the artist added "exploded views" of the head which had probably been dissected only after he had sketched the whole body. Wechtlin shows here a series of views of the brain being removed from the skull, step-by-step, with even the cranial nerves depicted in one remarkable detail.[19]

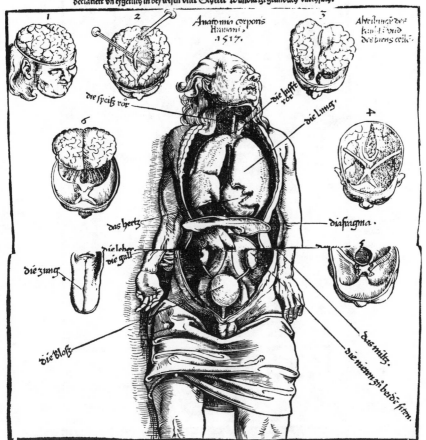

Hans Wechtlin, Woodcut print of an Anatomized Cadaver, from Laurentius Phryesen, *Spiegel der Artztney* Strasbourg, 1518. Francis A. Countway Library of Medicine, Harvard University, Boston, Mass.

Next pictured is a page from the 1556 Latin treatise *De re metallica* by Georg Bauer (Agricola). This large and learned volume on the mining and metallurgical industry is a recognized classic of the German wood-block artist's skill.[20] Here we see a beautifully composed picture of a double suction pump deployed in a mine shaft. The artist applied the "cutaway view" to the surface of the earth so that the insides of the mine are exposed like the viscera in Wechtlin's cadaver. He also showed the mechanism of the suction pump in a separate "transparent view" and again the disassembled parts of the pump "exploded" on the ground at lower right. These by now taken-for-granted conventions were similarly applied in all the illustrated, printed scientific literature of the later sixteenth century, especially in the wealth of anatomy books which fol-

186 SAMUEL Y. EDGERTON, JR.

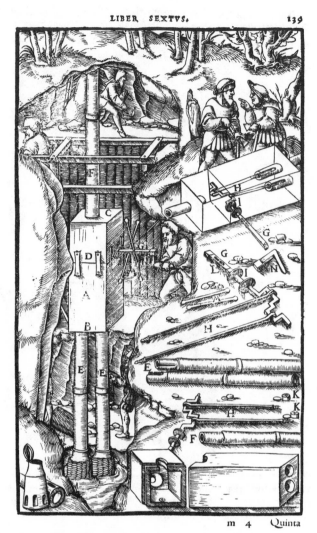

Woodcut print from Georg Bauer Agricola, *De re metallica*, Basel, 1556. Chapin Rare Book Library, Williams College, Williamstown, Mass.

lowed the lead of Andreas Vesalius's *De humani corporis fabrica* after 1543. Vesalius's illustrator, an artist very close to Titian if not Titian himself, established a mode of anatomical representation which has never been surpassed in either aesthetic or informational quality.

The example from yet another masterpiece of sixteenth-century scientific illustration, Agostino Ramelli's *Le diverse et artificiose machine* of 1588,[21] contains a copper engraving of a windlass for raising water from a well. The operator turns a vertical crank which then turns a lantern gear beneath the ground but exposed in a "cutaway view." This gear, lettered *B*, rotates another,

DELL' ARTIFICIOSE MACHINE.

FIGVRE LXXXV.

Engraving from Agostino Ramelli, *Le diverse et artificiose machine*, Paris, 1588. Houghton Library, Harvard University, Cambridge, Mass.

lettered C, which is attached to a reel around which is wound a rope. This rope can be followed, or better imagined, as running under the ground to where it reappears again in another adjacent "cutaway" opening. Then we see it around a pulley where it is directed above the ground and onto the windlass, E. At the lower left is another view of the same gear and reel, C, suspended so that we may examine it in more detail.

A. *Bethlehem ciuitas Dauid.*
B. *Forum vbi soluitur tributum.*
C. *Spelunca, vbi natus est Christus.*
D. *IESVS recens natus, ante Præsepe humi in fœno iacens; quem pannis Virgo Mater inuoluit.*
E. *Angeli adorant Puerum natum.*
F. *Ad Præsepe bos & asinus nouo lumi ne commoti.*

G. *Lux è Christo nato fugat tenebras noctis.*
H. *Turris Heder, idest gregis.*
I. *Pastores ad turrim cum gregibus.*
K. *Angelus apparet Pastoribus, & cum eo Militia cælestis exercitus.*
L. *Angelus, qui pie creditur missus in Limbum ad Patres mentius.*
M. *Stella & Angelus ad Magos missi, eos primum ad iter impellunt.*

Jerome Wierx, *Nativity*, engraving from Jerome Nadal, *Evangelicae historicae imagines ex ordine Evangeliorum*, Antwerp, 1593. Chapin Rare Book Library, Williams College, Williamstown, Mass.

One especially interesting application of this new Renaissance didactic, scientific vocabulary is noteworthy because the scene shown here has nothing to do with science but with teaching the Roman Catholic religion. This engraving is one of 150 published in 1593 with a text by a Spanish Jesuit named Hieronymus Nadal. His publisher, the famous Christophe Plantin of Antwerp, commissioned these engravings for a book intended for use by Jesuit

missionaries serving in China and Japan.[22] The purpose was to furnish the missionaries with field propaganda. The engravings were to be used as tools of the faith just as the machine and anatomical illustrations we have been examining were tools of science.

In the Christian religion, all Gospel stories are related and, of course, divinely foretold. The *Nativity of Jesus,* as depicted above, was announced to the shepherds by an angel and to the Magi by a star. Since early Christian times it had been commonplace in art to have these associated holy events all represented in a single picture even though they occurred at different places and times. This tradition continued even after the advent of linear perspective. Renaissance viewers became as accustomed as their medieval ancestors to suspend time unity in these religious pictures, just as they could suspend their sense of space unity in contemporaneous scientific illustrations. Religious art, like scientific art, shared a common didactic enterprise, and both came to rely on the same pictorial conventions. In the Nadal *Nativity,* we see, behind and to the right of the Holy Family in a cave manger, a little angel marked *K* hovering over the shepherds in the middle ground overlooking the city of Bethlehem, in whose open square we see the census takers, *B.* At the upper right, we note another little angel in the far distance, setting out the star, *M.* At the bottom right, there is a "cutaway view" in the ground beside the manger, exposing yet another little angel, *L,* this time announcing to Limbo the coming of the Savior. All these details and their accompanying letters are identified in alphabetical order in the text below the picture.

It is a relevant fact that not only was Nadal's book and all its engravings taken to China by the Jesuits but so also was Agostino Ramelli's. Furthermore, both of the illustrations we have just examined were copied by native Chinese artists during the early seventeenth century. One of the first acts of the Jesuit missionaries after they established themselves in Peking in 1601 was to found a library for the latest European books on religion and science, as tools for proselytizing among the Chinese.[23] The Europeans also encouraged their converts to translate and publish these books in the Chinese vernacular. These woodcut prints copied by Chinese artists after Nadal's *Nativity* and Ramelli's windlass pump respectively. The first appeared in a Chinese manual on the Rosary published about 1620. The second was included in a book entitled *Ji Qi Tu Shuo,* printed in 1627 by a Chinese convert named Wang Cheng. The latter was a scholar and admirer of the many European machine treatises like Ramelli's in the Jesuit Library. With the aid of Johannes Schreck, one of the most learned Jesuits of the period, Wang Cheng selected some fifty pictures from the various "theater of machines" books and had them copied and printed along with a digest of the texts. His title translated means "Diagrams and Explanations of Wonderful Machines (from the Far West)."[24]

One immediately notices in these printed copies how completely the Chinese artists "orientalized" the scenes, substituting not only Chinese physiognomical types for the principal figures but also Chinese parallel for Renaissance converging perspective. Chinese artists were also unfamiliar with chiaroscuro, the

Woodcut of the Nativity from a Chinese edition of João da Rocha, *Metodo de Rosario*, Lisbon, 1619/20. Institutum Historicum S.I., Rome.

rendering of uniform light and shade. Thus, both prints here illustrated have none of the relief quality which always distinguishes European art of the Renaissance. In the Chinese *Nativity* copy, the artist not only failed to appreciate the dramatic lighting effect of the manger cave with the Christ Child as symbolic source of illumination, but he also misunderstood the meaning of the darkened convex exterior of the cave underneath the wooden shed roof. He apparently thought the dark cross-hatching of the engraver's burin indicated some sort of reed matting, such as one frequently finds in the Orient. Thus he misconstrued the cave altogether, rendering its mysterious darks as so many

轉重第一圖

Woodcut from Wang Cheng, *Ji Qi Tu Shuo*, Peking, 1627. Harvard Yen Ching Library, Cambridge, Mass.

mats nailed to the cross beam below the roof, forming a flat, irregular opening into an ordinary shed. One observes also that the Chinese copyist left out all the little typological details, because he apparently did not understand the convention. In the heavenly aureole about the *Nativity*, for instance, he omitted the angels carrying the lettered banderole.[25]

Let us follow how the Chinese copyist interpreted Ramelli's machine. We shall make no aesthetic judgment and ask only whether or not the picture communicates information about how the well works; whether or not any viewer, Chinese or European, could make use of this illustration—as we assume he could Ramelli's original—to build from it a working model. Our first observation confirms that the Chinese artist, who was unfamiliar with the "cutaway view," was especially confused about the machinery which Ramelli showed beneath the ground. Indeed, since he had no parallel convention in his own style, he substituted for the unclear (to him) edges of the cutaway hole in the ground, a number of squiggly shapes which Chinese artists often used to denote apparitions or miraculous events. In the meantime, the artist did not concern himself with the all-important rope, which ran from the gear-driven reel, passed under the ground, and ran up again to the windlass. The artist did show a bit of this cord just below the well, but its crucial connection to the winding reel was ignored. Also, since he had no similar convention for the "exploded view," the Chinese illustrator copied Ramelli's detail of the reel and gear at the lower left with no understanding that it was the same component working together with the other parts of the apparatus at lower right.

Is it possible that the Chinese artist possessed his own special conventions, which his own audience understood, for communicating information about such a machine? This seems doubtful, especially if we examine another Chinese copy of Ramelli's device published in 1726, in *Tu Shu Ji Cheng,* the great encyclopedia of the Qing Dynasty. This print was not made directly from Ramelli's but was copied from the *Ji Qi Tu Shuo.* Here we see clearly that the second Chinese artist not only reproduced the same errors but even misunderstood the earlier copyist's Chinese conventions. The later artist was unsure of what the little squiggles represented, which the *Ji Qi Tu Shuo* illustrator substituted for the "cutaway view." Instead of an apparition, the second artist thought these wavy lines stood for water, so he translated them into another convention, the common Chinese representation for billowing surf.

What are we to make of these strange incongruities in Chinese so-called scientific illustration? It must be understood that the *Ji Qi Tu Shuo* (the rest of its fifty-odd plates have all similar if not even more egregious misinterpretations) is not an isolated case. It can not be dismissed on the grounds that a more talented Chinese artist could have made truly intelligible copies. Not only do all Chinese pictures of technical subjects, in the hundreds of books published in China from the ninth to the nineteenth century, lack systematic chiaroscuro and linear perspective, but they are just as consistently impressionistic. They only suggest the forms and functions of the things represented and never show accurate dimensions or proportions to scale. This is true even in Chinese

Woodcut from *Tu Shu Ji Cheng*, Peking, 1726. Harvard Yen Ching Library, Cambridge, Mass.

pictures of indigenous technical and scientific subject matter. The Chinese illustrator was expected to be decorative, not didactic in his representations of the objects described in the verbal texts.[26]

One might wonder what Wang Cheng himself thought when he first examined the "page proofs" of the illustrations for his book. Like the mandarin

he was, this author seems not to have considered the artist as his intellectual and social equal. At least he did not share with him his own knowledge of how the Western machines were supposed to work. Indeed, members of the Chinese mandarin class generally considered the mechanical arts to be socially demeaning. They enjoyed the results of a clever water pump, but the matter of its building should be left to laborers who would not be expected to appreciate pictures. In Europe, on the other hand, quite a different attitude was shared by many aristocrats such as Galileo's own patron, the Grand Duke Ferdinand II of Tuscany, Francis Bacon in England, and Thomas Jefferson in America, that knowledge of technical matters was an upper-class social duty. In fact, the deluxe illustrated books we have been examining, such as Ramelli's, could be afforded only by the rich. I propose that this developing European attitude of sympathy for science and the mechanical arts was both incited and encouraged by the illustrations in these sixteenth-century printed books. In China, as we have noted, the visual arts offered no encouragement to technology and science at all. Never, as far as I know, do we have a case where a Chinese designed a machine solely by means of pictures as did Taccola, Francesco di Giorgio Martini, Leonardo, and Ramelli, or used pictures to solve problems of anatomy as did Vesalius. Separate geniuses of art and science the Chinese had aplenty, but never in China was genius for both art and science combined in one person like Francesco di Giorgio or Leonardo.

The relative states of the arts and the sciences in the oriental civilizations during the sixteenth and seventeenth centuries offers a veritable laboratory for studying and isolating factors which promote or impede scientific and technological growth in any society. What happened or did not happen in these oriental civilizations while the Jesuits were bombarding them with foreign ideas may reveal insights even of the origins of our own Western scientific revolution. Art historians, science historians, and even perceptual psychologists with fluency in the Eastern languages should devote research to the school textbooks in China, Japan, and the progressive Islamic countries from the seventeenth through this century, to discover just when, and how much, Western-style illustrations replaced the native in these books. My hunch is that such research will reveal some ratio between the influx of Western pictorial forms and the rate of expanding industrialization and adaptation to modern science in the Eastern nations. If this could be proven, then, indeed, we might infer a similar relationship also existed in Renaissance Europe. At least we should have a *prima facie* case that Galileo could not have done what he did in Ming Dynasty China. He needed precisely the kind of visual education, the familiarity with Renaissance-style pictures in contemporaneous textbooks, only available in the school rooms of sixteenth-century western Europe.

When the documents are finally in, and the so-called Third World has reached full scientific and technological parity with the West, it may well be understood that one of the fundamental problems revolutionary peoples had to solve, transcending the polarized politics of capitalism and communism, was the psychological adjustment to the peculiar visual conception of the natural world first set forth by the artists of the European Renaissance.

NOTES

*This paper, while containing many of the same examples and arriving at the same conclusion, is an extension of that given before the Folger Symposium in 1978. The original lecture, entitled "The Renaissance Artist as Quantifier," was published in Margaret Hagen, ed., *The Perception of Pictures* (New York, 1980), 1:179–213. I am especially indebted for many of my thoughts and inspirations in both essays to James S. Ackerman, Creighton E. Gilbert, Thomas B. Settle, Cyril Stanley Smith, and Nathan Sivin. My sincere thanks also to Father Charles O'Neill, S. J., for his hospitality and generosity in allowing me to consult the holdings of the Institutum Historicum S.I. in Rome.

1. Two recent papers by historians of science are refreshing exceptions to my generalization; see Eugene S. Ferguson, "The Mind's Eye: Non-Verbal Thought in Technology," *Science* 197 (1977): 827–36, and Bert S. Hall, "Technical Treatises 1400–1600: Implications of Early Non-Verbal Thought for Technologists" (Unpublished lecture read before the meeting of the Society for the History of Technology, Washington, D.C., 22 October 1977). Two other useful if conventional surveys of scientific illustration are Alois Nedoluha, "Kultur-geschichte des technischen Zeichnens," *Blätter für Technikgeschichte*, 19 (1957), 20 (1958), and 21 (1959); and F. M. Feldhaus, *Geschichte des technischen Zeichnens* (Wilhelmshafen, 1959). The history of medical illustration, while considerably more studied than that of technical drawing, seems to be pursued in complete ignorance of the latter. For instance, many of the conventions invented by early Renaissance engineers for making clear their drawings of machines, such as the "exploded" and "cutaway views," only later applied to anatomical diagrams, are treated in the current medical history literature as the singular achievement of anatomical illustrators, Leonardo in particular (see especially, O. Benesch, "Leonardo da Vinci and the beginning of Scientific Drawing," *American Scientist* 31 (1943): 311ff., and Robert Herrlinger, *History of Medical Illustration from Antiquity to 1600* (New York, 1970; translated from the German edition, Munich, 1967). I am currently working on a book about art and science in which one of the major themes is the relationship between Renaissance machine drawing and anatomical illustration, particularly the influence of the former on the woodcuts of Andreas Vesalius in his *De humani corporis fabrica* of 1543.

2. A rare exception, as always, is Erwin Panofsky; see his "Artist, Scientist, Genius; Notes on the Renaissance 'Dämmerung',"in W. Ferguson et al., *The Italian Renaissance, Six Essays* (New York, 1962), 121–82.

3. See also Erwin Panofsky, *Early Netherlandish Painting* (Cambridge, Mass., 1959), 1:1–51.

4. See especially Bertrand Gille, *Engineers of the Renaissance* (Cambridge, Mass., 1970; translated from the French edition, Paris, 1964); and Lynn White, Jr., "The Flavor of Early Renaissance Technology," in B. S. Levy, ed., *Developments in the Early Renaissance* (Albany, N.Y., 1972), 36–58. See also the useful older studies on the profession of artisan-engineer in the Renaissance: Carlo Promis, *Biografie di ingegneri militari italiani dal secolo xiv alla metà xviii* (Turin, 1874), originally published under the title, *Dell'arte dell'ingegnere e dell'artigliere in Italia* . . . (Turin, 1841); T. Beck, *Beiträge zur Geschichte des Maschinenbaues* (Berlin, 1900); Alexander Keller, *A Theater of Machines* (New York, 1965); and William Barclay Parsons, *Engineers and Engineering in the Renaissance* (Cambridge, Mass., 1976; originally published in 1939).

5. Marshall Clagett, *Archimedes in the Middle Ages*, 3 vols. to date (Philadelphia, 1964 +); see also A. G. Drachmann, *The Mechanical Technology of Greek and Roman Antiquity* (Copenhagen, 1963).

6. See H. R. Hahnloser, ed., *Villard de Honnecourt, kritische Gesamtausgabe des Bauhütten-buches* (Leipzig, 1935).

7. See A. R. Hall, "Guido's *Texaurus*, 1335," in B. S. Hall and D. C. West, eds., *On Pre-Modern Technology and Science: A Volume of Studies in Honor of Lynn White, Jr.* (Malibu, Calif., 1976).

8. See E. Wickersheimer, ed., "L'*Anatomie* de Guido da Vigevano médicin de la reine Jeanne de Bourgogne (1345)," *Archiv für Geschichte der Medizin* 7 (1913): 1–25.

9. See, for instance, Jan B. Deregowski, "Pictorial Perception and Culture," *Scientific American* 227, no. 5 (1972): 82–90.

10. Taccola's manuscripts have been edited and published by James H. Beck, ed., *Liber tertius*

ingeneis ac edifitiis non usitatis di Mariano di Jacopo detto il Taccola (Milan, 1969); Gustina Scaglia, ed., *Mariano Taccola de machinis; the Engineering Treatise of 1449; Introduction, Latin Texts, Description of Engines and Technical Commentaries* (Wiesbaden, 1971); and G. Scaglia and Frank D. Prager, eds., *Mariano Taccola and his Book De Ingeneis* (Cambridge, Mass., 1972).

11. See F. D. Prager, "A Manuscript of Taccola, Quoting Brunelleschi on Problems of Builders and Inventors," *Proceedings of the American Philosophical Society* 92 (1968): 131–50.

12. Sheldon Shapiro, "The Origin of the Suction Pump," *Technology and Culture* 5 (1965): 571–80.

13. Francesco di Giorgio Martini's major manuscripts have been published in facsimile by Carrado Maltese and Livia Maltese Degrassi, eds., *Francesco di Giorgio Martini Trattati di architettura ingegnaria e arte militare*, 2 vols. (Milan, 1967). See also F. Paolo Fiore, *Città e Macchine dell'400, nei disegni di Francesco di Giorgio Martini* (Florence, 1978).

14. Now the Codex Ashburneanus 361, Biblioteca Laurenziana, Florence, Italy.

15. Ladislao Reti, "Francesco di Giorgio Martini's Treatise on Engineering and its Plagiarists," *Technology and Culture* 4 (1965): 287–98.

16. Martin Kemp, "The Quattrocento Vocabulary of Creation, Inspiration, and Genius in the Visual Arts," *Viator* 8 (1977): 347–99.

17. See Erla Rodakiewicz, "The *Editio Princeps* of Valturio's *De re militari* in relation to the Dresden and Munich mss," *Maso Finiguerra* 5 (1940): 15–82.

18. Giorgio Vasari originally claimed these reliefs for Francesco di Giorgio, but more recent scholars have acknowledged that at least some of the subjects were copied from Valturio by Ambrogio Barocci, father of the famous painter Federigo. See Pasquale Rotondi, Michele Provinciali, and Mauro Masera, *Francesco di Giorgio nel Palazzo Ducale di Urbino* (Novilara, 1970).

19. Phryesen's book, *Spiegel der Artztny*, and its illustrations by Wechtlin are discussed by Ludwig Choulant, *History and Bibliography of Anatomic Illustration*, ed. and trans. Mortimer Frank (Chicago, 1920; original German edition, Leipzig, 1852), 130–35.

20. Agricola's book has been republished in facsimile with English translation and notes by Herbert Clark Hoover and Lou Henry Hoover, London, 1912 (and reissued by the Dover Press, New York, 1950).

21. Ramelli's book has been reprinted in facsimile with extensive notes and English translation substituted for the original Italian and French by Eugene S. Ferguson and Martha Teach Gnudi, eds., *The Various and Ingenious Machines of Captain Agostino Ramelli* (Baltimore, 1976).

22. Nadal's book, published thirteen years after his death, was one of the most ambitious undertakings of the famed Christophe Plantin press in Antwerp. Plantin himself spent years of time and trouble on it, seeking out artists to do the engravings and sponsors to put up the money. He, too, died before the book's completion, and it finally went to press under his successor Martinus Nutius, in 1593, entitled: *Evangelicae historiae imagines ex ordine Evangeliorum, quae toto anno in Missae Sacrificio recitantur, in ordinem temporis vitae Christi digestae*, See Josef Jennes, *Invloed der Vlasmsche Prentkunst in Indiä, China, en Japan, tijdens de XVIe en XVIIe eeuwe* (Louvain, 1943). For more recent art historical scholarship on Nadal's book, see Thomas Buser, "Jerome Nadal and Early Jesuit Art in Rome," *The Art Bulletin* 57 (1976): 424–33, and Lief Holm Monssen, *"Rex Gloriose Martyrum;* A Contribution to Jesuit Iconography, *The Art Bulletin* 63 (1981): 130–38.

23. This collection was known as the *Bei tang* Library, named for the "North Church," one of the four Jesuit missions established in Peking after 1601. A catalog of the original collection has been published by H. Verhaeren, *Catalogue of the Pei-t'ang Library*, 3 vols. (Peking, 1944–48). The author also published a more accessible preview of the above in *Monumenta Serica* (1939), 4.2, 605–26.

24. See Fritz Jäger, "Das Buch von den wunderbaren Maschinen; Ein Kapitel aus der Geschichte der abendländisch-chinesischen Kulturbeziehungen," *Asia Major*, n.s., 1, nr. 1 (1944): 78–96; also Joseph Needham, *Science and Civilisation in China* (Cambridge, 1954), vol. 4.2, 211–18. I am grateful to Mr. Chin-shing Huang of Harvard University for his help in the translating of the *Ji Qi Tu Shuo*.

25. This Chinese copy and fourteen other prints after Nadal's *Imagines* were published in China

to illustrate Father João da Rocha's *Metodo de Rosario* of 1619/20. It has been reproduced along with the entire series and their original prototypes in Pasquale D'Elia, S.J., *Le origine dell'arte cristiana cinese, 1583–1640* (Rome, 1939), 67ff.; see also John E. McCall, "Early Jesuit Art in the Far East; part IV: In China and Macao before 1635," *Artibus Asiae* 11 (1948): 57–58.

26. A good survey of the Chinese printing industry during the Ming Dynasty is given by K. T. Wu, "Ming Printing and Printers," *Harvard Journal of Asiatic Studies* 7 (1942/43): 203–60. The author tends to blame any deficiencies in printed pictures and books at this time on the decadence of the Ming period in general.

Diagrams and Dynamics:
Mathematical Perspectives on Edgerton's Thesis

Michael S. Mahoney
Princeton University

[A] mathematician, however great, without the help of a good drawing, is not only half a mathematician, but also a man without eyes.

Lodovico Cigoli to Galileo Galilei, 1611[1]

Newton's *Mathematical Principles of ‹Natural› Philosophy,* by which the science of motion has gained its greatest increases, is written in a style not much unlike [the synthetic geometrical style of the ancients]. But what obtains for all writings that are composed without analysis holds most of all for mechanics: even if the reader be convinced of the truth of the things set forth, nevertheless he cannot attain a sufficiently clear and distinct knowledge of them; so that, if the same questions be the slightest bit changed, he may hardly be able to resolve them on his own, unless he himself look to analysis and evolve the same propositions by the analytic method.

Leonhard Euler, 1736[2]

In "The Renaissance Artist as Quantifier" Samuel Y. Edgerton sets forth a new defense of Erwin Panofsky's thesis that the technical innovations of Renaissance art, in particular linear perspective and chiaroscuro, laid essential foundations for the Scientific Revolution of the seventeenth century.[3] Exercising some caution at the outset, Edgerton hesitates to assert a causal link between the two achievements; rather, he emphasizes their striking concomitance. "I would like to propose," he says,

that instead of trying to discover elusive, one-on-one connections between individual geniuses of Renaissance art and seventeenth-century science, we concentrate our investigations on the shared uniqueness of the Western European scientific *and* artistic revolutions.[4]

The two areas of innovation thereby become manifestations of some unspecified, more fundamental change in Europeans' experience or perception of the world. Without the one, the other is unlikely to appear.

But that caution soon gives way to boldness. Edgerton goes on to argue that "the new Renaissance pictorial language allowed . . . the ability to invent machines solely by means of drawings. . . ."[5] Then, after presenting evidence that Chinese illustrators could not "read" the pictures of machines in the 1588 edition of Agostino Ramelli's *Le diverse et artificiose machine*[6] and possessed no equivalent language of their own, Edgerton concludes that the Chinese could not invent machines solely by drawing them and finds the conclusion perplexing: "In fact, by Western standards, it is hard to comprehend how Chinese science and technology was [*sic*] able to progress at all with so little involvement of artists or pictures." To put the matter that way would seem to make changes in pictorial representation not a concomitant of scientific innovation but a prerequisite to it.[7]

Several assumptions lie behind Edgerton's perplexity, and they warrant careful consideration before we agree to share it with him. First, he supposes that new techniques for depicting machines led to the invention of new machines, or more precisely, that the machines drawn by Renaissance artist-mechanics were new machines invented on the drawing board. Second, he assumes that these new machines, by virtue of the means by which they were conceived, played an essential role in the Scientific Revolution. This second assumption appears to derive from the more fundamental premise that the Scientific Revolution consisted in essence of the creation of the science of mechanics and of the mechanistic world view. Edgerton's strong thesis thus comes down to the claim that the new pictorial techniques were a prerequisite for the new science of mechanics and for the new world-machine described by that mechanics.

Several arguments militate against this thesis, even if one accepts (as I do) the underlying characterization of the Scientific Revolution. First, quite apart from the difference between invention and design, the machines being drawn in new ways during the Renaissance consisted of components devised in previous ages. Renaissance devices may have been larger and more intricate than their ancient or medieval prototypes, but they were not different in kind. They still essentially compounded the five simple machines to transmit the force of weight, wind, water, and animals.[8] The ingenuity of the combinations and the occasional innovations in linkages between components do not suffice to alter the basically derivative nature of the technical content of Renaissance treatises on machines. The *disegnatori* may have been drawing in new ways, but they were not drawing new things.

Second, neither the things they drew nor the ways they drew them contributed to revealing the working of machines, at least not in the sense of a

scientific account. The science of mechanics followed other paths to that reve-
lation. The theoretical discipline began in the late sixteenth century as a science
of machines considered as systems of weights in equilibrium. In the early
seventeenth century, mechanics expanded to become the science of motion,
which conceived of machines as systems of bodies moving under constraint.[9]
Fundamental to either line of inquiry was its concept of the machine as an
abstract, general system of quantitative parameters linked by mathematic rela-
tions. Conceptualization of this sort rested on a small and long-familiar empir-
ical base, namely the five simple machines and the common hydrostatical
phenomena, which was expanded in the early seventeenth century by the
pendulum considered both as a phenomenon and as an instrument of experi-
ment.[10] Whether new or not, whether real or fancied, Renaissance additions to
the inventory of machines added nothing to that empirical base. Moreover, it is
difficult to see how more accurate depiction of the basic phenomena as physical
objects could have conduced to their abstraction into general systems. For the
defining terms of the systems lay in conceptual realms ever farther removed
from the physical space the artists had become so adept at depicting. Those
terms could not be drawn; at best, they could be diagramed.

That leads to a third argument. The vehicle of abstraction in mechanics was
mathematics, which from the outset served as the language for expressing and
analyzing mechanical concepts. Neither the earliest forms of mathematical
mechanics nor its subsequent development lends support to Edgerton's thesis.
The Renaissance search for a science of machines began in emulation of Ar-
chimedes' geometrical treatment of statics in terms of spatial arrangements
considered in equilibrium. Here the initial steps of abstraction, namely the
reduction of a machine's physical structure to a geometrical configuration,
followed long-standing forms of mathematical depiction. Galileo took his
mathematic diagrams from the classical Greek mathematicians; some he drew
from medieval prototypes. Despite the Renaissance pictorial techniques evi-
dent in the woodcuts of his *Two New Sciences*, as mathematical diagrams they
remained classical in form.[11]

Further stages of abstraction, together with the mathematics for handling
them, placed a strain on the classical form, especially in the transition to a
science of motion. The introduction of dynamical parameters, that is, of the
forces that determine the laws of machines in action, brought with it quantities
that did not fit into three-dimensional space and hence had no place, except by
proxy, in a geometrical diagram representing a spatial configuration. But that
lack of fit could not be remedied by new modes of representing space picto-
rially. Temporary adaptations of geometrical technique ultimately gave way to
an altogether different form of mathematical representation: to infinitesimal
analysis couched in the language of symbolic algebra.

In taking the path to analytical mechanics, mechanicians at the turn of the
eighteenth century followed a line of conceptual development on which mathe-
matics itself was by then well embarked. As I have argued in detail elsewhere,
the domination of seventeenth-century mathematics by algebraic modes of

thought freed it from its ties to physical intuition and opened it to the con-
sideration of abstract structures defined by combinatory relations.[12] Only by
reaching into realms for which no physical correlate existed, for example the
realm of imaginary numbers, could mathematicians achieve the theoretical gen-
erality they claimed for their subject. Mathematicians reached those realms not
by looking at the physical world in a new way but by looking beyond it
altogether. To the extent that mechanicians followed suit, the science of me-
chanics that epitomizes the Scientific Revolution manifests modes of thought
antithetical to those of Edgerton's inventive *disegnatori*.

The discussion to follow will concentrate on the changing nature of the
diagram in seventeenth-century treatises on mechanics, that is, on the third
argument just outlined. By way of transition into that subject, however, some
remarks concerning the second argument seem in order.

The first treatises of machines captured in pictorial techniques many (but not
all) of the tactile methods of the traditional engineer, whose job it had long
been to devise ingenious mechanisms to overcome the difficulties of a particular
situation.[13] The treatises collected various mechanisms, depicted them in action
to show both what they did and how they were put together, and explored
ways in which new combinations might be assembled to carry out new but
related tasks. During the fifteenth and sixteenth centuries, the methods of
depiction clearly improved, as Edgerton shows. The machines represented on
the two-dimensional page looked increasingly like their three-dimensional
models as seen in action, even as the artist exploded them, bored through to
their internal parts, and twisted and turned their components.[14]

But to show what machines do or how they are assembled is one thing; to
show how they work is quite another. However accurately and fully a complex
mechanism may be portrayed, an understanding of its operation as a whole
rests ultimately on familiarity with the operations of its basic components.
Treatises of the genre under discussion took that familiarity for granted. Their
authors could not do otherwise, given the nature of their medium. A picture of
a windlass, or of a system of pulleys, cannot in and of itself set forth the laws
that define the device's mechanical advantage. A drawing of a closed tube
standing in a pool of water and having a piston with a valve that opens in one
direction only will still not explain a water pump until the readers know the
laws (or at least the rules of thumb) that link the reduction of air pressure to the
rise in the head of a column of liquid.[15] Readers must bring knowledge or
experience of such matters to the illustrations in order then to appreciate or
profit from the ingenuity with which the basic machines are combined or
adapted to particular circumstances.

Such active participation by the knowledgeable reader is especially required
when the machine depicted is extrapolated from the world of experience to the
realm of fantasy. Several of Ramelli's devices, if actually constructed, would
surrender all mechanical advantage to internal friction. To know that does not
detract from an appreciation of their ingenuity, but it does place that ingenuity
in a different light. If Vittorio Zonca's *Teatro nuovo di machine ed edificii*

(Padua, 1607) holds closer to the line of actual mechanical practice, the author nonetheless caps his presentation with a perpetual-motion machine.[16] Again, the experienced reader will admire the ingenuity but not be misled by it. Yet, discernment lies in the eye (or rather the mind) of the beholder, not in the depiction of the machine. The picture itself cannot distinguish between the feasible and the fantastical. For that, one needs a different medium.

Treatises on mechanics first appeared about a century after the earliest collections of drawings began to circulate.[17] Although the authors of these treatises may have been motivated to their subject by the mechanical activity around them, their manner of treating it drew inspiration from more distant sources, namely from the *Mechanical Problems* attributed to Aristotle, from the *Pneumatics* and the other mechanical fragments of Hero of Alexandria, from Book 8 of Pappus of Alexandria's *Mathematical Collection,* and from the statical and hydrostatical works of Archimedes. Following these sources, the sixteenth-century treatises on mechanics began with an inventory of basic devices, usually the five simple machines. But, rather than assuming their mechanical action as known and then compounding them, as the theaters of machines did, the treatises of mechanics analyzed them as compound phenomena to discover what principle or principles explained their action in general.

From the outset, then, mechanics as the science of machines aimed not at variety through ingenious adaptation to specific tasks, but at uniformity through derivation of the general laws that defined the limits of adaptation and ingenuity. While treatises on machines displayed the products of the engineer's craft, treatises on mechanics probed the basis of his know-how. Behind the design and application of machines lay the engineer's experience of the physical world, and it was in that experience, rather than in the machines, that writers on mechanics sought understanding of how machines—and the world— worked. Relatively little of the experience could be captured, much less examined, within the confines of pictorial space, however sophisticated the techniques for organizing it.

What did engineers know that writers on mechanics found noteworthy? Engineers knew that getting something from a machine meant putting something into it; usually more went in than came out. For example, to move a heavy weight through a short distance a small force had to travel over a great distance. Engineers knew that, if a given force sufficed to hold a given weight in equilibrium, the slightest additional force would move the weight; they also knew that *some* additional force was necessary in practice. Engineers knew that a small weight moving quickly could have a greater effect on an object than did a large weight simply resting on it. Engineers knew that making machines bigger did not necessarily increase or even maintain their mechanical advantage. Engineers knew that there was a limit to the height to which water could be pumped under the best of conditions and that the practically attainable height lay below that. Engineers knew that, when one presses on a fluid, it spurts out in all directions. And so on.

Engineers knew such things and others like them—call them "maxims or precepts of engineering experience"—in many different forms and at many levels of specificity.[18] Transforming them into the principles of a science of mechanics meant analyzing them into a body of concepts susceptible to mathematical expression and manipulation. At first, the mathematics for such an enterprise came from the same classical sources as the notion of the enterprise itself: from Archimedes, Hero, Pappus, and the corpus of geometrical knowledge on which they had drawn.[19] From the same sources came also the models for the diagrams in which writers like Galileo abstracted physical bodies and processes; they were the same sorts of diagrams that had lain on the leaves of geometrical manuscripts for almost a millenium, be the language Greek, Arabic, Latin or Italian. If, as Edgerton claims here and, even more forcefully, in his *Renaissance Rediscovery of Linear Perspective,* Galileo and his·contemporaries were seeing the spatial world in new ways, they did not alter the geometrical patterns by which they represented and analyzed the metrics of that space.[20] As far as spatial abstraction is concerned, Galileo's world looked the same as Archimedes'.

Yet, as far as physical theory is concerned, Galileo's world looked quite different from Archimedes', and the crux of the difference lies precisely in Galileo's conclusion that the mechanical world has other than simply spatial parameters. For Archimedes, the science of mechanics was the science of bodies held in equilibrium, either by simple machines like the balance or by fluids.[21] His approach to such statical phenomena was similarly statical and, for that reason, also spatial. It rested on the principle that materially homogeneous bodies balance (that is, have no sufficient reason to move from their resting position) about points, lines, and planes of spatial symmetry. In each instance, he began with a system in equilibrium; his diagram represented a cross-section of the system by a plane of symmetry, and his various theorems followed from the ways he could rearrange the elements of that cross section while maintaining the initial symmetry.

Galileo's demonstration of the law of the lever in Day Two of the *Two New Sciences* captured this Archimedean style of analysis and demonstration.[22] Consider a uniform solid suspended from a balance beam by cords attached at either end. By symmetry the beam balances at its midpoint C. Now imagine the solid cut perpendicularly at some point D and the two resulting pieces temporarily supported by the common cord DE. Each thereby becomes a

smaller version of the original system and hence balances about its center, G on the left side and F on the other. Indeed, if portion AD were supported at its midpoint by a single cord LG and portion DB by a similarly placed cord MF, the other cords could be removed and the equilibrium maintained. It is a straightforward matter to show that $CG:CF = EI:EH = DB:AD$, the last two quantities being proportional in turn to the weights of the segments.

Note that nothing ever moves in the space of Galileo's diagram, either actually or virtually. Rather, space is simply redivided and the points and lines of symmetry correspondingly relocated. As an abstract depiction of the physical system, the diagram contains elements that directly represent the parameters of the theoretical explanation, namely weight and distance from the fulcrum. Those elements can be manipulated geometrically to reflect the various combinations of those parameters; at each stage the transformed diagram represents immediately an actual state of the physical system. One can "see" what is going on.

Galileo knew of an alternative to the Archimedean approach. Stemming originally from Aristotle's *Mechanical Problems*, it informed the treatises on weight ascribed to Jordanus de Nemore and dating from the thirteenth century.[23] The alternative mode of analysis defined equilibrium by the exactly countervalent effects of any assumed, or virtual, disequilibrium. Let bodies A and B be placed at opposite ends of a balance beam and suppose that B were to

descend, causing A to ascend. A and B would then each move in any given time through arcs proportional to their respective distances from the fulcrum. On the assumption that they move at uniform speeds, it follows that those speeds are inversely proportional to the respective arcs and hence also to the respective distances of the bodies from the fulcrum. On the further assumption that the speeds are directly proportional to the forces moving the bodies, it follows that the force causing B to descend is to the force causing A to rise inversely as the respective distances of those bodies from the fulcrum. If, then, the weights of A and B were likewise inversely proportional to their distances from the fulcrum, the weight of A would precisely counteract the force exercised to raise it by the weight of B acting through the beam. Hence, no motion would occur, and A and B would be in equilibrium.

Clearly, the diagram of the system plays in this analysis of its workings a role quite different from that of the diagram in Archimedean statics. The rear-

rangement recorded by the former takes place not in space but in time. The arcs connect the endpoints of the beam in two positions separated by an interval of time and themselves represent the trajectories of those endpoints. The weights remain unchanged throughout and their magnitudes play no operative role in the diagram; hence, they are reduced to dimensionless points. In fact, little in the diagram plays any operative role, once we have ascertained that the arcs are proportional to the distances from the fulcrum. From then on, the reasoning takes place off the diagram, and the determinative parameters have no spatial representation, at least not in the same space as the system depicted. Speed, force, and weight can be located in the diagram only by transformation of their various relations into relations among its elements. The rules of transformation, that is, the laws of dynamics and kinematics used to link weight and distance, correspond to no geometrical operations executable directly on the diagram. Only when the rules turn out to be successively, and hence compositely, linear can one then take as surrogates for the weights the corresponding arms of the balance or the arc-lengths of any putatively incipient motion of the system.

In the research carried out during the 1590s in Padua, Galileo explored both the Archimedean and the Aristotelian/Jordanian approaches to statics—and hence to mechanics understood as the science of weight-lifting machines.[24] Indeed, in his *On Motion* composed just before moving from Pisa to Padua in 1592 he used Jordanus's analysis of the bent-arm balance to derive the law of the inclined plane. Here, having embedded the magnitudes of the weights in

those of the balance's arms, or segments thereof, he could move mathe-
matically from the ratios among these lengths to those between the heights and
lengths of the inclined planes coincident with the lines of action of the weights
in different positions.

But by the time Galileo composed his *Mechanics,* sometime around the turn
of the century, he was favoring the statical Archimedean approach, terming the
dynamical Jordanian merely "in agreement [with fact]" and "probable."[25] The
reason for his preference seems evident: the dynamical approach relied more on
"physical" than on "mathematical" reasoning. Within a few more years, he had
even more cause to suspect the Jordanian mode, for he had learned that the
dynamics on which it (and his own use of it) rested was not correct. As he
pressed forward with his investigations into the science of motion,[26] he found
that the theory that accounted for the mechanical advantage of an inclined
plane did not lead to an explanation of the motion that occurred when a body at
rest began to roll down the plane, picking up speed as it went. Nor did the
combination of bent-arm balance and inclined plane account for the regular
motion of the pendulum, which by something akin to a gestalt-switch appeared
to the receptive eye in the diagram of the bent-arm balance when several
positions of the arm were depicted together. Bodies falling by virtue of their
weight do not move uniformly. They accelerate, and the relation between
motive force and rate of acceleration proved an elusive problem for Galileo.
"Good drawings" did not provide much help until he figured out what to
draw.

For various reasons not pertinent to the present argument, Galileo post-
poned the search for the parameters of dynamics until he had worked out
mathematically the kinematics of uniform and accelerated motion. Experi-
ments with the pendulum had convinced him that all bodies, regardless of
weight and size, fall at the same rate in the empty space of a vacuum, that the
speeds acquired in falling depend only on the height from which the bodies fall,
and that those speeds suffice to impel the bodies back up to their initial posi-
tions, again independently of the paths taken. On the basis of these empirically
determined principles, Galileo sought first to work out the mathematical pat-
terns of the ensuing motions.

As is well known, his mathematics initially got in his way.[27] Moving from the
pendulum to the inclined plane as the machine that served both as phenomenon
and as experimental apparatus,[28] he determined that the distances traversed
from rest varied as the squares of the times elapsed, and in a famous letter
written to Paolo Sarpi in 1604 he asserted that this law of falling bodies fol-
lowed from the principle that in uniformly accelerated motion the speed ac-
quired is proportional to the distance traversed from rest.[29] Many explanations
have been offered for this error, which Galileo himself almost boastfully ac-
knowledged in his *Two New Sciences.*[30] Spatial intuition, as reflected in Ar-
chimedean diagrams, must take some share of the blame. For those diagrams
depicted the apparatus as a spatial object and located the operative parameters
in its constituent elements. So too Galileo began the mathematics of motion on

an inclined plane—that is, motion according to the times-squared rule—with a picture of the plane and sought to locate the parameters of acceleration in its elements. Since the speed acquired depends only on the height of fall and is independent of the path taken, what would be more natural than to identify the base of the plane as the geometrical measure of the speed reached over the entire plane? Since acceleration is uniform, the speed at any intermediate point on the plane would then be measured by the line through that point and parallel to the base. That line is directly proportional to the height through which the body has descended vertically.

The theorem Galileo was trying to prove linked distance to time. But time as yet had no representation in the diagram, which lacked any element by which to express that parameter directly. For an indirect measure, Galileo appears to have resorted to a medieval notion of "total velocity" *(velocitas totalis)*, which transformed velocity conceived of as the intensive measure of a body's motion from instant to instant into an extensive quantity. In his notes:

> because the velocity with which the moving body has moved from *a* to *d* is composed of all the degrees of velocity [it] had at every point of the line *ad*, and the velocity with which it has traversed the line *ac* is composed of all the degrees of velocity [it] had at every point of the line *ac*, so the velocity with which it has traversed the line *ad* has to the velocity with which it has traversed the line *ac* the proportion [*read* ratio] that all the parallel lines drawn from all the points of the line *ad* up to *ah* has to all the parallels drawn from all the points of the line *ac* up to *ag*; and this proportion is the one that the triangle *adh* has to the triangle *acg*, to wit, the square *ad* to the square *ac*. Thus the velocity with which line *ad* is traversed has to the velocity with which the line *ac* is traversed the double proportion of *da* to *ca*.[31]

At this point only a paralogism based on the ambiguity of the term "inversely proportional" could save the argument. For the "total velocity" of medieval theory was equivalent to nothing other than the distance traversed. That distance, conceived of physically as the sum *over time* of the instantaneous de-

grees of speed, found mathematical representation in the sum of the lines corresponding to those degrees, i.e., in the area of the triangle of which one side represented the time of motion and the other the final speed attained. But Galileo summed the degrees of speed over distance, not time; as a result, he ended up with two dimensionally incompatible measures of the same physical parameter: the distance traversed was expressed both by the segments of the side *ab* and by the segments of the triangle *abk*.

Galileo soon recognized the contradiction and the means of correcting it. The speed acquired in uniform acceleration is proportional to the time elapsed, not to the distance traversed. The diagram did not seem to change much in accommodating that correction. The height of the plane became a measure of the elapsed time, the lines parallel to the base remained the measure of the

velocity, and the area now measured the distance traversed. But those are essential changes, for they make the diagram not a *picture* of the inclined plane, but a *graph* of the relation between time and speed in a mathematical space wholly divorced from the physical space in which the motion itself is taking place.[32]

In the kinematics of accelerated motion no perspective construction maps the three dimensions of space, time, and velocity onto a two-dimensional picture. The diagram that reveals the structure of a kinematical process cannot at the same time hold a representation of the moving body itself. To capture the changing velocity of a ball rolling down an inclined plane, Galileo had to convert the plane into a gradient of velocities and the ball into a point sliding

along the gradient at a uniform rate. To depict the body's motion through space over time required yet another shift of mathematical space, to one in which the moving point now traces a parabola. That parabola, in turn, should not be confused with the trajectory of a projectile launched into physical space, as found in the theorems in the Fourth Day of the *Two New Sciences*. There again the direct representation of a physical occurrence comes at the cost of removing the effective mathematico-mechanical parameters from the picture and thus of reasoning off the diagram.

If, then, Galileo started with diagrams that looked classical, he ended with a new sort of representation altogether: a configuration tracing the relation between two quantities in a mathematical space of which they define the dimensions—time and speed, time and distance, speed and distance, and so on. The relations between such configurations, that is, the rules for moving from one space to another, lay in the laws of motion. For example, by the law $S = vt$ (and by the mathematics of infinitesimals that is necessary to such reasoning but not to the exposition of the present argument) distance may be represented as an area in the space of speed and time.

Whatever the mathematician's eye is seeing here, it has little to do with new pictorial techniques for the accurate representation of physical objects in three-dimensional space. It is the mind's eye that is looking here, and it is peering into the structural relations among quantities belonging to many different conceptual (rather than perceptual) spaces. The more abstract those quantities and their relations become, the less helpful or revealing it is to model them in a graphic space analogous to the pictorial space of the body's eye.

Descartes saw this situation developing and argued in his *Rules for the Direction of the Mind* (ca. 1628) that the exploration of a new mechanical world would require a new mathematics, universal in its scope. For what the mind must see before it is the path of its reasoning, and it should restrict its picture of the objects under consideration to the features essential to the reasoning itself. Indeed, the mind needs not so much a picture as a set of symbols, a conventional notation recording no more nor less than what the mind requires for the operation at hand and, by the notation's very economy, allowing the mind to

maintain its bearings, as it were, by a mere glimpse at the symbolic record.[33] The mathematics Descartes had in mind was his version of symbolic algebra, meant as a language into which to cast all quantitative relations, whatever their particular physical manifestation.

Despite Descartes' admonition, for much of the seventeenth century Galileo's geometrical model set the style for mechanics. The result was remarkable success, combined with revealing episodes of an impending limit to the model's resources. Christiaan Huygens's derivation in 1659 of the period of a simple pendulum and the corollary he drew from the derivation regarding the trajectory that would render the pendulum's period independent of the amplitude of its oscillations display the mixture of pictorial and graphic representation inspired by Galileo.[34]

Huygens began with a schematized pendulum having its bob (at rest at) K supported by cord TK anchored at T. In swinging to its centerpoint Z, the bob follows the circular arc KEZ. In doing so, it accelerates over the arc, picking up

speed with the increase of its vertical distance from rest, as measured by successive segments of line AZ; e.g., at point D the velocity is a function of segment AB. That function is not linear; by Galileo's law of fall, BD, representing the velocity, varies as the square root of AB, and hence D lies on a parabola $AD\Sigma$. But note that the parabola itself is not a trajectory, but a gradient. It belongs not to a picture of the physical system, but to a graph of its workings; not to the pictorial space of the pendulum, but to the conceptual space of its kinematics.

Nonetheless, Huygens operated on both curves as if they belonged to the same space and, at a later point in his derivation and for mathematical reasons, substituted for the circular trajectory arc ZK of a parabola congruent to parabola $AD\Sigma$. That substitution, made under the assumption of very small oscillations (i.e., under the assumption that K lies quite close to Z), enabled Huygens to eliminate the measure of angle ZTE from the determination of the bob's motion at E and hence from the determination of the period as a whole. When, later, he explored how the substitution as an approximation brought about the elimination, he recognized that the approximation would become an exact relation if the bob's trajectory were not a circle but a cycloid.[35] Again, the

diagram superimposed on the picture of the physical pendulum a graph of its accelerated motion, and again one moved by relations among segments *BD*, *BE*, *BF*, and *BG* from the pictorial space to the kinematical. The geometrical mode of mechanics worked, but it demanded considerable flexibility in interpreting what the eye was seeing in the diagram.

Further consideration of Huygens's first diagram shows that it called for three levels of interpretation. It not only superimposed a kinematical graph onto a physical picture, but also added to the graph auxiliary curves needed for the solution of the mathematical problem posed by the combination of the first two curves. That solution necessarily rested on manipulation of infinitesimal elements, which the diagram could not accommodate directly, but only through transformations of relations between them into relations between finite elements. For example, Huygens began his analysis by taking infinitesimal segments of line *AZ* and of arc *KZ* at *B* and *E* respectively. Assuming that the segment *B* were traversed uniformly at the speed acquired by the bob at point *Z* and the segment *E* at the speed acquired in fall from *K* to *E* (or from *A* to *B*), he knew from Galileo's kinematics that

$$\frac{\text{time over } E}{\text{time over } B} = \frac{\text{length of } E}{\text{length of } B} \times \frac{\text{speed over } B}{\text{speed over } E}.$$

The first ratio on the right-hand side could be readily transformed via the newly developed method of tangents, which mapped it onto the ratio of the finite lengths *TE* and *BE*. Since the ratio of the speeds was already given by finite components of the parabola of acceleration, Huygens had

$$\frac{\text{time over } E}{\text{time over } B} = \frac{TE}{BE} \times \frac{BF}{BD}, \text{ or (by setting } BG = TE) = \frac{BG \cdot BF}{BE \cdot BD}.$$

BG and *BF* are constant magnitudes, but *BE* and *BD* vary with the pendulum's

motion, that is, with the changing position of E on arc KZ.

From point to point, then, or rather from instant to instant, the value of the ratio $\dfrac{\text{time over } E}{\text{time over } B}$ changes. From this Huygens inferred that the sum of all the values taken by that ratio over the distance AZ would yield the ratio of the time of fall over arc KZ to the time of uniform motion over the segment AZ.[36]

The inference posed both technical and conceptual problems, which the geometrical mode of analysis tended to exacerbate rather than mitigate. Conceptually, aside from the question of how an infinite number of finite quantities might sum to a single finite quantity, the transition from an infinite sum of ratios to the ratio of two infinite sums required a hardy leap of the imagination. Although the geometry helped in the first question, suggesting an area under a curve as the sum of all the ordinates to the curve, it could throw no light on the steps beneath the leap. As will be clear presently, these conceptual problems took on dynamical as well as mathematical significance in Newton's *Principia*.

Technically, Huygens's inference required that he determine the sum of the values taken on by the expression $\dfrac{BG \cdot BF}{BE \cdot BD}$ for every point on AZ. To carry out that determination, he transformed the expression containing two variables into an expression containing only one by constructing BX such that $\dfrac{BX}{BF} = \dfrac{BG \cdot BF}{BE \cdot BD}$. The curve $RXNS$ on the far right side of his first diagram is the graph of the values of BX over the interval AZ, and the sum of all BX is represented by the area $AZSNR$. Similarly, the sum of all BF is the rectangle $AZ\Sigma K$. But how to measure the first area? To do so, that is, to carry out what we now term an integration, he undertook a series of further constructions which amount to what again we now term transformations of variable. It was these transformations and the possibility of determining the curvilinear areas they produced that led Huygens to the approximation referred to above. That is, the mathematics dictated the approximation that ultimately led to the cycloidal pendulum.

But that mathematics does not appear in the diagram, which records not the transformations themselves, but the resulting curves only. For example, nothing in the diagram suggests visually (or operationally) that $\dfrac{BX}{BF} = \dfrac{BG \cdot BF}{BE \cdot BD}$ or that, once E is placed on parabola ZK, $\dfrac{BX}{BF} = \dfrac{BG \cdot AZ}{BF \cdot BI}$, where BI, the sole variable on the right side, lies on semicircle AIZ. Even setting aside the inadequacy of the diagram for representing the infinitesimal elements of Huygens's solution, one still cannot "see" what is going on among its finite elements, which give no sign of their structure in terms of the original spatial, kinematical, and dynamical parameters.

Hence, Huygens's diagram requires another sort of flexibility besides that needed to separate physical from kinematical space. It demands that one recognize in the lines and areas of mathematical space traces of a mathematical

argument taking place in another conceptual realm altogether. The body's eye looking at the diagram gains little insight into that realm, which is open only to the mind's eye and which, Descartes had long since argued, requires a different system of representation, to wit, symbolic algebra. That is the system in which Pierre de Fermat had ultimately couched his theory of the transformation of areas understood as sums of infinitesimal elements, the theory from which Huygens was working here.[37] Only in algebraic form did the transformations become analytically transparent, so that one could "see" the ongoing process by which individual parameters shifted their structural roles in successive configurations.

As already noted above, the use of infinitesimal arguments only emphasized the inadequacies of the geometrical modes of representation and analysis. Quite apart from the paradoxical behavior of infinite sums of infinitesimal quantities, the latter lacked the dimension to have more than mere position in the space of a configuration of finite elements. Representing infinitesimal quantities geometrically required moving to yet another mathematical space dimensionally incompatible with the pictorial space of physical objects. Thus, to the extent that dynamics concentrated increasingly on relations involving infinitesimals and their sums, the relation of its mathematical space to the physical space of machines became ever more complicated, and the geometrical representation of dynamics ever more opaque.

The early theorems of Book 1 of Isaac Newton's *Mathematical Principles of Mathematical Philosophy* (London, 1687), or *Principia*, show by their very sequence the analytical difficulties posed by the geometrical mode of mechanics. To demonstrate in Theorem 1 that a body moving under the constraint of a centripetal force sweeps out with respect to the center of force areas

proportional to the times, Newton divided the time into equal infinitesimal intervals and let line AB represent the distance covered during the first such interval by a body moving at an initial velocity. Imagining the continuous force broken up into a regular sequence of impulses acting on the body at the end of each interval of time, he let the body's motion change at B and determined its resultant path BC by means of Bc, the path it would have followed inertially if not subjected to the impulse, and cC drawn parallel to SB and proportional in length to the impulse delivered. From there, it is a matter of elementary geometry to show that $\Delta SAB = \Delta SBc = \Delta SBC$ and by repetition of the argument to continue the equality: $\Delta SAB = \Delta SBC = \Delta SCD = \ldots$. Allowing the interval of time to decrease indefinitely will not affect that property of equal areas traversed in equal times. But the evanescence of the interval makes the sequence of impulses coalesce into a continuous force, while the rectilinear segments AB, BC, CD, etc. approach ever more closely a continuous curve.

Leaving aside for the present the legitimacy of Newton's move to the limiting case,[38] note that it means a shift to a space of another dimension and that in the shift two parameters disappear from the configuration: the rectilinear segments AB, BC, CD, ..., which had served as measures of the velocity at points A, B, C, ..., and the segments cC, dD, eE, ..., which had measured the force (or rather the average force concentrated in the impulse). Getting these important parameters back into the limit-configuration became a task in itself for Newton. The velocity at any point was easily restored; it can be represented by the perpendicular drawn from the center of force to the tangent

to the trajectory at that point.[39] Expressing the force as a combination of elements of the configuration proved trickier, and the first six theorems culminate in the solution (or rather, solution-schema) of that problem. In general, the force at P is given by the limiting value of the expression $\dfrac{QR}{SP^2 \cdot QT^2}$, where QP represents an infinitesimal segment of the trajectory, RPZ is tangent to the trajectory at P, and QR is parallel to SP, the distance from P to the center of force at S. The precise relations among these infinitesimal elements depend on the nature of the trajectory; for example, if P lies on an ellipse of which S is a

focus, the value of $\dfrac{QR}{QT^2}$ is constant, and hence the force is proportional simply

to $\dfrac{1}{SP^2}$, that is, to the inverse square of the distance.

Like Huygens's diagrams, Newton's, too, superimpose process on object by adding to the picture of the trajectory lines and areas representing not only kinematical but also dynamical parameters that dimensionally have no place in the space of that picture. Also like Huygens's diagrams, Newton's cannot accommodate the mathematical transformations that constitute the body of his reasoning, especially when the transformations move in and out of the infinitesimal realm. The diagrams hold, at best, traces of those transformations in the elements of the configuration. Yet, tied to the configuration, even those traces mask, rather than reveal, their structure in terms of the parameters of the problem. For example, as line lengths in the last figure above, QT and QR give no hint of the nature of their dependence on the trajectory. That is why each application of Newton's measure of force to a new trajectory required its own demonstration. Before the variables could be rearranged, they had to be extricated from their geometrical setting.

As Leonhard Euler later complained, then, it took a highly practiced eye to "see" Newton's system of central-force dynamics in the diagrams of the *Principia*. There was nothing "natural" or evident about them. They formed, rather, intricate patterns of lines analyzable only by a body of sophisticated, at times even counterintuitive, concepts. To succeed at analyzing one such pattern gave no guarantee of succeeding with the next. Continental mathematicians of the generation before Euler's, schooled in a Cartesian tradition, felt that in Leibniz's calculus as articulated by the Bernoullis they had a mathematical language adequate to setting forth those concepts explicitly. Soon after the appearance of the *Principia*, they undertook to recast Newton's work into that language, which they thought more suited to it than its original geometrical style. For example, in a series of memoirs presented to the Academy of Sciences in the early 1700s,[40] Pierre Varignon showed, among other things, that if y is the central force acting on a planet, r the radial distance of the planet from a fixed center, S the distance along the planet's orbit from a fixed point, and t the time, then $y = \dfrac{dS}{dr} \times \dfrac{d^2S}{dt^2}$. When translated into his preferred coordinate system of radius r and arc z ($= r\phi$, where ϕ is the angle between r and the axis linking the center and the fixed point), the general rule becomes $y = \dfrac{d^2r}{dt^2} + \dfrac{dz}{dr} \cdot \dfrac{d^2z}{dt^2}$. Applied to various astronomical hypotheses, it leads by mathematical calculation to the precise relations inherent in them among central force, center of force, orbit, and measure of time. For example, from the assumption that a planet is subject only to a centripetal attraction and to a counteracting centrifugal force, i.e., that $y = \dfrac{d^2r}{dt^2} - \dfrac{1}{r}\left(\dfrac{dz}{dt}\right)^2$, where each term represents a force, it

follows that the planet sweeps out areas proportional to the times, i.e., that $r\,dz = k\,dt$, and conversely. From the latter it easily follows that the measure of the resultant force is $\dfrac{d^2r}{dt^2} - \dfrac{1}{r^3}$. If, in addition, the planet travels on an ellipse with the center of force at one focus, the force then varies inversely as the square of the distance from that focus, i.e., $y = \dfrac{k'}{r^2}$.

Using algebraic symbolism to represent the mathematical description and analysis of quantitative physical relations thus opened to view the nature of the correspondence that such an interpretation of nature posited between the structure of those relations, or of the mechanisms that embody them, and the structure of the relations among the mathematical quantities themselves.[41] The equation $v = \dfrac{dS}{dt}$ as a statement of the calculus relates three domains of quantity in expressing the physical notion that motion is change of distance over time and that the velocity of motion is the relative rate of change of distance with respect to time. The equation $a = \dfrac{dv}{dt}$ describes a corresponding notion of acceleration as the rate of change of velocity with respect to time. To move from the first equation to the statement that $S = \int v\,dt$ is to assert a correspondence between the mathematical operation of integration—the formation of a limit-sum—and the physical process of motion over time resulting in traversal of distance. More importantly, to use the first equation to rewrite the second in the form $a = \dfrac{d}{dt}\!\left(\dfrac{dS}{dt}\right) = \dfrac{d^2S}{dt^2}$ is to posit a correspondence between the mathematical operation of differentiation and the physical process by which velocity changes from instant to instant of time. Newton's definition of force as mass times acceleration, expressed in the form $F = ma = m\dfrac{d^2S}{dt^2}$, then leads from this group of kinematical relations into the series of dynamical relations presented above, each tied to the others by the operations of algebra and the calculus, each exhibiting its composition out of the basic parameters immediately measurable in the physical world.

In the view of Lodovico Cigoli, an artist alert to the currents of scientific thought in his time, a good diagram gave sight to the mathematician investigating nature. In the view of Euler, a mathematician setting the course of scientific thought in his time, a diagram, however good, formed a curtain hiding the essence of mechanics; it took algebra to lift that curtain. That contrast between late Renaissance artist and early Enlightenment mathematician cannot be resolved into different stages along the same line of progress. The positions lie on different trajectories.

A clear line of development links the treatises of Taccola and Francesco di Giorgio Martini in the early fifteenth century to Diderot's *Encyclopédie* and the subsequent *Description des arts et métiers* in the mid-eighteenth.[42] Thereafter, that line branched. Illustrated encyclopedias and manuals of machines con-

tinued to catalog an ever-expanding inventory of new devices right through that latter part of the nineteenth century that is commonly referred to (for some mysterious reason) as the "*First* Machine Age." At the same time the work of Monge and others in descriptive geometry defined a new body of techniques for mechanical drawings which, when coupled with advances in the machining of precision tools, enabled machinists to build machines directly from engineers' drawings.

By contrast, despite the efforts and apparent success of Galileo, Huygens, and Newton, mechanicians at the turn of the eighteenth century described machines—and in particular the great machines of the heavens—not by drawing pictures of them but by writing differential equations for them. Analytic mechanics, that is, mechanics expounded in the language of symbolic algebra and by the methods of infinitesimal analysis, became the premiere science and the touchstone for natural philosophy in the mechanistic mode. As such, it epitomizes the Scientific Revolution of the previous century, at least as an intellectual phenomenon. Historical and cultural explanations for that unique occurrence must, therefore, take account of the conceptual structure of the algebraic, analytic approach to mechanics in particular and to mathematics in general. Part of that structure involves a conscious move away from the visual, tactile world of immediate experience and into abstract, logical worlds of imaginative construction, where mathematical reasoning could operate freed from the constraints of physical ontology, where the mind could summon into mathematical existence whatever composite quantitative relations it required to make systematic sense of the perceived world.

The emergence of the fifteenth and sixteenth centuries of new conventions of pictorial representation may well prove to have developmental themes in common with those of the new mathematics a century later.[43] But to link in a directly causal manner new techniques for the accurate depiction of machines with the emergence of the science of mechanics is to ignore the line of thought that drove the diagram from dynamics.

NOTES

1. Quoted by Giorgio de Santillana, *The Crime of Galileo* (Chicago, 1955), 22.

2. *Mechanica sive motus scientia analytice exposita* (St. Petersburg, 1736), Preface, [*iv*].

3. Presented originally to the Folger Symposium out of which the present volume grew, Edgerton's paper appears in Margaret A. Hagen, ed., *The Perception of Pictures* (New York, 1980), 1:179–212. Panofsky set forth his thesis at a conference held at the Metropolitan Museum of Art in 1952; the paper appeared in revised form as "Artist, Scientist, Genius: Notes on the Renaissance Dämmerung," in *The Renaissance: Six Essays* (New York, 1962).

4. Edgerton, 181.

5. Ibid., 195.

6. Repr. in photo-offset, Westmead, Farnborough, Hants., England, 1970. English translation, *The Various and Ingenious Machines of Agostino Ramelli*, trans. Martha Teach Gnudi, annot. by Eugene S. Ferguson (Baltimore, 1976). Excerpts in A. G. Keller, ed., *A Theater of Machines* (London, 1964; New York, 1965).

7. Edgerton, 210. In the version of the paper read to the Folger Symposium, Edgerton went so far as to ask rhetorically: "Dare we say that Chinese attitudes toward art per se inhibited an indigenous Chinese scientific revolution?" Evidently he has since drawn back from such outright assertion of a direct causal relation.

8. The one essentially new device, for which Taccola's notebooks offer the first documentary evidence, was the suction pump with valved piston. It figures prominently in the theaters of machines, e.g., in Francesco di Giorgio Martini's *Trattato d'architettura* of 1475, in Leonardo's drawings of about 1480, and in Agricola's *De re metallica* of 1530. See Sheldon Shapiro, "The Origin of the Suction Pump," *Technology and Culture* 5 (1964): 566–80.

9. Compare, for example, Galileo's *Le meccaniche* (ca. 1600), in which mechanics consists of the statics of simple machines, with Newton's *Principia* (1687), the Preface of which defines mechanics as "the science, accurately set forth and demonstrated, of the motions that result from any forces whatever, and of the forces that are required for any motions whatever."

10. The pendulum was perhaps the single most important mechanical phenomenon of the seventeenth century. Its mathematical description, in particular the measure of its period, posed a fertile problem for theoretical analysis. It provided a means of both qualitative and quantitative experimentation on falling and colliding bodies. It gave an accurate measure of time, especially when fitted to a weight-driven or spring-driven clock. Its variations, in particular the cycloidal pendulum, gave rise to the mathematical theory of evolutes. Variations in its period at different locations on the earth required new theories of the shape of the terrestrial globe and of the distribution of gravitational force. For an initial orientation see P. E. Ariotti, "Aspects of the Conception and Development of the Pendulum in the 17th Century," *Archive for History of Exact Sciences* 8 (1972): 329–410. Cf. also below, n. 34.

11. It would be helpful to have a comprehensive, critical study of mathematical diagrams in early modern scientific writings, looking both at the (possibly changing) function they served within the text and at the way in which they were produced for printing. At present only a scattering of case studies exists.

12. M. S. Mahoney, "Die Anfänge der algebraischen Denkweise im 17. Jahrhundert," *RETE* 1 (1971): 15–31 (Engl. translation in Stephen Gaukroger, ed., *Descartes: Philosophy, Mathematics & Physics* [Sussex and Totowa, 1981], chap. 5).

13. William B. Parson's *Engineers and Engineering in the Renaissance* (Baltimore, 1939; rpt. Cambridge, Mass., 1967) concentrates on the actual projects of civil and structural engineering carried out by engineers of the period, while Bertrand Gille's *Engineers of the Renaissance* (Cambridge, Mass., 1967; French orig., Paris, 1954) focuses on their writings and drawings. What remains largely untreated in the current secondary literature is the structure of the engineering community: who became an engineer, how did he do so, what did he do in carrying out his *métier*? Until that set of questions is addressed, it will be difficult to know precisely what purpose was served by the literature on machines.

14. Let us set aside for the moment the difficult problem of how much of the "realism" of a depiction lies in the eye of the viewer, or more precisely, in the mind of the viewer (cf., for example, E. H. Gombrich's *Art and Illusion* [Princeton, 1956] for one classic exploration). Here it suffices to say that from the fifteenth century on the fit between what was portrayed and what was built from that picture by widely scattered practitioners grew increasingly close.

15. Not everyone knew those rules. As late as the 1620s Genoa built a water-supply system that failed because it required raising a head of water greater than 20 *braccia* (\approx 36 ft.); cf. Stillman Drake, *Galileo at Work* (Chicago, 1978), 312.

16. Keller, *Theater*, 8; cf. Arnold Pacey, *The Maze of Ingenuity* (London, 1974; Cambridge, Mass., 1976), 108.

17. The drawings apparently circulated in manuscript for about a century before they were published in printed books. Hence, the treatise on mechanics and the theater of machines are roughly coeval.

18. It was, of course, the writers who put them into words. Most of the examples cited are taken, in substance if not verbatim, from Galileo's various works. Other examples from other writers (Stevin, Torricelli, Descartes, etc.) readily spring to mind.

19. Aristotle's *Mechanical Problems,* while it expounded the idea of a mathematical science of mechanics (thereby echoing remarks made in passing in other works), offered little by way of specific mathematical techniques. Moreover (to anticipate a point about to arise), when in the mid-seventeenth century geometers began to take mathematical account of the affine space of the perspectively viewed world, they again took their start from classical sources most notably Pappus's *Mathematical Collection.*

20. Versions of that claim and assertions of its radical, transforming importance to Western scientific thought are scattered throughout Edgerton's book (New York, 1975); see, for example, the conclusion on pp. 164–65.

21. See in particular his *Equilibrium of Planes* and *On Floating Bodies* (English translation in T. L. Heath, *The Works of Archimedes* [Cambridge, 1897; rpt. New York, 1950]). On the transmission, circulation, and influence of these texts up to the mid-sixteenth century, see Marshall Clagett, *Archimedes in the Middle Ages* 1 (Madison, 1964), 2–4 (Philadelphia, 1976–80).

22. *Discorsi e dimostrazioni matematiche intorno à due nuove scienze* (Leiden, 1638), 110; cf. the Engl. translations by Crew and DeSalvio (New York, 1914), 111, and Drake (Madison, 1974), 112.

23. For the original texts see Marshall Clagett and Ernest A. Moody, *The Medieval Science of Weights* (Madison, 1952). For Galileo's use of the Jordanian approach see I. E. Drabkin and S. Drake, *Galileo: On Motion and On Mechanics* (Madison, 1960), 64ff. *(De motu)* and 156ff. *(Le meccaniche).* The figure is taken from ibid., 155.

24. For an account of Galileo's work in Padua, especially in the areas of mechanics of concern here, see Maurice Clavelin, *The Natural Philosophy of Galileo* (Cambridge, Mass., 1974; French orig., Paris, 1968), chaps. 3, 6, 7.

25. Probable, as opposed to demonstrative, argument could lend support to a conviction or even shed further light on it, but only demonstrative argument could establish full conviction itself.

26. *Scientia de motu,* the study of motion as set forth in Aristotle's *Physics* and articulated by the logicians of Merton College and the University of Paris in the fourteenth century; cf. Marshall Clagett, *The Science of Mechanics in the Middle Ages* (Madison, 1959). Despite Clagett's title, *scientia de motu* had nothing to do with machines; nor, except for forms of the balance, did the science of weights, which he also includes in his account.

27. Alexandre Koyré first made the point in his *Etudes galiléennes* (Paris, 1939), 2, *La loi de la chute des corps. Descartes et Galilée.* Both men, but especially Descartes, fell victim to what Koyré termed *géométrisation à outrance,* a conceptual block that results from neglecting the temporal, i.e., non-spatial, nature of motion.

28. Note the shift here in the function of the inclined plane. Instead of being used to lift weights, it serves to slow down the acceleration of a falling body. Thus it changes from a statical to a dynamical machine.

29. *Opere,* ed. Favaro, 10:115; quoted by Koyré, *Etudes,* 2:4, n. 2: " . . . che il mobile naturale vadia crescendo di velocità con quella proportione che si discosta dal principio del suo moto."

30. *Discorsi,* 163–65; Crew/DeSalvio, 167–68; Drake, 159–61. For an explanation that aims at exculpating Galileo *malgré lui,* see Drake, *Galileo at Work,* 100ff. Drake's account lays emphasis on Galileo's assertion found in the fragment about to be discussed here: "Questo principio mi par molto naturale, e che risponda a tutte le esperienze che veggiamo negli strumenti e machine che operano percottendo, dove il percuziente fa tanto maggiore effetto, quando da più grande altezza casca. . . ."

31. Galileo, *Frammenti attenenti ai Discorsi, Opere,* ed. Favaro, 8:373; quoted by Koyré, *Etudes,* 2:21ff., n. 1.

32. *Discorsi,* Dialogo terzo, Theorem 2. Note the addition to the diagram of line *HI,* "along which the uniformly accelerated body falls from point *H,* as from the first beginning of motion." *HI* is the body's physical trajectory, now divorced from the inclined plane along which the motion takes place.

33. "Those things that do not require the present attention of the mind, but which are necessary to the conclusion, it is better to designate by the briefest symbols [*nota*] than by whole figures: in this way the memory cannot fail, nor will thought in the meantime be distracted by these things

which are to be retained while it is concerned with other things to be deduced. . . . By this effort, not only will we make a saving of many words, but, what is most important, we will exhibit the pure and bare terms of the problem, such that while nothing useful is omitted, nothing will be found in them which is superfluous and which vainly occupies the capacity of the mind, while the mind will be able to comprehend many things together." *Regulae ad directionem ingenii,* Rule 2, in *Oeuvres de Descartes,* ed. Adam and Tannery, 10:454; quoted by Mahoney, "Beginnings of Algebraic Thought," 150.

34. For further details of the example to follow, see M. S. Mahoney, "Christiaan Huygens: The Measurement of Time and of Longitude at Sea," in H. J. M. Bos et al. eds., *Studies on Christiaan Huygens* (Lisse, 1980), 234–70, esp. 239ff.

35. Nothing in the diagram itself suggested the nature of the curve in question. Rather, quite by coincidence, Huygens recognized in one of the relations among elements of the configuration a property of the cycloid. The mathematical reasoning took place yet again off the diagram. Cf. ibid., 241–46.

36. At the terminal speed reached at Z; by Galileo's results, that time was half the time taken by a body accelerating in free fall from rest over the distance AZ. Hence, Huygens ultimately compared the time of the pendulum's swing to that of its free fall over the same vertical distance.

37. Cf. Mahoney, *Fermat,* chap. 5.

38. On the mathematical difficulties of Newton's transition to the limit, see Eric J. Aiton, *The Vortex Theory of Planetary Motions* (London and New York, 1972), 103–5; for a more extensive discussion of their pertinence to Newton's concept of force, see Richard S. Westfall, *Force in Newton's Physics* (London and New York, 1971), chap. 8.

39. Newton did not publish this corollary as part of the text until the third edition in 1726. He had entered it, however, presumably at some early date, into his own interleaved and annotated copies of the first edition; see *Isaac Newton. Philosophiae naturalis principia mathematica. Third edition (1726) With Variant Readings,* ed. A. Koyré and I. B. Cohen (Cambridge, Mass. 1972), 1:90–91 (apparatus).

40. The titles of the first three of those memoirs, published in the *Mémoires de l'Académie Royale des Sciences* for 1700, convey the scope of Varignon's project: "Manière générale de déterminer les forces, les vitesses, les espaces, & les temps, une seule de ces quatre choses étant donnée dans toutes sortes de mouvements rectilignes variés à discrétion" (22–27), "Du mouvement en général par toutes sortes de courbes, & des forces centrales, tant centrifuge que centripètes, nécessaires aux corps qui les décrivent" (83ff.), "Des forces centrales, ou des pesanteurs nécessaires aux planètes pour leur faire décrire les orbes qu'on leur a supposés jusqu'ici" (218–37).

41. See Clifford Truesdell's now classic "A Program Toward Rediscovering the Rational Mechanics of the Age of Reason," *Archive for History of Exact Sciences* 1 (1960–62): 1–36, for some of the deeper insights that emerged from early eighteenth-century analyses.

42. Eugene S. Ferguson, "The Mind's Eye: Nonverbal Thought in Technology," *Science* 197 (1977): 827–36.

43. It would be interesting, for example, to explore the connections (if any) between Descartes' criteria and justification for a conventional notation in mathematics—that is, for a symbolic mathematics in the modern sense (above, n. 33)—and contemporary shifts in the nature and purpose of symbolic representation in painting; cf. E. H. Gombrich, "*Icones symbolicae:* Philosophies of Symbolism and their Bearing on Art," in his *Symbolic Images: Studies in the Art of the Renaissance* (London, 1972; rpt. 1975).